PORTRAITS OF LOVE

First published in France by Editions Filipacchi, Société Sonodip, *Paris Match*.

Copyright © 2002 Filipacchi Publishing, for the present edition
1633 Broadway
New York, NY 10019

Introduction © 2002 by Janet Maslin

Lauren Bacall By Myself, by Lauren Bacall, copyright © 1978 by Caprigo, Inc.
Used by permission of Alfred A. Knopf, a division of Random House, Inc.

Graphic design: Eléonore Thérond
Picture research: Nicole Lucas
Editorial: Nicolas Rabeau
Copy editing: Jennifer Ditsler
Color separation: Eurésys
Printed in France by Clerc

Translated from French by Simon Pleasance and Fronda Woods

ISBN: 2 85018 724 0

PORTRAITS OF LOVE
Great Romances of the 20th Century

With an introduction by Janet Maslin

PREMIERE

filipacchi publishing

Introduction

The sight of famous people in the bloom of love has a way of prompting mixed emotions. There they are: beautiful, enraptured, widely admired and endlessly photographed, inspiring images that will travel the world and roost in our collective memory. But the tenderness stirred by such pictures is liable to be accompanied by a touch of skepticism. Can it be that we're more interested in these lovestruck luminaries than they are in each other?

The weight of tremendous responsibility rests upon their well-toned shoulders. After all, they bear the burden of our tabloid dreams. They are expected to generate high drama with the simplest amorous exchanges, and the milestone events in their lives may have the staying power of history. How can private passion ever measure up to demands like this?

There are two kinds of photographs to be found in this book: deliberate and inadvertent. The latter, apparently candid shots are in some ways more memorable, if only for their hot-blooded carelessness. Visions of Richard Burton and Elizabeth Taylor mad for each other, lounging by the sea, convey a wild spontaneity that has nothing to do with cameras. They seem to have been caught off guard. Nobody has staged these moments. Had publicists been on hand, somebody would have whisked those packs of cigarettes out of camera range.

Candid images like these are alive with guilty pleasure, not only for the participants but also for the spectator. They validate our best hopes that these lovers enjoyed something real. Even when they capture the first stirrings of trouble—most famously, as Marilyn Monroe and Yves Montand shoot off sparks even in

the company of their spouses, Arthur Miller and Simone Signoret—these pictures attest to passion. They prove that those whose every move is scrutinized in public can still stake out private lives.

But it is the intentionally posed portraits in this book that are more deeply revealing. When high-profile couples choose to immortalize their love in this fashion, they present something more than unfiltered emotion. They acknowledge the complicity of the viewer, and they send some kind of willful message. Whether it is the sight of Humphrey Bogart and Lauren Bacall acting out scenes of domestic bliss (even in their doghouse!) or John Lennon and Yoko Ono in history's most awkwardly exhibitionistic nude shot, these pictures have been devised with a third party in mind.

And there is something vastly touching in that gesture—however many millions of times it may have been executed, by people in every possible stage of fame or bliss. Whatever their real lives are like, they have decided to create something even better for the camera's benefit. Never mind whether the arranging of kitchen equipment chez Bogart, with one child on the way and another looking weary of his fancy-dress photo session, is really the end of the rainbow for Hollywood royalty: this is still some press agent's version of the ideal.

And it goes hand in hand with the hidden side of love, at least when it comes to those who are this celebrated. They are in love not only with their sweethearts and spouses but also with the idea of love made immortal. The more radiant these visual love stories are, the longer they glow.

Janet Maslin

Contents

Marilyn & Arthur Miller

A "father's" love

Marilyn was an orphan. She needed a daddy. But she couldn't keep herself from destroying the man who loved her. When she first met the author of *The Crucible*, she was dazzled by the playwright who "looked like President Lincoln, only more intellectual."
– Outside Marilyn's home on Manhattan's Sutton Place, June 22, 1956. The press had been summoned for four P.M. Finally, at six, the sensational announcement.
– On June 29, 1956 in Connecticut, the writer and the Hollywood goddess would marry.
– A facsimile of middle-class life. "It's fantastic to have a career, but you can't cuddle up with it at night when you're cold," says Marilyn.
– At the Waldorf-Astoria hotel, for the "April in Paris" ball, an annual celebration of French elegance.
– For her, he was everything: guardian, secretary. For her, he sacrificed both his writing and his career. People would call him "Mr. Monroe."
– During the shooting of *The Misfits*, in 1960, she dressed him up as a tough guy from a *bal musette*— a French dancehall with an accordion band.
– Marilyn met Yves Montand in 1959, in New York City. They were reunited for the making of *Let's Make Love*, and their liaison hastened the demise of her marriage to Arthur Miller.

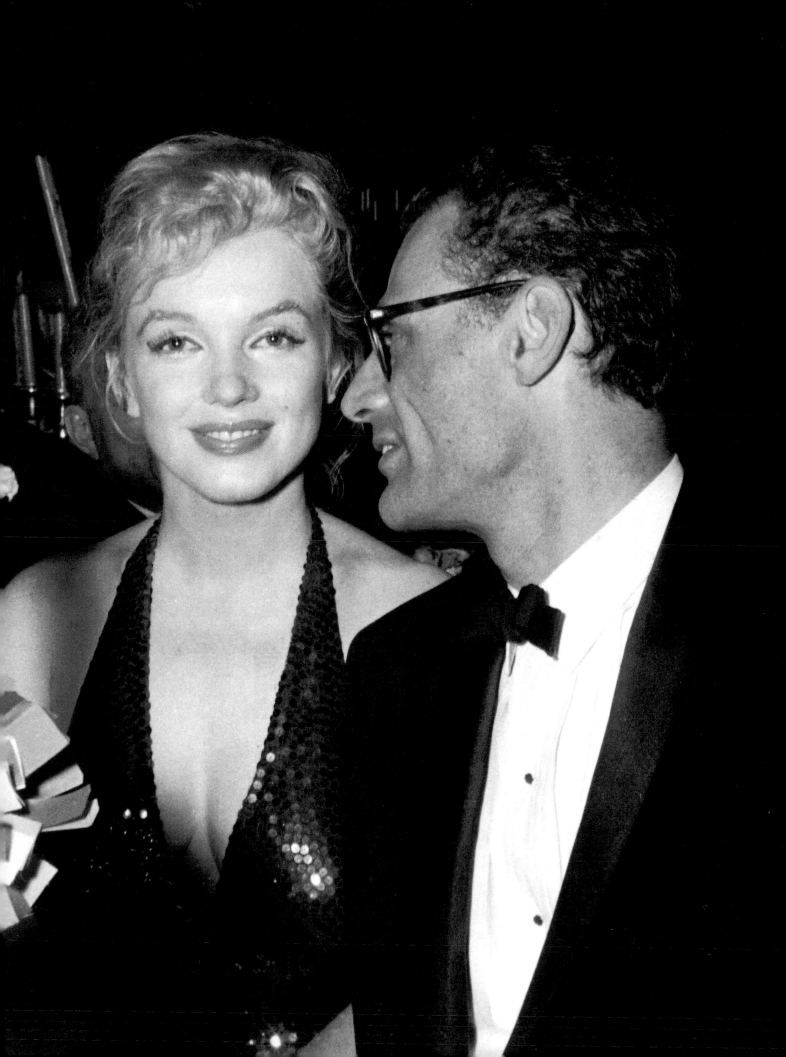

Earl Wilson, the columnist covering Broadway for the *New York Post*, didn't get a wink of sleep for three nights running. He'd received an important tip-off on November 8, the day the country was voting for the next U.S. president. He burst like a madman into the office of his editor in chief, Paul Sann: "Marilyn and Miller are divorcing!" Sann leapt to his feet: "That's fantastic!" Then he thought for a moment: "If we publish this scoop today, it'll be buried on the back page under tons of election news. Let's try to keep it secret for three days." It was risky, but the risk paid off.

On the afternoon of November 11, 1961, there was a scramble for copies of the *New York Post*. A few hours later, under a barrage of phone calls from all over the world, Marilyn Monroe confirmed the news. Arthur Miller got some friends to publish this terse bulletin: "Yes, it's true, we're getting divorced, by mutual consent."

Reno, Nevada, in the '50s, lives off two industries: gambling and divorce. Arthur Miller had spent the mandatory six weeks as a resident there in 1956, to put an end to his first marriage: he wanted to marry Marilyn Monroe. The cowboys at the ranch run by a certain Madam Stix, and a delicate young woman at her wits end from a broken marriage, provided him with the idea and setting for two short stories. That same year, using those short stories, he came up with his first original screenplay, *The Misfits*.

Marilyn's dream was to act in a film written by her husband. In *The Misfits*, she had a part that was tailor-made for her. All that was left for the director, John Huston, to do was complete the cast list, which he wanted to be dazzling. At the end of July, Clark Gable, Montgomery Clift and Eli Wallach joined Huston and Arthur Miller in Reno. Marilyn had to go by way of Hollywood first: there were a few link shots for *Let's Make Love* to be done at the Fox studios.

Yves Montand, America's new heartthrob, had been cast opposite Marilyn in *Let's Make Love*, and he was on his way back to Hollywood at that very same moment, to shoot *Sanctuary*, based on the Faulkner novel. The two costars found themselves on their own, without their respective spouses, at the Beverly Hills Hotel, where that spring the Millers and the Montands had shared the same floor of a bungalow on the hotel grounds. Right away, the front pages of the newspapers started talking about a romance. Yves and Marilyn met up at the Fox studios, but no one was able to say for sure whether they had seen each other elsewhere. Whatever the case, Simone Signoret caught the first flight to Hollywood. And on the preordained day Marilyn travelled to Reno to be with Miller and start shooting. Reno—fateful backdrop for so many broken hearts.

Like all Reno hotels, the Mapes had its own casino, where tourists gambled the night away amid a deafening hubbub. It wasn't exactly the ideal getaway for actors exhausted as much by the heat as by their very demanding roles, shot almost exclusively on location. It took anywhere between two and four hours by car to get to the shoot each morning. Miller would get there first, on his own, to discuss the day's work ahead with the crew. Marilyn, who was notorious for turning up late, had a more unpredictable schedule. She would turn up in her uniform—blue jeans and white blouse—with her usual retinue: hairdresser, makeup artist, dresser, and last but by no means least, her drama coach, Paula Strasberg, who acted as her general adviser and looked like a sort of large crow—invariably clad in black from head to toe. Marilyn was amazingly energetic. One day, near the dried-up lake where they were due to shoot with a herd of wild horses and some cowboys, she cried out: "Today's the day, isn't it, when the horses have to get used to the actors?" It took her quip to stir the listless, exhausted troupe out of their apathy. Evenings, when they returned to the hotel, the elevator doors closed behind Marilyn and Arthur. That was the last sign of them until the following morning, because they never went out in the evening. The crew would fondly murmur: "That's a couple of people in love for you." Clark Gable had rented a house in the suburbs where he stayed with his wife Kay, who was expecting. Marilyn got along very well with Montgomery Clift, whom she called "her brother," and Eli Wallach was a friend from way back. But they were all so tired that all they ever thought about was getting some sleep. On Sundays, their only day off, Marilyn would spend her time on Indian reservations. She would happily chatter and play with the copper-skinned children, but her eyes betrayed a deeper emotion: Did they remind her of her own wretched childhood?

On August 22, after five days shooting in the desert in temperatures too hot for almost anyone to bear, drama reared its head: all of a sudden, and for no apparent reason, Marilyn burst into tears. Neither Miller, nor Gable, nor Huston managed to calm her down. Everyone reckoned it was just her nerves—quite natural after all that crazy work. But despite a weekend spent resting up, Marilyn, once on the set, started sobbing uncontrollably again and finally collapsed, unable to utter a word. She had to be taken back to Hollywood. Filming came to a halt. In Dr. Engelberg's clinic, where Marilyn was made to rest in a darkened room, Arthur stayed by her bedside, attentive to her every need, loving, and worried.

In all that imposed idleness in Reno, people started to raise

questions. The lovebirds may have touched the hearts of those technicians, but were Arthur and Marilyn really as together as everyone thought?

With hindsight, people observed that when all was said and done, Arthur and Marilyn weren't together that often. They didn't stay deliberately apart from one another, but they didn't go looking for each other either. Miller, by nature, was an extremely reserved man, quiet, serious and certainly never one to make a scene in public. He inspired enough respect in his wife so that she did her best to control herself. But it was well known, from the most reliable sources, that the rumors of a romantic idyll between Marilyn and Montand had greatly upset Miller. He regularly went to look at the rushes, but Marilyn did not. People recalled that she had gone to San Francisco to hear Ella Fitzgerald sing—without her husband—but accompanied by that blackbird, Paula Strasberg. Paula, wife of Lee Strasberg who ran the famous Actors Studio, made herself indispensable to Marilyn. She was energetic and authoritarian, and would keep an eagle eye on her pupil's acting performance—something that irritated more than one director and co-actor. In Reno, rumor had it that Miller was no longer as friendly toward Paula as he had once been. The long and the short of it was that she got on his nerves.

The fact was that for Miller *The Misfits* was not just Marilyn's film, the way the others had been. It was, also first and foremost, his film and his work. As the film's author, he was much less of an assistant, confidant and secretary to his wife—touching roles, maybe, but just minor roles he'd held with her during the making of *Let's Make Love*, for example. During that period he had devoted himself to her completely, putting his writing career off until later. His friends lamented the fact under their breath: "It's a shame, they would say, to see America's greatest playwright reduced to being his wife's governess, and watch him wasting his time talking about her wardrobe and her publicity, and rewriting the hackneyed lines for some operetta-like dialogue. Look at him: ever since *A View from the Bridge*, in 1955, he's been Mr. Monroe, he hasn't done a damn thing.

Yet, on September 5, when a healed, rested Marilyn went back to Reno accompanied by Miller, everything seemed to have settled down. Miller was still the attentive husband people had always known. They appeared to be very affectionate toward one another. When the shooting was over on October 20, the Millers flew back to Hollywood where they stayed at the Beverly Hills Hotel and worked on the final scenes at Paramount studios.

The Millers had arranged to go back to New York on November 5, but this time Arthur and Marilyn took separate flights. Arthur took a room at a hotel, while Marilyn went back alone to their Upper East Side apartment. When Wilson's "bomb" exploded in the pages of the *Post*, Miller went into hiding—nobody knew where. Shut away in her apartment, Marilyn got her secretary to answer all her visitors and phone calls with the same statement: "Miss Monroe isn't seeing anybody. She doesn't feel very well. She doesn't wish to discuss her personal problems."

But whether Marilyn was available or not, everyone was talking about her and Miller. The reason behind the divorce was Yves Montand, said some. Others thought that Arthur Miller had had it with the Hollywood life. The third theory was that Marilyn was never satisfied with what she had. She was "unbearable," because her painful teenage years had made her emotionally unstable. Miller had taken everything on board for love of Marilyn. He had turned into her round-the-clock slave. But the more he did for her the less she respected him.

Perhaps, quite simply, Miller had grown tired of his life as the husband of a great movie star, invaded by publicity, drained by having to make concessions and compromises to mediocre and superficial people. He'd had a taste of sacrificing his writer's career to make his wife happy, and he realized that the sacrifice was too great. Marilyn's happiness didn't have anything to do with being a thoroughly fulfilled wife, dutifully waiting at the fireside while her husband finished writing his daily quota of pages. She not only wanted to be an actress—she wanted to be the most famous actress in the world. The conflict between these two artists, each carrying their creative demon, had no solution—the creative passion that had inspired each of them before they ever met, had already sealed their lonely fate.

A scarf over her fair hair, her eyes reddened behind dark glasses, Marilyn summarily dismissed the photographers thronging outside her front door. This was the first time she'd been out since the announcement of her divorce. She was on her way to see Paula Strasberg, the black-winged bird who had become the guardian angel of her career.

<div align="center">Stéphane Groueff</div>

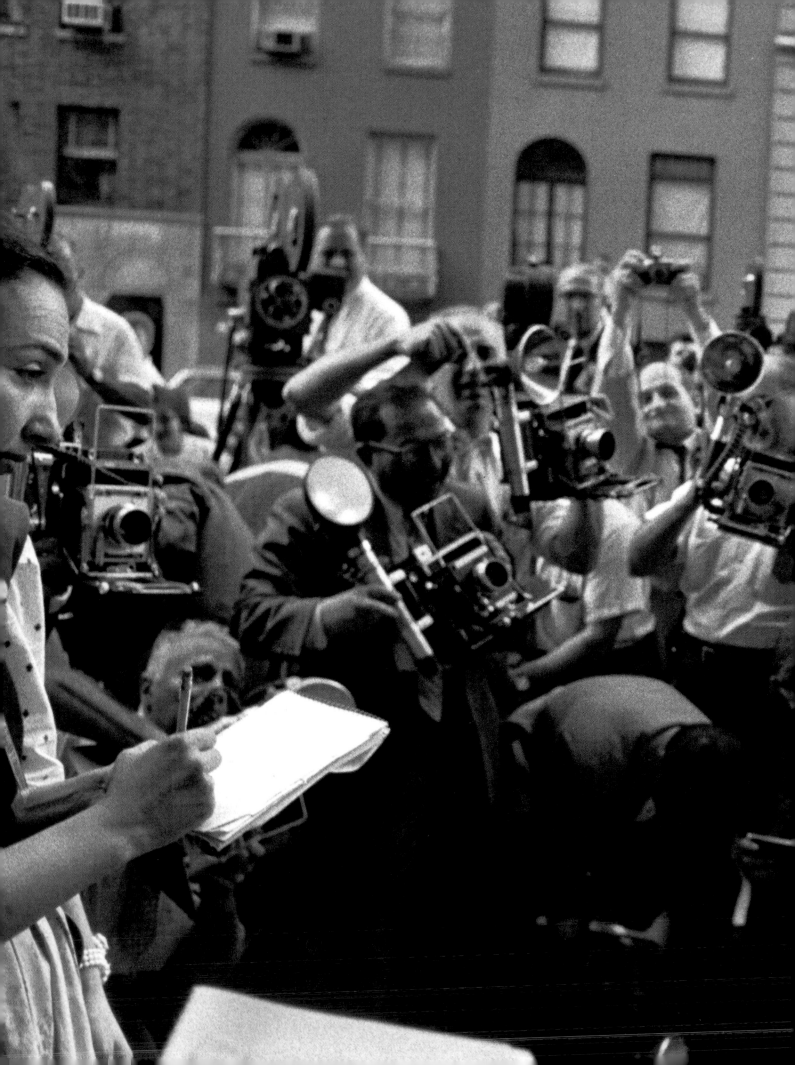

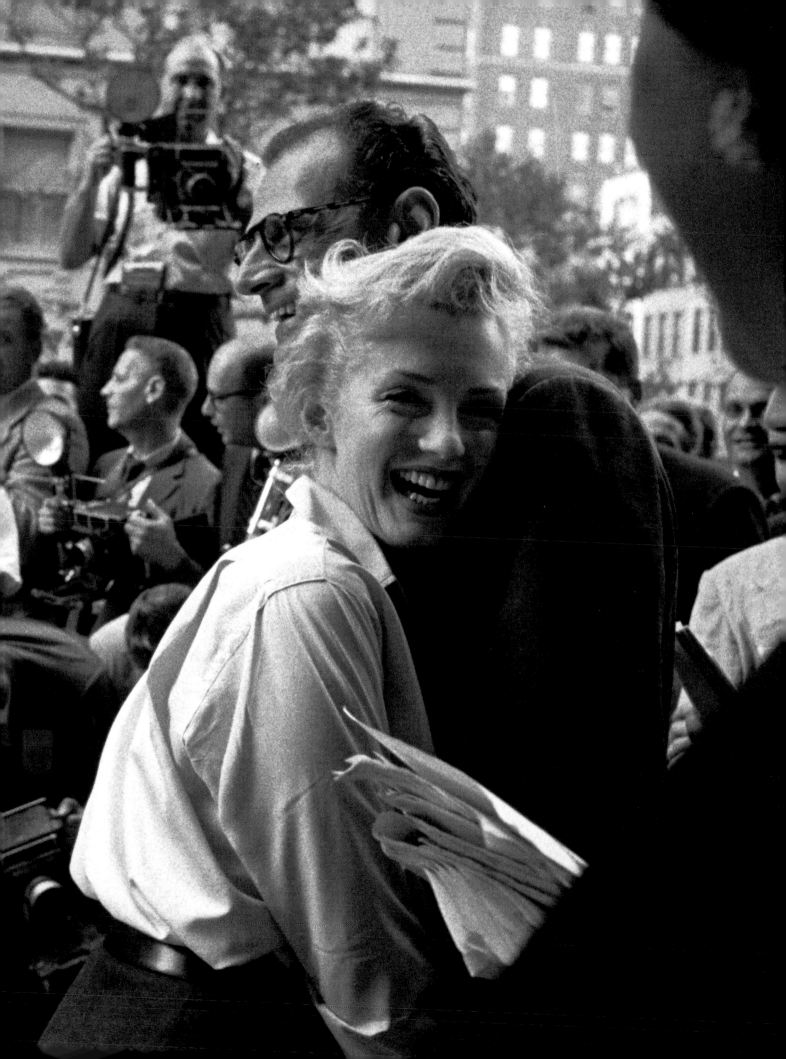

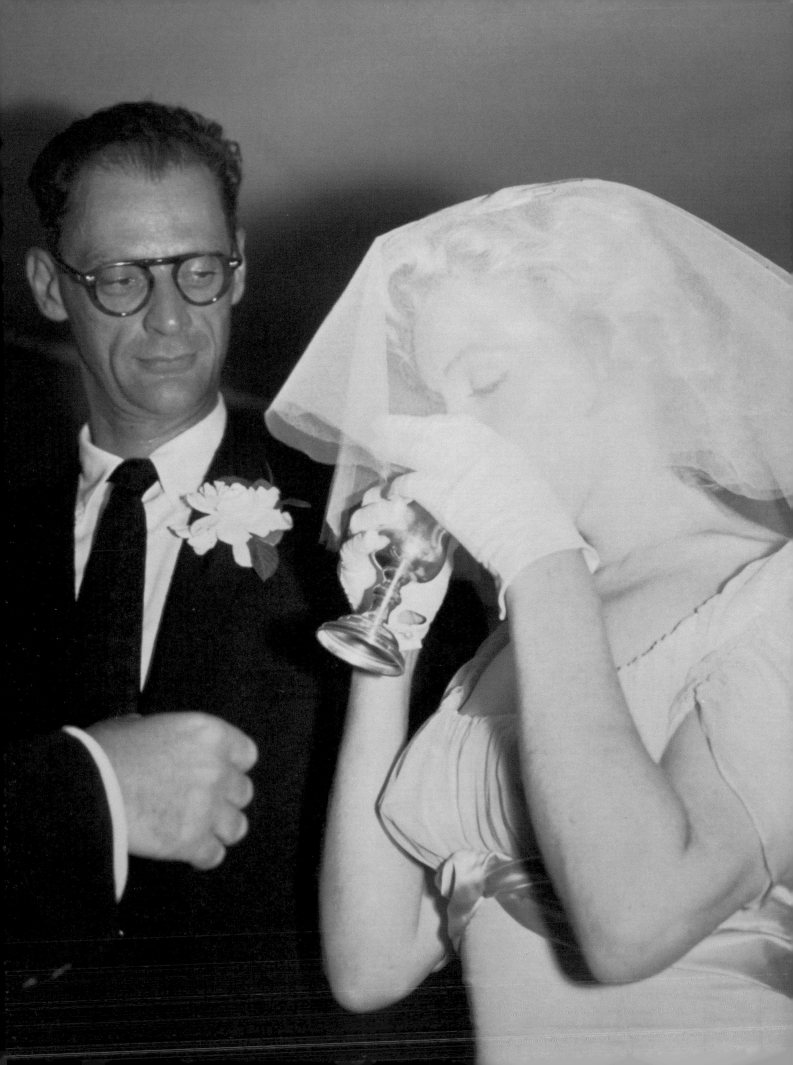

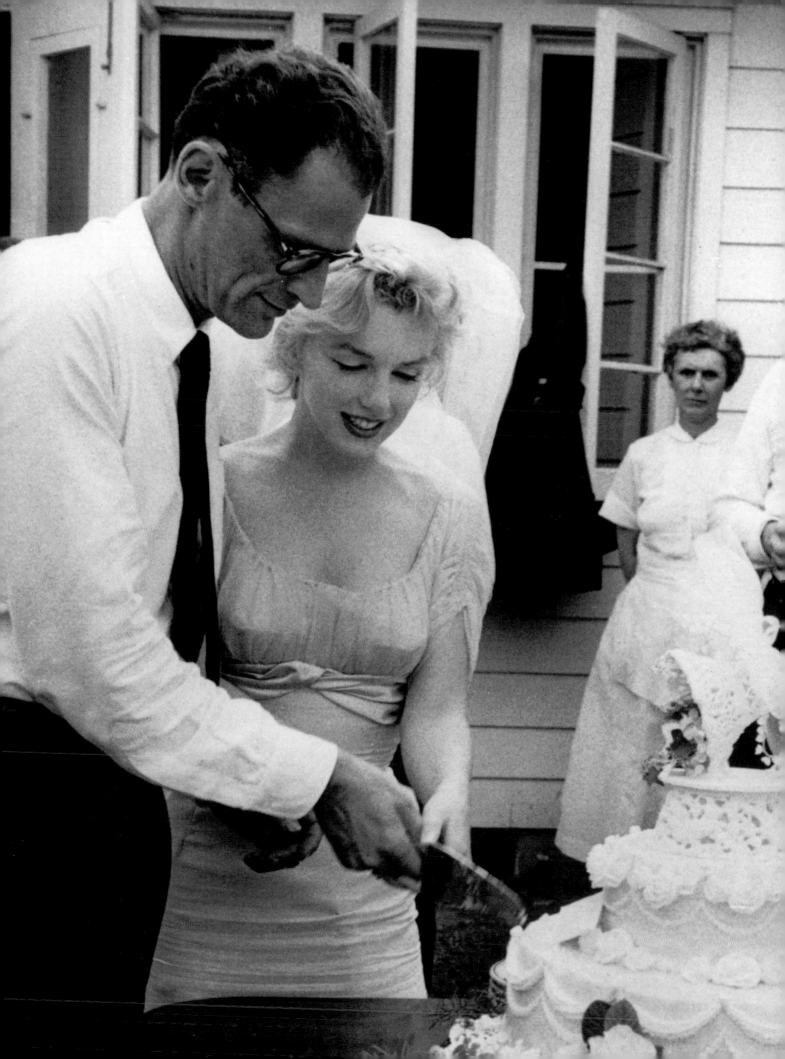

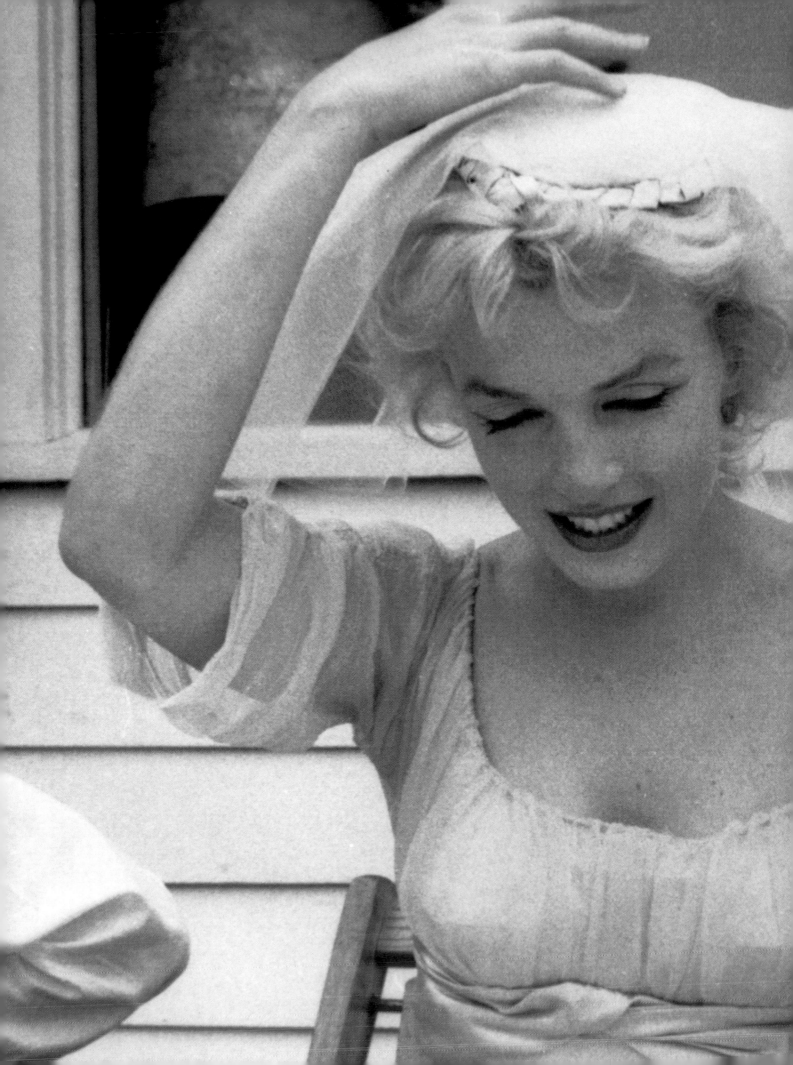

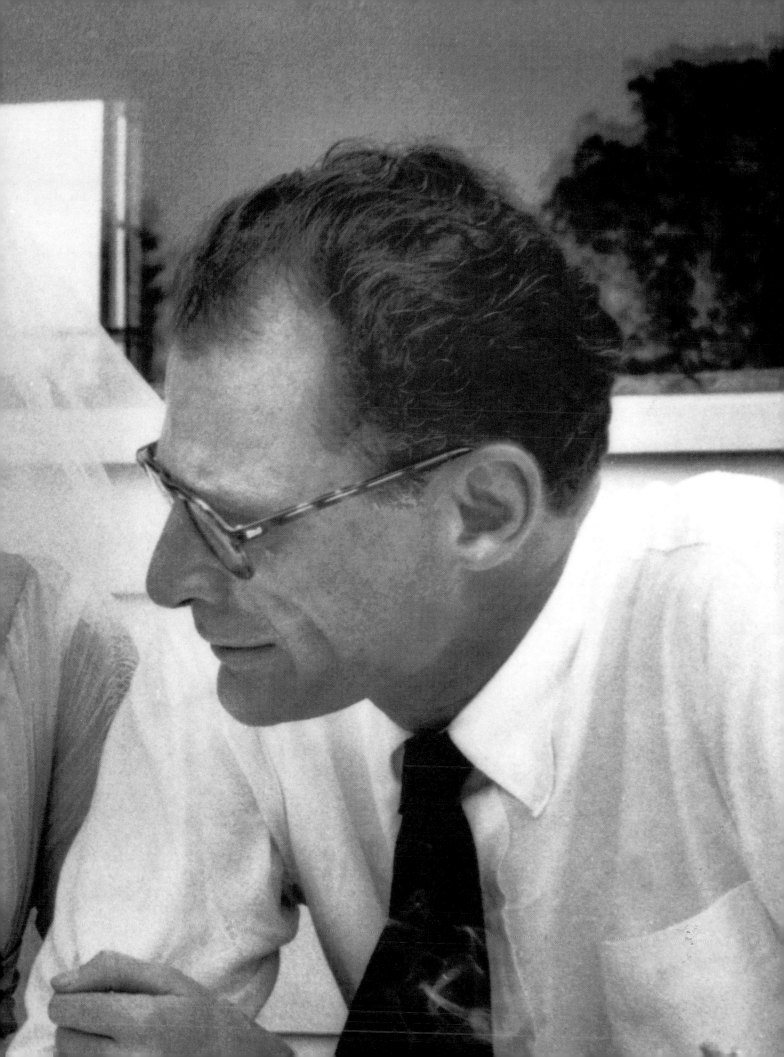

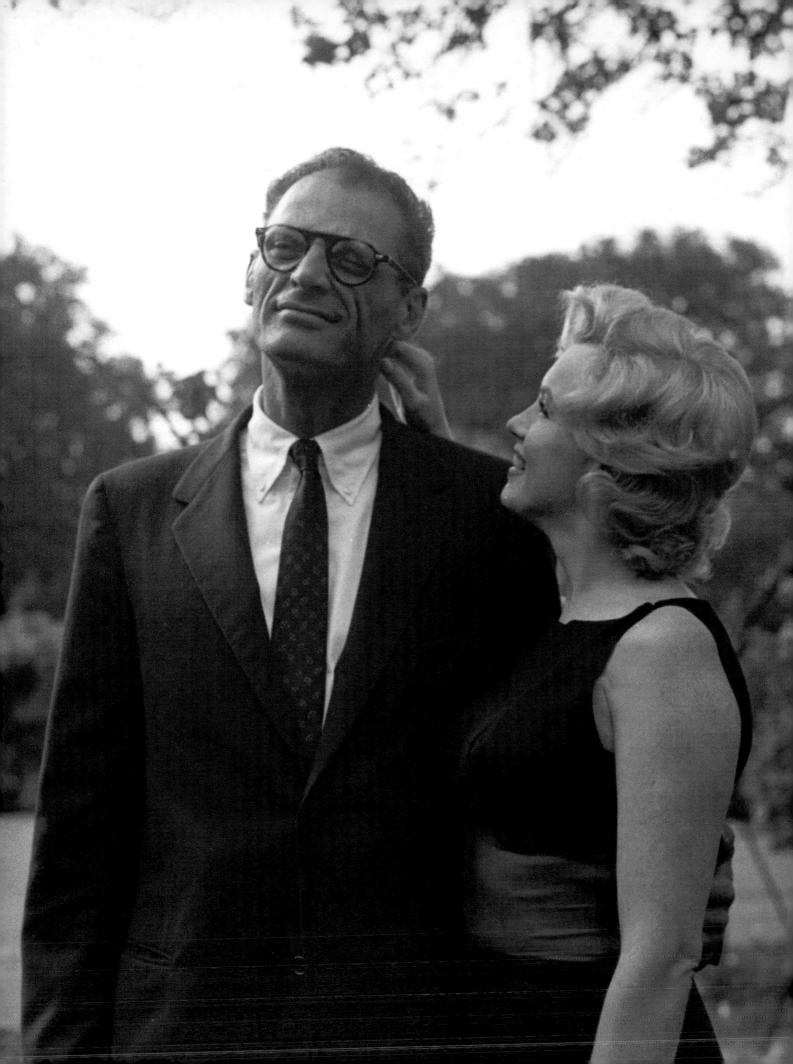

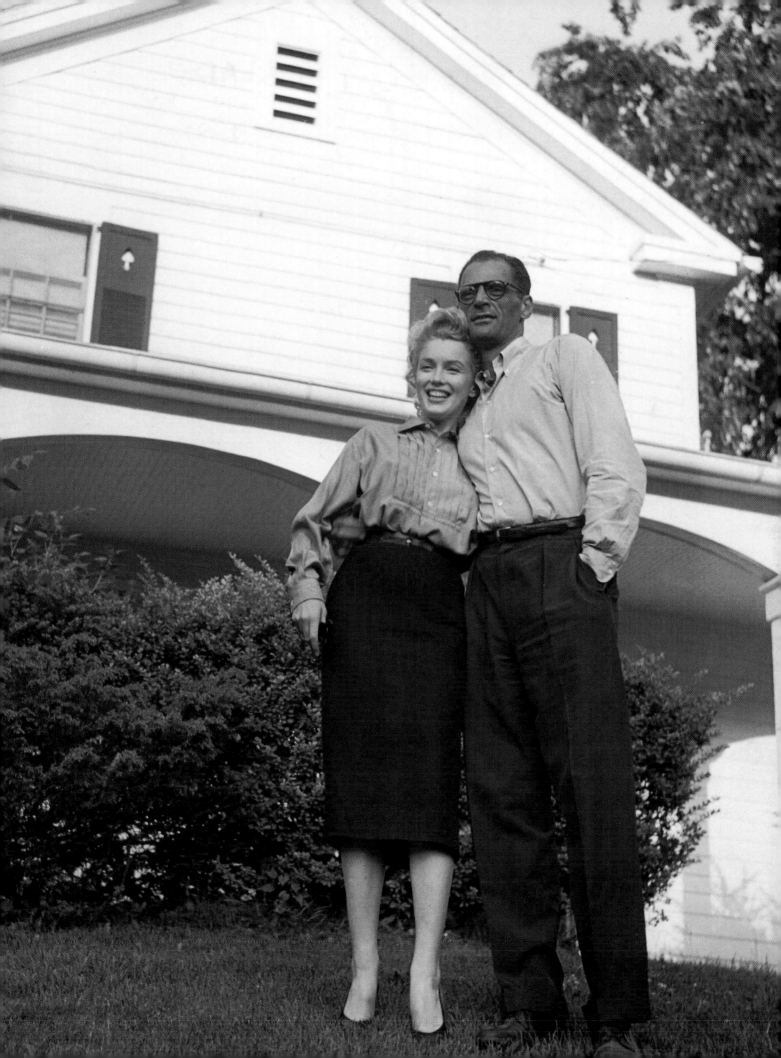

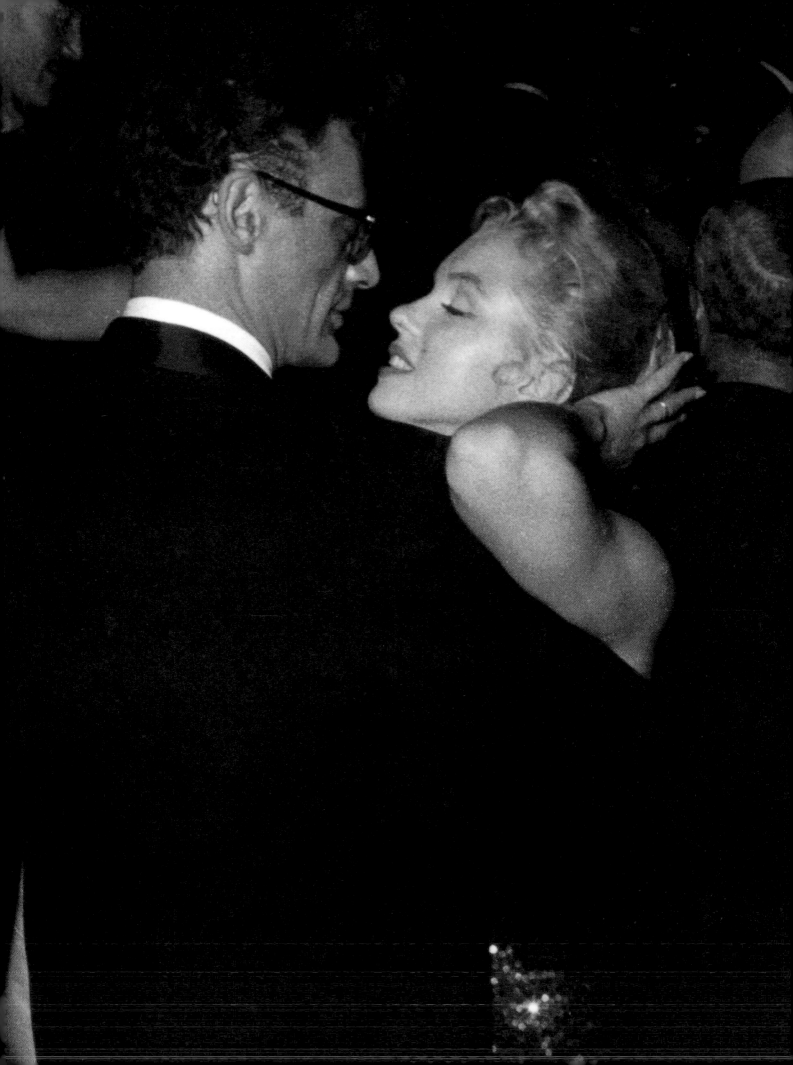

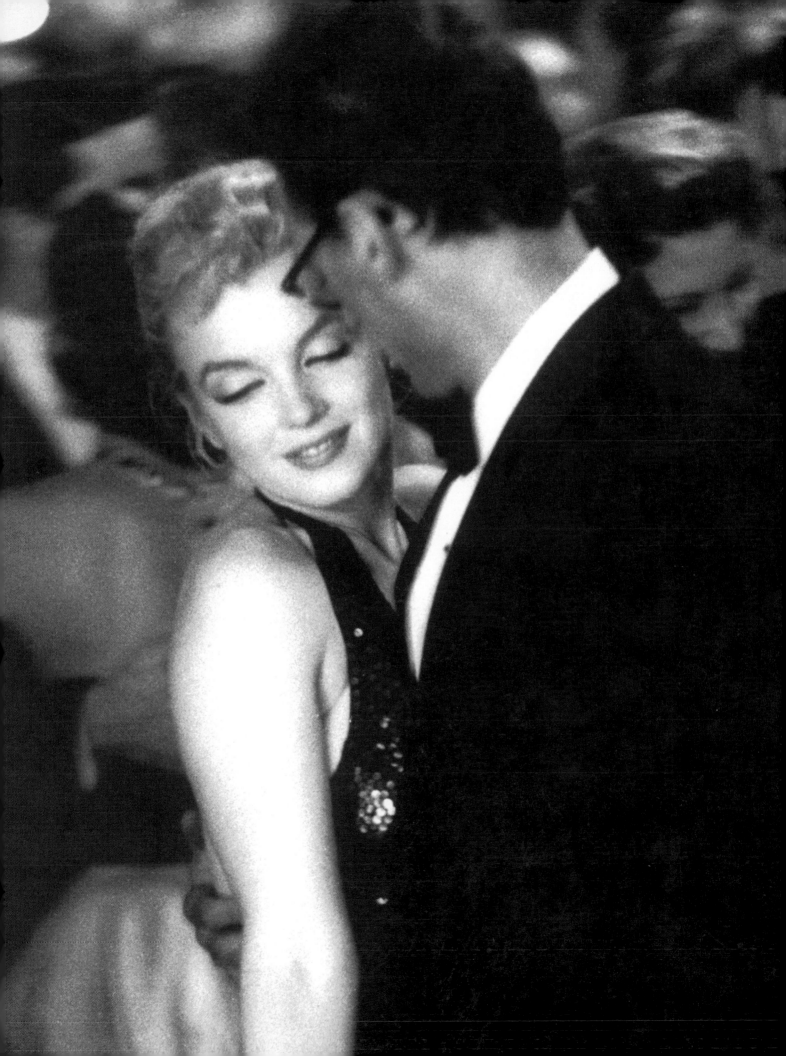

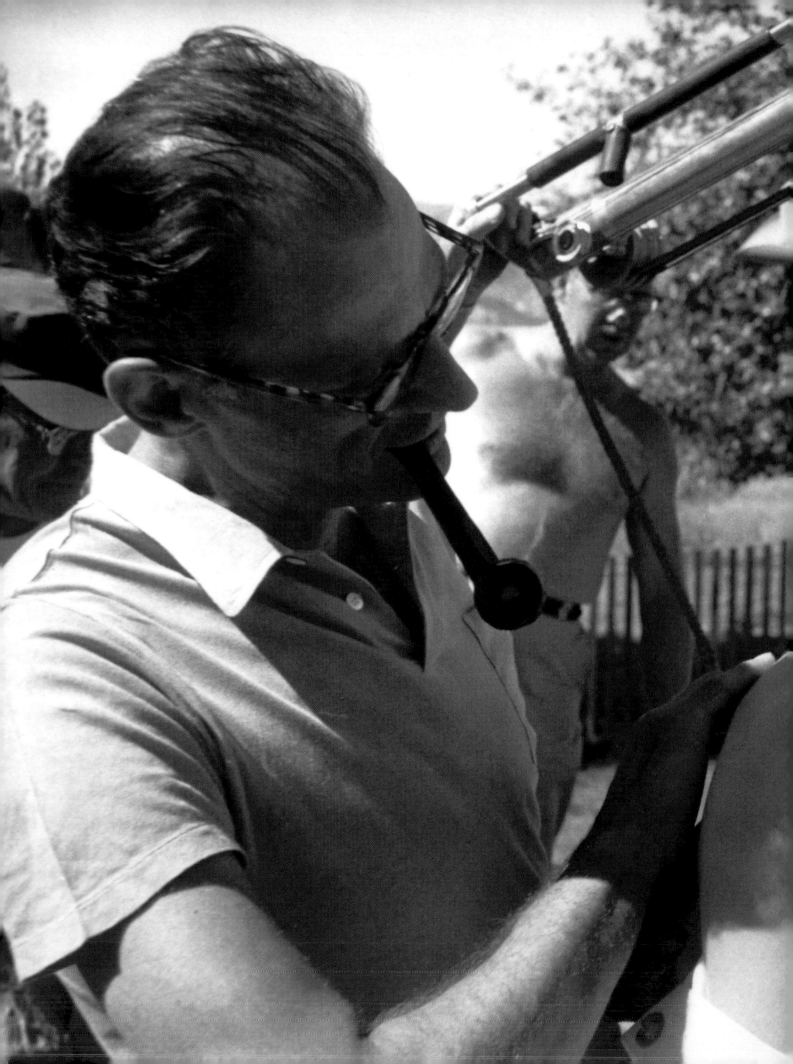

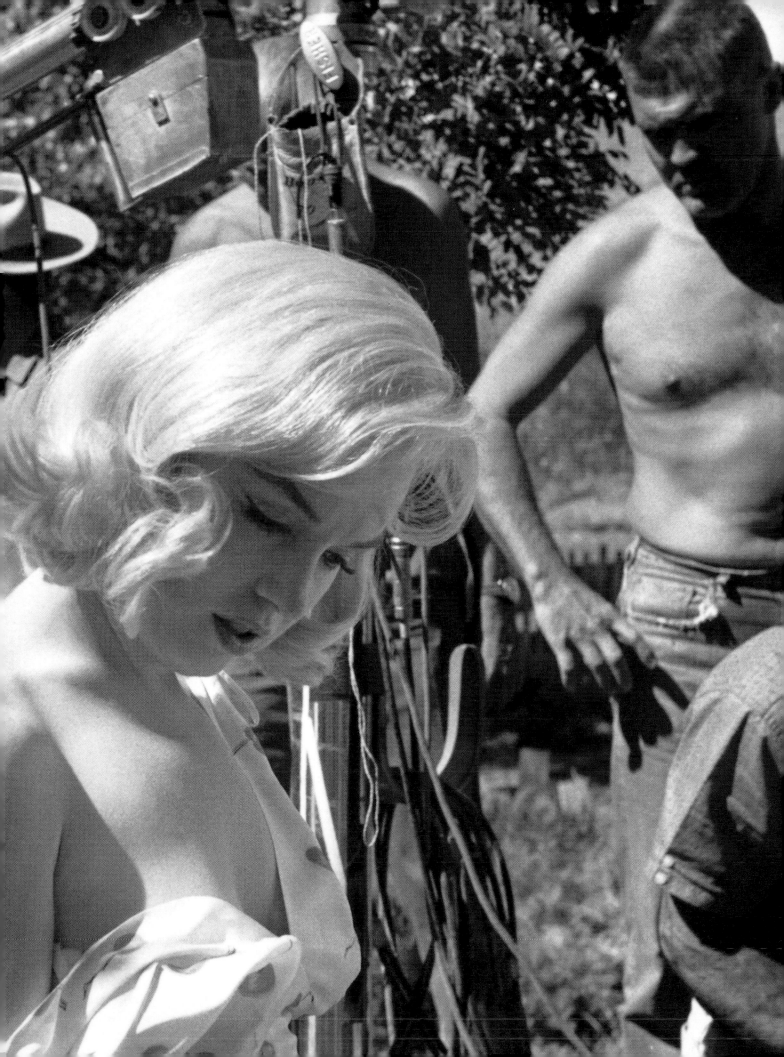

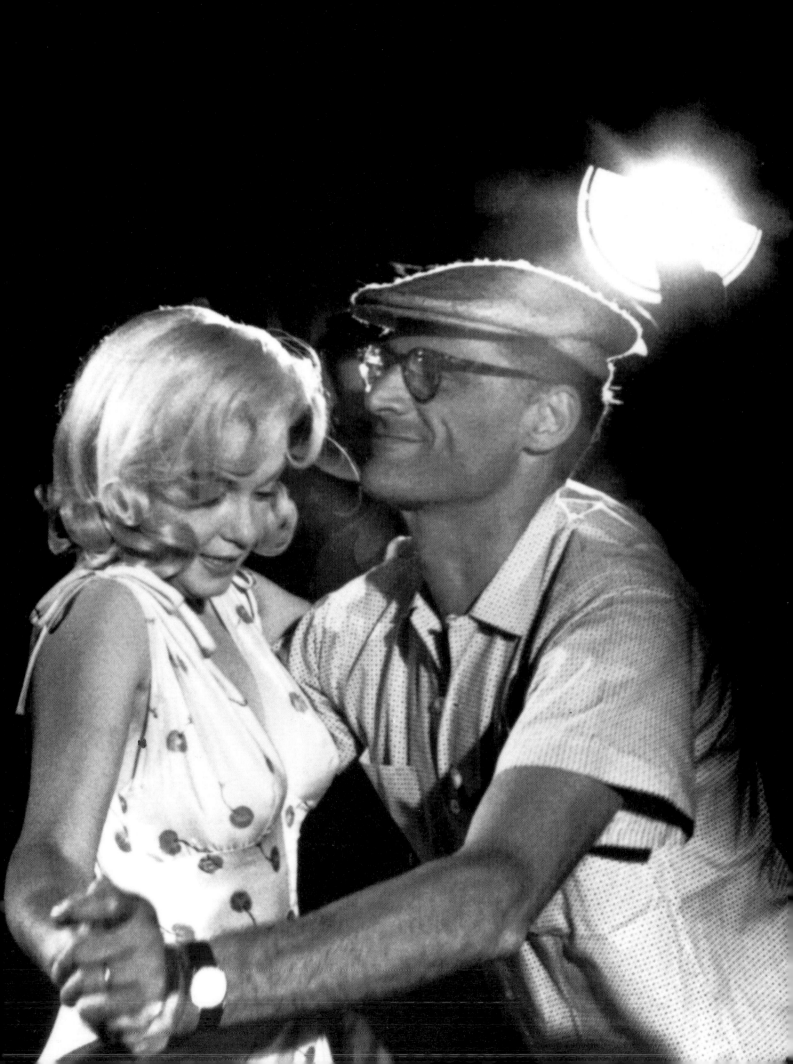

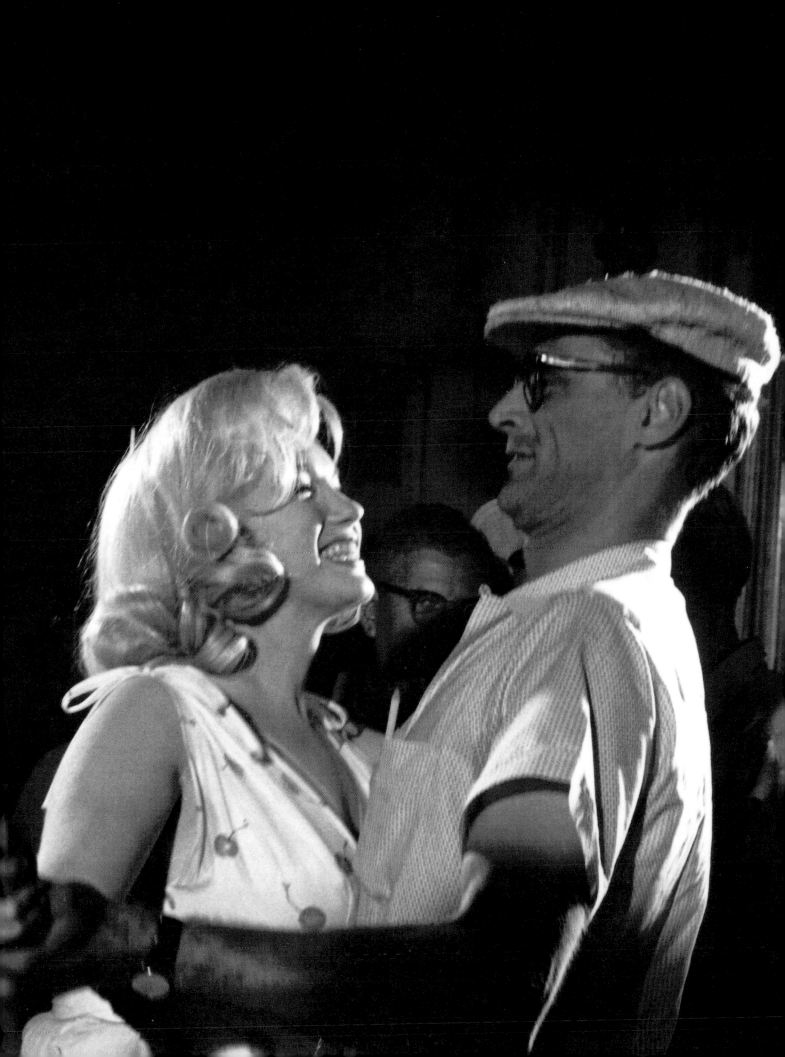

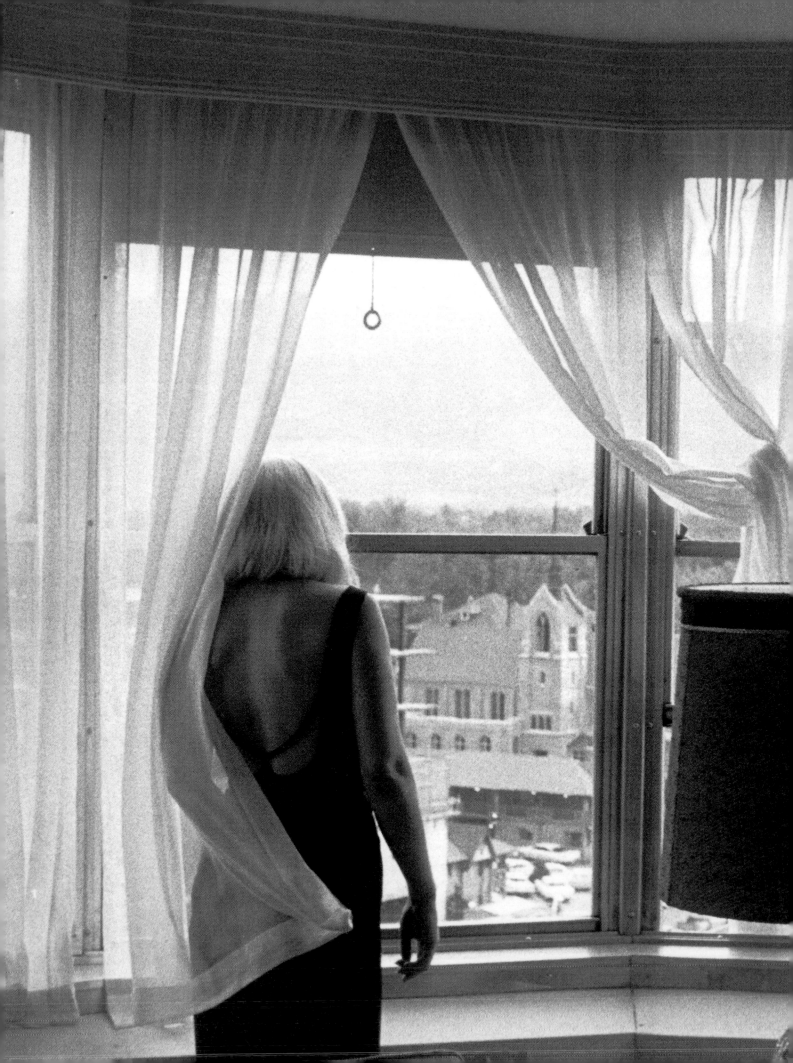

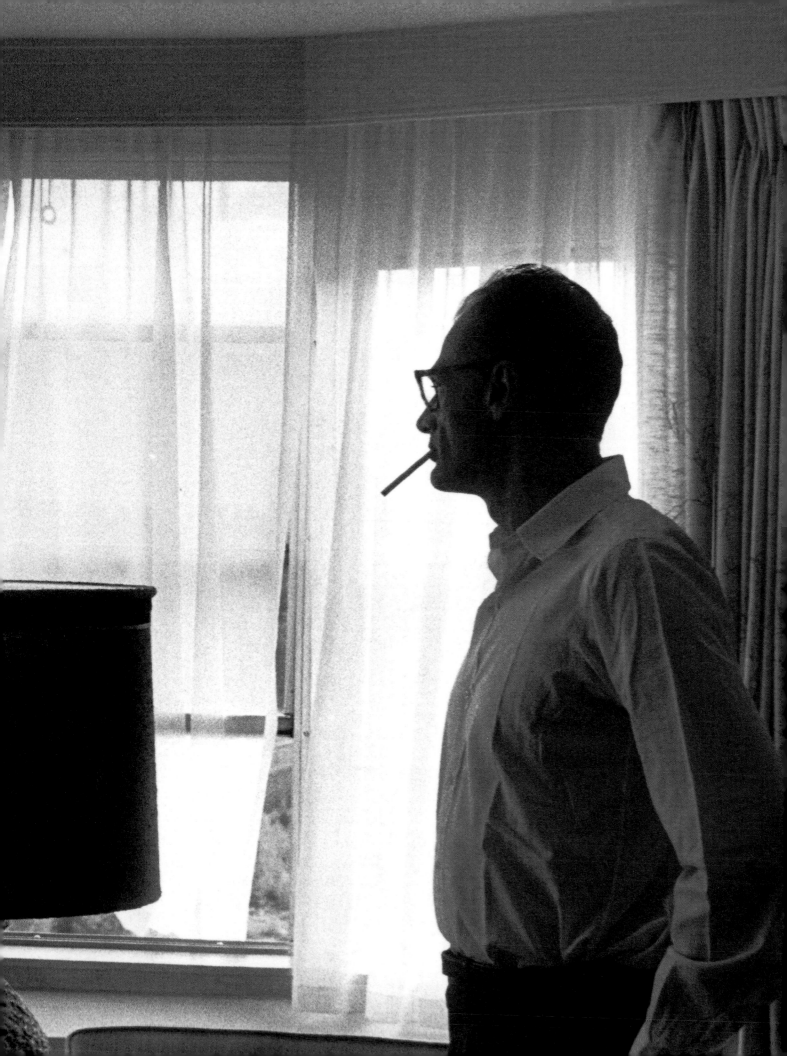

Bacall & Bogart

Meteoric love

"From their very first scene in *To Have and Have Not*, I knew something unique was going on between those two." (Director, Howard Hawks).

– 1944, *To Have and Have Not*, Bacall"s first film, made when she was 19. The sparkle in her eyes swiftly earned her the nickname "The Look." Two years later, the Hollywood couple were playing opposite each other again in *The Big Sleep*.

– At Newport, Rhode Island, he introduced her to his great passion, sailing. His yacht was named after his production company: La Santana.

– On May 21, 1945, scorning their 24-year age difference, they were married in Ohio. Bogart was deeply moved and wept throughout the ceremony.

– 1948, by the pool at their Benedict Canyon home. Now and then she would remind him that they still hadn't had their honeymoon. His answer: "We've already had a three-year honeymoon."

– On January 6, 1949, their first child, Steve, was born. Bogie, who feared that he might lose his wife's attentions and affections to a child, in the end took great delight in the joys of fatherhood. Leslie was born in 1952.

– On the set with his children—before being struck down in 1957, by throat cancer.

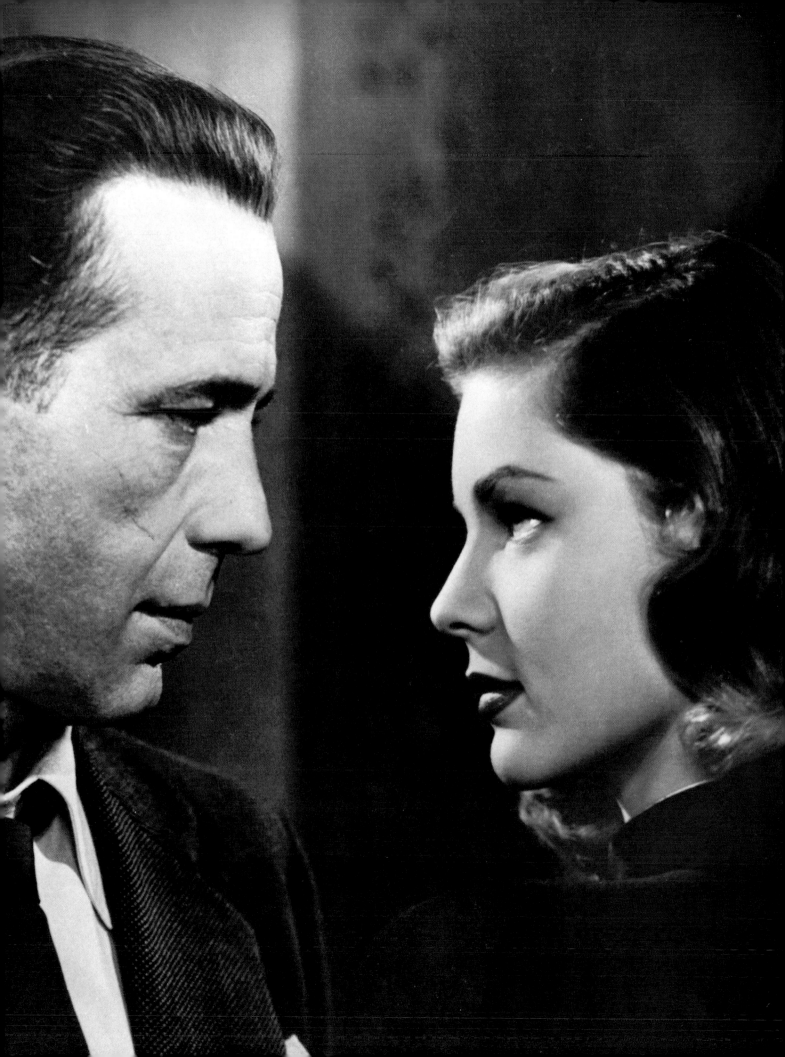

There was no clap of thunder, no lighting bolt, just a simple how-do-you-do. Bogart was slighter than I imagined—five feet ten and a half, wearing his costume of no-shape trousers, cotton shirt, and scarf around his neck. Nothing of import was said—we did not stay long—but he seemed a friendly man.

One day, a couple of weeks before the picture was to start, I was about to walk into Howard's office when Humphrey Bogart came walking out. He said: "I just saw your test. We will have a lot of fun together." Howard told me Bogart had truly liked the test and would be very helpful to me. I went onto the set the first day of shooting to see Howard and Bogart—I would not be working until the second day. Bogart's wife, Mayo Methot, was there—he introduced us.

Bogart tried to joke me out of it—he was quite aware that I was a new young thing who knew from nothing and was scared to death. I found out very quickly that day what a terrific man Bogart was. He did everything possible to put me at ease. He was on my side. I felt safe—I still shook, but I shook less.

He was not even remotely a flirt. I was, but I didn't flirt with him. There was much kidding around—our senses of humor went well together. Bogie's idea, of course, was that to make me laugh would relax me. He was right to a point but nothing on earth would have relaxed me completely!

I don't know how it happened—it was almost imperceptible. It was about three weeks into the picture—the end of the day—I had one more shot, and was sitting at the dressing table in the portable dressing room combing my hair. Bogie came in to bid me good night. He was standing behind me—we were joking as usual—when suddenly he leaned over, put his hand under my chin, and kissed me. It was impulsive—he was a bit shy—no lunging wolf tactics.

He took a worn package of matches out of his pocket and asked me to put my phone number on the back. I did. I don't know why I did, except it was kind of part of our game. Bogie was meticulous about not being too personal, was known for never fooling around with women at work or anywhere else. He was not that kind of man, and also he was married to a woman who was a notorious drinker and fighter. A tough lady who would hit you with an ashtray, lamp, anything, as soon as not.

I analyzed nothing then—I was much too happy—I was having the time of my life. From the start of the movie, as Bogie and I got to know each other better—

as the joking got more so—as we had more fun together—so the scenes changed little by little, our relationship strengthened on screen and involved us without our even knowing it. I certainly didn't know it. I'm sure Howard became aware fairly early on that there was something between us and used it in the film.

At the end of the day of the phone number, I went home as usual to my routine; after eating something, I looked at my lines for the next day and got into bed. Around eleven o'clock the phone rang. It was Bogie. He'd had a few drinks, was away from his house, and just wanted to see how I was. He called me Slim—I called him Steve, as in the movie. We joked back and forth—he finally said good night, he'd see me on the set. That was all, but from that moment on our relationship changed.

He invited me to lunch at Lakeside a few times—or we'd sit in my dressing room or his with the door open, finding out more about one another. If he had a chess game going on the set—he was a first rate chess player—I'd stand and watch, stand close to him. Physical proximity became more and more important. But still we joked. I said nothing to anyone about seeing Bogie outside the studio.

But anyone with half an eye could see that there was more between us than the scenes we played. I'd listen for his arrival in makeup in the morning. He'd get there at about 8:30 A.M.—he wore no makeup, just had his hair blackened in a bit in front where it was getting thin, but he'd come to see me having my hair combed out.

Sometimes we'd go to the set together. I'd always leave my dressing room door open so as not to miss him if he passed by. There was never enough time for me to be with him. In the picture I wore a black satin dress with a bare midriff that was held together with a black plastic ring. One day I cut out a picture of Bogie and fitted it into the ring—walked over to him casually on the set until he noticed it and laughed.

Our jokes were total corn: "What did the ceiling say to the wall?" "Hold me up, I'm plastered. "Do your eyes bother you?" "No." "They bother me." And I'd make my gorilla face, which consisted of putting my tongue under my upper lip and dropping my jaw. All silly but marvelous. We started to drive home together, leaving the studio with Bogie in the lead in his car, me following in mine. We drove over a small street that was curved and very residential—almost no traffic would

pass through. We'd pull over to the side and he'd come over to my car. There we would sit, holding hands, looking into each other's eyes, saying all the things we couldn't say at the studio. We'd sit on our street for fifteen or twenty minutes, dreading the moment of parting, then he'd get into his car and off we'd go. As he made the turn, he'd wave his hand out the window—I'd do the same and go on to Beverly Hills. It was romantic—it was fun—it was exciting—it was all-encompassing.

By now, Howard of course knew something was going on and he didn't like it. As we neared the end of the picture, he summoned me out to his house one night. I was petrified. Just he and his wife, Slim, were there. He sat me down and began. "When you started to work you were marvelous—paying attention, working hard. I thought, 'This girl is really something.' Then you started fooling around with Bogart. For one thing, it means nothing to him—this sort of thing happens all the time, he's not serious about you. When the picture's over, he'll forget all about it—that's the last you'll ever see of him. You're throwing away a chance anyone would give their right arm for. I'm not going to put up with it. I'll wash my hands of you."

Of course I burst into tears. Slim said, "But what do you do, Howard if you're stuck on a guy? How do you handle it?"

I was aware of being nineteen and he forty-four but when we were together that didn't seem to matter. Bogie began awakening feelings that were new to me. Just his looking at me could make me tremble. When he took my hand in his, the feeling caught me in the pit of my stomach—his hand was warm, protecting and full of love. And I wanted to give Bogie so much that he hadn't had. All the love that had been stored inside of me all my life for an invisible father, for a man. I could finally think of allowing it to pour over this man and fill his life with laughter, warmth, joy—things he hadn't had for such a long time, if ever. My imagination was working overtime.

To Have and Have Not was almost finished. Howard was happy—Warners was—Charlie was. Bogie and I were happy with the movie, but miserable at the thought of our separation.

About a week after the movie wrapped, I received my first letter from Bogie. He said how unhappy he was because I was not with him.

"I wish with all my heart that things were different—someday soon they will be. And now I know what was meant by, 'To say goodbye is to die a little'—because when I walked away from you that last time and saw you standing there so darling I did die a little in my heart. Steve."

As I read Bogie's letters, which were frequent and long, I realized how much he had shaken up his life. Now that he had left wife number three, he was free at last to look forward to something again. He hadn't believed anything good would ever happen in his life again—that he would have children—or love—or want anything as much as he wanted us to have a life together. He wrote to his business manager, Morgan Maree, about his settlement with Mayo, and he sent me a copy of the letter.

He was careful that I should know every step. I saw that he had completely exposed himself emotionally, that he was as vulnerable as a child—as prone to jealousy and anxiety as any kid in love for the first time would be.

I was a kid in love for the first time. Never in my life had or has a man cared so much for me, wanted so much to protect me, surround me with life's joys, share everything. It made me want to return the care. Bogie was taking me to "21" for dinner—our first in New York, alone, in front of everyone. But he promised to come up and meet my family, though he was less than enthusiastic, resenting anyone that took me away from him for five minutes. Bogie took me to Bleeck's—the Artists' and Writers' Club, just under the *New York Herald Tribune*, hangout for newsmen. So I was part of something new and something that was Bogie's.

And he educated me about Hollywood. Also that all through one's life one meets—and, in our business especially, is exposed to attractive people. The circumstance of seeing them every day, playing love scenes, going on location can make a love affair very tempting. But you must always weigh a quick romance against what your life is—think whether it's worth the risk. It almost never is. And he would chide me: "Long after I'm gone you'll remember this and see that I'm right."

From *By Myself,* by Lauren Bacall.

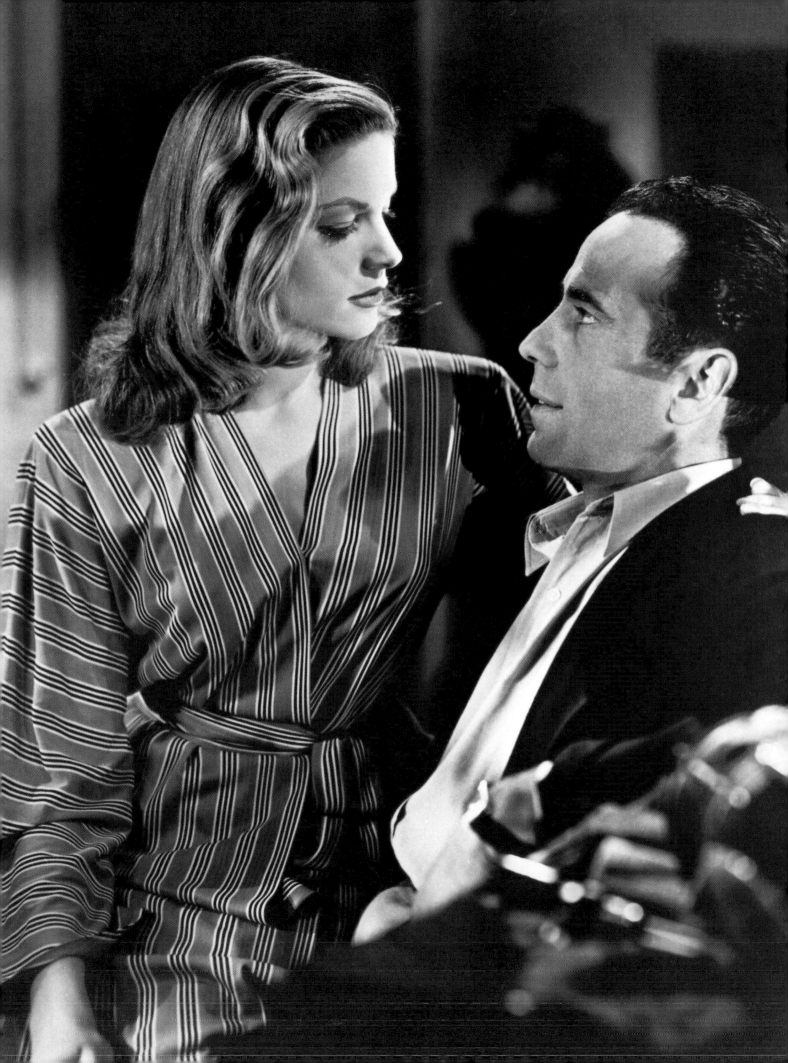

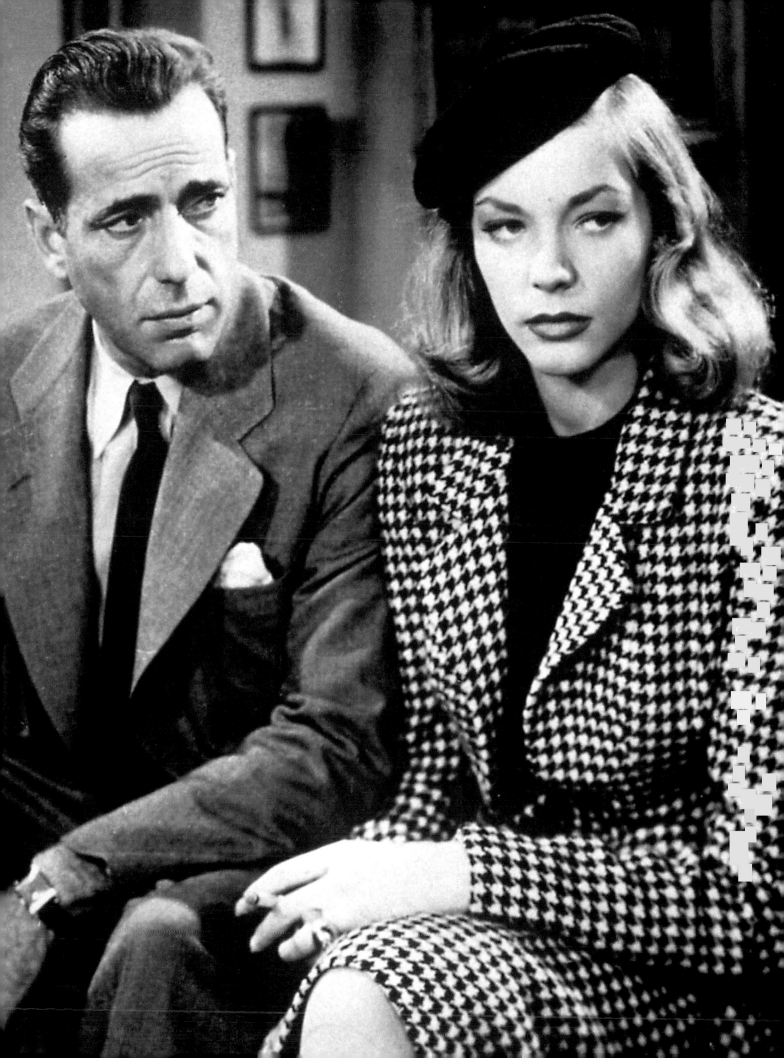

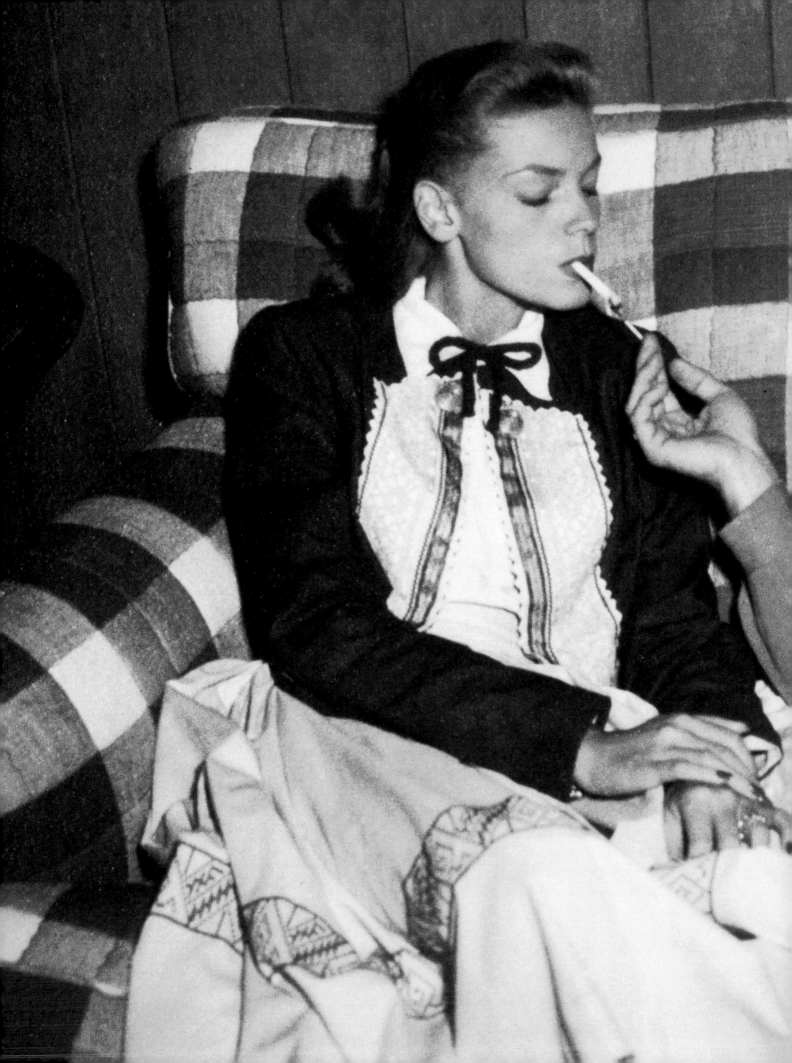

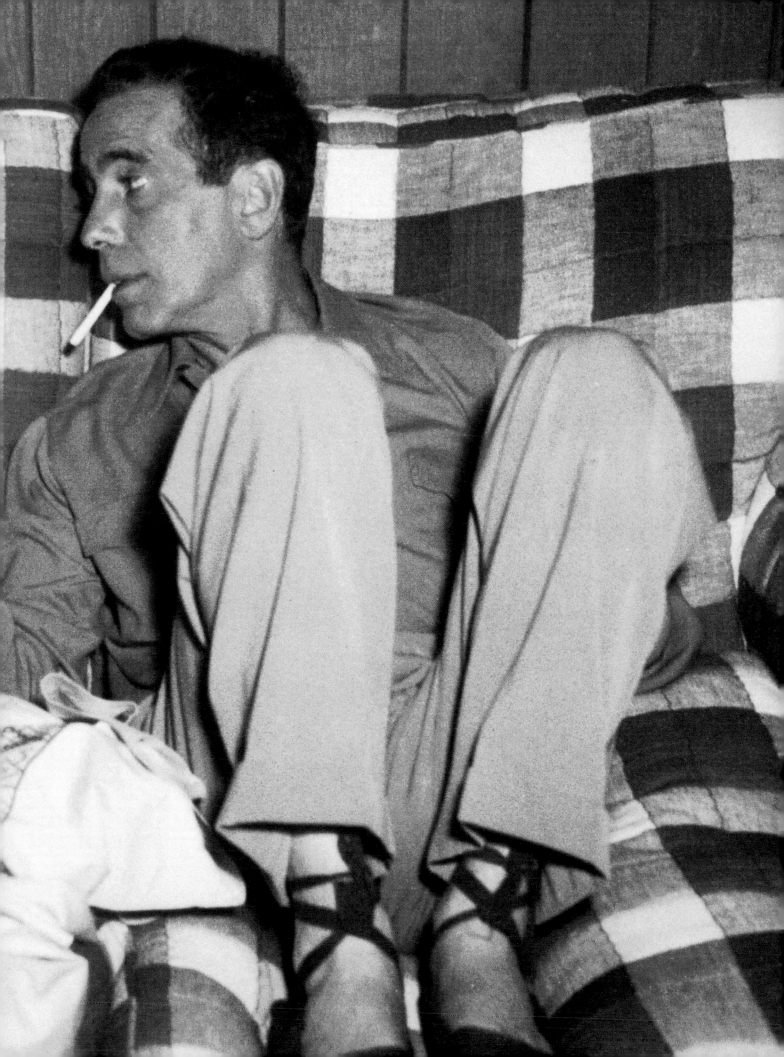

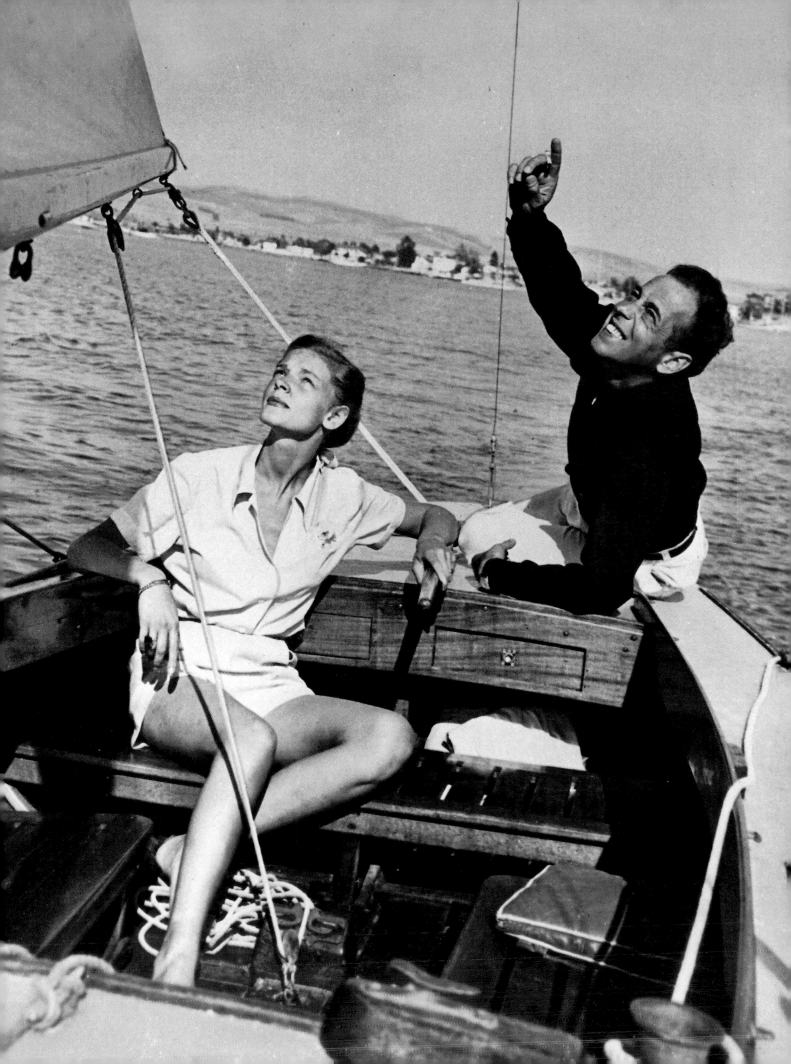

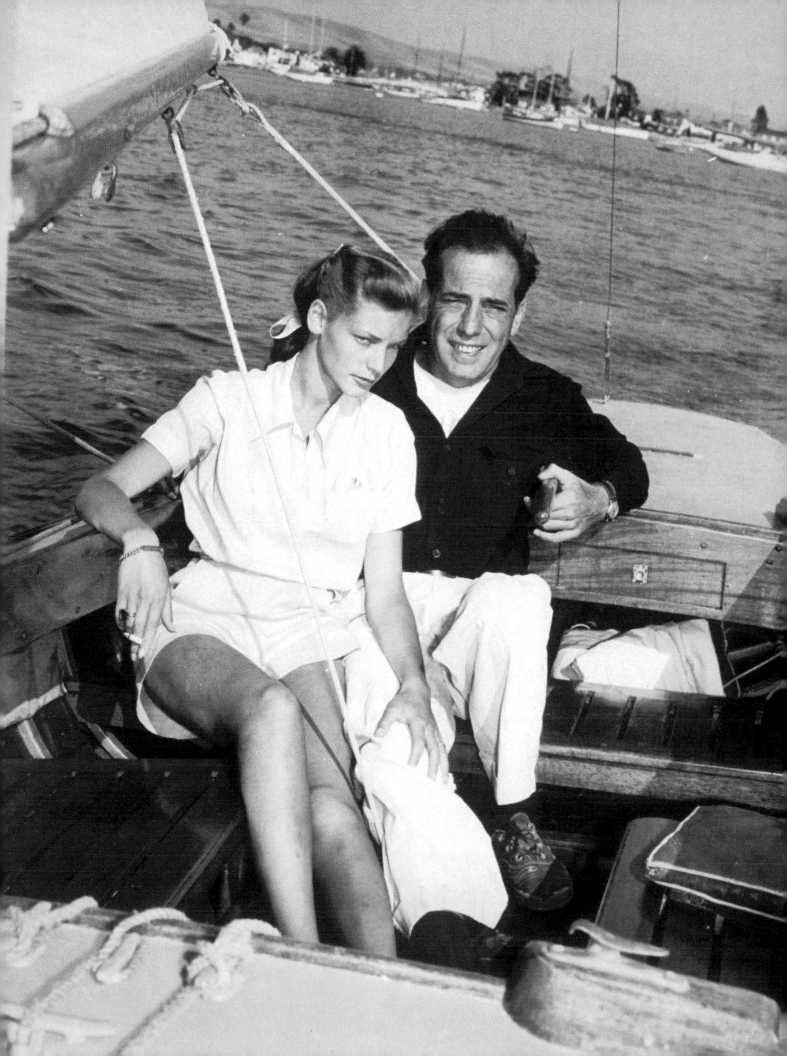

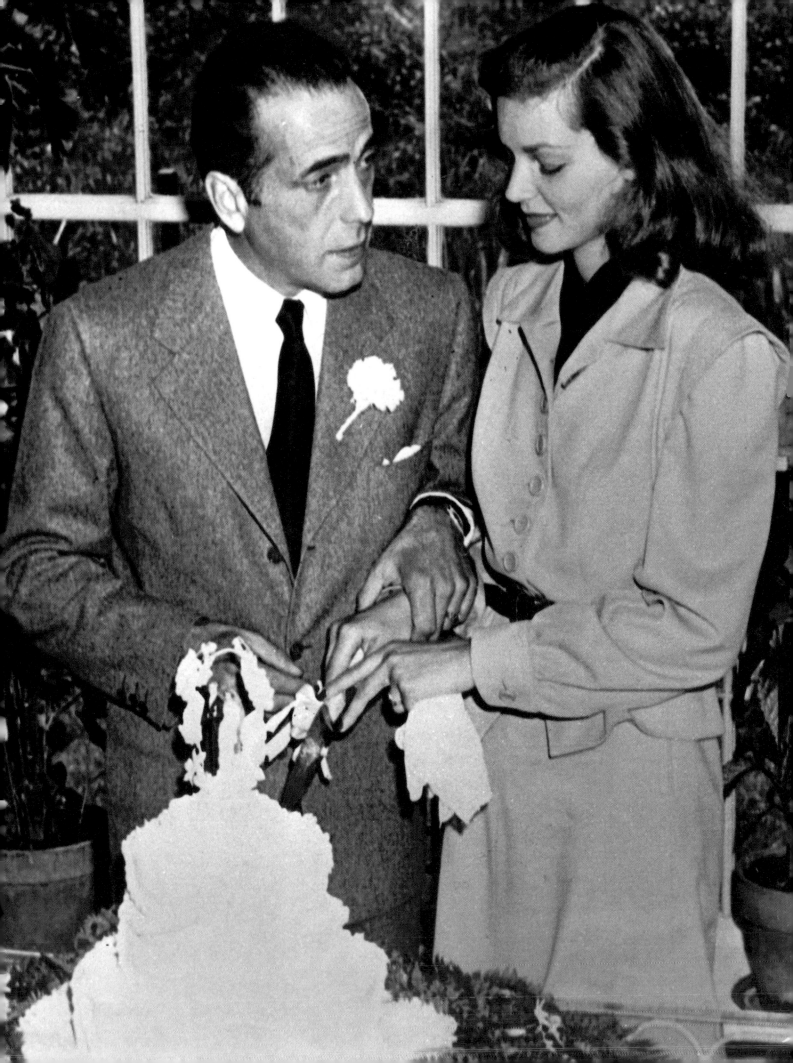

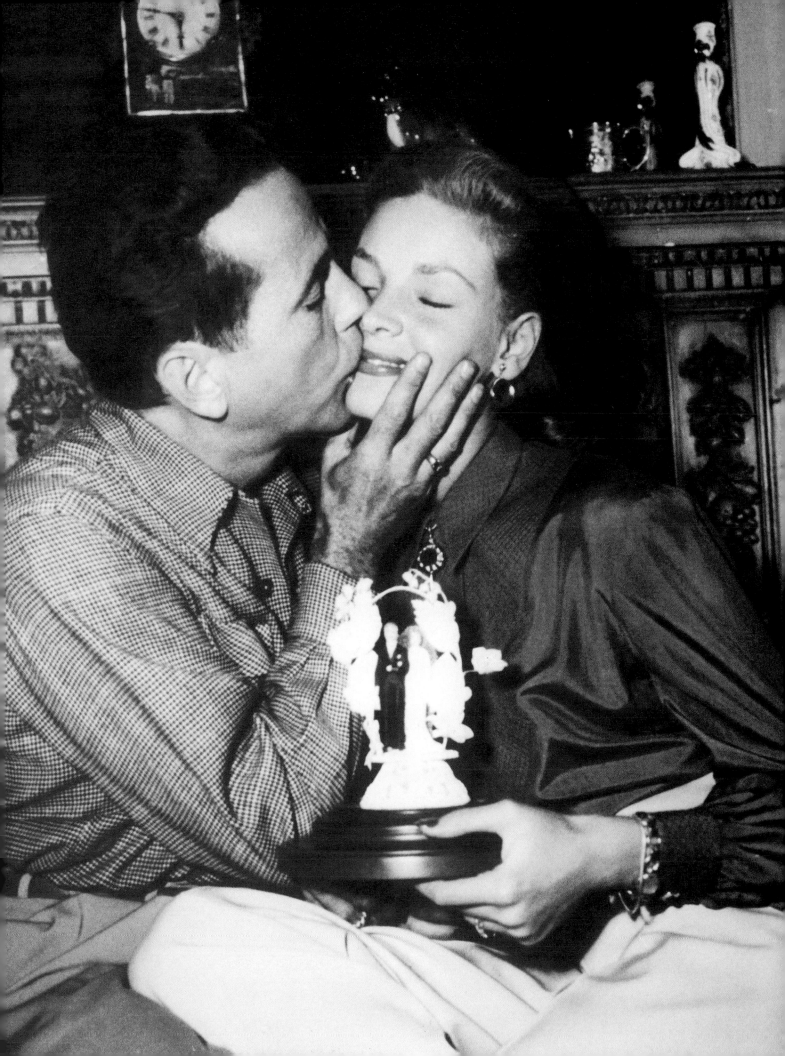

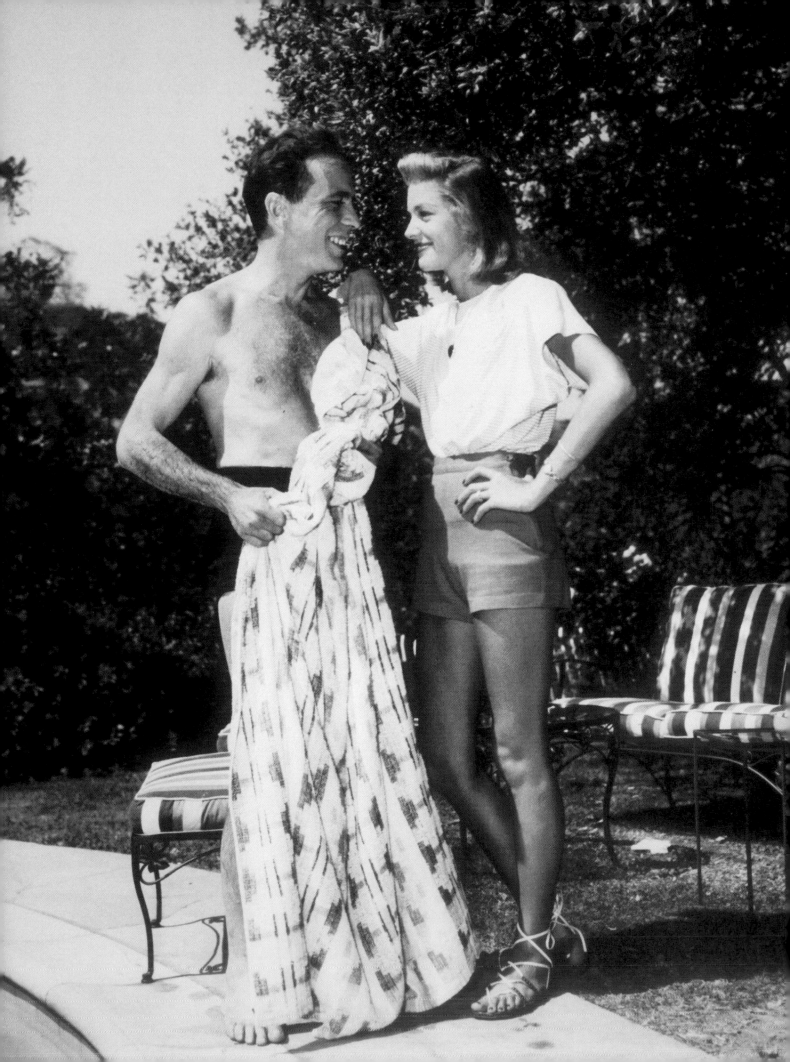

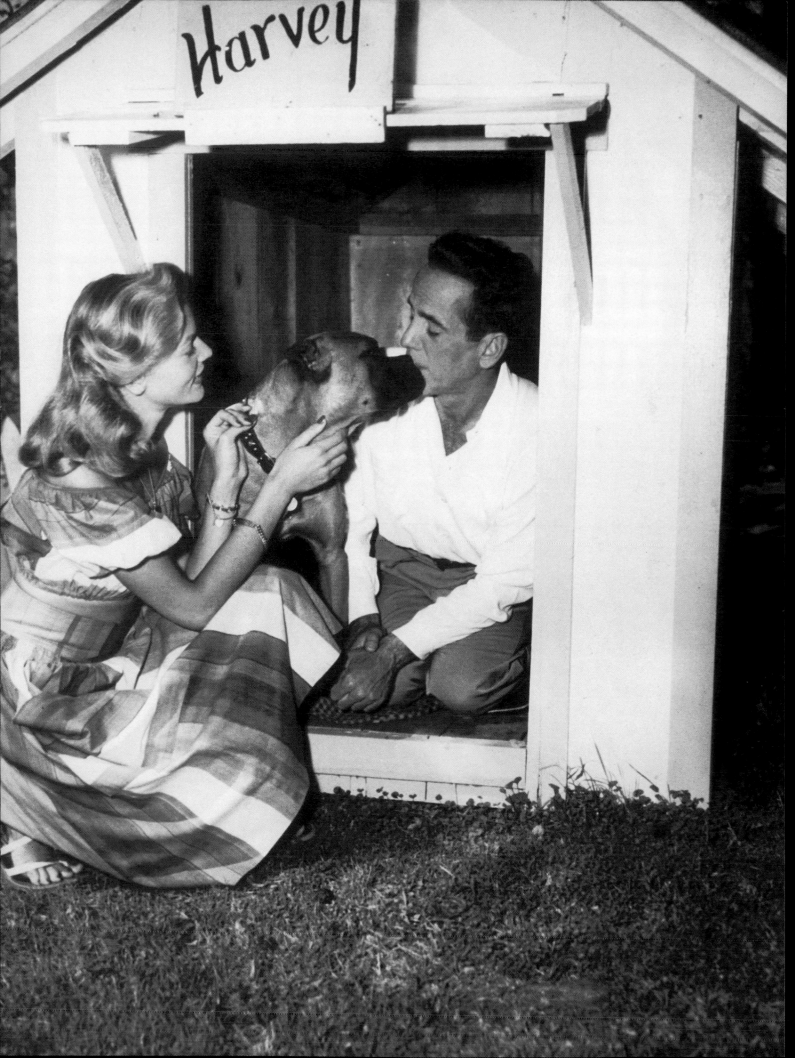

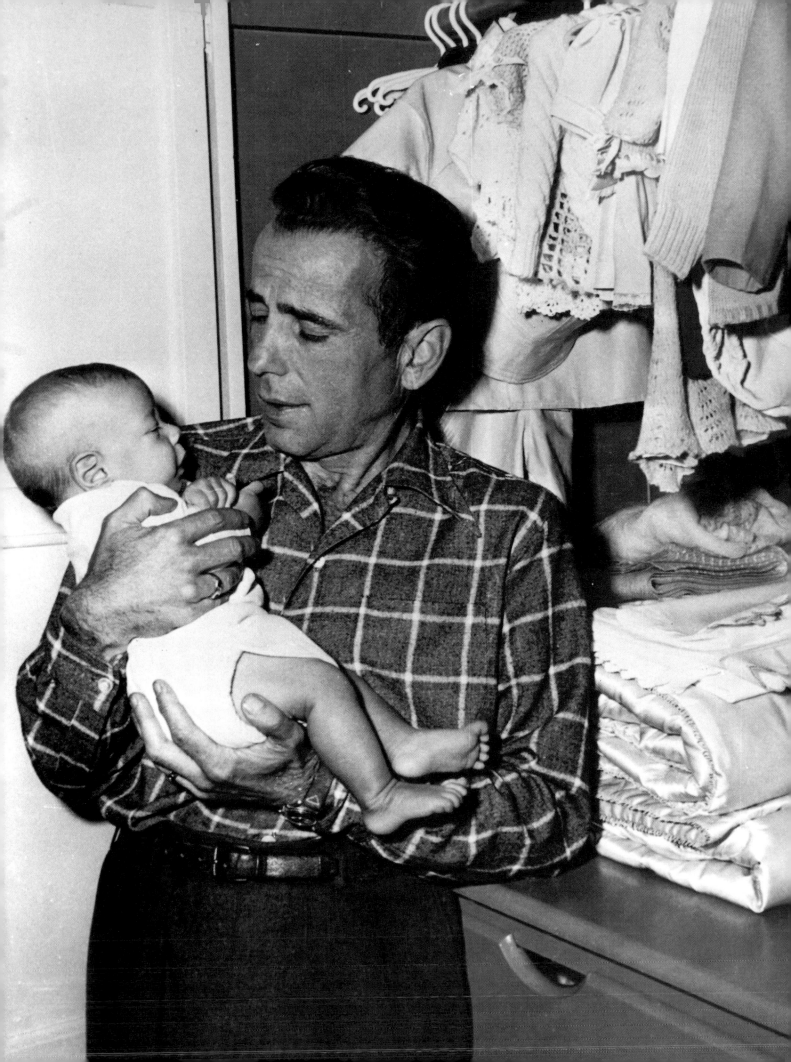

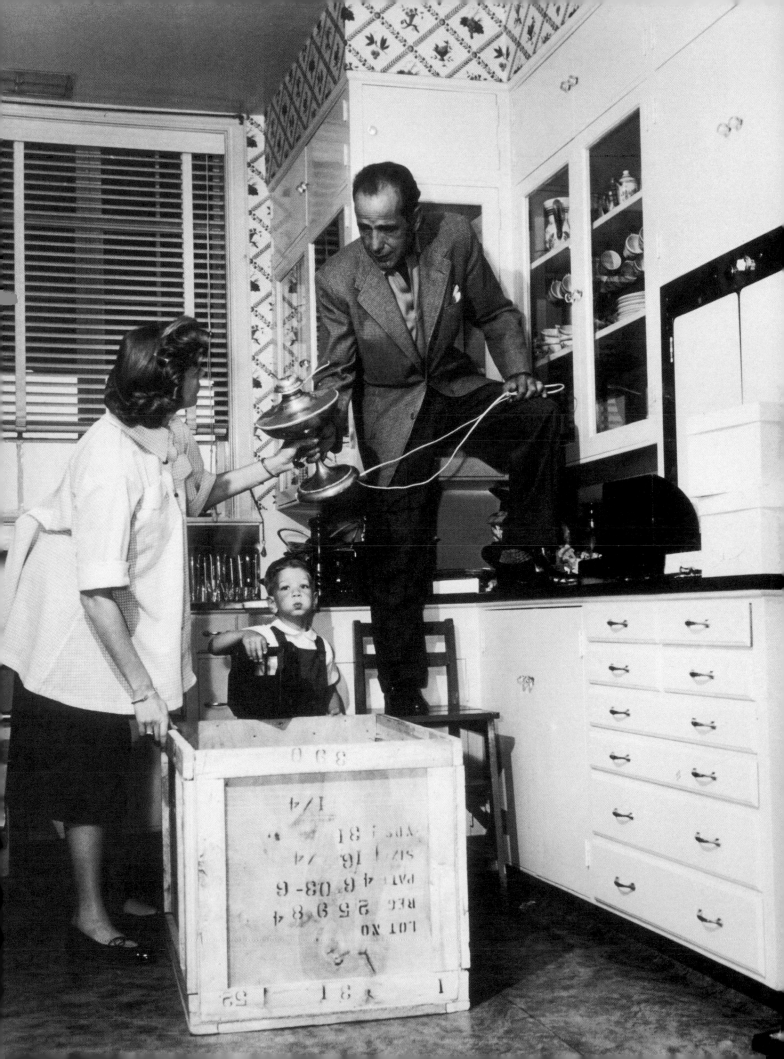

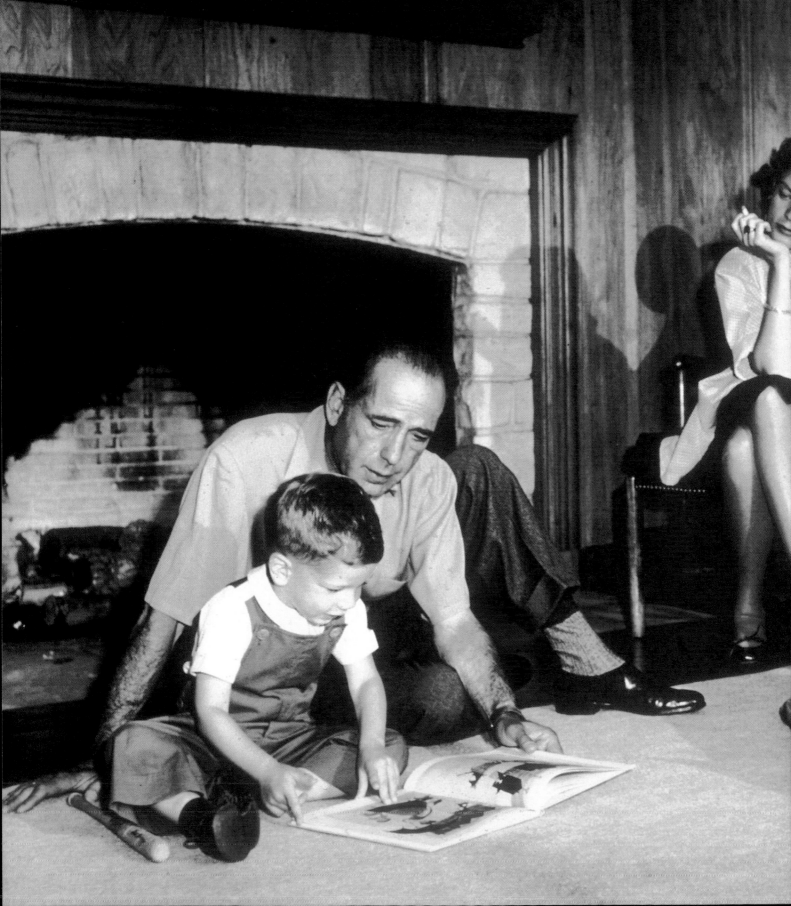

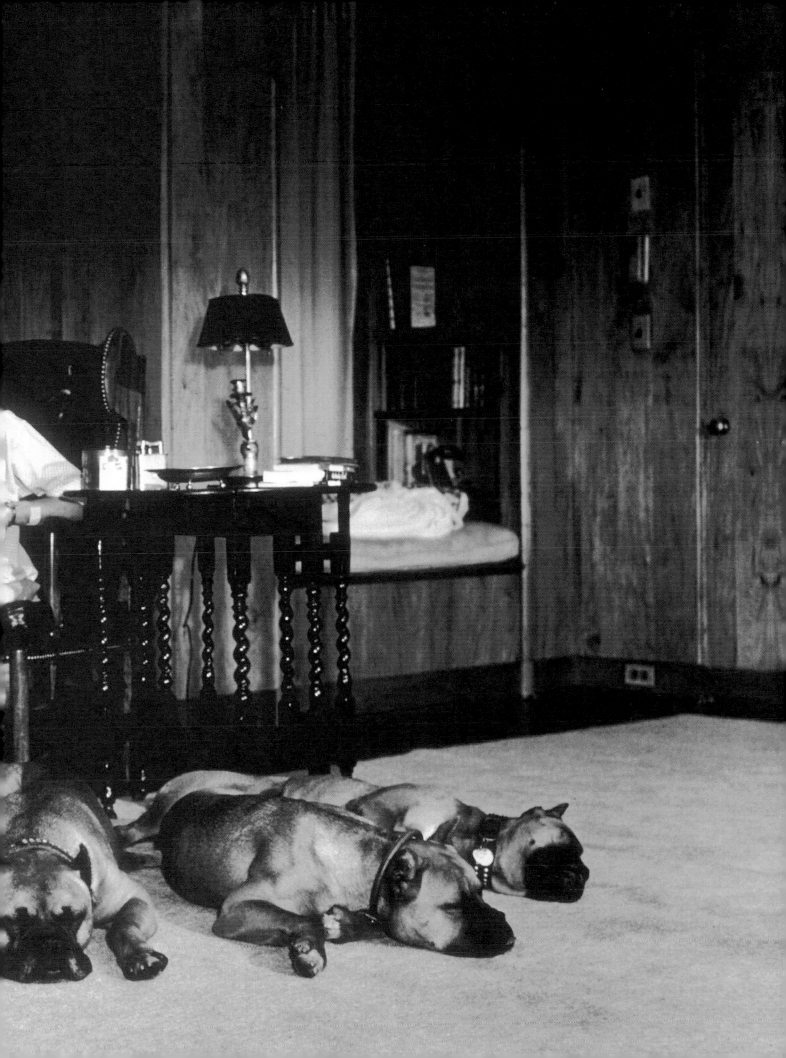

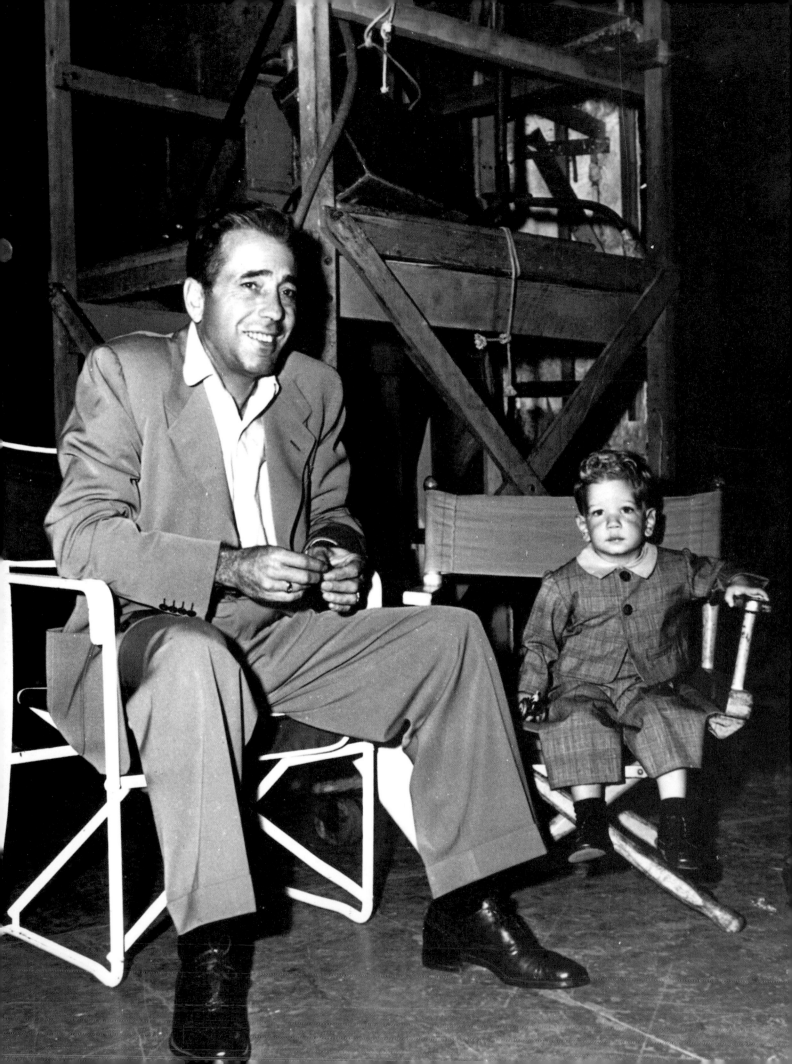

Dali & Gala

Crazy love

Dali was a virgin. He was twenty-five. Gala would be at his side—wife, friend, and manager of his worldly possessions—every step of the way, till the day he died.

– "Darling, we'll never part," Gala said when she first met Dali in 1929. She was thirty-six. He had stolen her from the poet Paul Eluard.

– Never at a loss when it came to eccentricity, he cut off all his hair to celebrate their love at first sight.

– She was his muse. And he painted her (*Leda atomica*, 1949).

– The beauties of Cadaquès and Port Lligat, in Catalonia. On the rocks he painted *Studies for the Ecumenical Council*.

– He was knocked out by Gala's back from the moment he saw it, and loved to loll against it.

– She made him a cocoon—a large, round living room. "Gala built me a hermit crab's shell, with the result that in external relations I came across like a fortress, whereas within I continue to age in weakness."

– "She reads, I work, and every now and then I try to touch her foot, but I never can."

– Age didn't bother them. A couple beyond the realm of time. "Gala drove the forces of death away from me. She restored me to the light through the love she gave me."

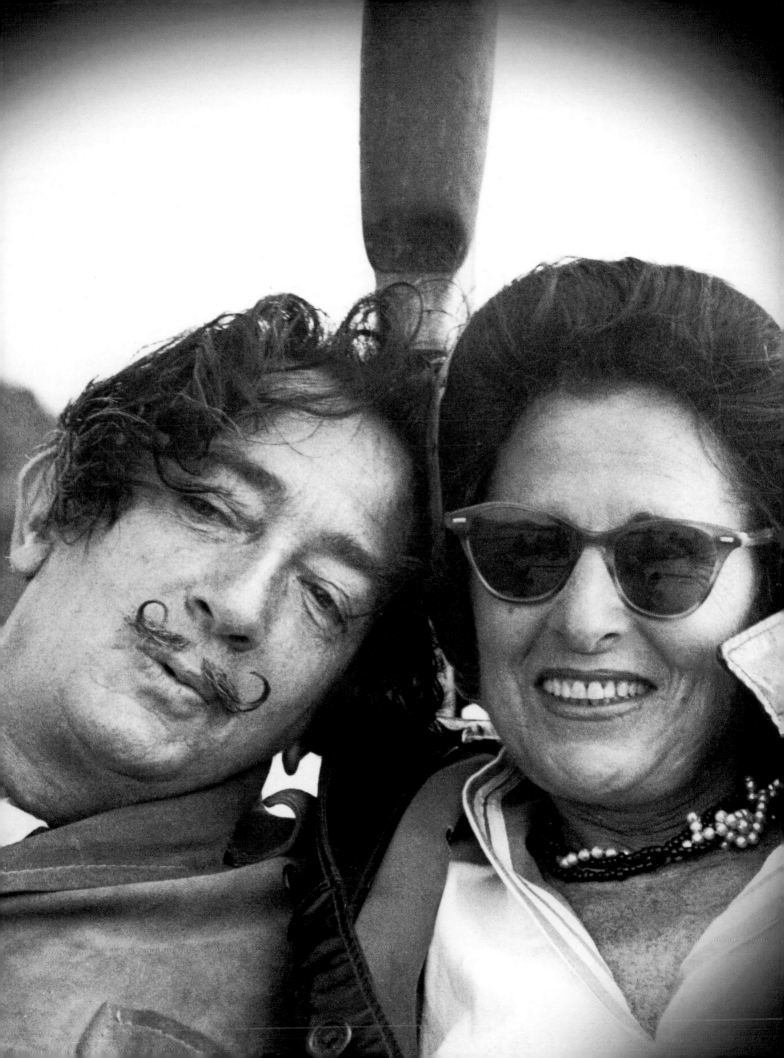

In that split second when he first saw her, he knew she alone would be his work. On that morning in 1929, Salvador Dali felt, for the very first time, caressed by a desire for eternity. That feeling filled his heart and soul with an unutterable happiness, as soon as he pushed open the shutters and spied her. It was not so much her that he saw, just her bare back, a few yards away from him, on the sand, as if a wave had given birth to her. The crazy love story of Dali and Gala started just like that, at an hour when the sun had not yet reached its zenith.

On that morning in 1929, shortly before noon, after opening the blinds, Salvador closed his eyes. Confronted by the vastness of a sea dotted with dark rocks and flecked with white sea foam, he wavered. In the setting of Cadaqués, whose bluish loveliness he had so often painted, he tottered. The surge of light forced him, for an instant, to keep his eyes shut. When he opened his eyes again, he let them stray over that back with its milky skin, and then he recognized his friends from Paris. Squeezed into two convertibles, and accompanied by the art dealer, Goemans, they had come to Spain to pay him a visit and there they were lounging on the beach, waiting for him to wake up.

From his window Dali recognized the painter Magritte and his wife Georgette; and beside them, Eluard and his wife. That alabaster back, which made him feel quite dizzy, must have been hers. Dali went out to greet them. When Gala turned round, he introduced himself. And in that superb creature, with her jet-black hair and tuberose complexion, he recognized a face that had been haunting him since childhood. At the age of six, the young Salvador had in fact seen, in a glass ball set in a bone penholder, a wonderful lady, as beautiful as a fairytale princess, slide languidly in her sleigh over spotless snow. Dali saw Gala. And he felt as if he'd known her forever. That aristocratic face with its delineated eyebrows, that body befitting a rootless empress, that faraway look of a resolute exile, she was his princess in the sleigh, it was Her. He realized, in a flash, that his life was beginning in that very moment when time stood still. He wanted her, and started to laugh like a madman. And when Gala saw that handsome, suntanned fellow, with his excessively brilliantined hair (she couldn't help noticing that with his hair slicked back and plastered down without a single wild shimmering strand out of place, as if it had been soaked in virgin olive oil, he looked just like a tango dancer), she, too, burst out laughing—mingling her own melodious voice with the voice of that madman about to fall head over heels in love. That day, as he walked through the maze of village streets, Dali came to realize who the lady on the sleigh was.

As night fell and the horizon became a glowing strip of red sky, Salvador went back to his window and gazed once more at Gala, who had used the pause as if to bind him to her. He devoured her with his eyes. He noted that the body of this woman, twelve years his senior, had the skin of a child. Her shoulders lent her the athletic look of a teenager. But the small of her back was extremely feminine, with a wasp waist separating her proud upper body from her delicate buttocks. Dali didn't sleep a wink that night. He fantasized about Gala's body. Salvador was a virgin; with all his senses aroused and his mind in a ferment, he spent a fitful night both imagining a thousand and one ways of winning that woman over, and dreading the moment when she would be gone.

In the presence of Magritte, but more importantly in front of a petrified Eluard, Gala whispered to Dali: "Darling, we'll never part." Their life together, sparked, as it had been, at a fiery twilight hour, would blaze for all of fifty-six years. Salvador was terrified by the idea of sexual intercourse, so he tried to put it off. The carnal act seemed to him too violent for his weak physical strength. Day after day and night after moonlit night, they walked over the rocks, or took a boat out into the waves, making quite sure that not even the palms of their hands brushed against one another, for so so agitated were Dali's nerves that such a touch would have shattered them. Until one evening when the painter summoned up both his sinews and his courage, and told his partner that that night, on the beach, in front of the wild sea, he would have her, body and soul, on the very shore. She decided to go to him, waiting for her dressed all in white, arms wide open in a long, immaculate robe which made him look like a butterfly about to take flight. They made love for hours. When they awoke, Dali knew that Gala had resolved to take him, make him hers forever and turn him into a unique artist.

"I love her more than my father, more than my mother, more than Picasso, and even more than money."

"Now I want just two things: to love Gala, and learn how to die."

"So I touch her ear lobe and turn it into my Aladdin's lamp. Straightaway, in harmony and all at once, all the peak visual moments of my life loom before me."

"It's Gala who discovers and brings me all the essences, which I then turn into honey in the busy hive of my mind. Without Gala, the world would have no genie: Dali would not exist."

Henry-Jean Servat

Florence Saugues:

– *Was the Gala-Salvador Dali couple surrealistic in the manner intended by the movement, which championed freedom, dreams, and fantasies?*

Robert Descharnes:

– That couple was the union of two extreme beings: a Russian woman and a Catalan man. Their relationship was very special because of Dali's unfulfilled impulses. Gala was a woman who needed a man to give her his all—his company as well as his sex. Dali was not a consumer. He was a masturbator as well as a peeping Tom.

– *Yet it was with Gala that he made love for the first time, at the age of twenty-five?*

– Absolutely, but he was happier just looking at her.

– *Were they both free to have affairs?*

– From the very start they drew up a list of rules beyond which they couldn't go. Gala has her lovers. Dali has his fantasies. She didn't take her men back home. And he, for his part, organized pornographic scenes involving several people, though he never partook himself.

– *Was their meeting love at first sight?*

– For him, yes. But he had to win Gala's heart. She was married to Paul Eluard, and invited to visit Dali in Spain for the holidays. During their stay, she was captivated by his genius, and not just his brilliance with his brushes, but by the brilliance of his whole mental machinery. They stayed together all their lives.

– *Did Dali behave like a small child in her presence?*

– He made too much of a show of worshipping her to really be like a small child.

– *But she was the domineering one?*

– I've rarely known such balance in a couple. Their personalities were perfect complements to each other. She organized things so that all the conditions were in place for him to express his genius. She managed everything, even though, when she was with Paul Eluard, she could not stand being a housewife.

– *She was ten years older than he: did she mother him?*

– No, but she protected him. As soon as anyone criticized Dali, she turned into a real tigress.

– *A lot of people describe her as a very hard woman?*

– She was bad-tempered. With other people she could be calculatedly insolent. When she decided a person was mediocre, she was terribly unpleasant with him.

– *It's been said that she was obsessed by money?*

– No. She was afraid of not having any, but she didn't dream of hoarding it.

– *With such a strong character, how could she pose as Dali's model?*

– She adored people adoring her. She was fond of showing herself off. But she did what she was told and followed "her" Dali's orders to the letter.

– *Did she suggest any creative ideas to him?*

– No, Dali alone invented his works. She followed him. Then she might give him her opinion.

– *Did he listen to her?*

– More than anyone else. Gala had a good eye. She would go into his studio when he'd painted only part of the canvas. And there she might comment on the position of an arm, or the way a knee looked. When he didn't change things, he would regret it later and say: "Gala was right."

– *So Gala was more than just a muse?*

– She was a driving force. She created the bonds that were the points of reference in Dali's life.

– *Was their relationship a fiercely passionate one?*

– They never raised their voices at each other. Gala usually got what she wanted. She knew how to get Dali to accept her freedoms by hanging a sword of Damocles over their relationship—the threat that she might leave him.

– *And yet she couldn't do without him because she accepted Amanda Lear being there?*

– Age was catching up, Gala was getting tired. Dali, who was ten years younger, was still bursting with energy. She knew she would manage to keep him hers by letting Amanda Lear bring him what she no longer could. She took a back seat but never went away. She went to live in her castle at Pubol, in Catalonia—Dali had given it to her.

– *Dali was so vital to her that she dropped her last lover so that she could be with him when he was ill...*

– Yes, and this hurt her a lot. This was the lover who enabled her to go on thinking and believing—even as an old woman—that she was still beautiful. She gave that up for Dali.

– *Would Dali have been Dali without Gala?*

– He would have done great things but he wouldn't have had the same destiny. He wouldn't have been one of the leading lights of the century. She turned him into somebody.

Robert Descharnes was interviewed by Florence Saugues.

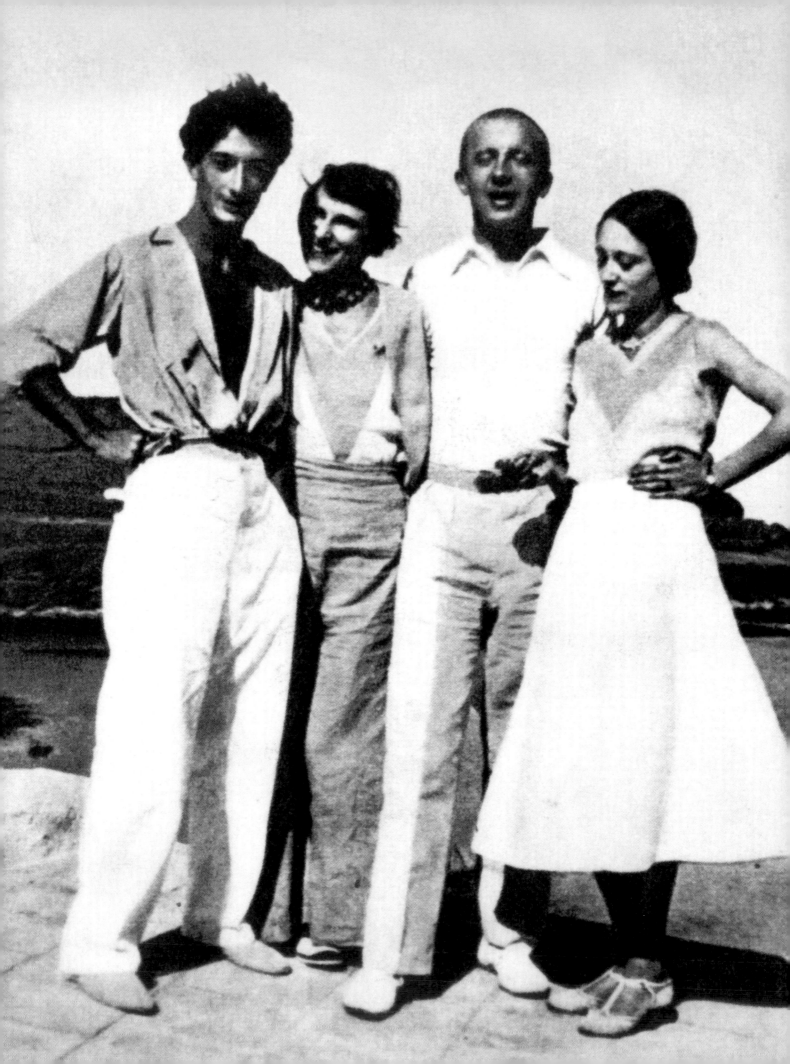

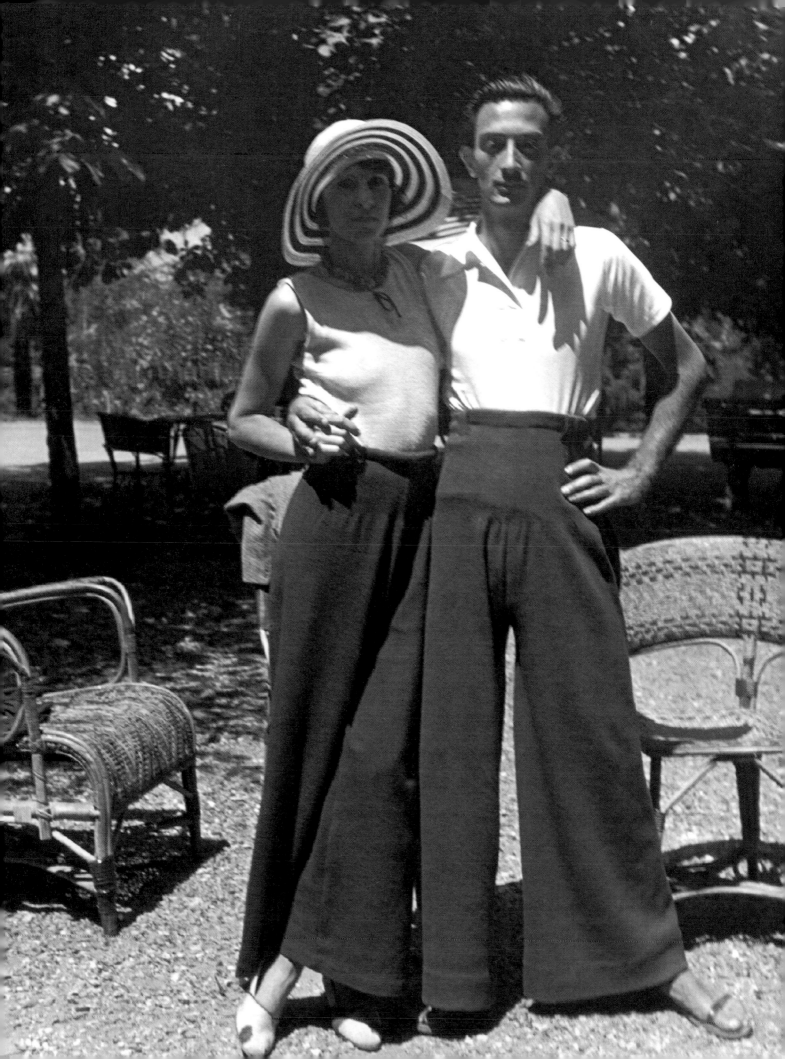

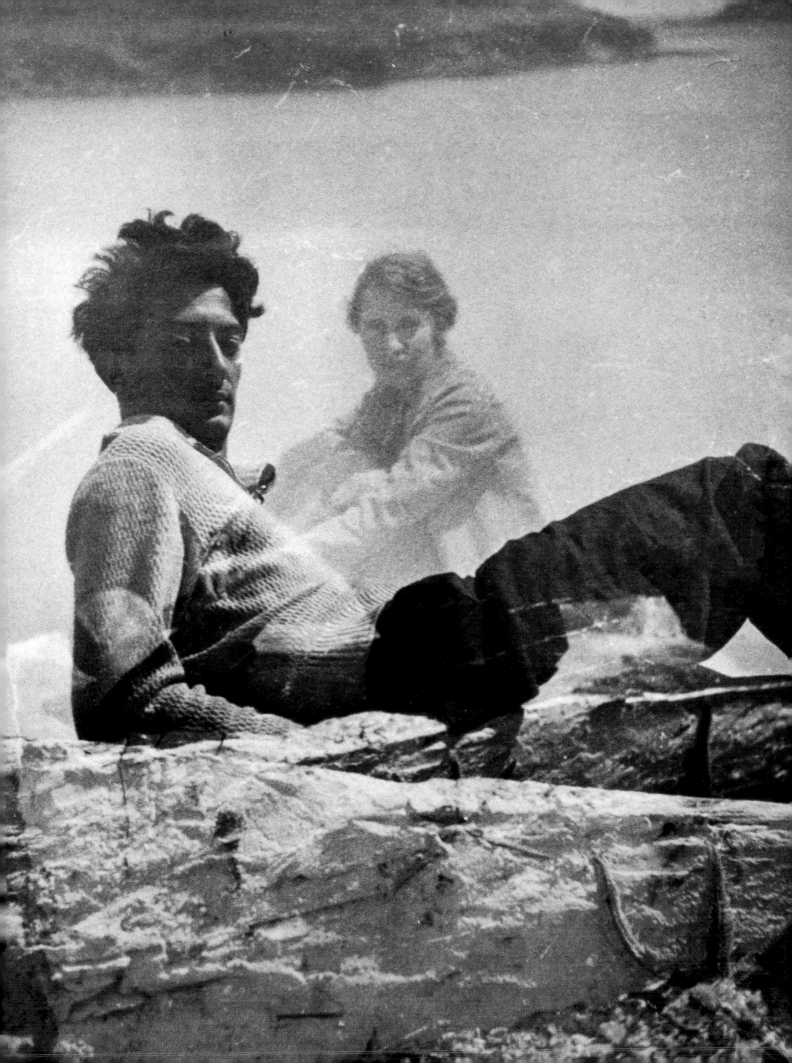

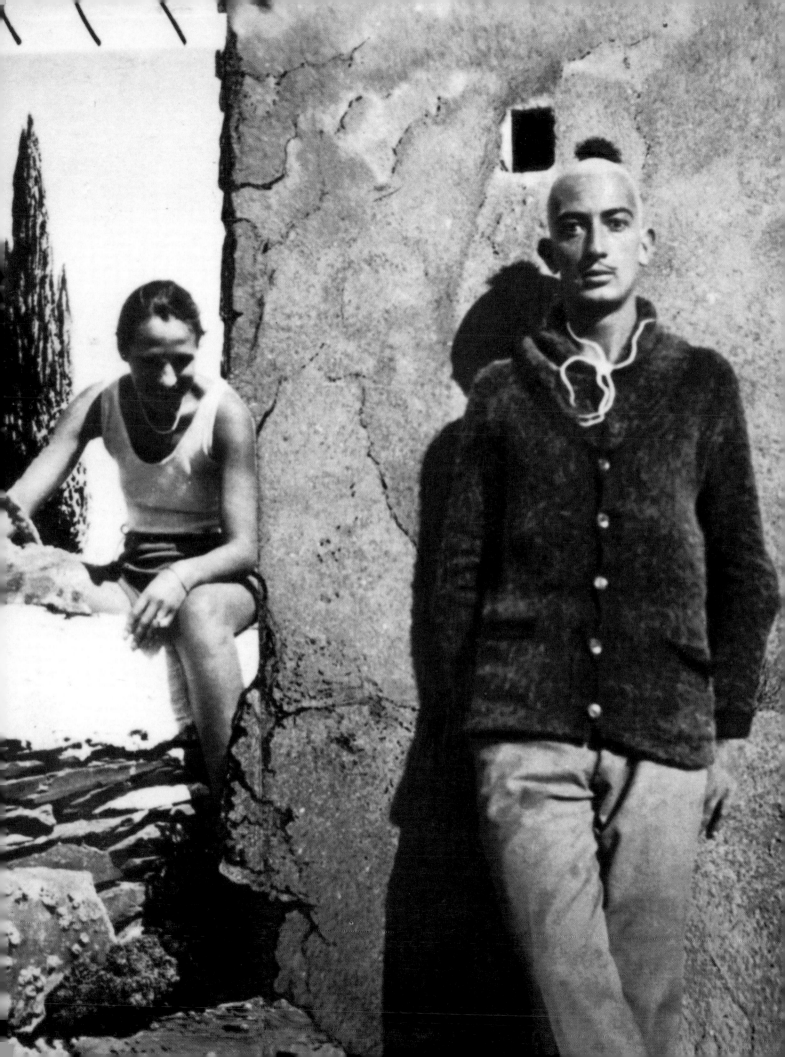

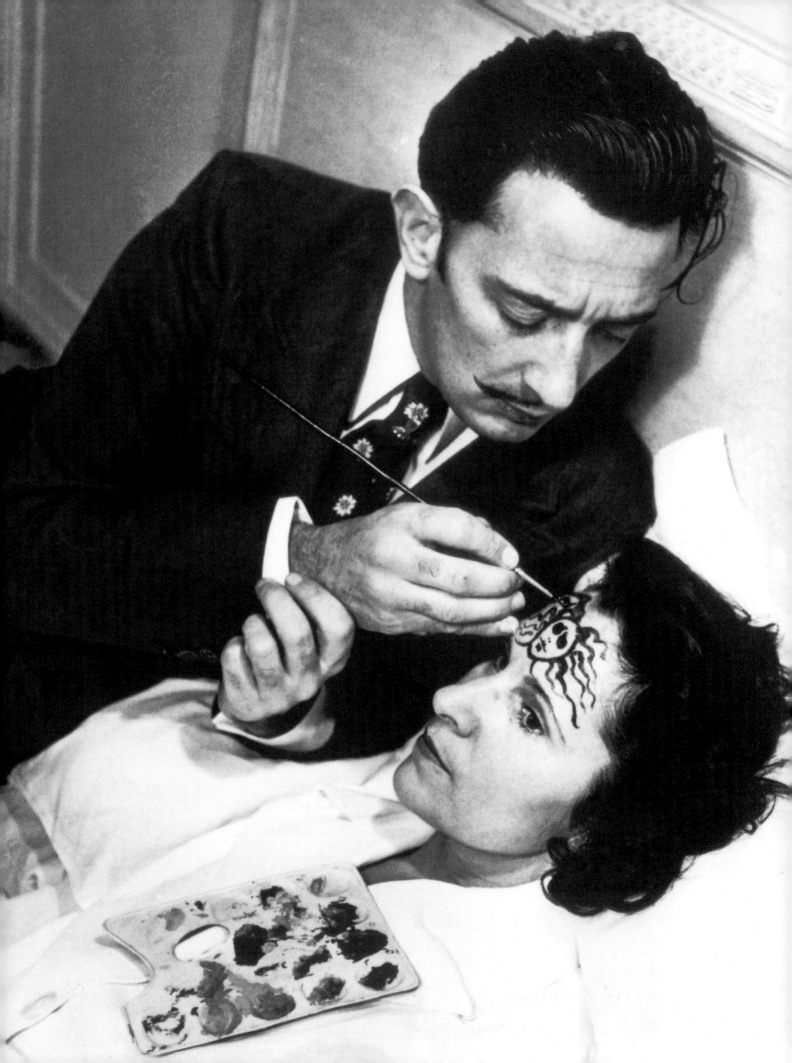

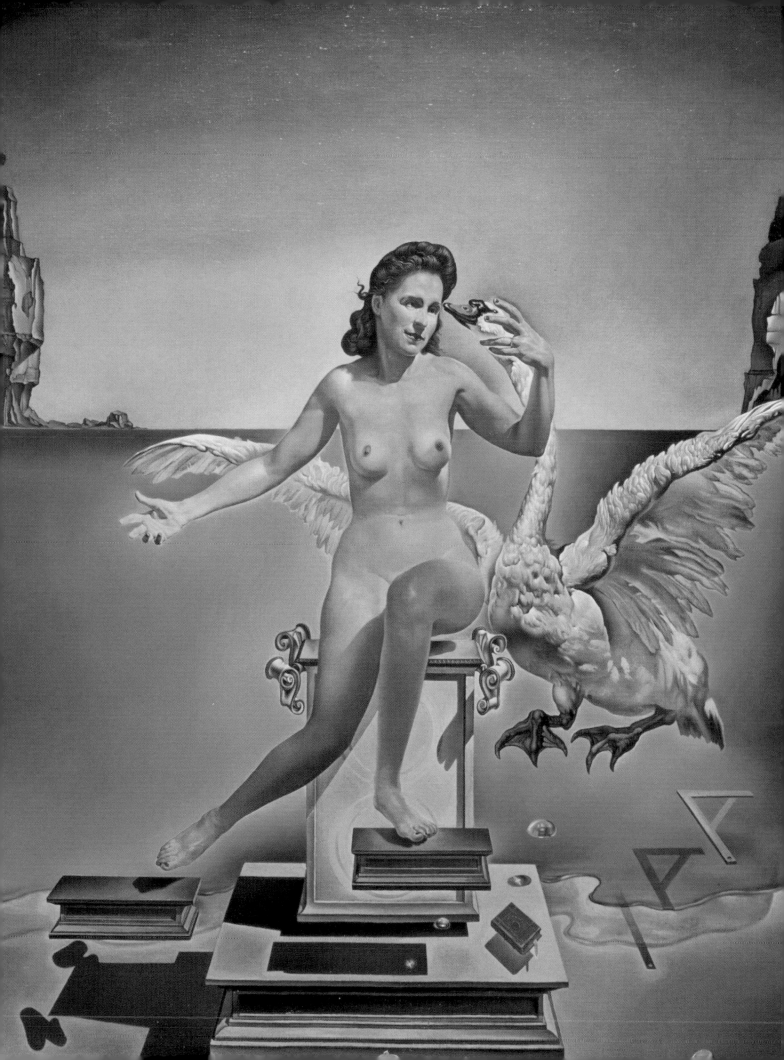

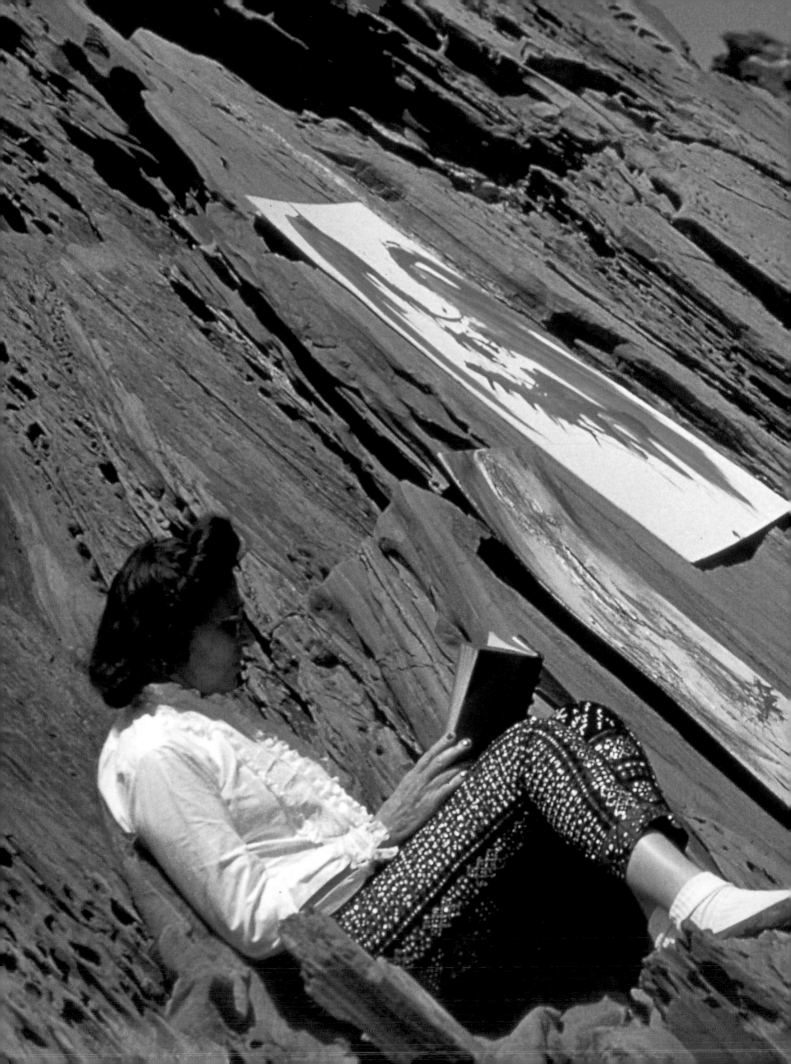

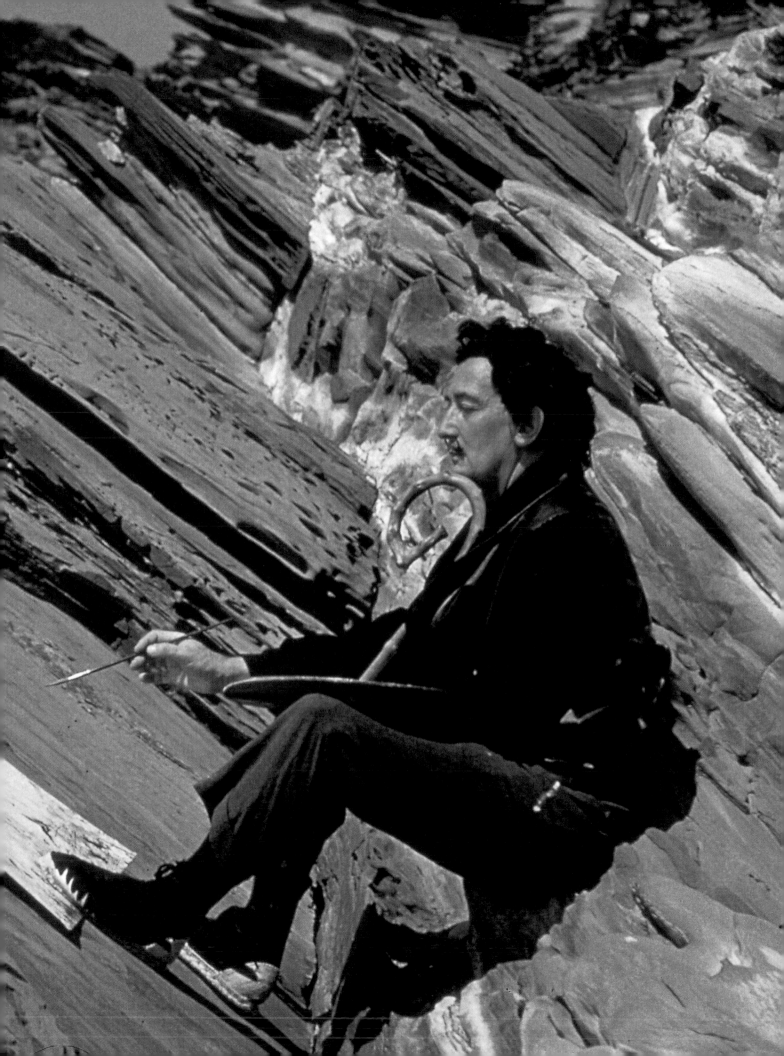

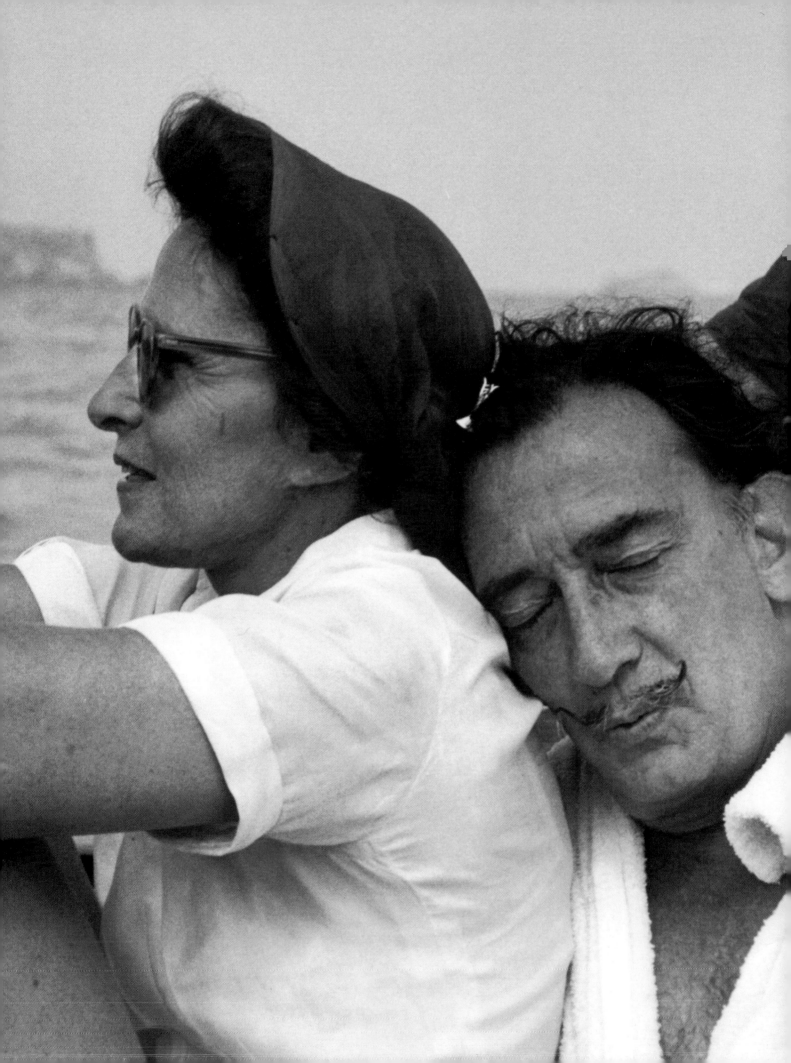

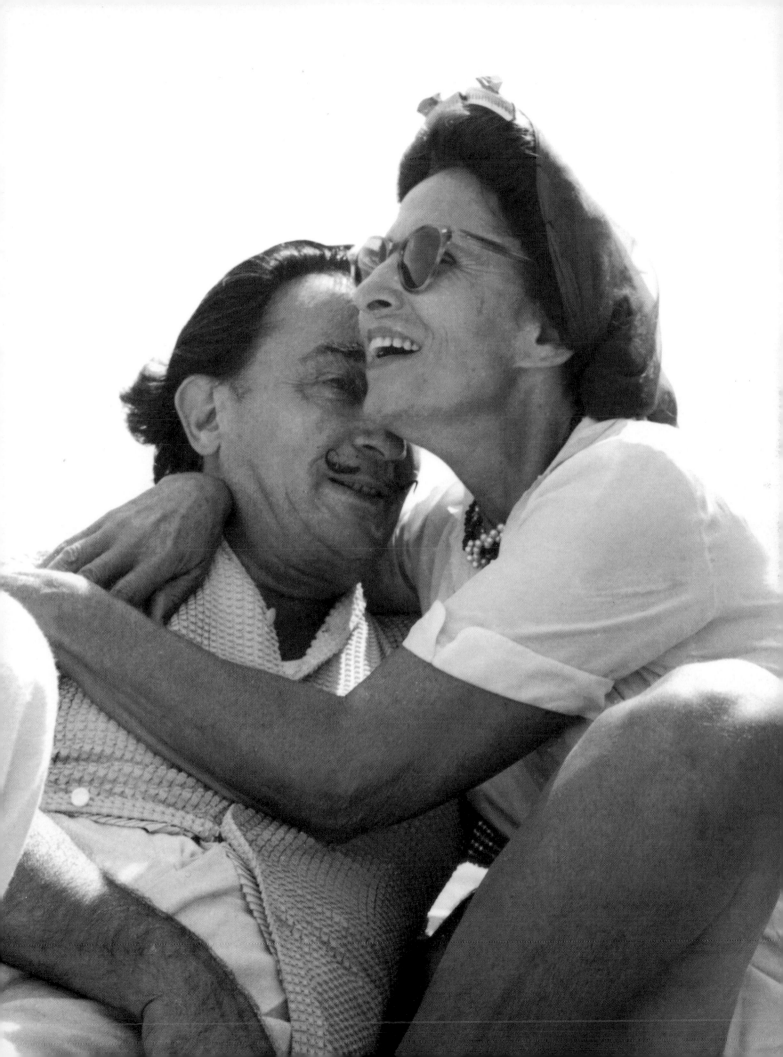

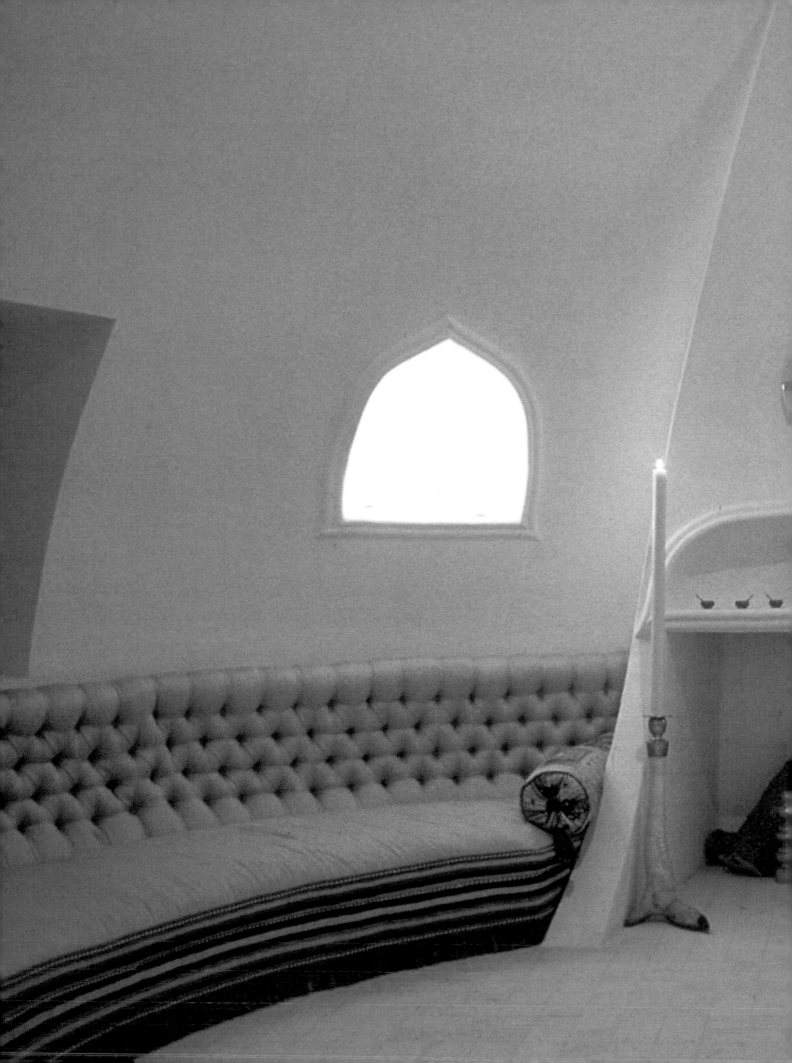

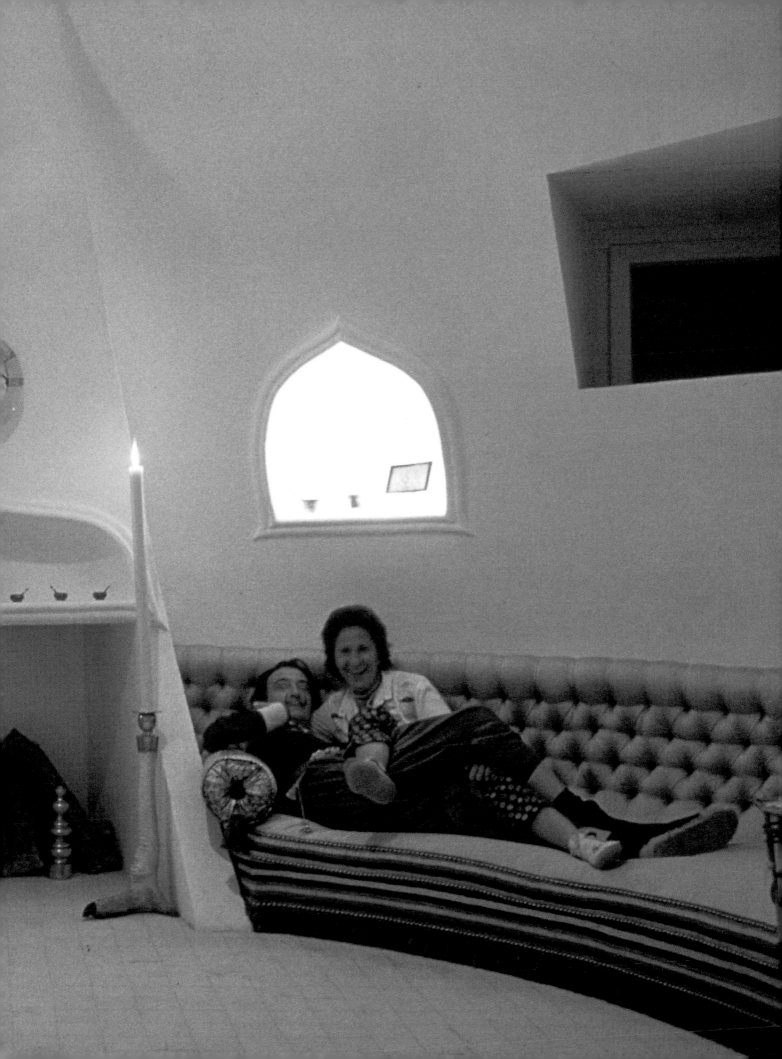

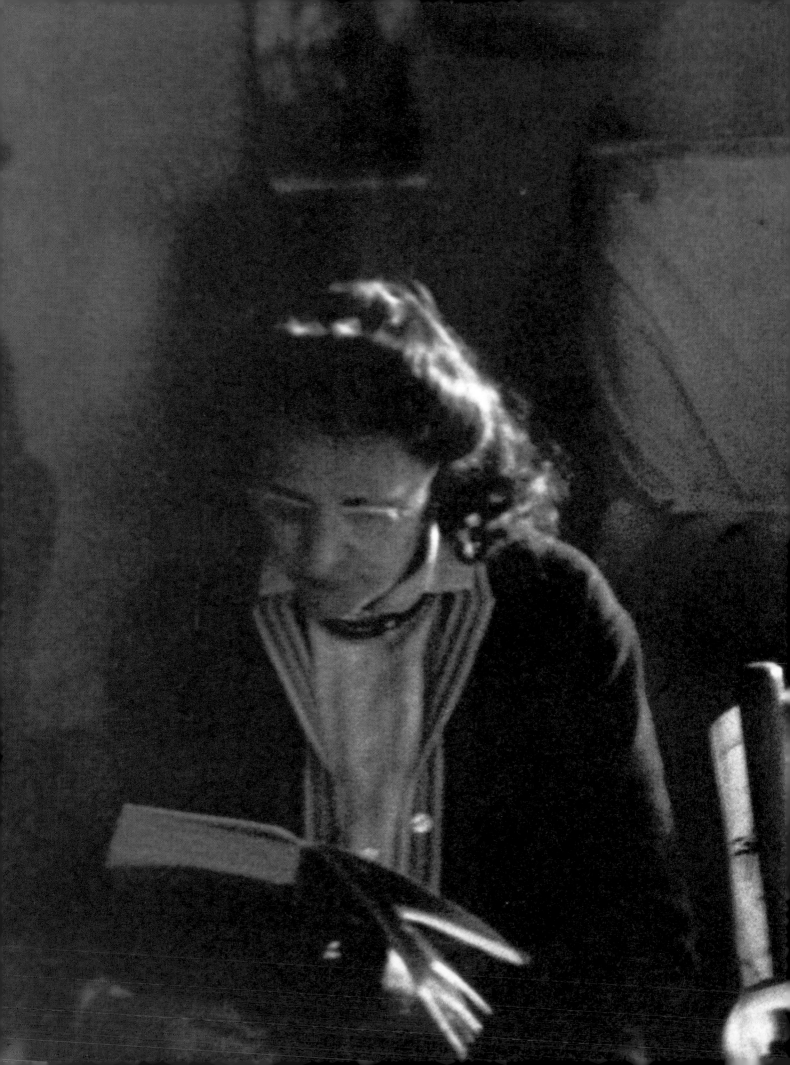

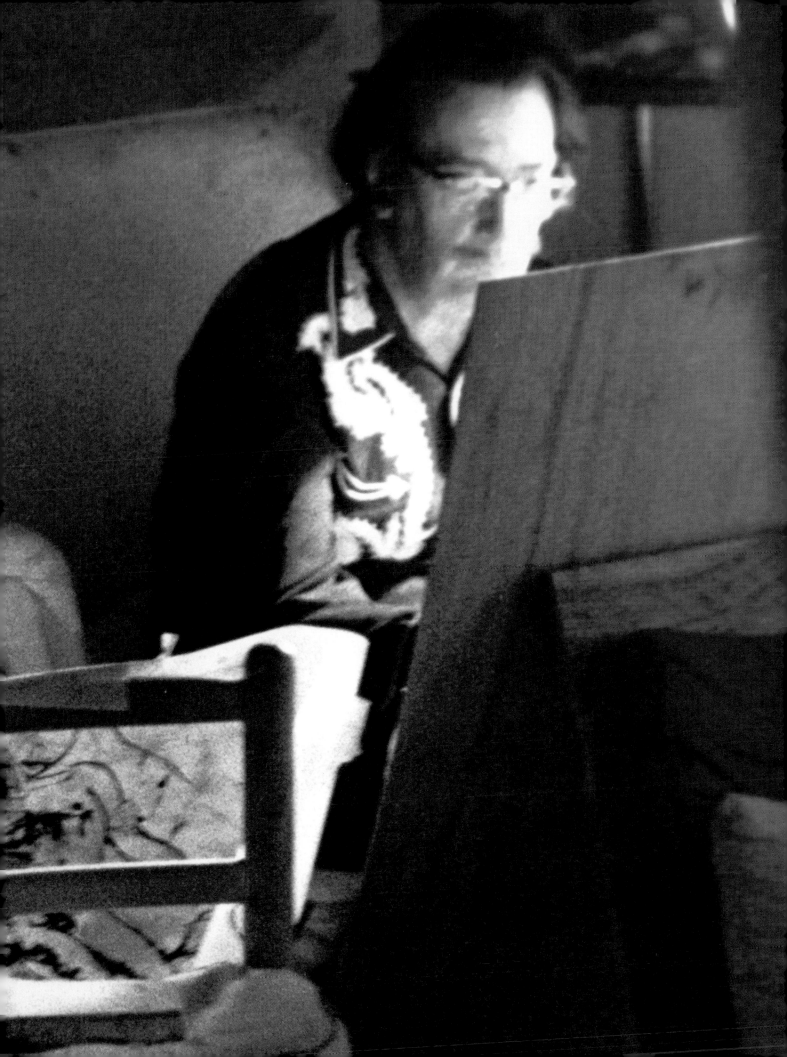

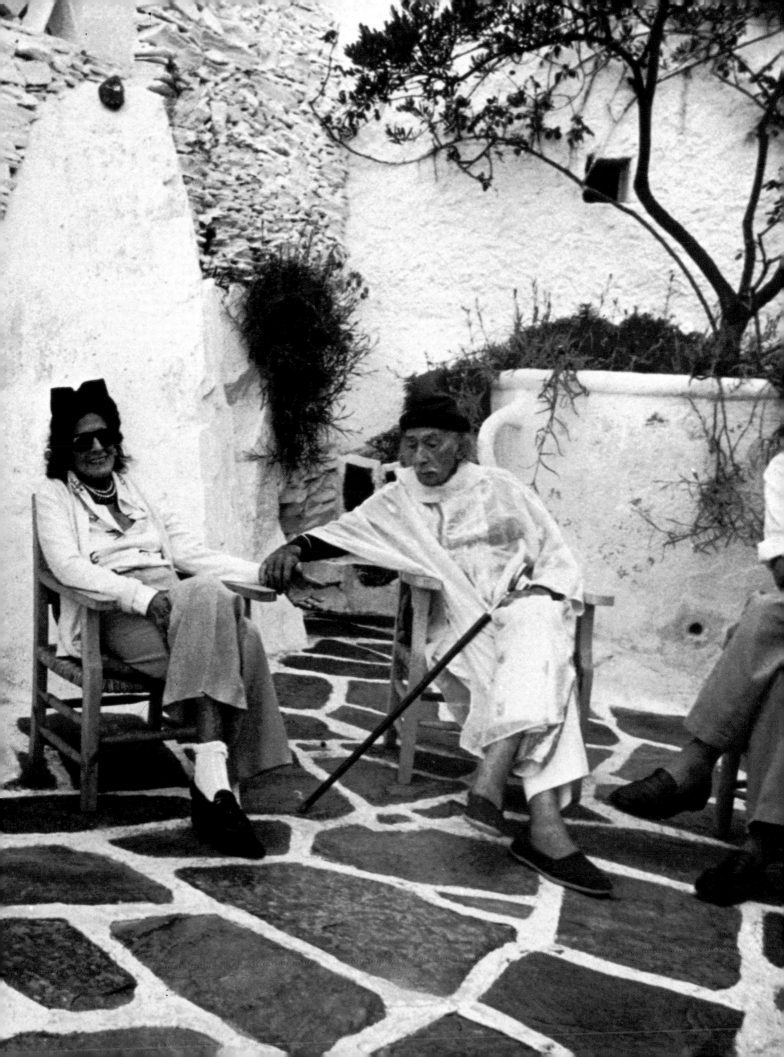

Maria Callas & Onassis

A Grecian love

Neither one of them was born in Greece, but both were deeply affected by that country, its beauty and its traditions. She divorced for him, and he for her. When he felt he was dying in Paris, it was she whom he called, in spite of Jackie Kennedy. "I loved you, not always well, but so much, and to the best that I was capable of."

– Elsa Maxwell, the gossip columnist who had become Callas's friend, invited her and her husband to the Venice festival. Onassis was there.

– June 1959, in London after performing *Medea* at Covent Garden; the ageing husband holds on.

– July 1959. On board the *Cristina*, ship of passion. There was no longer any doubt that this cruise would make serious waves. Tina, Onassis' wife, chatted with Churchill while Callas and Onassis began their own private dialogue.

– A visit to the amphitheater at Epidaurus.

– The cruise was over, the dye was cast.

– At La Scala, in 1960, she triumphed in *Polyeuctes*. Onassis and Prince Rainier were in the nearest box.

– She abandoned her career to be with Onassis in high society. She took Greek nationality. But Onassis did not marry her as she'd hoped he would.

– Though married to Jackie, he whisked Callas away on St. Mary's day, and kissed her passionately.

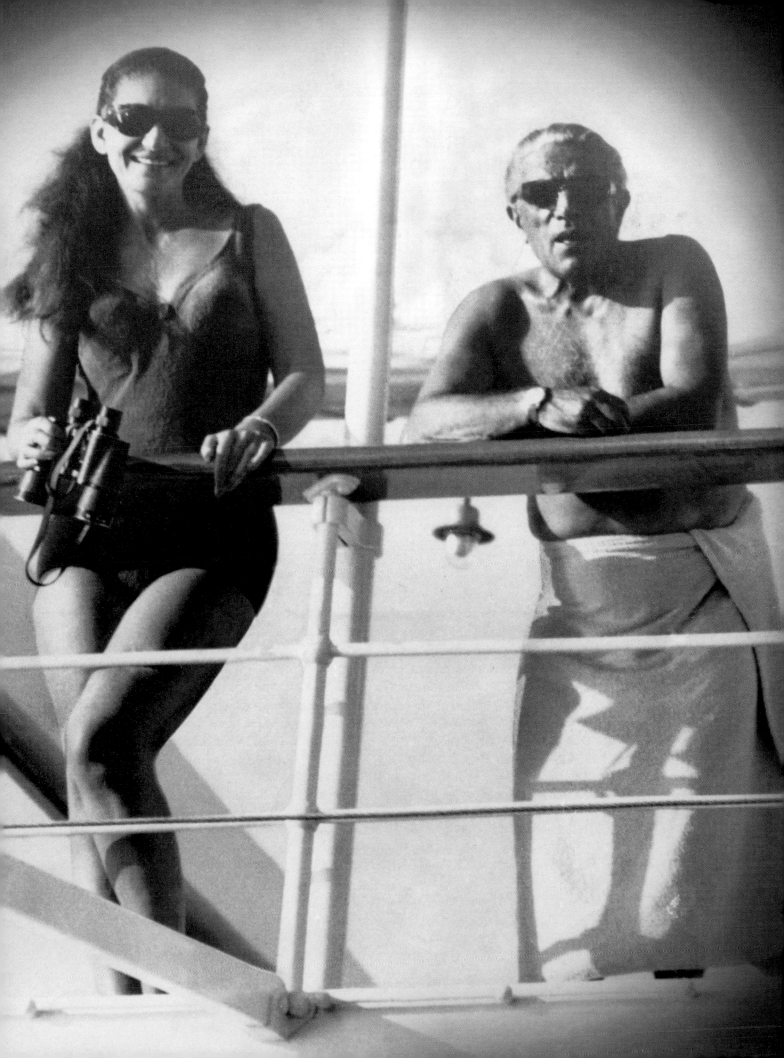

On September 16, 1977, toward midday, the silence of death extinguished the most famous voice of her century. Maria Callas had rendered unto the gods of art and passion the tormented soul that had turned her into a figure who was worshiped by the throng. She had died a first time some years earlier, when her magnificent voice had suddenly taken a turn for the worse. All that remained of the Callas myth were recordings of the great operas in which she had excelled, and the loneliness of a heartbroken woman chasing her own image. Her break up with Onassis would fatally wound the Greek legend with the imperfect face and who'd had the world at her feet. Aristotle Onassis preferred Jacqueline Kennedy, still at the height of her beauty, to Callas. Only a handful of people bore witness to those grim years when the superstar lived in solitary splendor, and only one man could pride himself in having offered her almost daily company during the final years of her life. His name was Frédéric Simogli, the hairdresser she entrusted with both her jet-black hair and her most private secrets.

Virginie Merlin:
– *How did you meet La Callas?*
Frédéric Simogli:
– In 1966, I was working at the famous Alexandre salon, when Baroness Von Zuylen, Callas's best friend, recommended me to her. I entered a 1900 building on Avenue Georges-Mandel in Paris. On the third floor, Callas's maid, Bruna, let me in. In the hall of the apartment I found overly ornate Venetian furniture, with two blackamoors on consoles to greet visitors. Impressive! Bruna led me down a corridor to the pink-and-white marble bathroom, bigger than any living room, and lit by two huge windows. In it, were a large sofa, a low table, a bathtub fitted into a mirror-lined alcove, and a large dressing-table; Maria Callas herself was waiting for me, seated. I got on with my work under her relentless gaze. She had superb long dark hair, which I would put into a chignon, the way she wanted. I must have passed the test because for eleven years—in other words, from then until she passed away—I went to do her hair for her almost every evening. She got to like me little by little. I always got there at 6:30 P.M. We would talk about music, and about her, and we'd swap our opinions about things. She would even phone me some Sundays just to say to me: "I'm so fond of you, my dear," which, as I realized later on, meant that she was alone, and depressed. The only family she had was Bruna, her maid, and Ferucco, her chauffeur and butler. They lived in with her and virtually never left her side.

– *Did she have any quirks?*
– She was a terribly tidy woman, almost obsessively so. She applied this same rigor to herself, and she would have liked to build her life the way she'd built her career.
– *Did she really love Aristotle Onassis?*
– She often told me that because of him she'd become a woman, and a woman twice over since the day when she'd lost her voice. "Living with Aristotle," she said, "is a fine ending for Callas." Pleasing Onassis had become the sole purpose in her life. What he loved about her was definitely not the Callas voice—he didn't even care about it, because he didn't have an ear for music—but her fame and celebrity. As far as she was concerned, she'd been impressed by the shipping magnate's power. She was horrified when she lost her voice, and knew that before long she would no longer be able to give Onassis what he wanted from her.
– *When you knew Callas, was her love affair with Onassis still going well?*
– Yes, but I watched it wane little by little. She was hoping he'd ask her to marry him. She often said to me, as if to comfort herself: "In bed, he can't lie to me!" She also knew that Onassis's children, Christina and Alexander, didn't like her, and reproached her for having been the cause of their parents' divorce. Callas found them bad-mannered and too spoilt. They were very hard with her but she gave as good as she got.
– *When Onassis was in Paris, did they live together?*
– No, but he would visit her every evening. She feared them because she wanted so to please him, come what may, and seduce him. Remember, her career was over and he was all she had left.
– *When he was due to pay her a visit, did she get into a state?*
– Oh yes! She was either a bag of nerves or as happy as a lark, depending on the day. She was quite determined to seduce him. Sometimes she would behave like some starry-eyed young thing, which I found extraordinary. When she was happy, she would play like a girl with her two miniature poodles, Djedda and Pepsi, even going as far as trying to teach them how to sing! Or else she'd kiss them, laughing, and roll about on the carpet with them.
– *And when Onassis wasn't there?*
– He would phone her, and sometimes ask her to go and be with him. Then it was pandemonium. She would leap onto the first flight and go wherever he was. For him, she was 100% available, and completely under his thumb. She nurtured the illusion that he loved her for herself, because he didn't like lyric art; unlike her mother and Meneghini, who loved her solely for her voice, and wanted

to make the most of it for themselves as much as for her.

– *What was her relationship with her mother like?*

– Appalling! She reproached her mother for having pushed her into singing, so that she, herself, would find fulfillment, but, above all, for all the money she would make out of it. People had told her: "There's gold in your daughter's voice." When Maria refused to send her mother money on several occasions, she wrote her these few words: "You're too miserly, my child. I hope you get throat cancer!" That drove Callas mad, quite literally.

– *Why did she refuse to help her mother?*

– She wasn't a generous person, and was always afraid of being short of money. It was terrible. Sometimes she would tell me you must never put your money in a private bank in case it went bankrupt. The only bank she trusted was the National Bank of Switzerland. She didn't want to take any risks, and was extremely cautious. Money comforted her. She was born stingy, but not when it came to putting Callas in the limelight: gowns and dresses by top couturiers, her Mercedes 600... she bought herself jewels and she told me: "Aristotle likes me to wear them, because, that way, everyone thinks it's he who's given them to me. But it's not him, it's me!"

– *But she was very rich!*

– Immensely rich! Because of her records and her concerts. What's more, Onassis gave her an oil tanker which she leased out to the Japanese, and that made her a whole lot of money.

– *Why did her relations with her mother and Meneghini— whose very name she couldn't bear being mentioned in her presence—get so bad?*

– Because, according to her version, they'd exploited her and she'd already given them plenty of money. She didn't feel she owed them anything. She wanted to be free. But they were the ones who inherited her fortune when she died, and it was valued at more than $10 million.

– *Did she believe in God?*

– In her own way, yes. She wasn't devout but she would often say: "I thank God. What more can I do?" She had very strict morals. She would say: "Why air your private life in public?" She was always terribly shocked when some artist or other would kiss and tell.

– *Did she have a lot of friends?*

– It was hard to be her friend. Callas wasn't an easy person to handle. She got into terrible arguments and she found only very few people interesting, because she was always a prisoner of her own myth.

– *Tell us how she was abandoned by Onassis.*

– I was in the middle of doing her hair for a photo session and all of a sudden we heard a flash on the radio that he'd just married Jackie Kennedy. It was a terrible blow for Callas. She burst into tears. I've never seen anyone sob and cry like that. She felt incredibly panicked, a catastrophe had just struck her and she knew that it was irreversible. She'd already got wind of the romance between Onassis and Jackie Kennedy, but she'd never for one moment believed that he would leave her. In tears she spluttered: "I'll never be his woman in the shadows! I'll never play back street, never. I hate him!" Thank God, the photographer was waiting for us in the living room and hadn't seen a thing. I suggested to Callas that she put off the session. She refused, pulled herself together, dried her tears and posed just as planned.

– *It was a complete break—final?*

– No! Less than a week after he married Jackie, Onassis phoned Callas. She slammed the phone down on him once, then ten times. Less than a month later, he came knocking at her door. She refused to open it, screaming in Greek that he was a filthy orange peddler and telling him to go to hell! A few more days passed. One day, she did let him in, afraid, so they say, that he was about to make a huge scene in her building. "We have interests in common" was what she thought she ought to tell him. He came back often. She consoled him because he wasn't happy. Callas likewise. When he fell ill, she suffered as much as he did. She often visited him in the American Hospital in Paris. One day she even rushed over to Dior to buy the cashmere blankets he would eventually die in.

When he did die, on March 15, 1975, she went to pieces. She had just lost the only man she had ever loved. And, to make matters worse, he didn't leave her so much as a word, or the tiniest thing to remember him by. She was mortally wounded, and nothing mattered any more. Maria Callas shut herself away in her apartment, and didn't want to see anyone. She cried a lot, and just couldn't pull herself out of it. My visits to her gradually became fewer and fewer. But I was with her the day before she died—eighteen months after Onassis. Her arm was giving her a lot of pain and she'd asked me to do her hair. For the first time since his death, she wanted to look beautiful once again....

Frédéric Simogli was interviewed by Virginie Merlin.

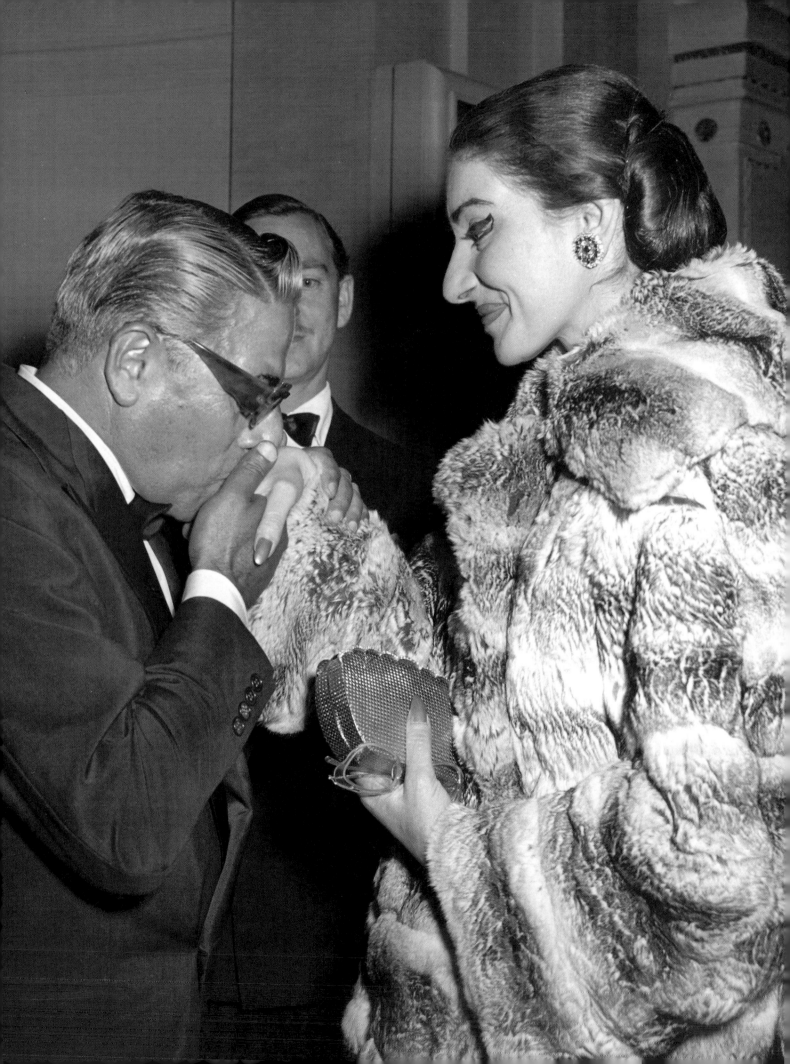

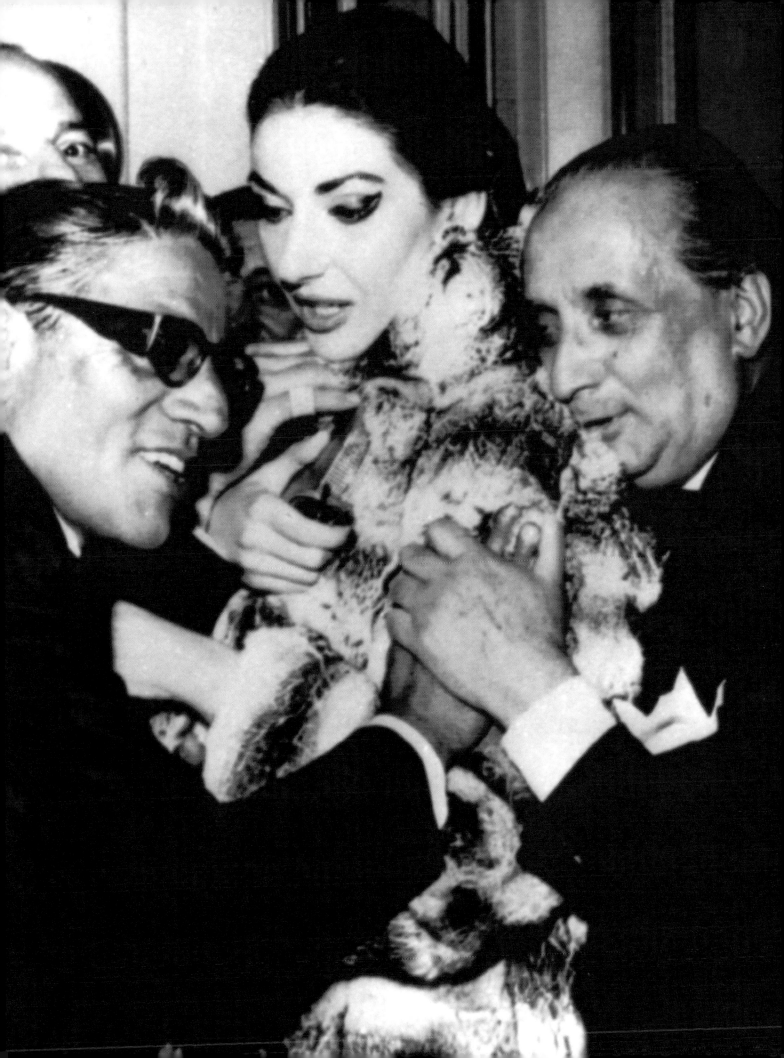

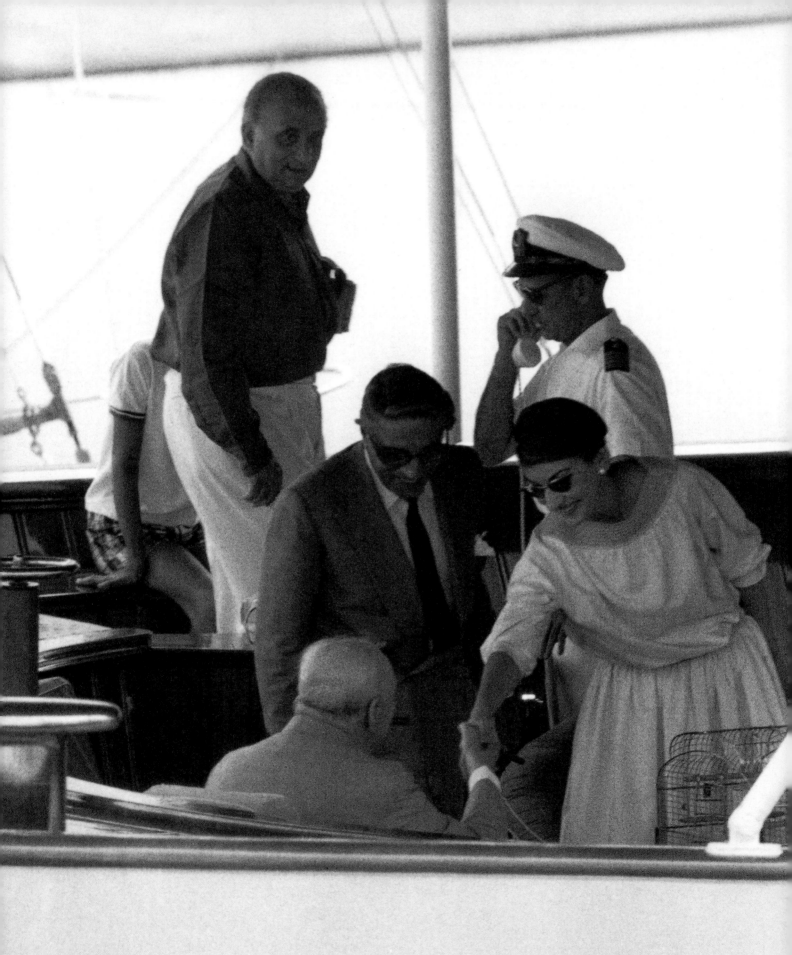

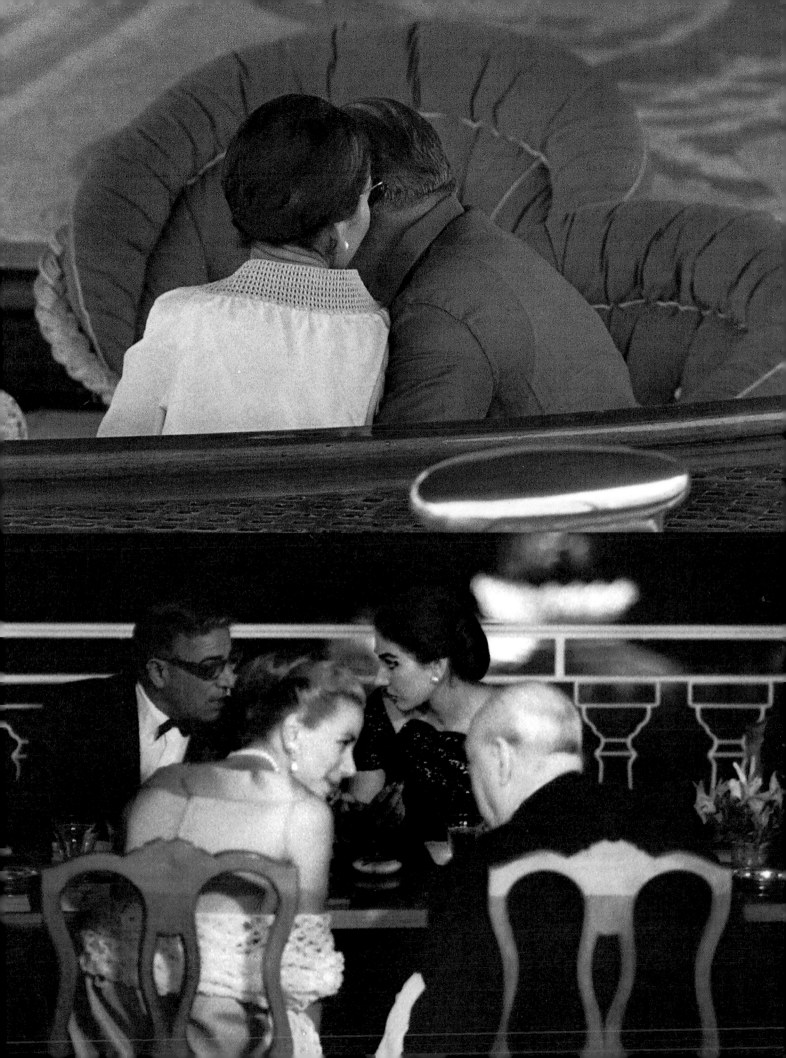

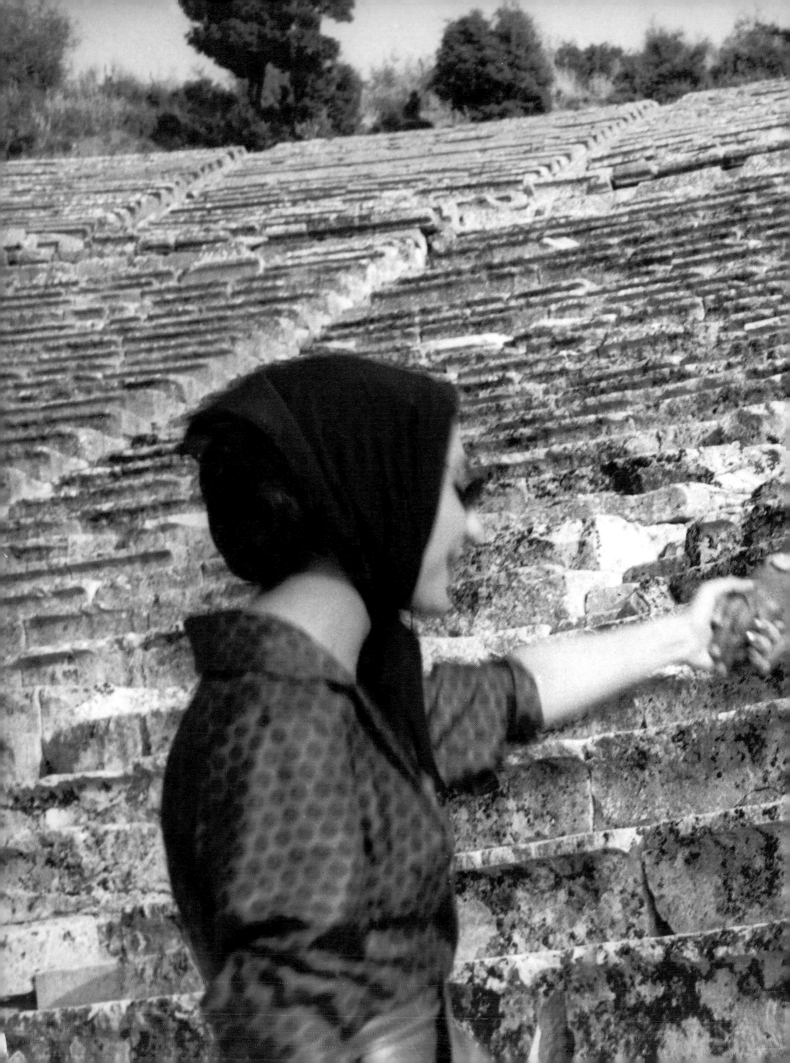

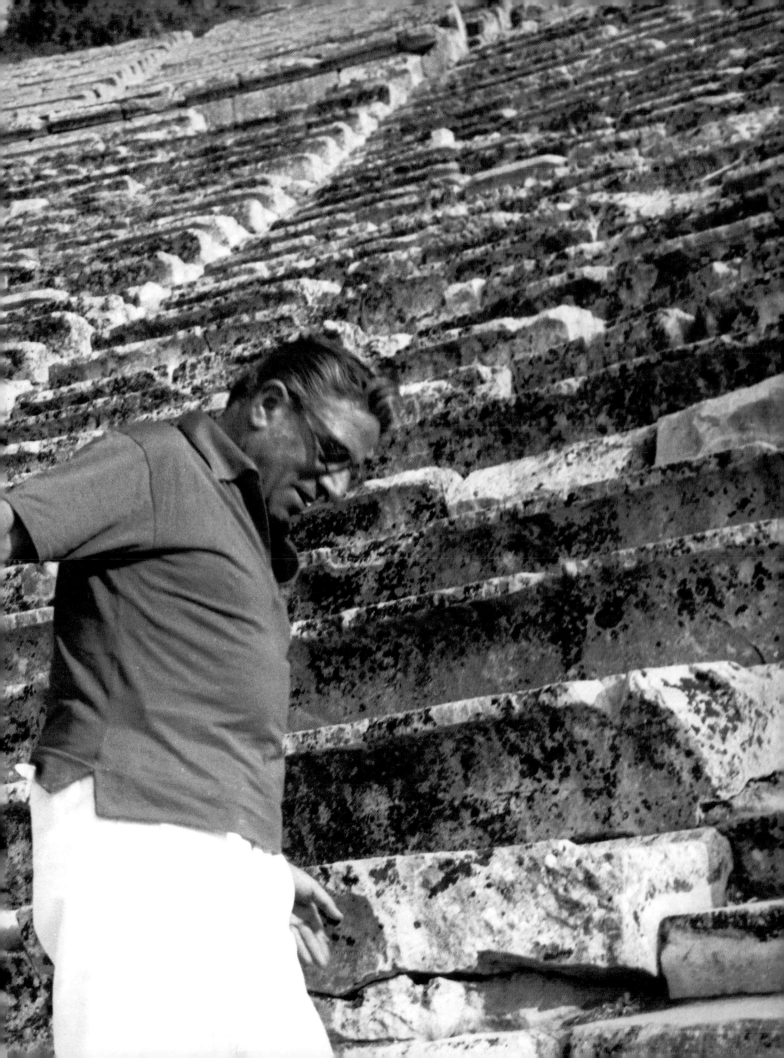

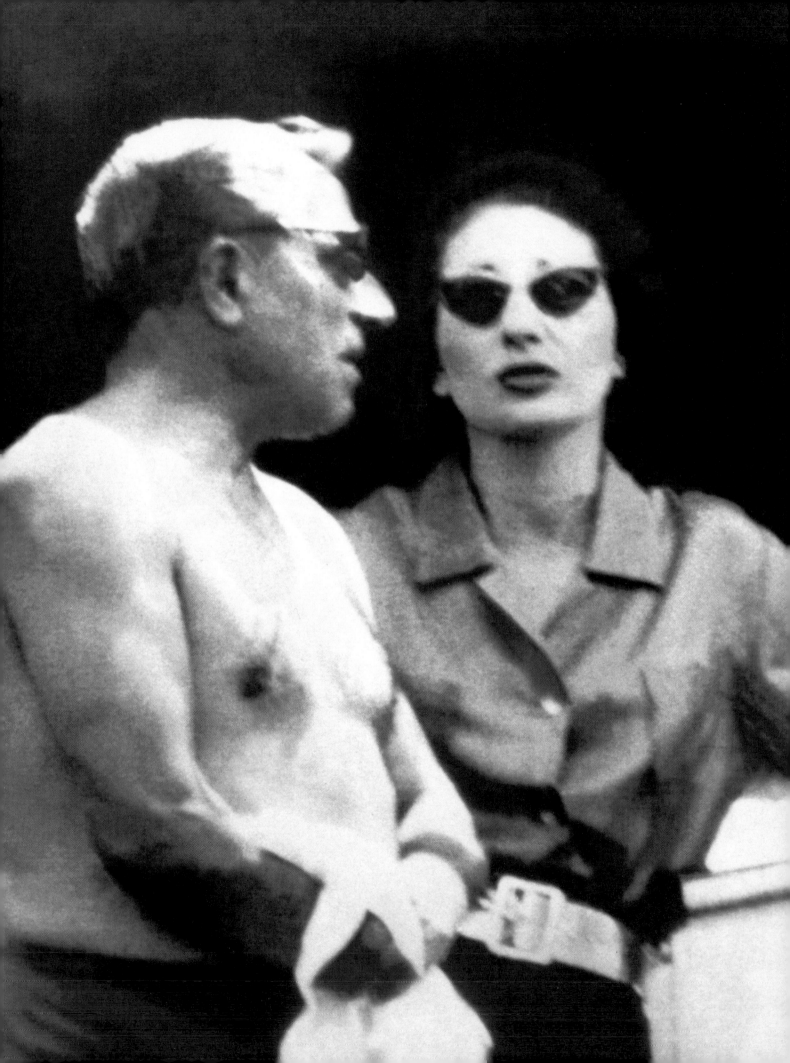

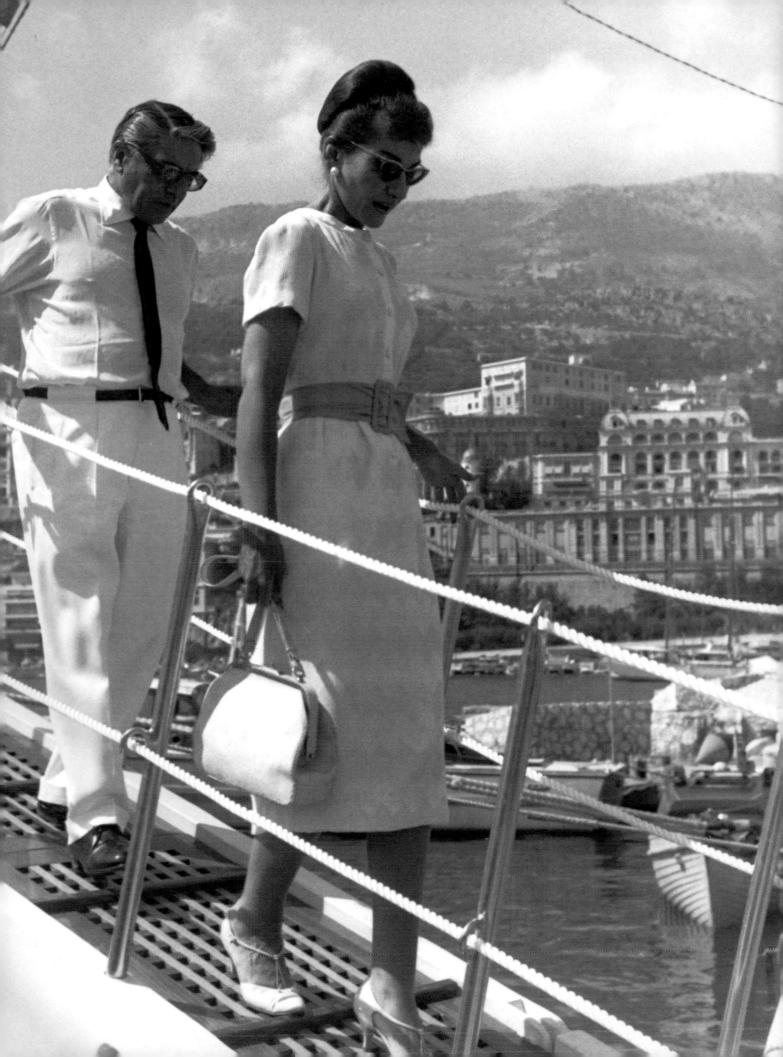

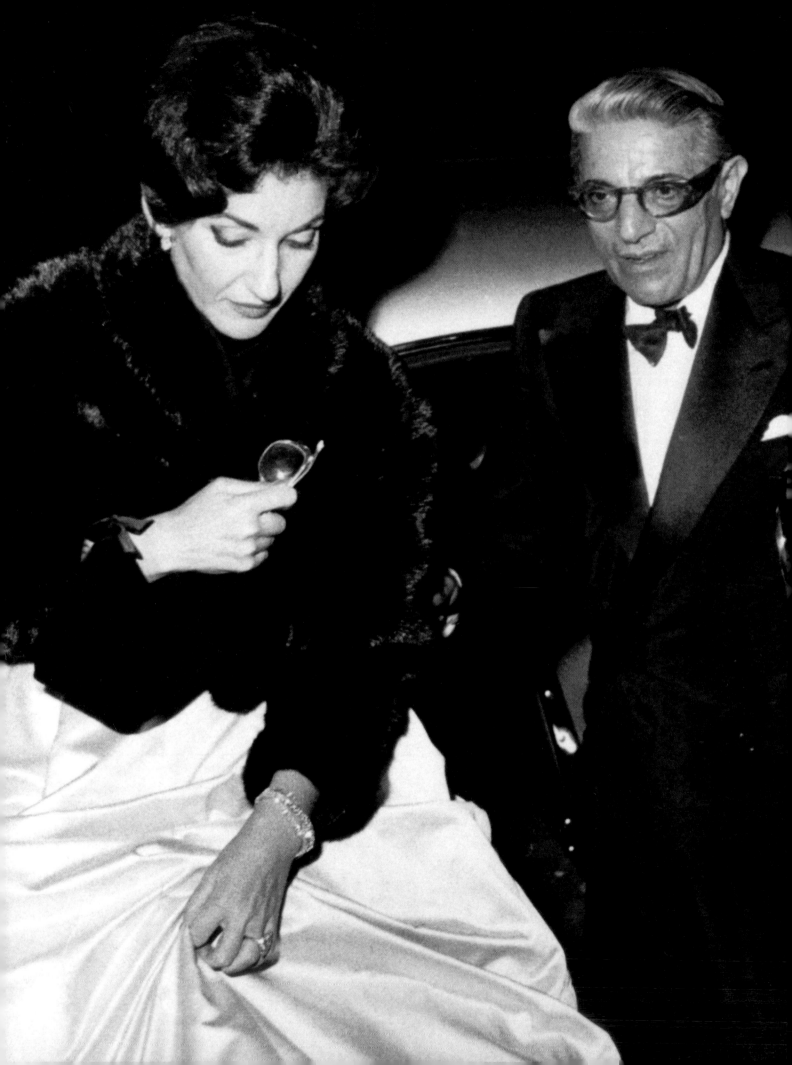

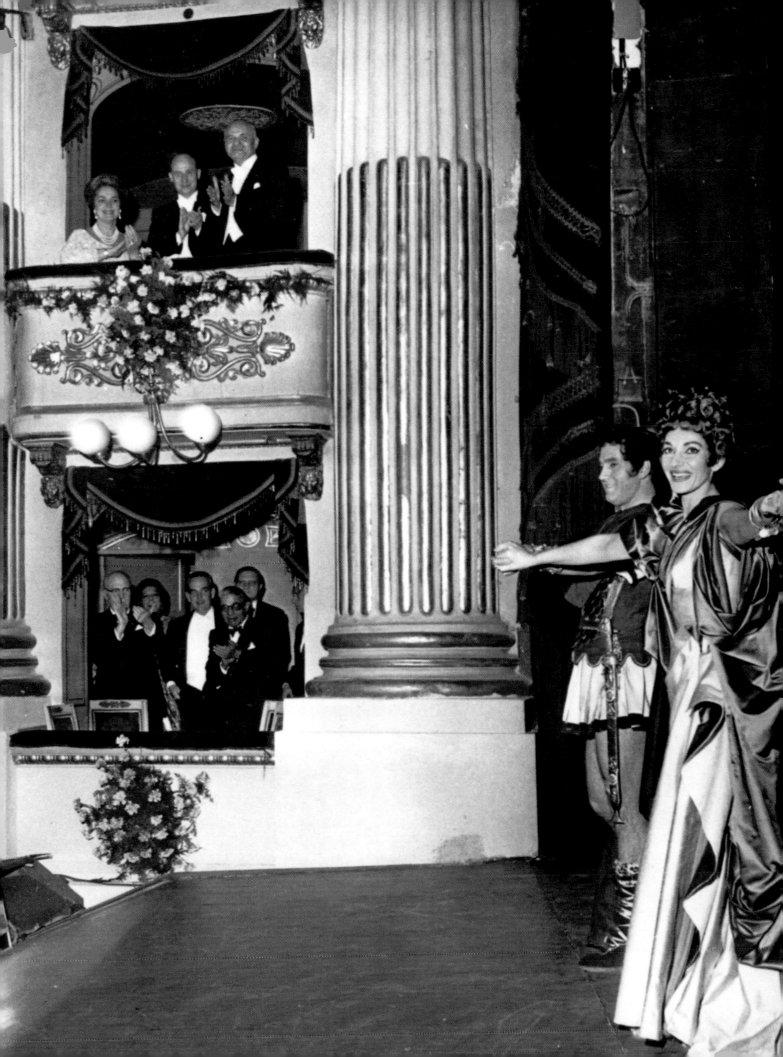

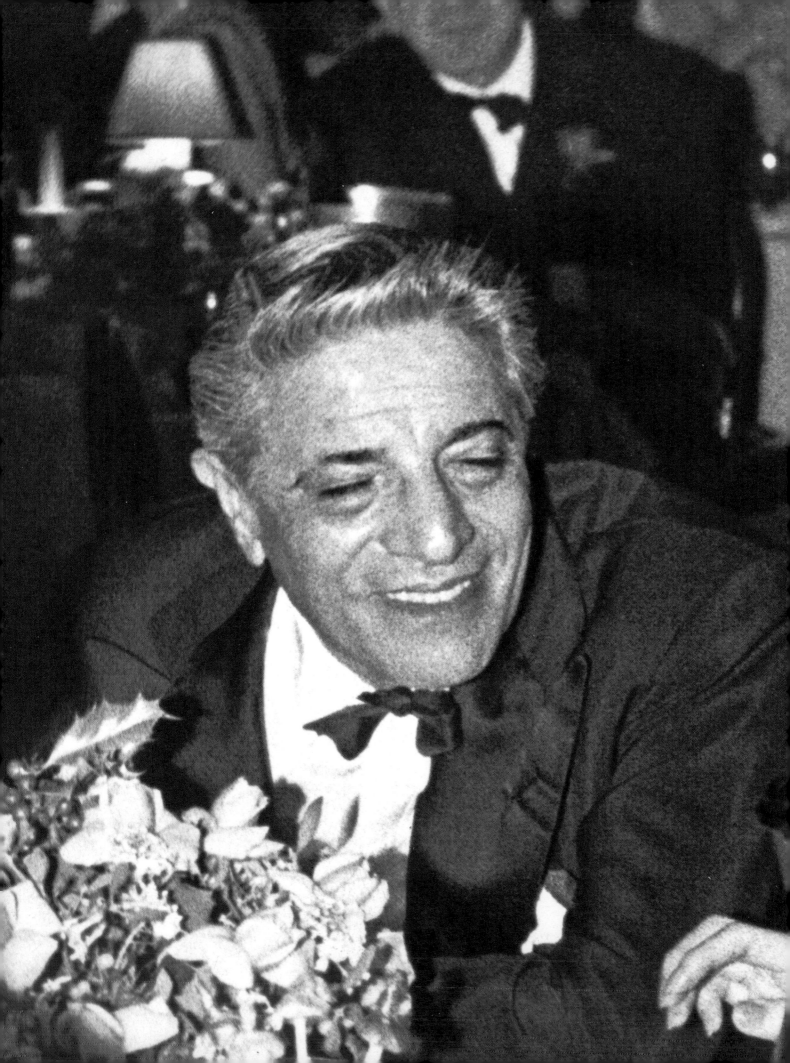

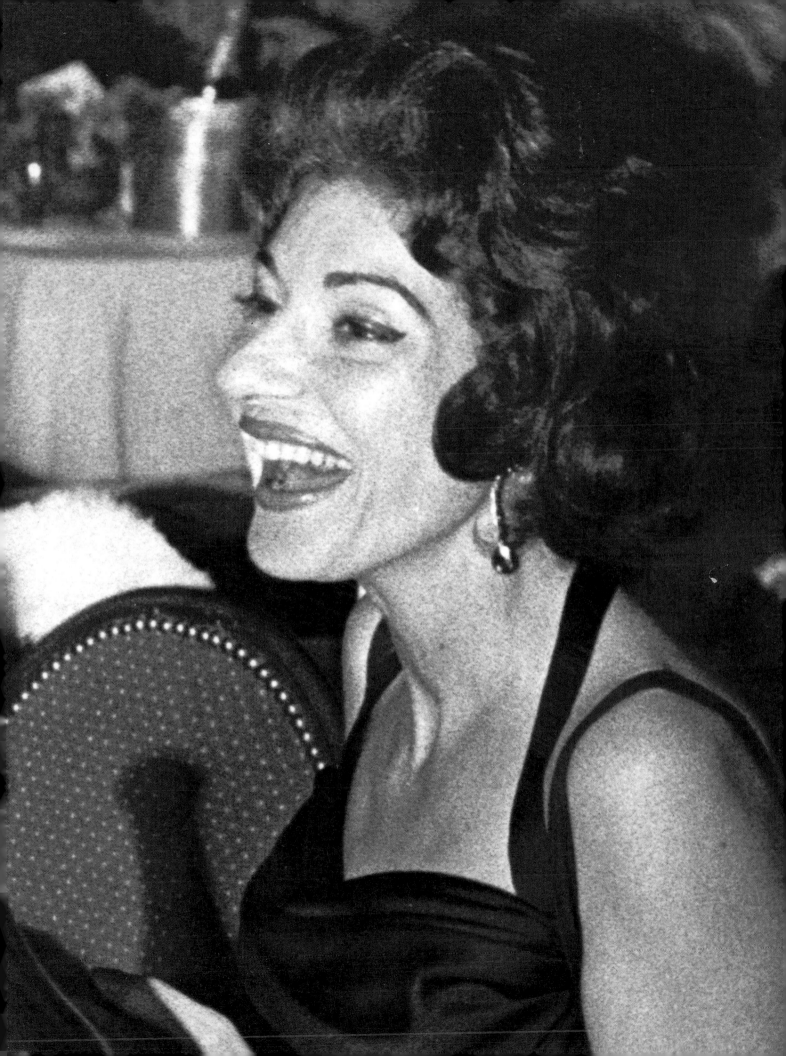

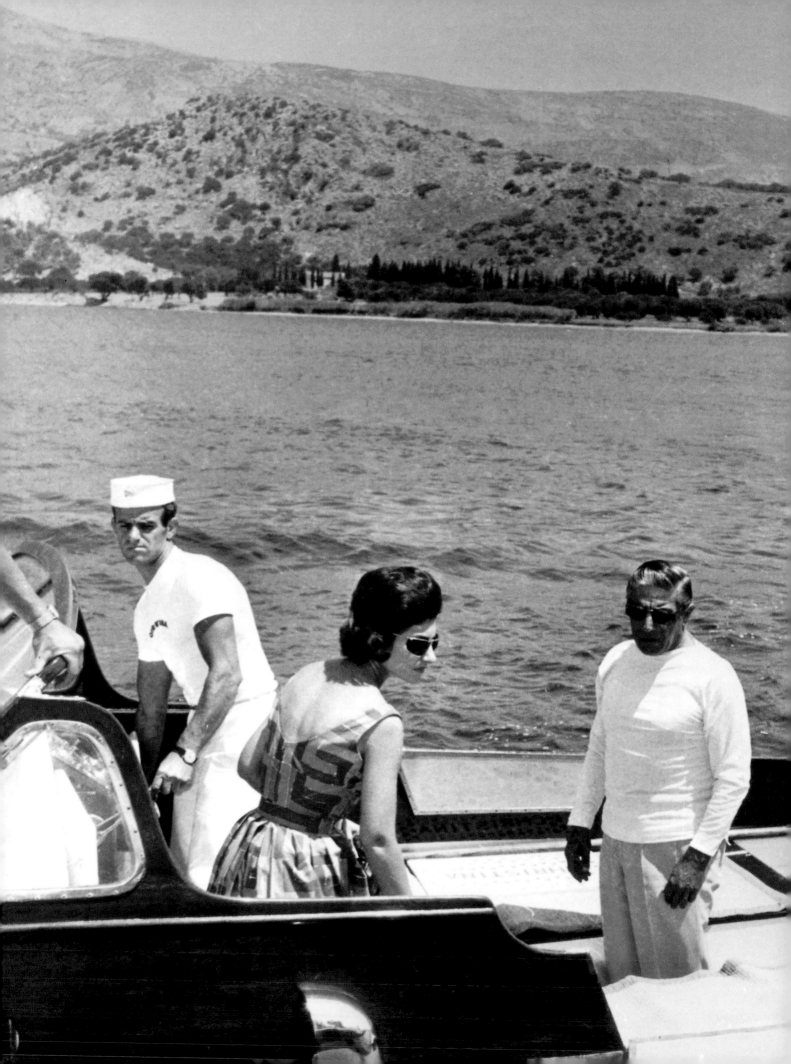

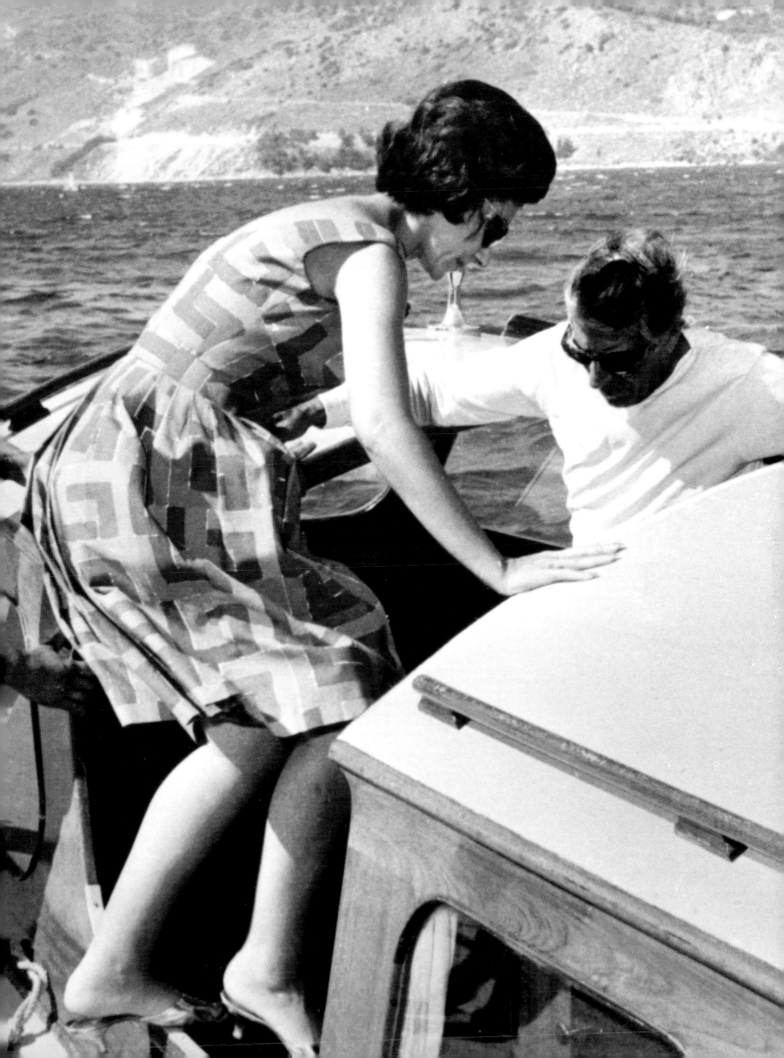

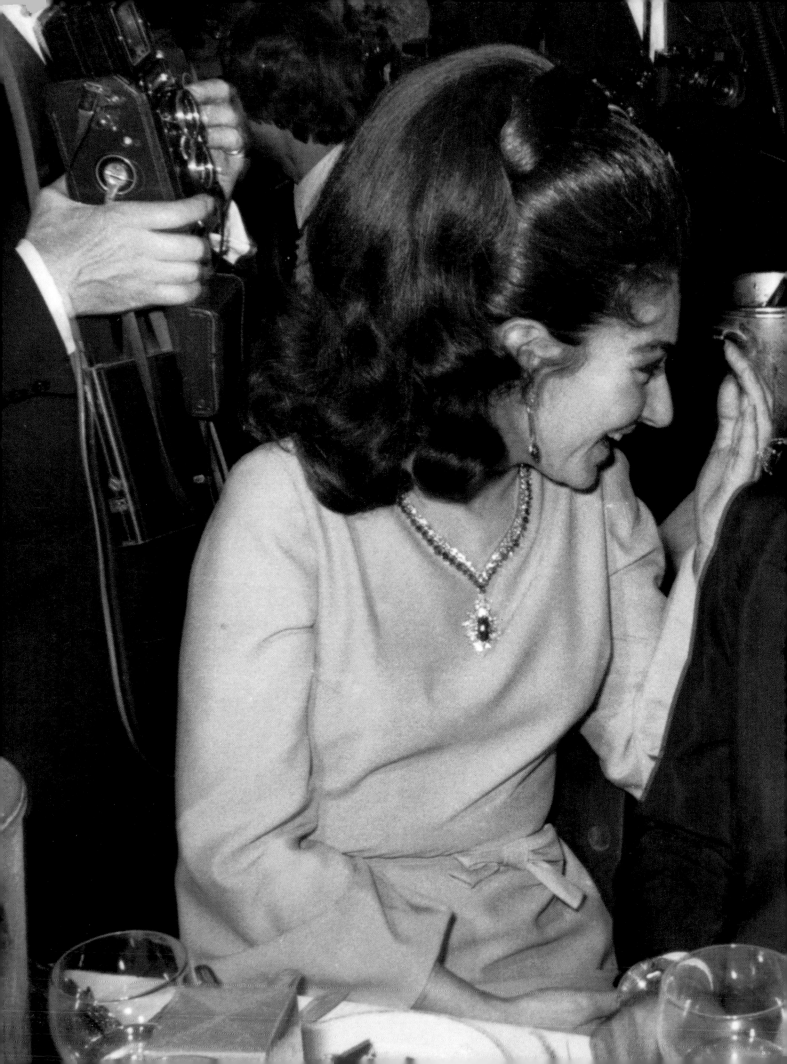

Liz Taylor & Burton

Addictive love

He married her once. Then twice. And two years before he died, he wanted to marry her a third time. A fearsome love. Terrifying. Distressing.

– When they met, she had already made thirty films, he six. Then came *Cleopatra* (1963). The two of them went down in history, along with their love story. They didn't even attend the premiere of the world's costliest movie. They were busy enjoying a lovers' dinner, and preparing their wedding.

– Under the Mexican sun, letting go.

– Those little gestures that come before great passion.

– The tenderness of newlyweds. The ceremony took just fifteen minutes, with no guests. And the very next day they were back on stage.

– They drank, tore each other apart, hurt one another. "An emerald for an insult, a diamond for a slap."

– He gave Liz the most beautiful fur coat in the world. Forty-two Kojah hides—from mink reared on one farm only. Dying flames, they posed for *Look*.

– She broke down in a taxi in Rome.

– Fourteen months apart, then Liz and Richard married again in the Botswana bush.

– They celebrated his 50th birthday in each other's arms. Their romance went on right up until Burton's death.

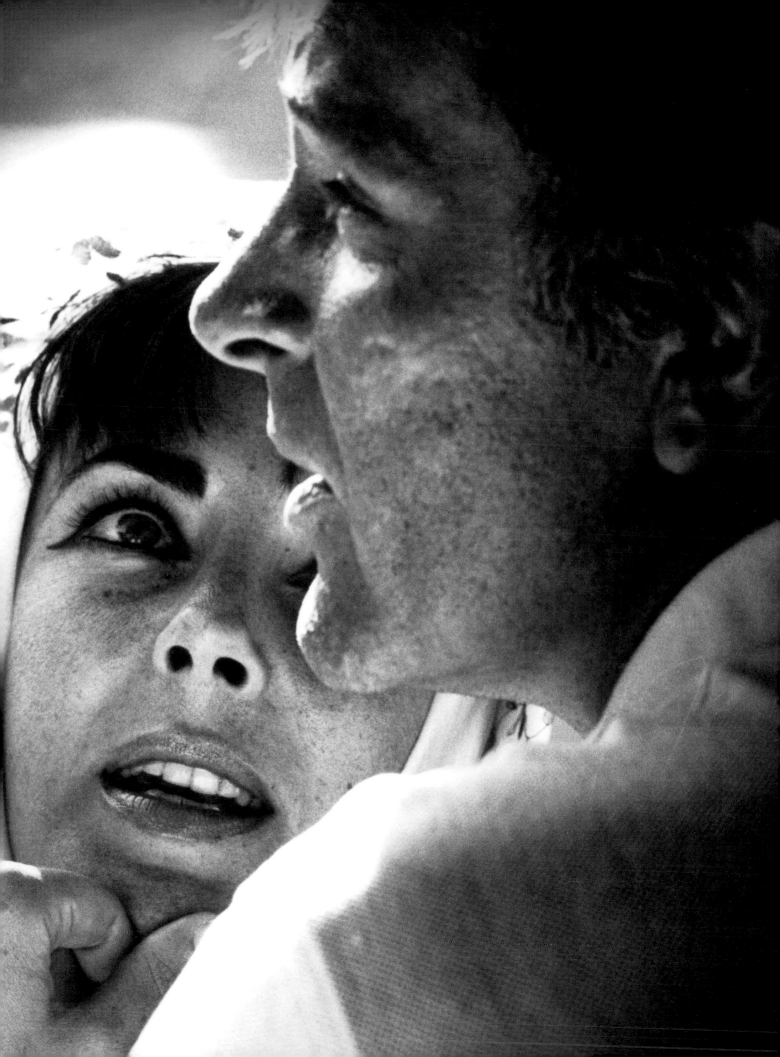

"If I've got to confront Miss Tits, I'd better keep my armor on!," quipped Richard Burton when he was offered the part playing opposite Liz Taylor. The year was 1961. Hollywood was getting ready to launch *Cleopatra*. Burton had a strange premonition about Liz, then the biggest star in Hollywood. But he shrugged his shoulders. It would take more than an epic queen to change his life! He picked up the pen and signed the contract. That signature would seal the fate of two superstars.

Elizabeth Taylor was born on February 27, 1932 in Hampstead, a chic part of London. Her parents were American immigrants. Her father, Francis Taylor, sold paintings and antiques. Her mother, Sara, dreamed of becoming a star. In June 1939, the Taylors set sail for Pasadena, California. Francis pursued his business activities, and Sara tried to charm the film producers. The couple was very close to the famous Hollywood gossip, Hedda Hopper. Hedda fell for Sara's daughter and introduced her to the studios. Liz got her first part when she was just nine. In 1951 she was acclaimed for her performance in *A Place in the Sun*, and from then on took her place as one of the great stars of the silver screen.

On the romance side, she lived in a giddy whirl. On May 6, 1950, Miss Taylor married Nick Hilton, son of the multimillionaire Conrad Hilton, who invented the modern-day hotel industry. But the young bridegroom spent his nights boozing, and hit his wife in public. Liz divorced him six months later. But she was unshaken by the unhappy experience, she believed in marriage and wed Michael Wilding, Mike Todd and Eddie Fisher one after the other. The first was a British actor, fifteen years her senior. She had two children with him, but he gradually became estranged from her. The second was handsome and very wealthy, and could well have been her ideal partner. Later she would say: "He never asked me for anything...he valued and appreciated me. He was irresistible." It was love with a capital L. Tragically, Mike Todd was killed in a plane crash. He left his widow masses of money, a daughter named Lisa, and his best friend, the singer Eddie Fisher. In November 1958, Liz was just twenty-six. She had made twenty-eight films and had been nominated for three Oscars. Her charisma outshone all the other stars, and her frankness both scared and thrilled Hollywood—she was the embodiment of rebellion. At this same time, Richard Burton was getting ready to make his entrance. He was thirty-three, thickset, with a face craggy from alcohol. His head was a bit too big, but there was something spellbinding about his almost limpid eyes, and the way they looked through you. As an actor, he had been trained in the Shakespearean school. Judging from his statements, however, it seemed he regarded fame, films and the star system with scorn. In a word, everything about Hollywood got on his nerves. Everything, except the big bucks. It should be added that he was a man who knew the value of money. He had been born in South Wales, into a family of miners, with thirteen children. Given his background, he might have been doomed to spend his life amid the maze of mine shafts. But a priest, who was also the village schoolteacher, made Richard work. In 1943, Burton won a scholarship to Oxford. That same year, he made his first stage appearance in Liverpool. Twelve months later, he went on tour in London. The war interrupted his budding career but in 1947 he was back on stage. He played in *Hamlet, Othello* and *Richard III*, and he met Sybil Williams. They were married in 1951, and had two children together. It was an odd marriage. Richard went on being an aggressive, womanizing macho man. But Sybil, who was loving and gentle, didn't give in. When she acted with Burton, she was the one the audience applauded. One day he blew his top: "Stay at home!" She obeyed, unhesitatingly. The strategy bore fruit. Ten years after their first kiss, their marriage was still in one piece.

Rome, January 22, 1962. Shooting *Cleopatra*, scene one. Liz was wearing a yellow silk robe, setting off her tanned shoulders and amethyst eyes to best advantage. Burton was suffering an awful hangover from a binge the night before. But she wasn't offended by his appearance. Quite the opposite. She wrote in her diary: "He was trembling so much and was so cute that I opened my heart to him. I felt like rocking him in my arms!" Their love took off, but nothing was decided. Liz confessed the whole thing to Eddie Fisher, yet refused to give in to Richard while he was still with his wife. Burton didn't dare come clean to Sybil: still the desire was there. "You'd need a fire hose to get them apart," as a cameraman put it to the press.

Liz burst into tears on the set. Richard suggested he quit the film...Hollywood was glued to their every move, but passing moral judgment too. A month after they'd finished with the film, in a small hotel on the shores of Lake Geneva, Liz was waiting for Richard. She knew he hadn't really turned his back on Sybil, but by that time it didn't really matter. Burton showed up driving a convertible, face tanned, hair blowing in the wind. Liz described the scene: "His eyes were bright like lanterns. When I saw him looking like that I decided to become his mistress. I knew that I was demeaning myself. I'd never shared a man before that. But too bad!"

In London, Burton commuted between Liz's favorite hotel, the Dorchester, and his family home. He drank, sobbed, threw fits. Sybil preferred to stay in the background and

from that moment on, the two lovers would be free. Liz saw herself being the perfect wife. "In the evenings," she told the journalists, "in front of a fire, we'll read all the books in the world, and it'll be paradise." Liz stopped making movies for a year. She was happy just to be with Richard. "It's perfect," he said, "I'm making interesting films and Liz is knitting in the wings." "Why make movies?" Liz asked. "I'm already a star. That's enough for me!"

They were married on March 15, 1964 in Suite 810 at the Ritz in Montreal. Meanwhile, though, the lovely dream had been tinged by nightmares. Passion carried the Burtons away in a whirlwind of emotions. They made four films a year and traveled all over the world like jet-set Bohemians. In their wake came their children, along with eight or nine hundred pounds of luggage. They bought diamonds, paintings and yachts. In 1966, they both starred in *Who's Afraid of Virginia Woolf?* Liz won her second Oscar; Richard won an Oscar nomination. It was a high point in their career. But it contained a warning too—Liz played an ageing harpy, Richard a resigned husband. "I should never have played that part," Burton said, "it gives me a bad image of a guy groveling before his woman." Liz got the message loud and clear. She performed in *The Taming of the Shrew,* a Shakespearean comedy in which her husband had a chance to...tame her. But it was too late. Alcohol, quarrels and angst had all conspired to get the better of Liz's beauty. She put on weight and spent more and more time in clinics. Richard took drugs. He drank himself into a stupor. He had to be sobered up every morning and carried onto the set.

On July 4, 1973, Liz issued a statement: "Richard and I are going to separate for a while. Perhaps we've loved each other too much. Pray for us!" She tried out a few fiancés, made three movies, and got her figure back. Richard went back on stage, stopped boozing, and seemed finally to be getting out of the tunnel. But their caravan was still rolling along the road of high passion. They met up in Rome and an old taxi driver drove them to the shores of the Mediterranean, Cleopatra's sea. There was a sunset, the everlasting sand of memories, and lukewarm waves of nostalgia. And then they would tell each other it was all over. As if love could die. As if life were just a film.

A year later, at the Saarinen courthouse in Switzerland, Liz was wearing dark glasses and a beige suit. The magistrate asked: "Are you saying that life with your husband is intolerable. Is that right?

– Yes, Liz replied in a whisper.

– I can't hear you very well. Please repeat that for me.

– Yes, your honor, intolerable."

The judge's hammer tapped the bar. They were divorced on June 26, 1974. The Burtons had been married for ten years. They had made thirteen films and earned $30 million. And it wasn't over yet.

Liz lived with a former car salesman named Henry Wynberg. Her new lover was perfect. He made love as well as he cooked. And yet she phoned Richard every day. In 1975 she wrote to him: "Soon I'll carry you off on a white charger. But I'd rather it was the other way round. One day, something will make you realize that you can't live without me, and you'll marry me!" No sooner said than done. On October 10, 1975 in South Africa, the Burtons were married for the second time. The roaring river and the chanting forest sang of their endless togetherness— again. There were even two hippos and a rhino. Liz was over the moon, Richard, struggling to come round from a fearsome hangover, was less enthusiastic.

"I wondered what the hell I was doing there!," he would write. He had good reason to be worried. Their reunion, papering over the cracks, began to crumble within six months, and ended up in a second divorce on August 1, 1976, in Haiti. Liz put on a huge amount of weight and hardly made any films, but she was still a living legend. Then she went into politics. She married John Warner, senator-to-be for Virginia, and backed his campaign. Burton also remarried, to Susan Hunt, a 27-year-old model. Back on stage, he was once more acclaimed. Film directors clamored for him, and the critics pronounced that he had rediscovered his former talent. When news reached Liz of his rebirth, it hit her hard. She left John, went on a desperate diet, and hastened to join Richard on the stage. They acted together in *The Viper* and, more importantly, in Noel Coward's comedy, *Private Lives*, which was based on their life. Liz came on stage squeezed into a scarlet dress. Richard, teetering on platform soles, staggered around like someone about to die. But they attracted a full house night after night. Burton, however, was worn down by drugs and alcohol. On August 4, 1984, his new wife found him unconscious in bed. A stroke. He died in the hospital. When the news reached Liz in Bel Air, she fainted. It took almost an hour to bring her back round. Burton had often said: "I'll drink myself to death, but Liz will survive. She has a world. My world is the theatre."

Jean Durieux

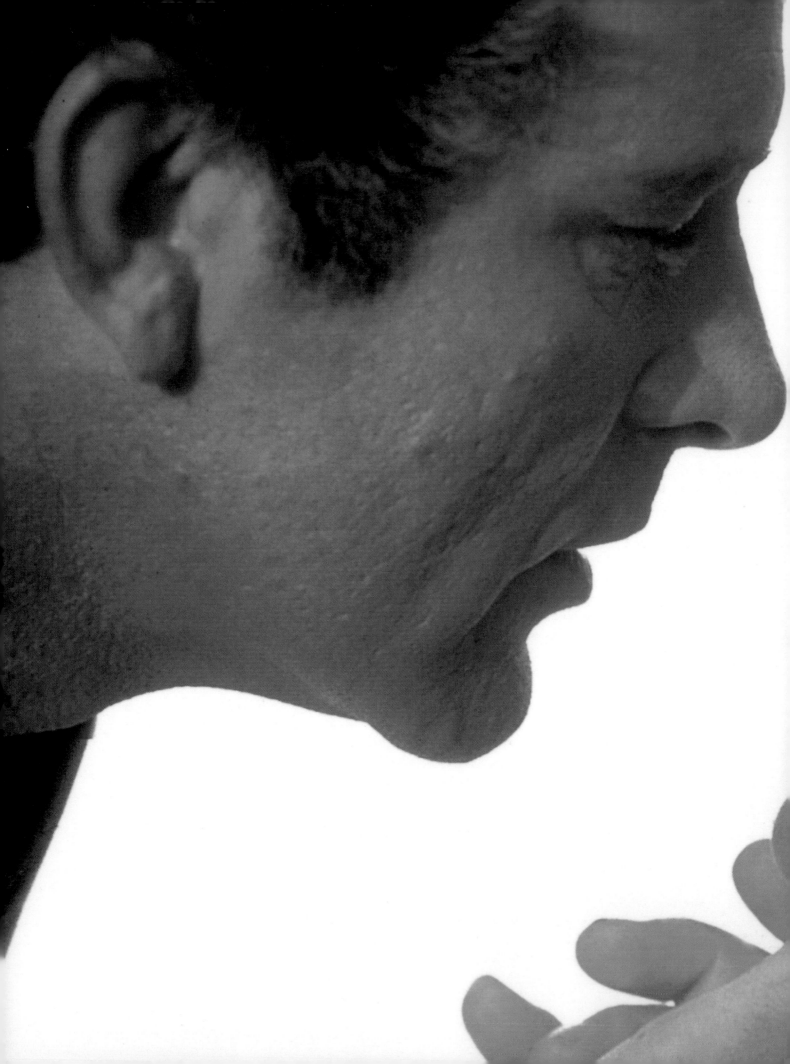

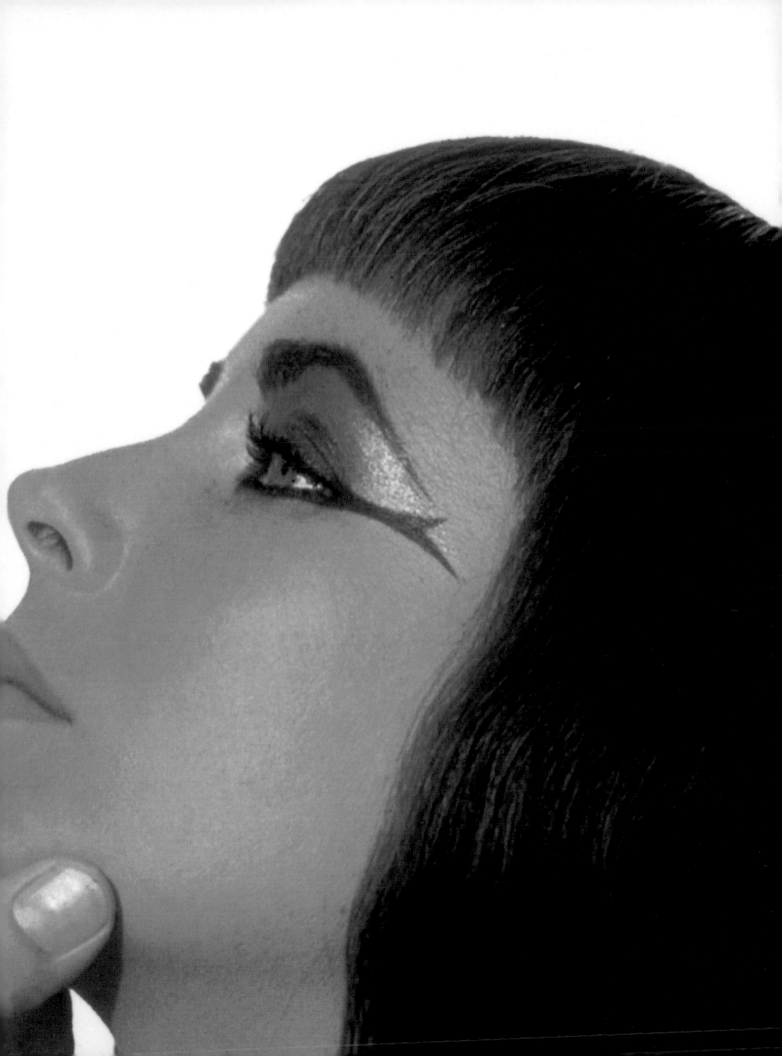

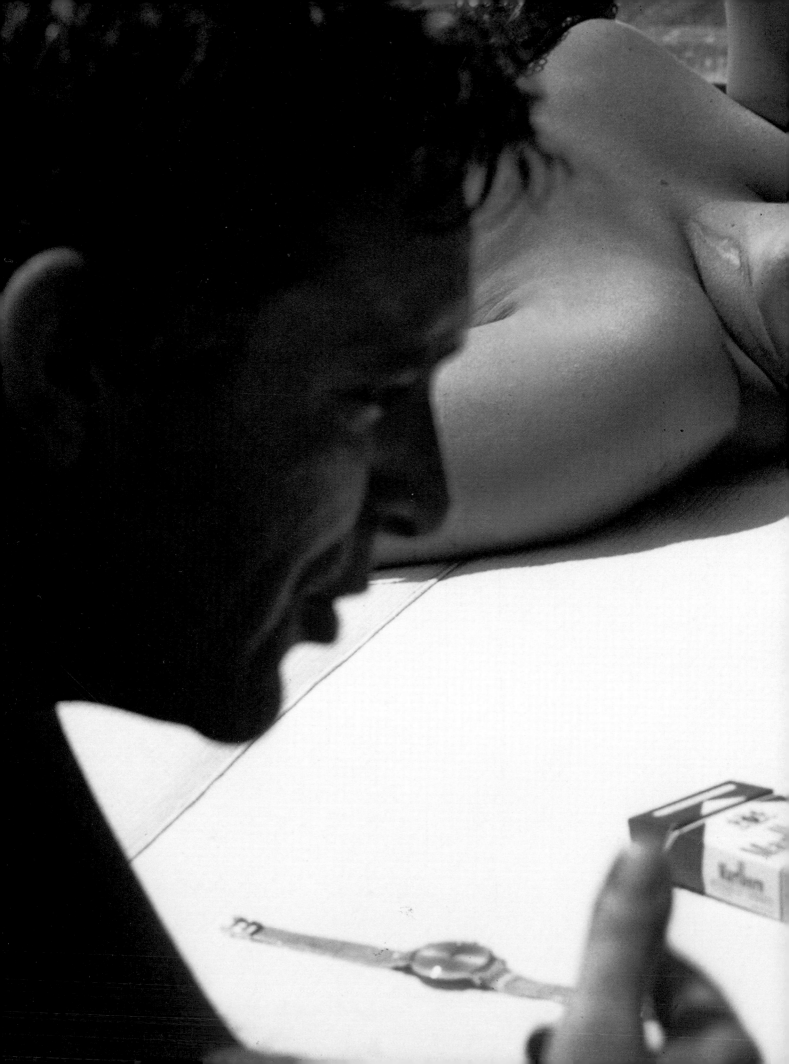

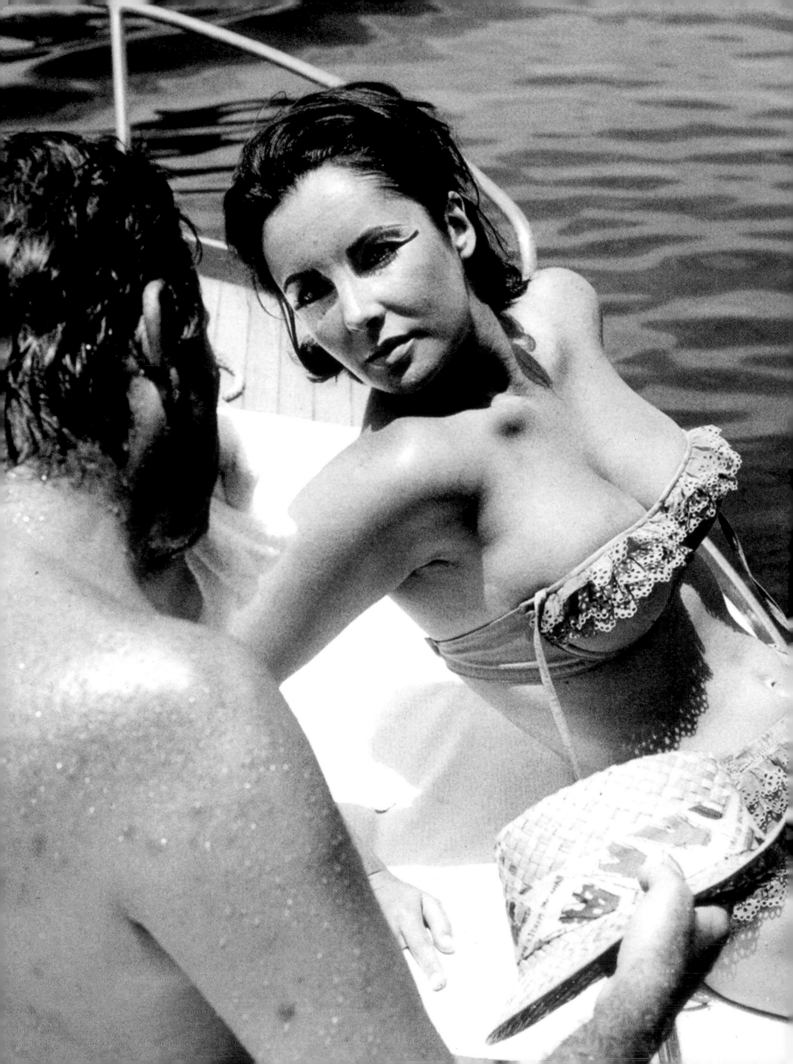

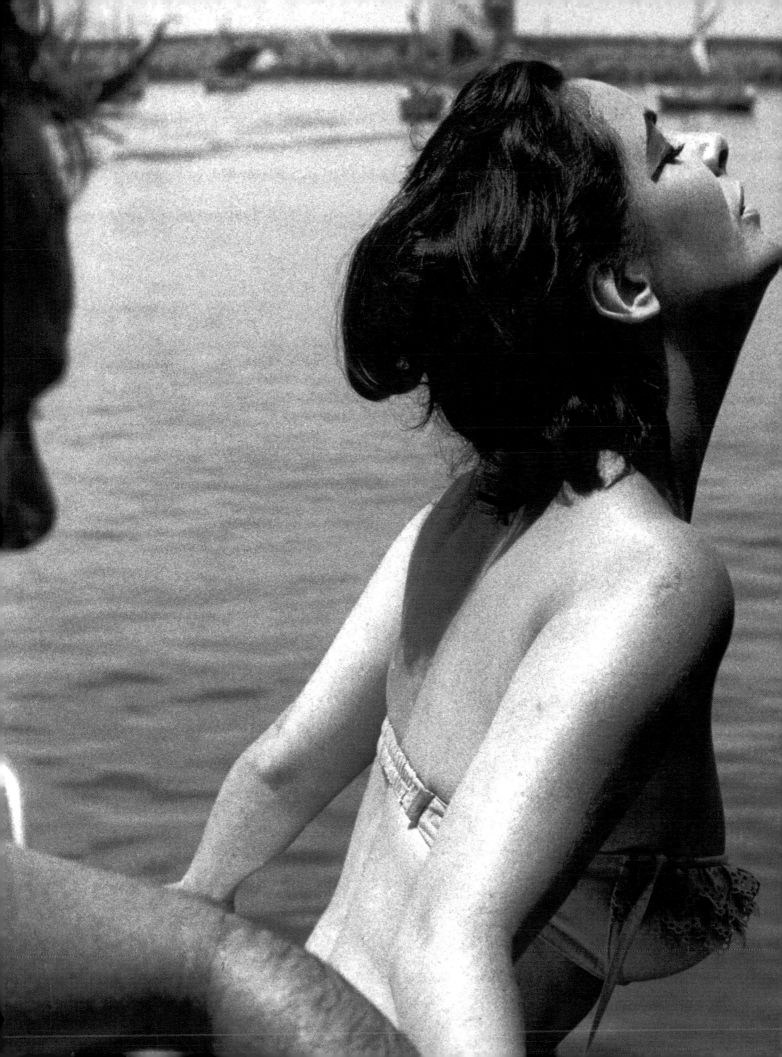

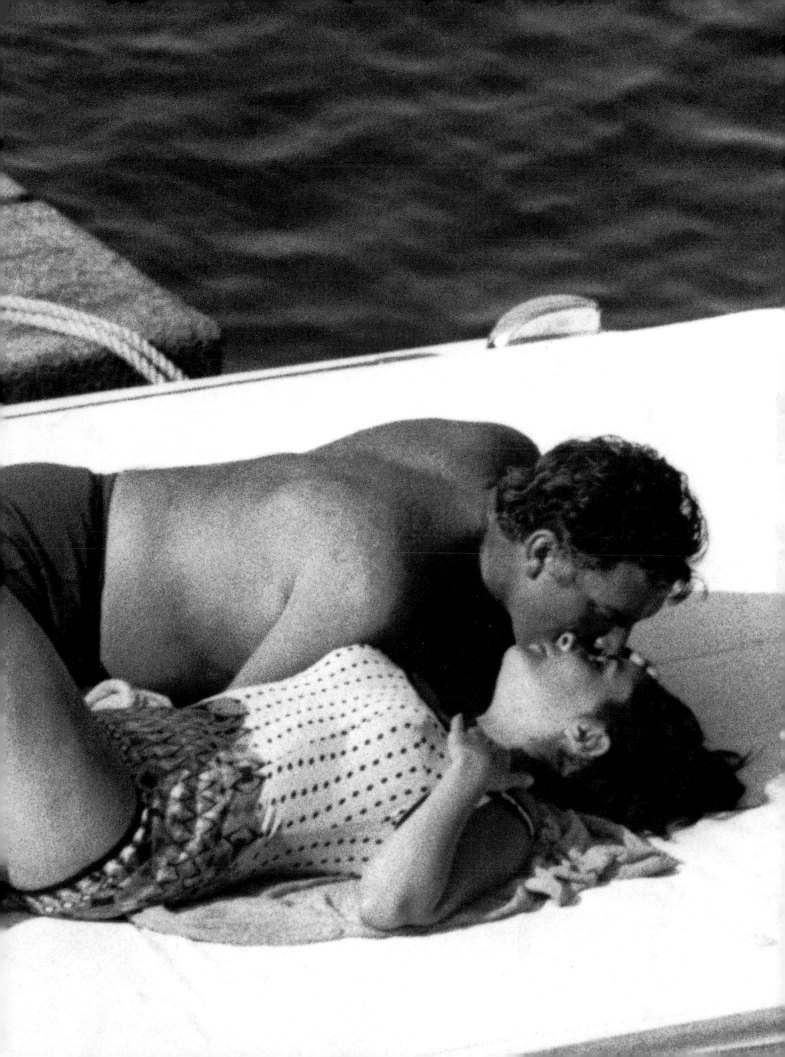

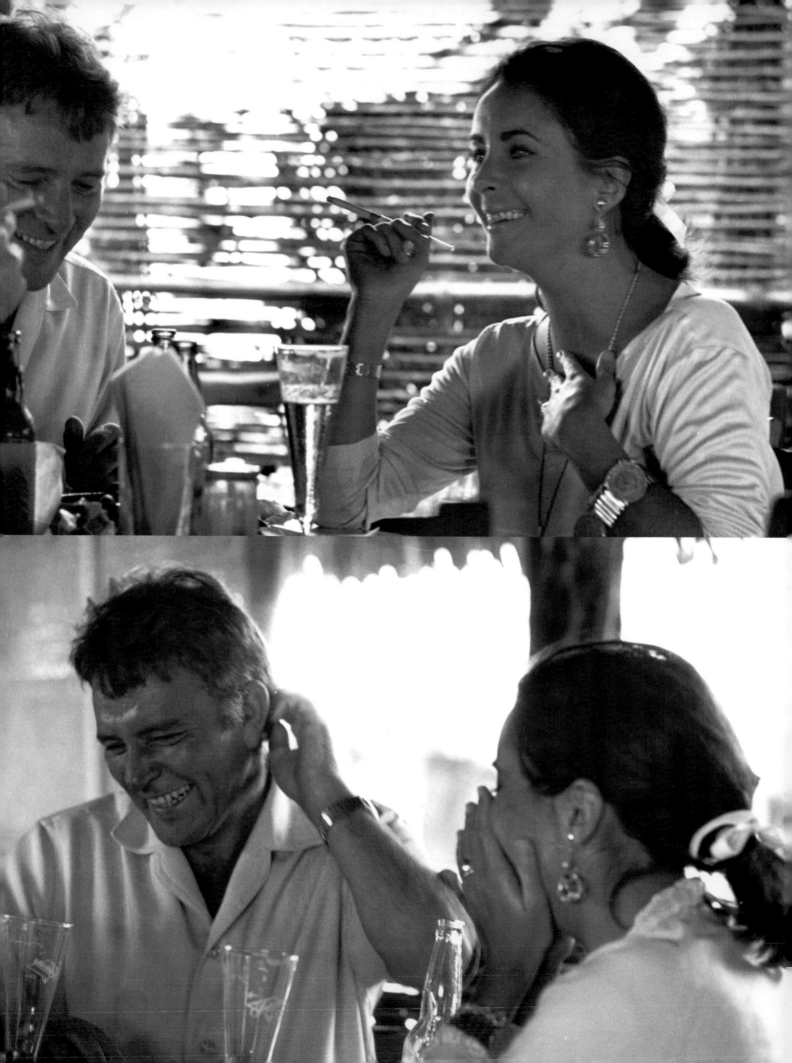

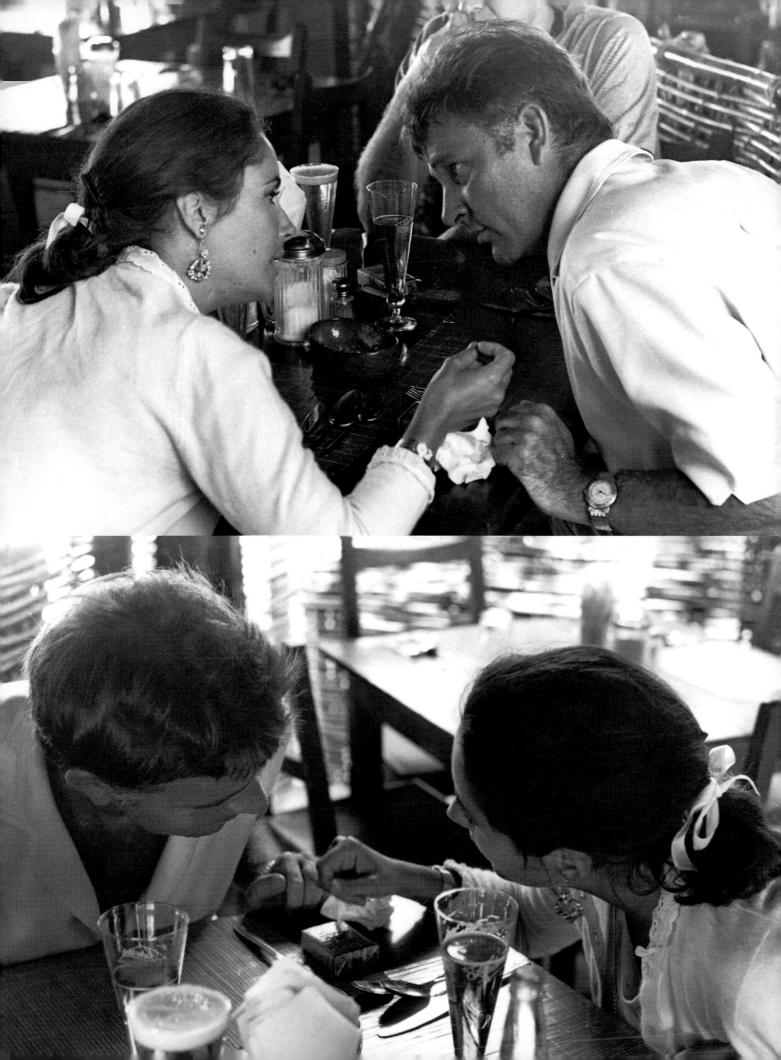

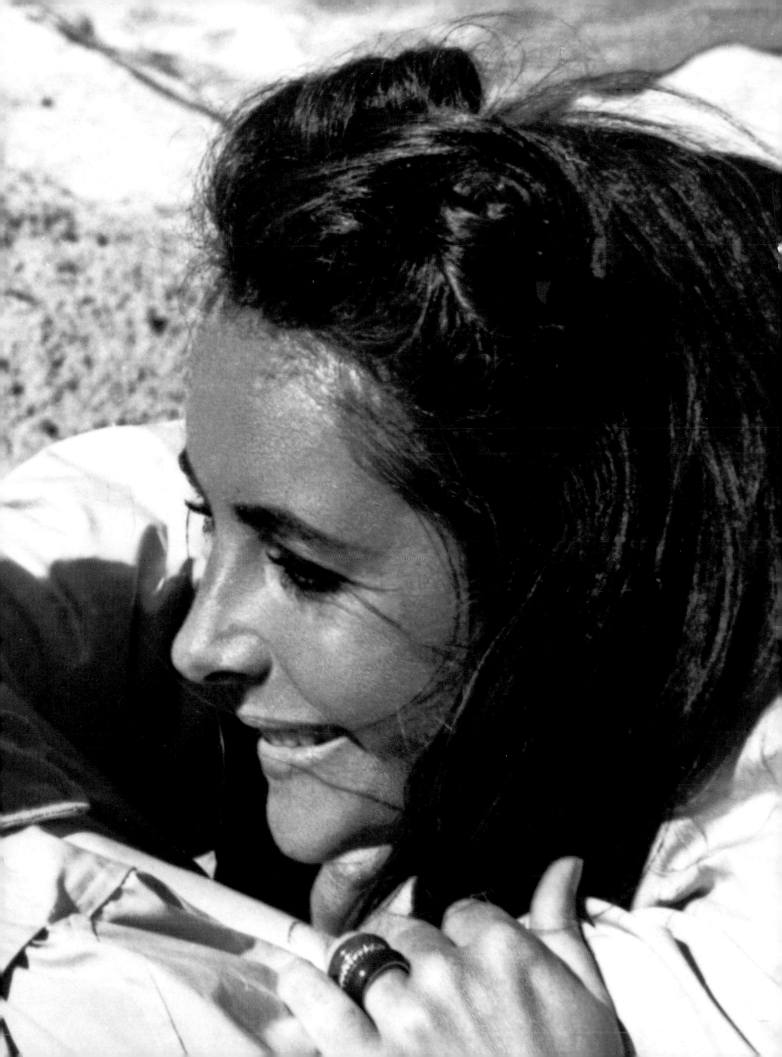

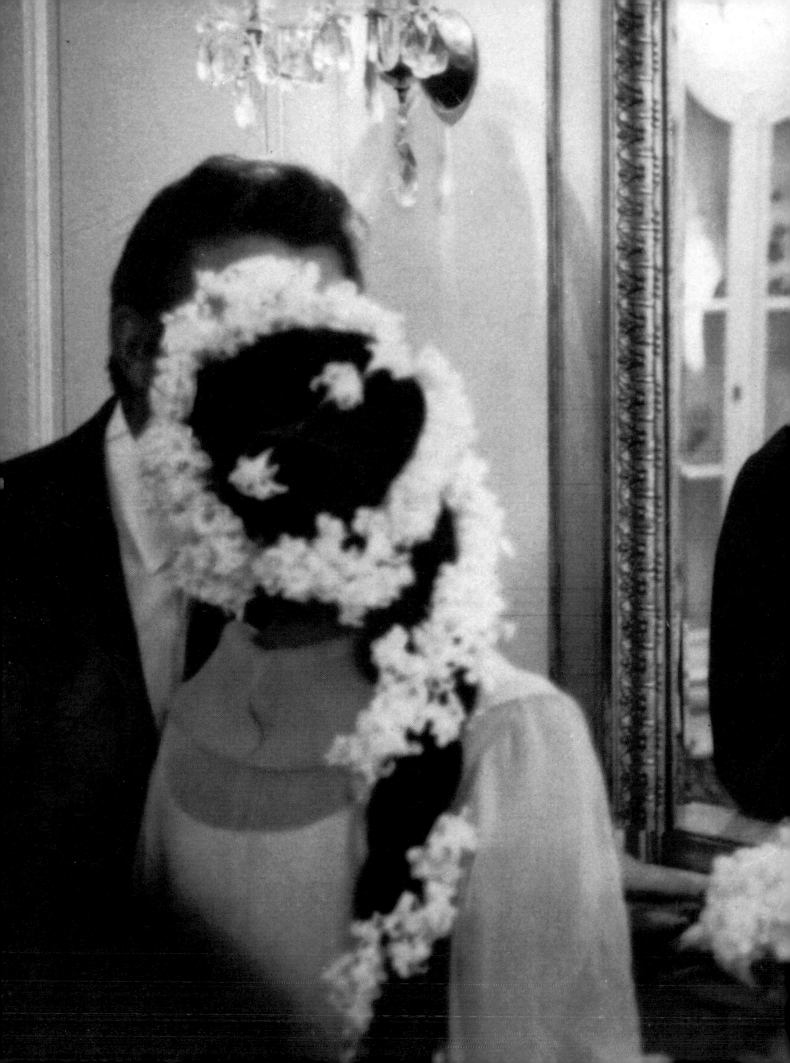

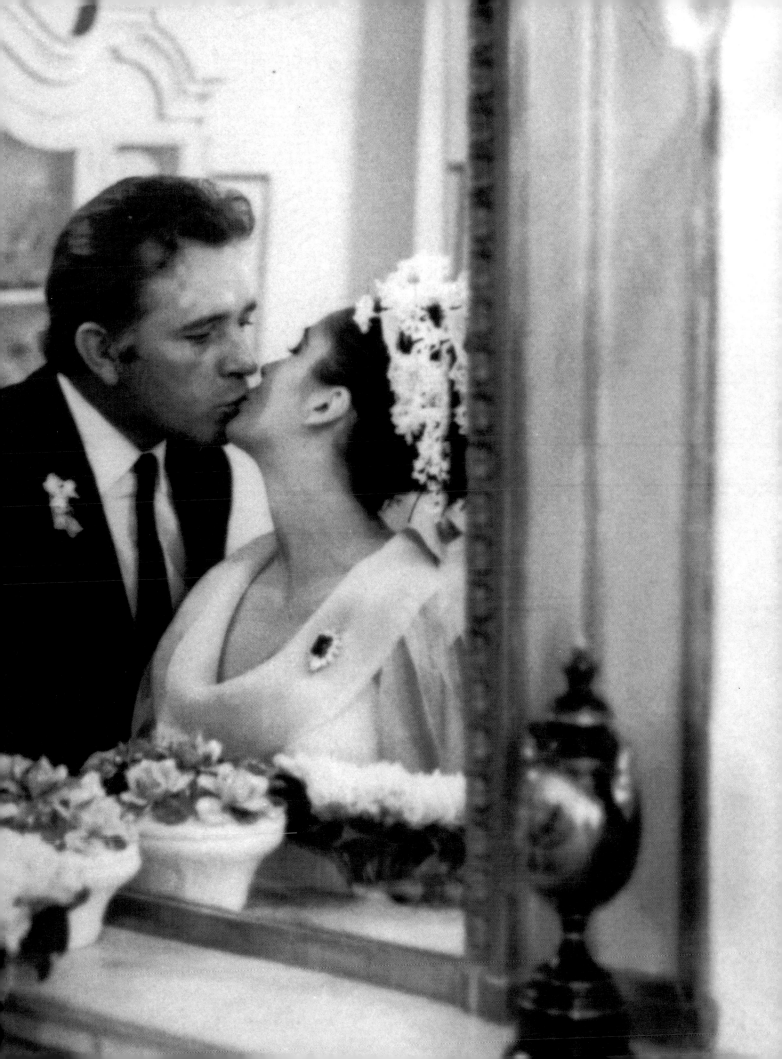

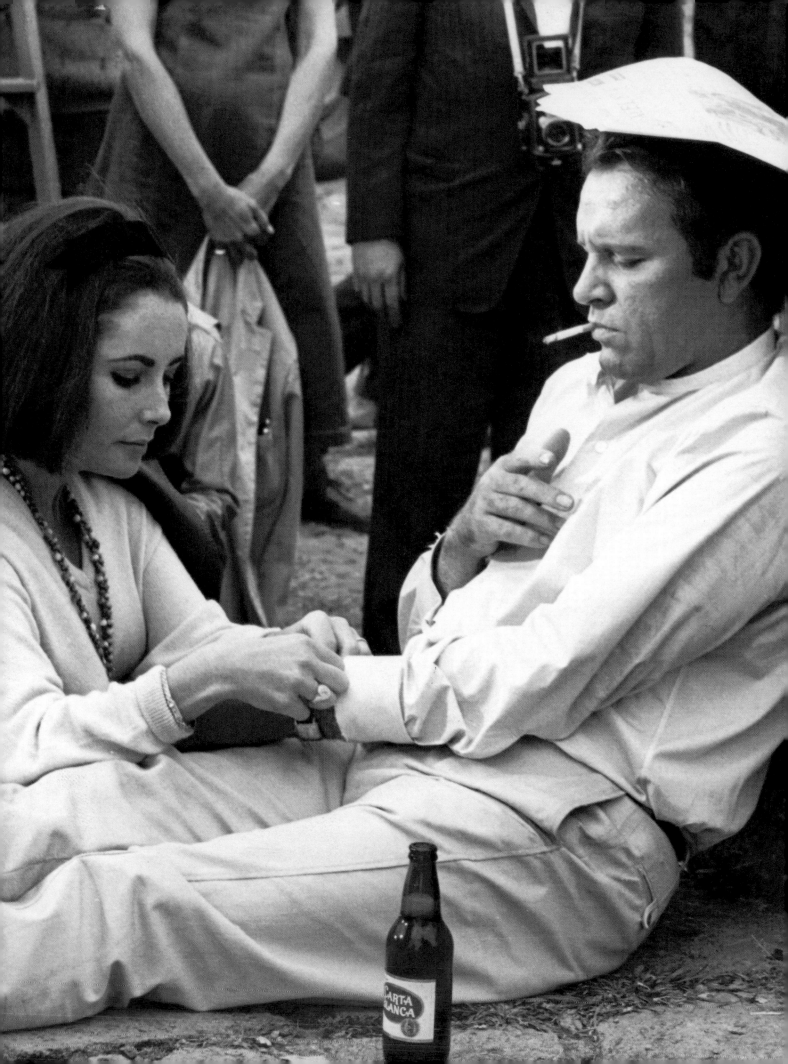

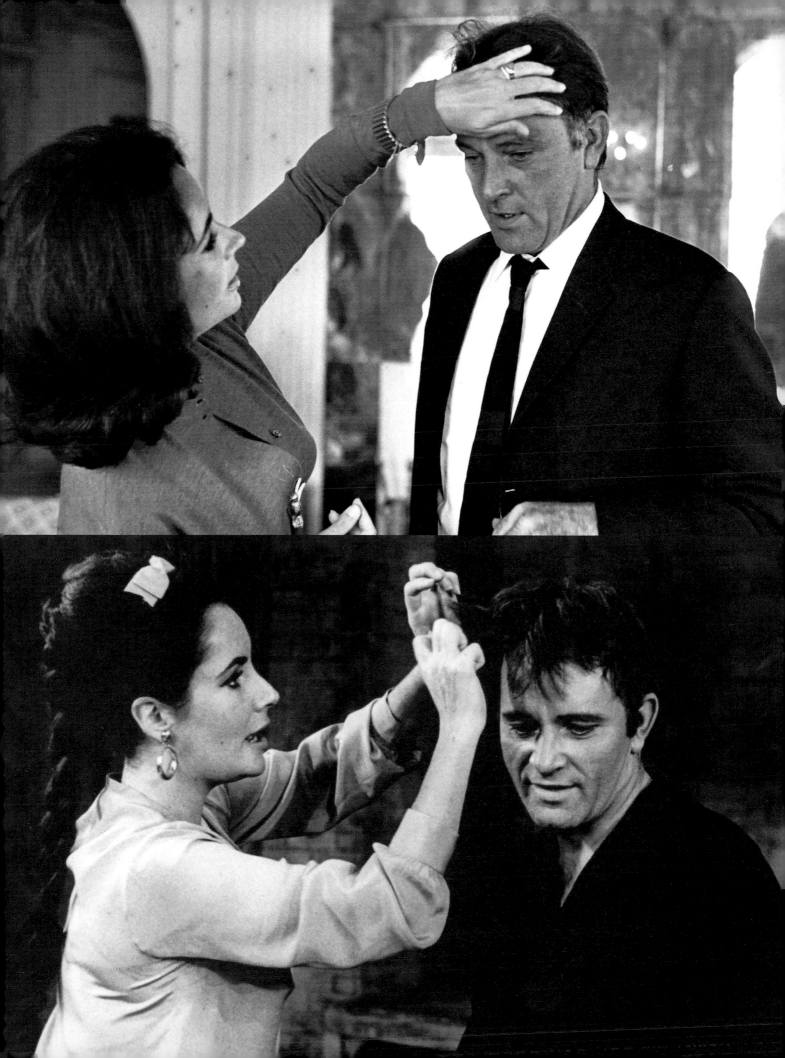

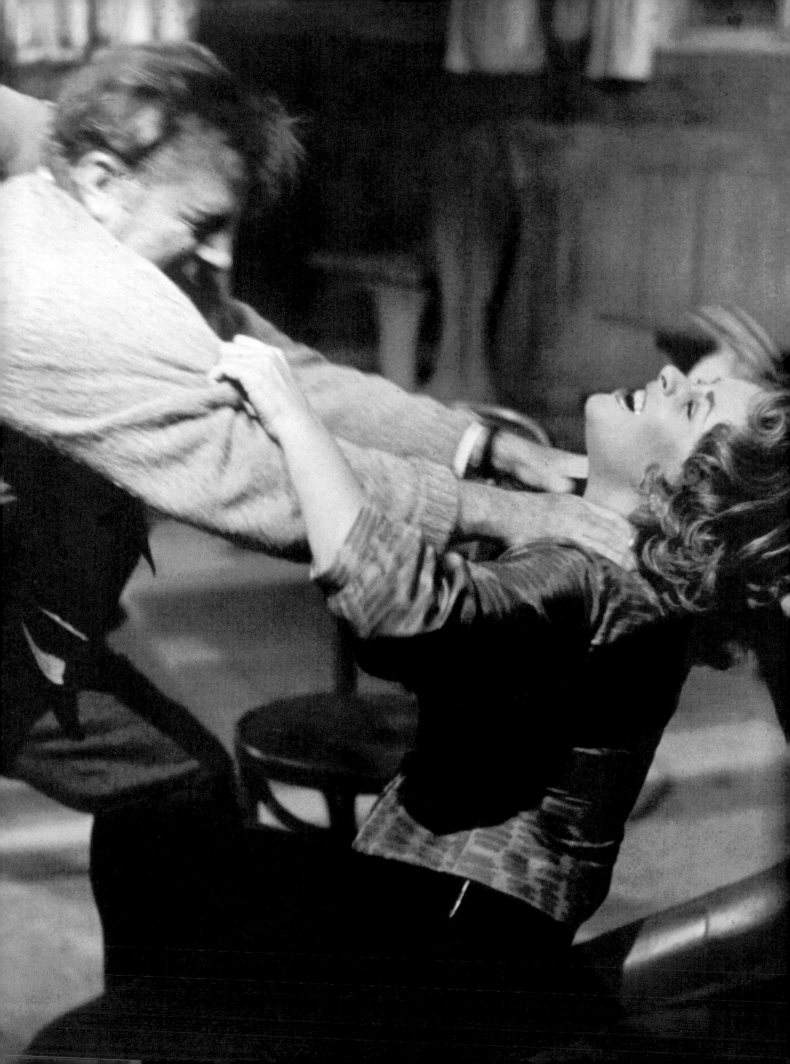

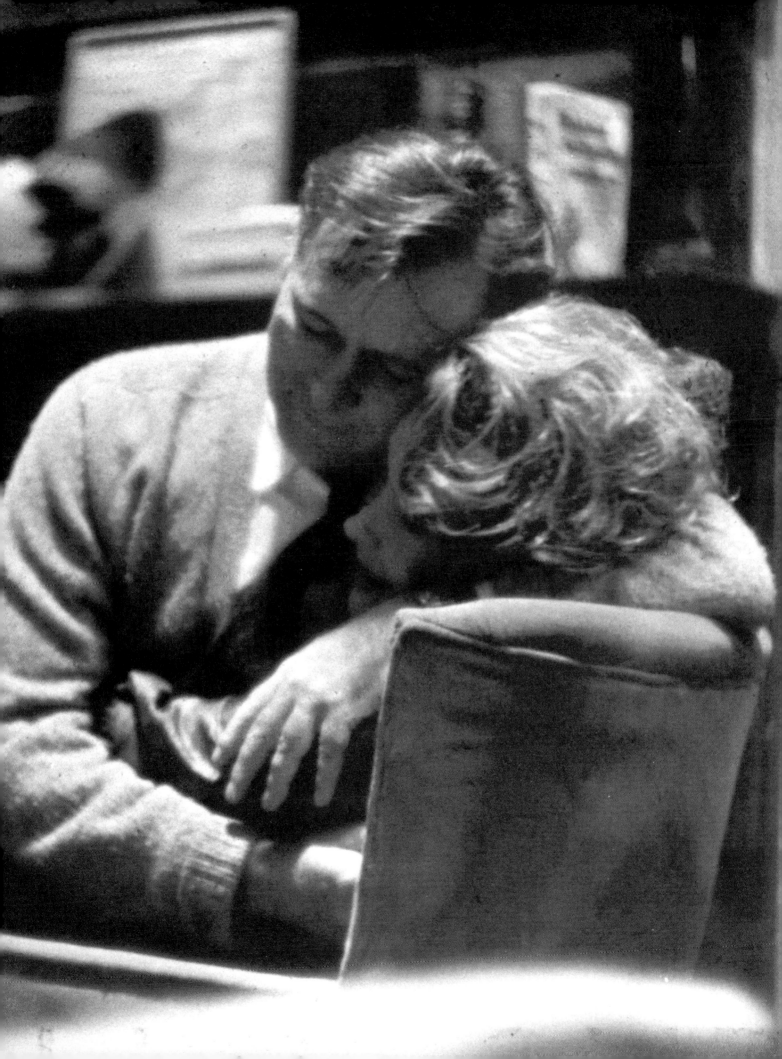

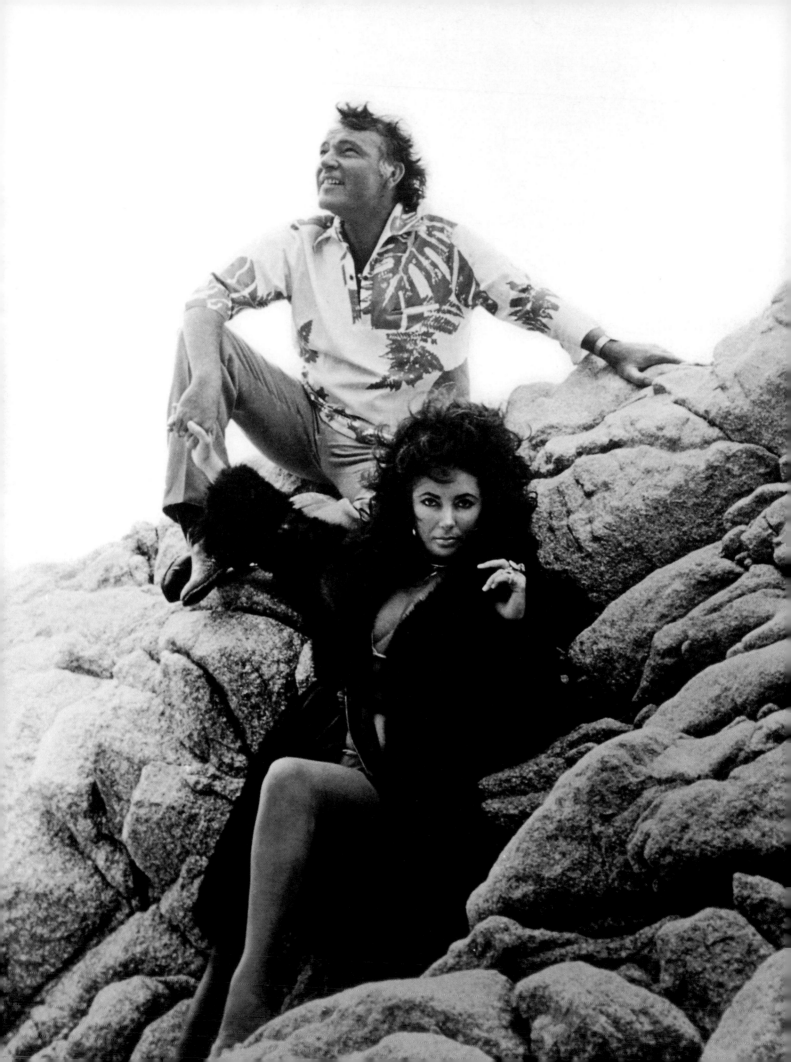

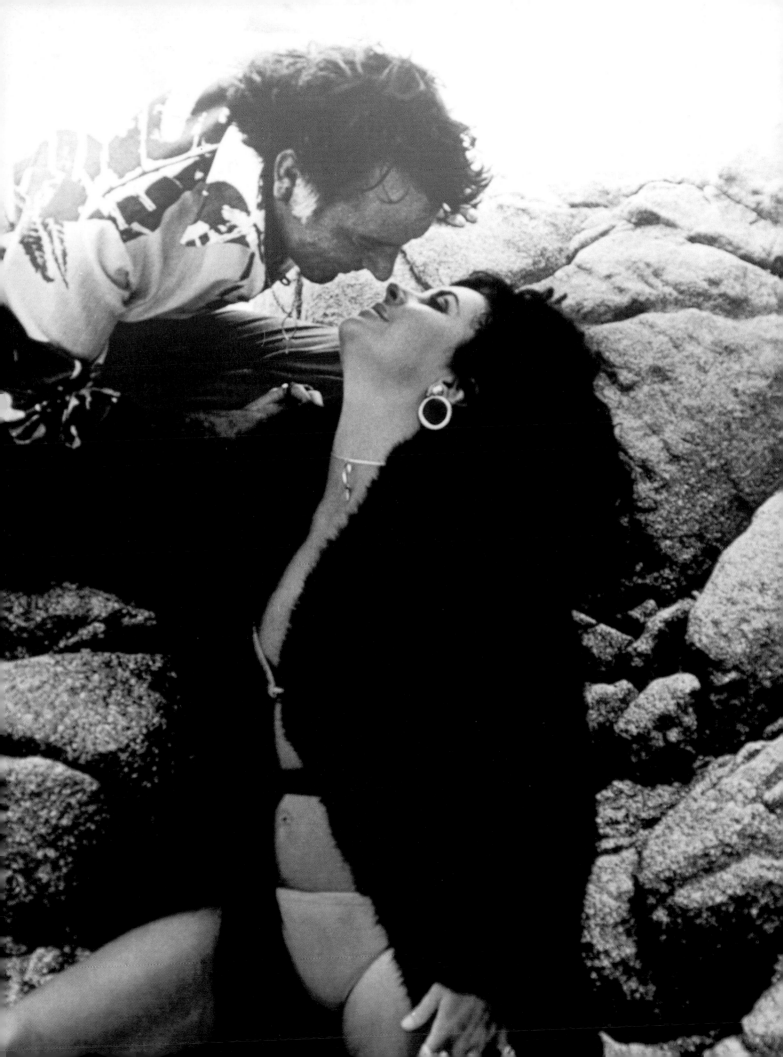

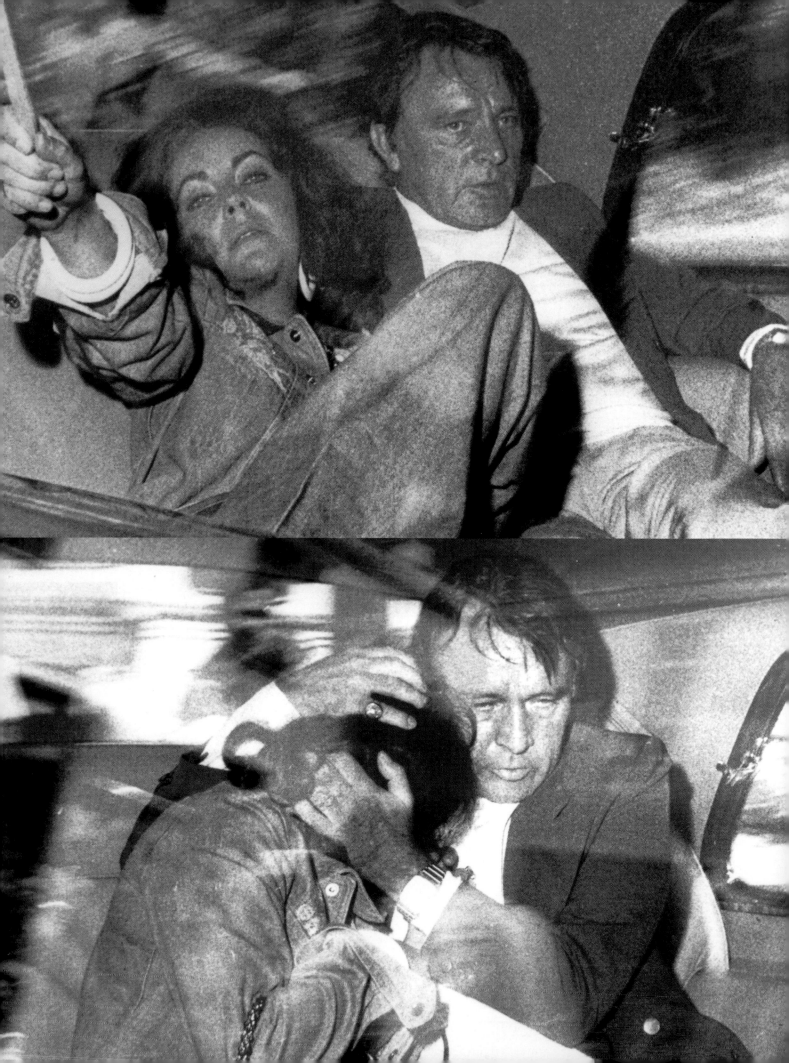

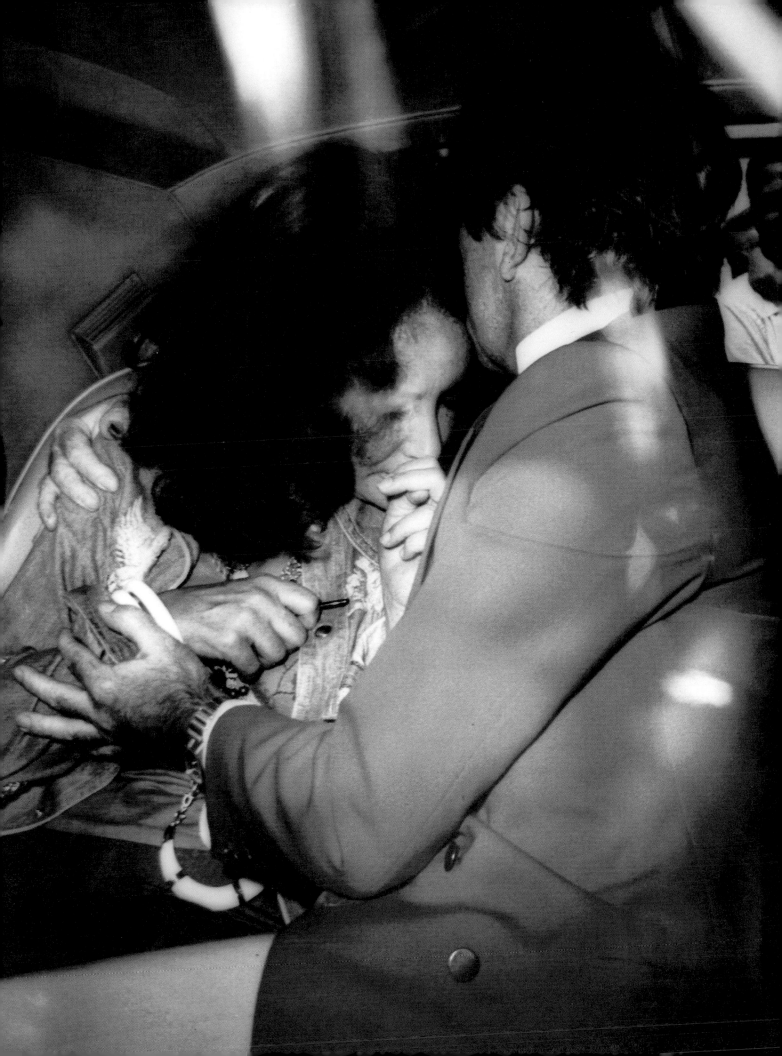

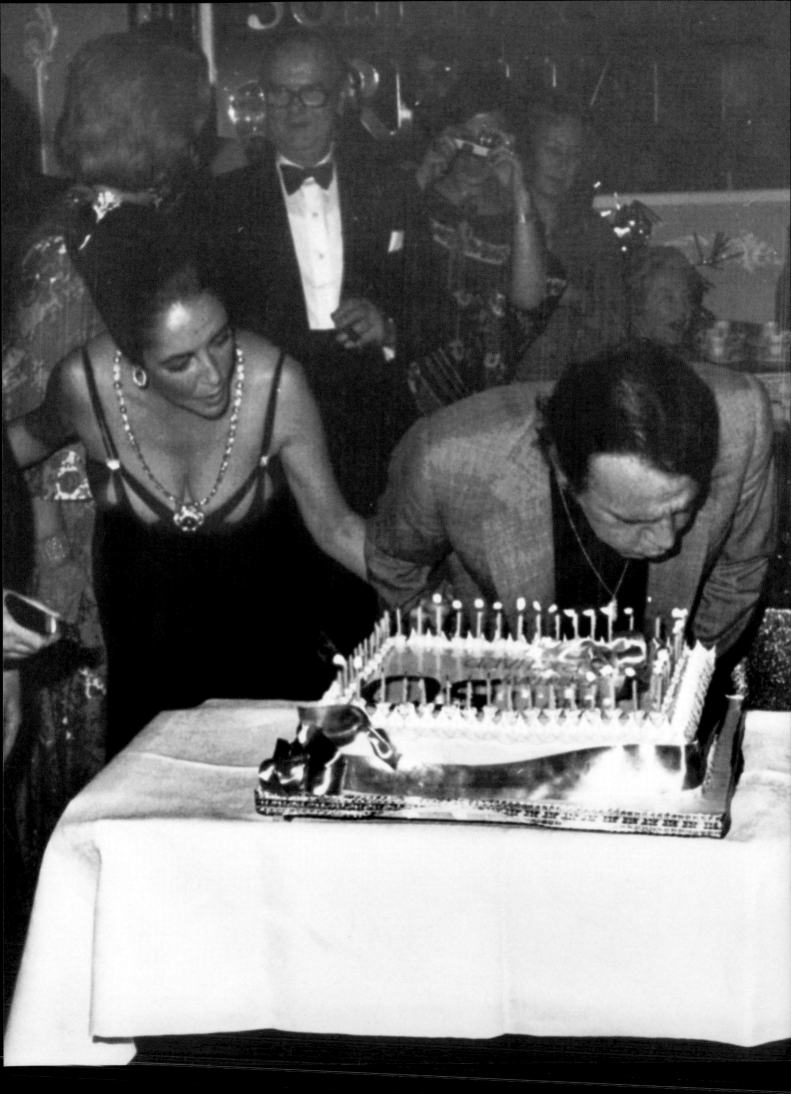

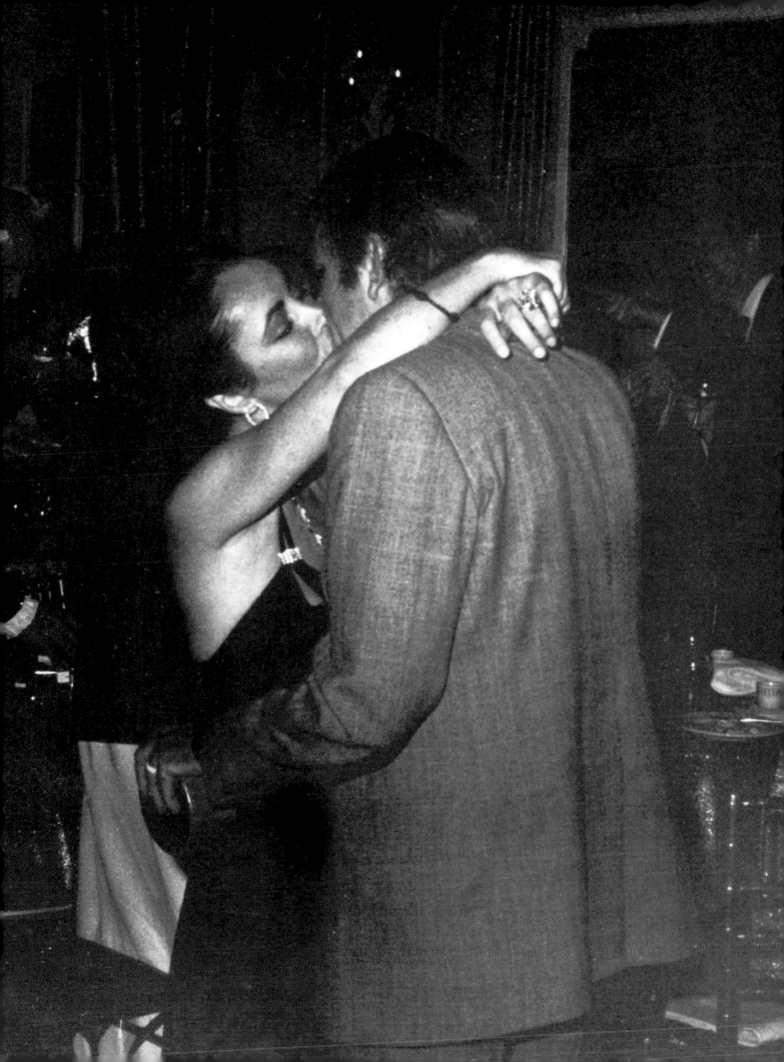

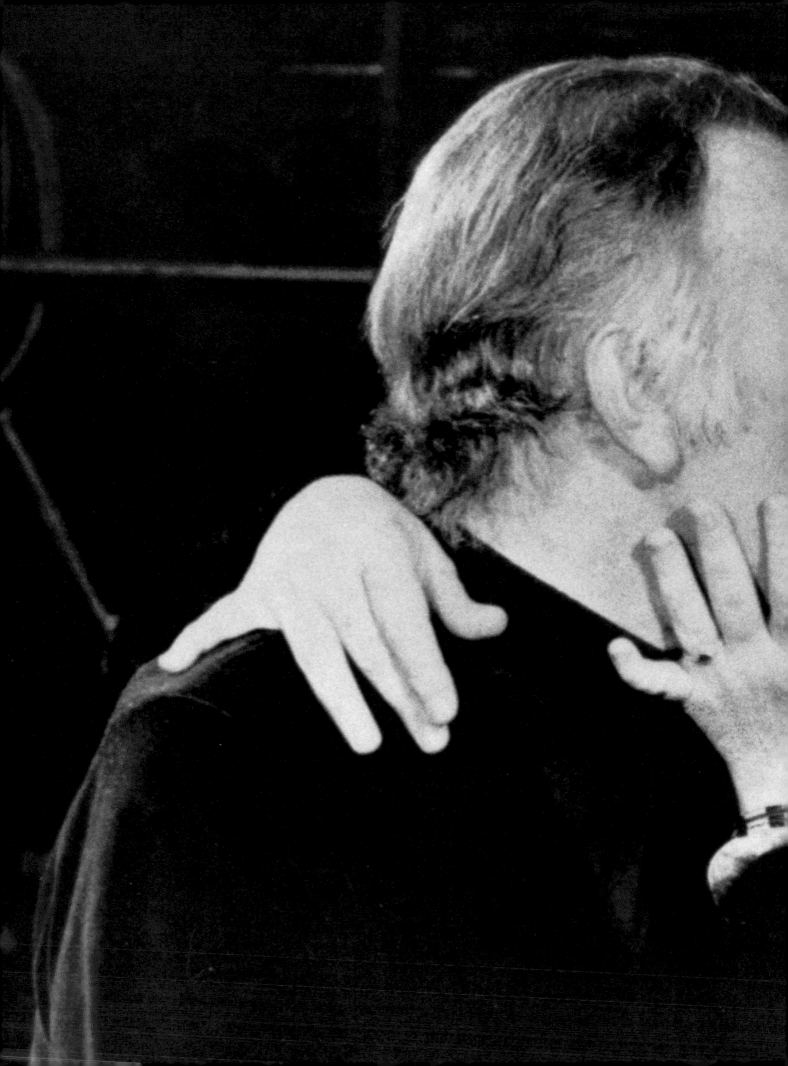

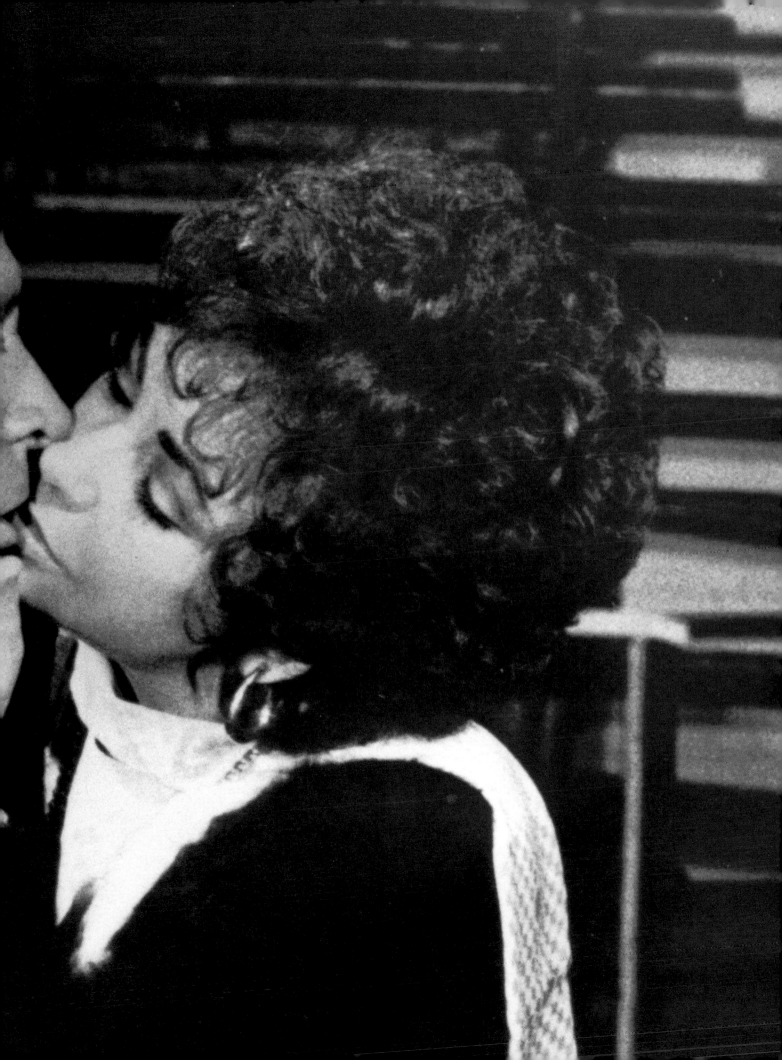

Rita & Orson Welles

A whirlwind love

From the time *Citizen Kane* hit the box offices, he was considered the most brilliant man in show business. She was Hollywood's most famous and least fulfilled star. All the GIs had her pinup, but her fame left her lonely. Beauty needs love and tending. Brilliance needs nurturing.

— You'd think she was a starlet. But she was a star.

— They flaunted their affair. But where was the tenderness?

— Legend has it that Welles married Hayworth after making a bet with his pal Joseph Cotten—$2,000 if he married the most beautiful girl in the world, that year. Their wedding took place on September 7, 1943.

— Rebecca was born on December 17, 1944. "As long as she doesn't have her father's beauty and her mother's intelligence," quipped Orson. Imitating a bullfight as they enter the baby's bedroom.

— 1946: Rita's 28th birthday, on board Errol Flynn's *Zaca*. That same year, she made *Gilda*, directed by Charles Vidor.

— He turned her into a blonde and cut her hair.

— And then there was *The Lady from Shanghai*, directed by Orson. It was a flop, and it marked the end of their story. As Rita herself put it: "The men in my life wanted to seduce Gilda, but it was me they woke up with."

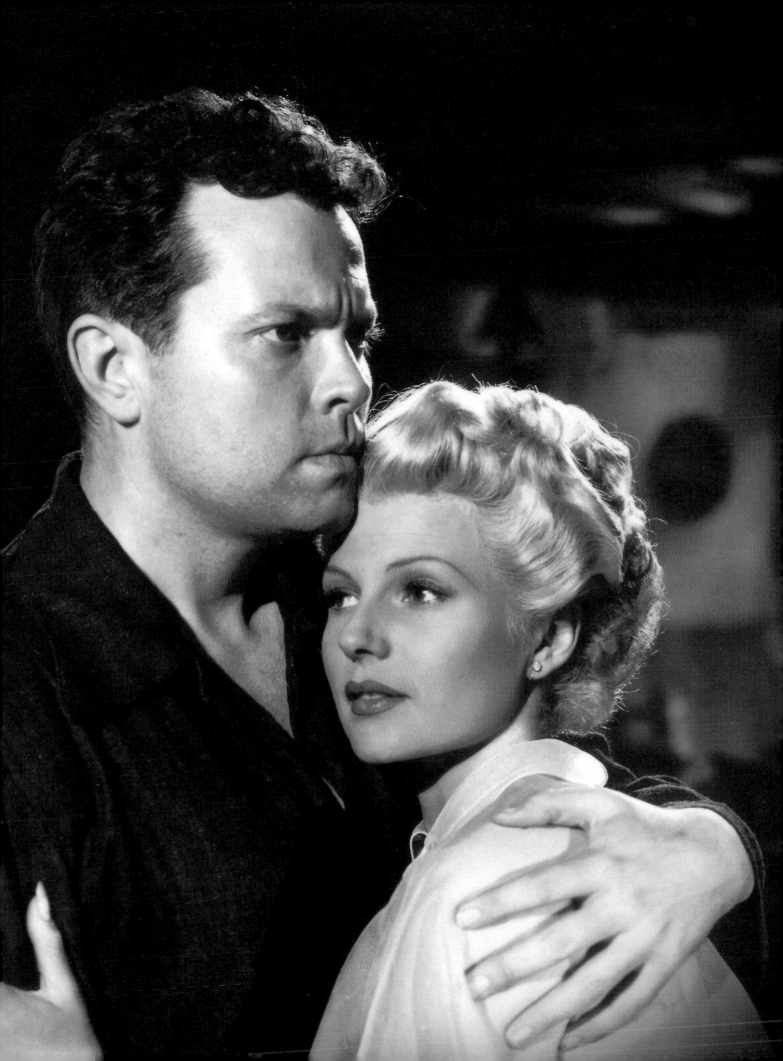

They were dubbed "Beauty and the Brain." They were like two suns in a Hollywood at its zenith, two stars of the 1940s. But Orson was a creator and Rita a creation. He saw himself as a rebel while she did what she was told. Yet they loved one another, and it was the craziest affair in an affair-rich decade.

Rita, whose real name was Margarita Carmen Cansino, was born in Brooklyn in 1918. Her mother, Volga, was a showgirl with the Ziegfeld Follies. Her father, Eduardo, a Spanish immigrant, traveled around the country flamenco dancing with his sister. They were called the Dancing Cansinos. Margarita learned how to dance, too, her father banned all schoolwork for her. When the Dancing Cansinos broke up, Eduardo took as his new partner his 13-year-old daughter. The two were in Tijuana when Rita's mother showed up and took everyone off to Hollywood. It was 1934. Three years and eleven films later, but Margarita's career had become stuck in its Spanish look and style.

Three men would alter her destiny. Margarita married the first, Eddie Judson, in 1937. "I wanted him out of love," she would say later, "but he saw me as an investment. I was his meal ticket." Judson decided to transform his young wife. He started by having her hair combed back. Many hours of electrolysis destroyed the roots of any superfluous hair. Three months later, Margarita was someone else, with a high forehead and hair tumbling in cascades around her now sophisticated silhouette. Rita Hayworth was born.

The second man, Henry Rogers, was in advertising. He filled Rita's wardrobe with borrowed dresses, and made people believe that she'd won the prize for the best-dressed starlet in Hollywood. *Look* published a six-page fashion spread.

The third man, Hollywood mogul Harry Cohn, founder and head of Columbia Pictures, was a dynamic and quick-tempered dictator. "Get yourself invited onto his yacht," Judson said to Rita, "and sleep with him!" That was the very first time the slave didn't obey her master. She accepted the cruise yet wouldn't let Harry touch her. The tyrant flew into a violent rage, but decided to give the rebellious young woman her lucky break. From then on, Rita made films with the greatest. Late in 1940, she was at the height of her fame but Judson found her success hard to cope with. He threatened to disfigure her. She gave him all the money she'd made and demanded a divorce.

Orson Welles was born on May 6, 1915, in Wisconsin. His father, Richard, made a good deal of money selling automobile headlights. His mother, Beatrice, came from a family of impoverished aristocrats. Their marriage didn't last. Orson attended the Todd School for Boys, a very chic boarding school in Woodstock, Illinois. As a boy, he gobbled up knowledge with incredible speed. He had the gift of gab, and was bursting with enthusiasm. A born actor, he effortlessly played all the great Shakespearean roles. In October 1931, Orson was signed on by the Gate Theatre in Dublin. When he got back home, he complained that America had forgotten all about him! But not Virginia Nicolson, the 18-year-old blue-eyed, fair-haired beauty who he met through a former schoolmate. Orson married her in November 1934. Meanwhile, the government was looking for an innovative director for the Federal Theatre Project. Mr. Welles's youthfulness was a plus point and he got the job. Orson put on a *Macbeth* with an all-black cast.

But there weren't enough hours in the day for this workaholic with an insatiable sexual appetite. Before long, Virginia was little more than a friend, but she had given Orson a daughter. In 1939, she left discreetly for Europe, and Welles plunged energetically into filmmaking, creating his masterpiece, *Citizen Kane*.

In 1942, he was dispatched to Brazil to make a film about the history of the samba. There he was deeply disturbed by the poverty of the suburbs, yet he adored the delights of carnival. It was in Brazil that he came upon a back issue of *Life* magazine where he spied Rita Hayworth in a lace-trimmed satin dress. Her eyes were magnetic; her body, an offering—he resolved that she would be his companion and his salvation.

In 1942, Hayworth was the most famous and least fulfilled star in Hollywood. All the GIs had her pinup, and yet she'd never felt so alone. Harry Cohn was treating her like a slave, her divorce was turning into a nightmare, her father was persecuting her, and her lover, Victor Mature, had enlisted in the U.S. Navy.

People told her that Orson Welles, who was keen to meet her, was a colossus of culture, intelligence and imagination. The description terrified her. She did everything to avoid meeting him. But to no avail. "I waited five weeks," Welles would later admit. "But I ended up getting over all the obstacles and that same evening we went out together." A series of secret dinners followed. At the beginning, Rita would shyly emerge from her silence, only to plunge straight back into it. Orson would take her hand and tell her he could read her thoughts. Finally she began to talk about herself; about an obedient young woman who was so scared of her masters. "You're a star!" Orson bellowed. "Make the most of it!" The couple set up home in Orson's house. And Rita, happy at last, quickly became insanely jealous. In Hollywood, Harry Cohn fumed—he was convinced that Rita belonged to him. In 1943, Beauty and the Brain put on

a circus show for the GIs. Welles had announced a conjuring act during which he would cut Miss Hayworth into bits, but Harry Cohn stopped Rita from taking part in the show, so Orson signed up Marlene Dietrich. Soon, the rebellious couple decided to get married. On September 7, 1943, during her lunch break, Rita left the set of *Cover Girl*, leapt into a limousine chauffeured by a dwarf called Shorty and sped with Welles to Santa Monica courthouse. She was wearing a beige suit, Orson, a dark chalk-striped one, complete with pink shirt and bow tie. Rita was so overcome with emotion she could hardly speak. Orson had trouble slipping the ring onto his bride's finger. "Change hands!" the judge advised. Just as she was about to say "I do," Rita burst into tears—tears of happiness. Cohn's riposte wasn't long coming. The Brain found all of Hollywood's doors barred to him, so he got deeply involved in politics with the Free World Association, which supported Roosevelt.

That November, Judson threatened to publish some compromising letters written by Rita during their marriage. Orson responded with a tremendous press conference. The blackmailer ended up in court, but Mr. and Mrs. Welles were left reeling. The Brain collapsed from a bout of viral hepatitis, and Beauty wept day after day.

The couple finally returned to Hollywood. Rita was pregnant. She prepared a large reception to show that she could be a star, a mother, and an accomplished lady of the house, all at once, but all this cost money and Mrs. Welles had to make her way back to the studio. Harry Cohn won a small victory. "You still owe me three movies," he said to her, "but I won't rush you. Start shooting, have your baby, and then we'll see." Orson started drinking and becoming restless. As a tireless supporter of President Roosevelt, he would harangue crowds all over the country. "How can you love me when you're miles away?" Rita would ask him. "Be patient," Orson would reply. "Would you like to be First Lady?" She would shrug her shoulders. "All I want is for you to be here when I have our baby."

On December 17, 1944, Rita gave birth to a daughter, Rebecca. Soon after, Orson left again and Rita was on her own. But even worse than that, Orson had agreed to make a love film with Claudette Colbert. Their quarrels would turn into horror stories; Rita would run to her car and speed off into the night, her husband, hot on her heels.

The Brain became scarce. He turned back into the Don Juan he had always been. He had an affair with Judy Garland, then he consorted with extras and with strangers, and, before long, with whores. Rita announced that she wanted a divorce. Orson went to New York. Harry Cohn was thrilled: the couple's trials and tribulations meant fantastic publicity for him. Indeed, *Gilda* was a triumph. *Life* magazine crowned her "Goddess of Love." Weeks passed. In New York, the author of *Citizen Kane* was preparing *The Lady from Shanghai*. "That guy's a dangerous lunatic," Harry Cohn said. "The girl was quite right to leave him." But Rita had put a halt to the divorce proceedings. Orson phoned her every day.

When Welles went back to Los Angeles, Rita invited him to dinner. "There we were, face to face, and petrified. All of a sudden, she said to me: 'Take me in the film, take me in your arms, and take me in your life.'" "What the hell's all this nonsense?" Harry Cohn roared into the phone—he'd just learned that Rita had had her hair cut and dyed platinum blonde for *The Lady from Shanghai*. Welles was about to realize the cost of altering the image of a star. The shoot was a whirlwind of parties. Mr. and Mrs. Welles faltered in the storm. On October 17, 1946, Orson celebrated his wife's 28th birthday. "They were still radiant," a guest noted, "but not like lovers. It was an advanced stage of indifference."

There were still one or two tender moments. Too late. The blonde Rita of *The Lady from Shanghai* had disappointed the public, and that failure put an end to their dying love. On November 10, 1947, they were divorced in Los Angeles.

One night in 1949, Orson had a telegram from Rita. He was in Rome. She was in Antibes, where she was to wed Prince Aly Khan. "She begged me to come and get her. She was waiting for me in a hotel. She leaned back against the bedroom door and said to me: 'Here I am... marry me!'" Orson left in the small hours. But that one night spent in each other's arms had not been enough to retrieve all that had once been between them.

Beauty ended up marrying the Prince. She had a daughter, Yasmina. And then Rita took a turn for the worse. People thought she'd gone crazy. In fact she was suffering from Alzheimer's disease.

Welles saw her one last time, in 1979, in Los Angeles. It was a scene that left him dumbfounded and horrified: "When her lips touched me, my blood froze in my veins. Her huge eyes stared at me, but they didn't know who I was."

Jean Durieux

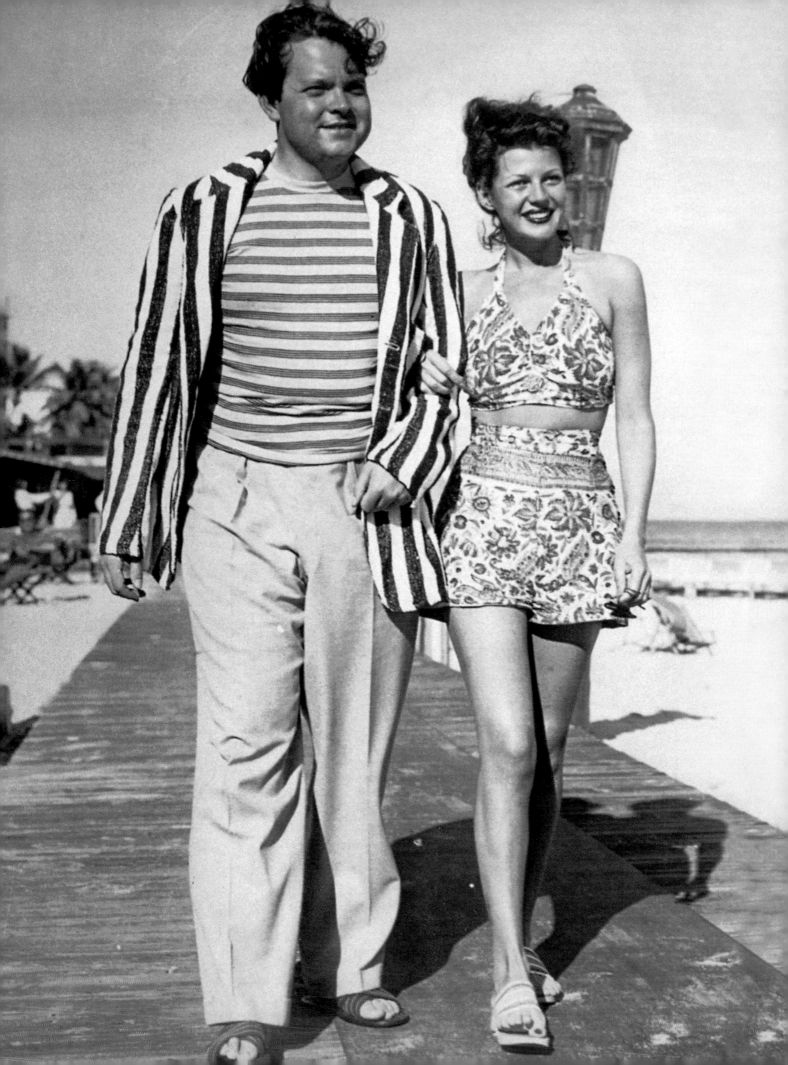

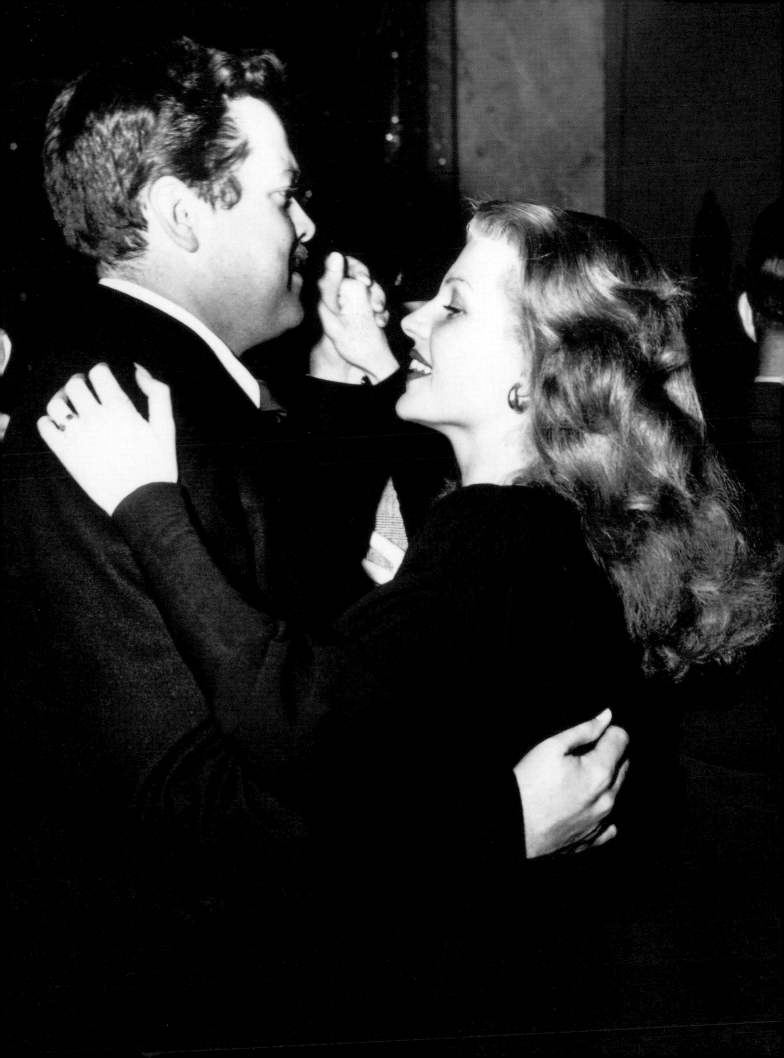

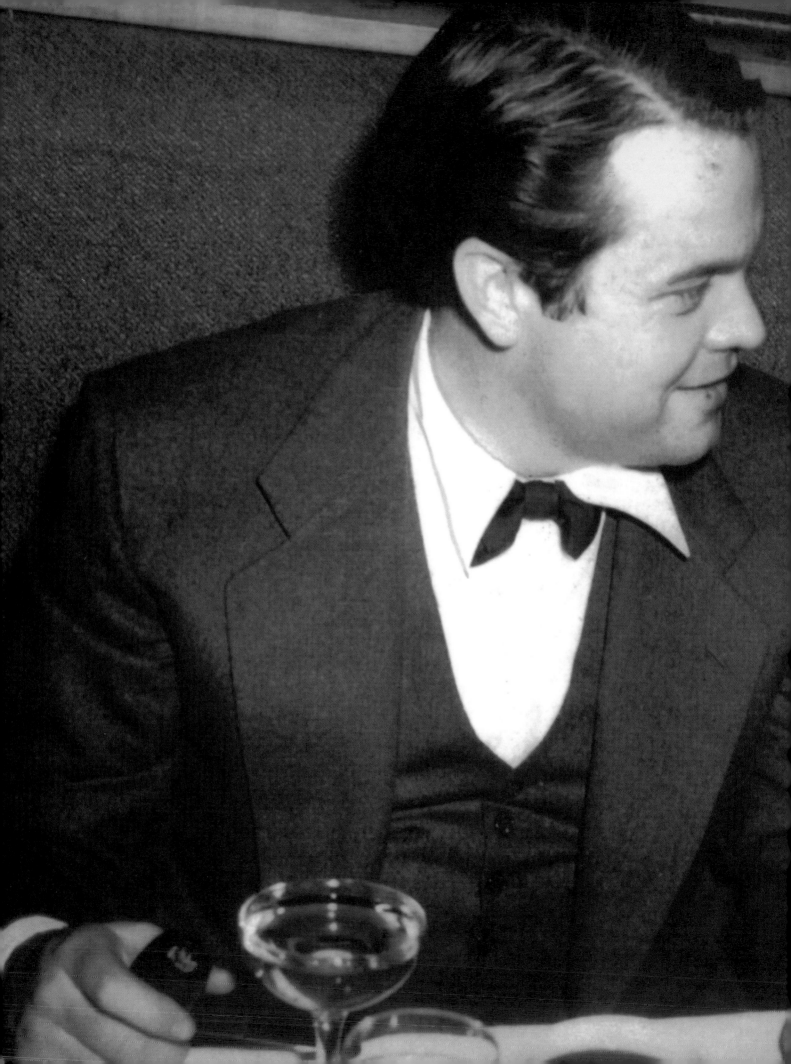

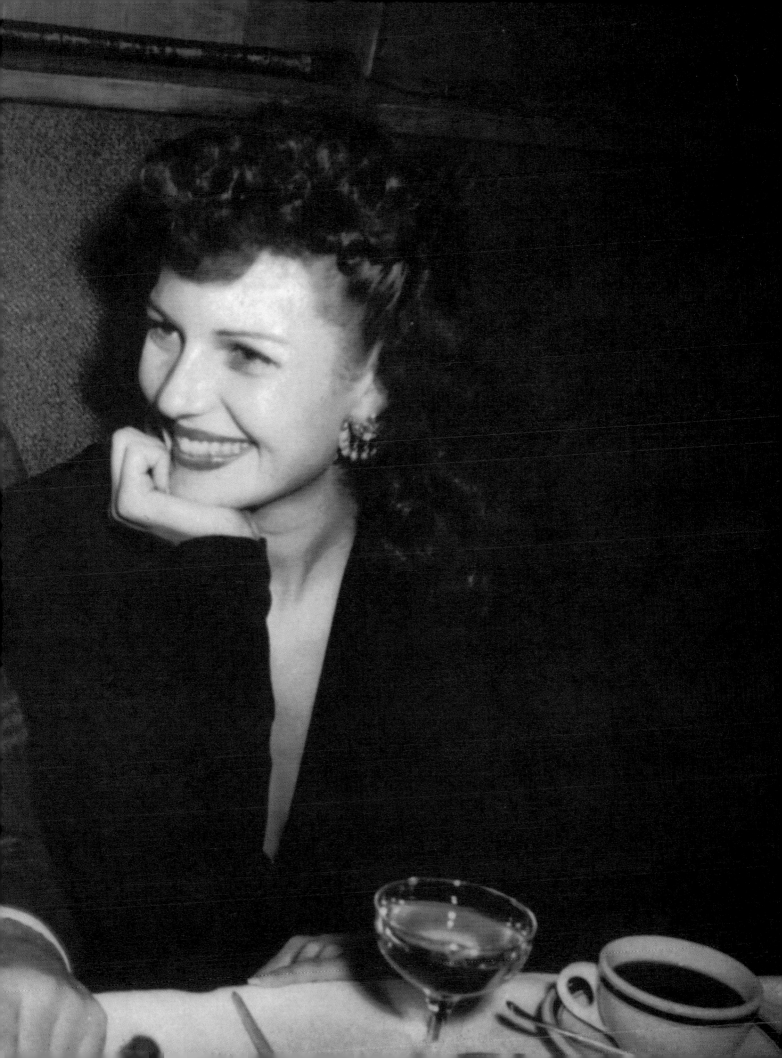

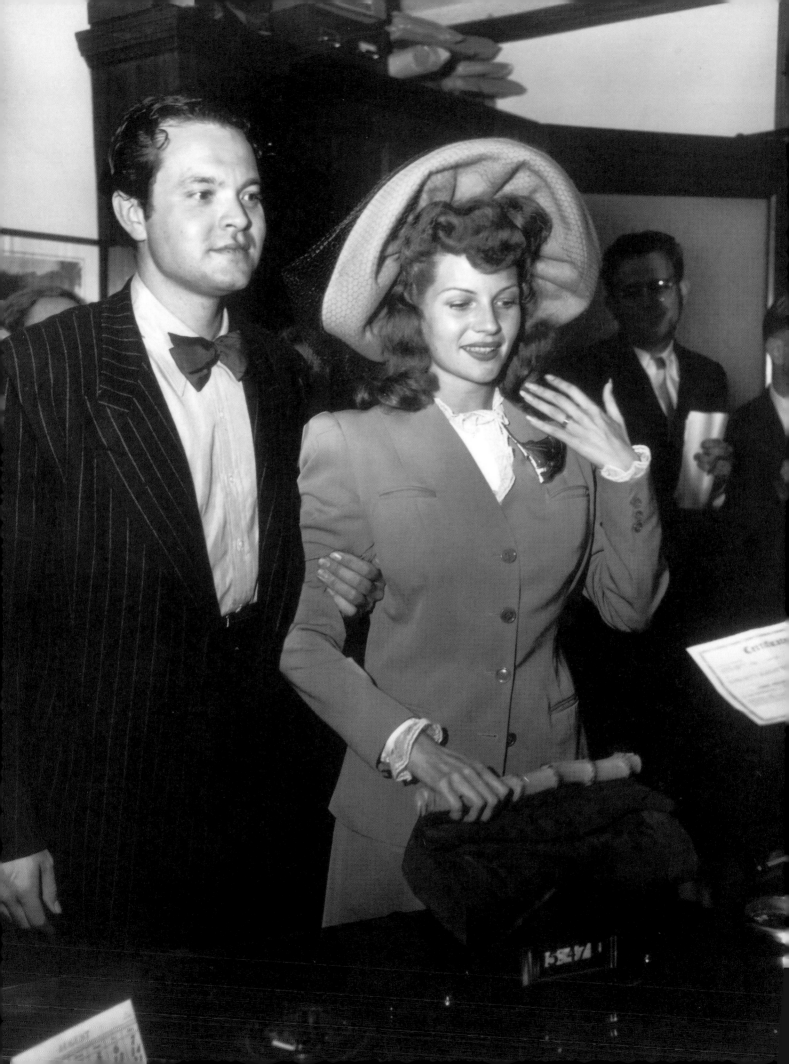

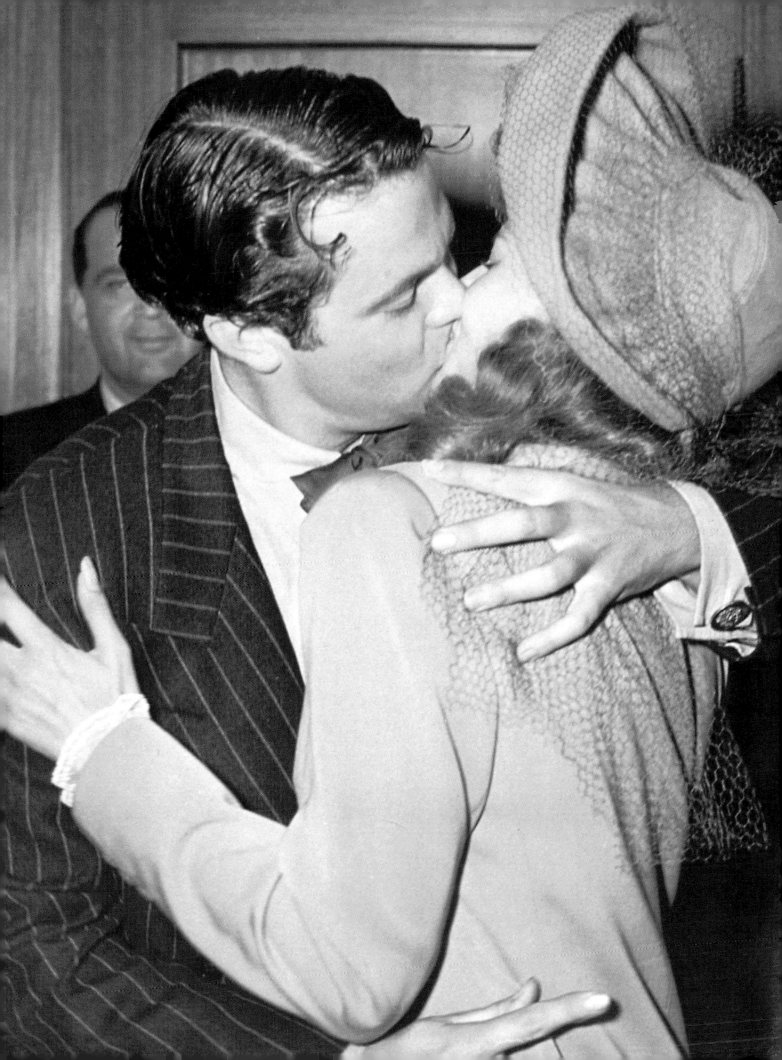

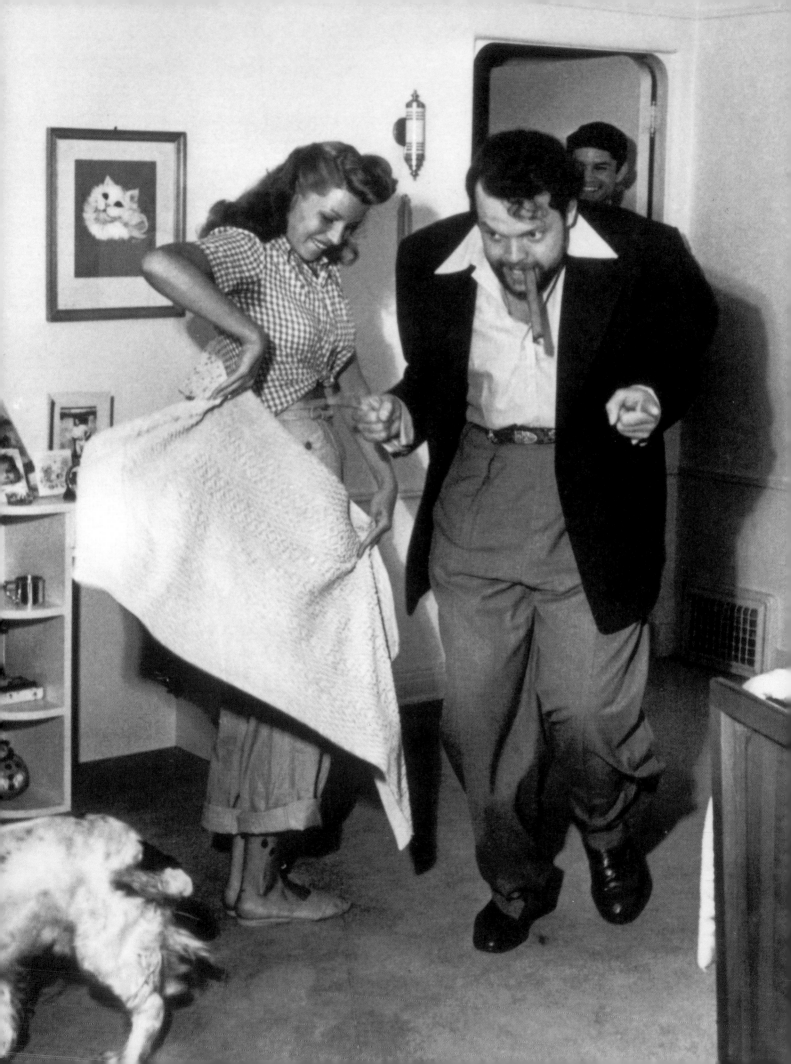

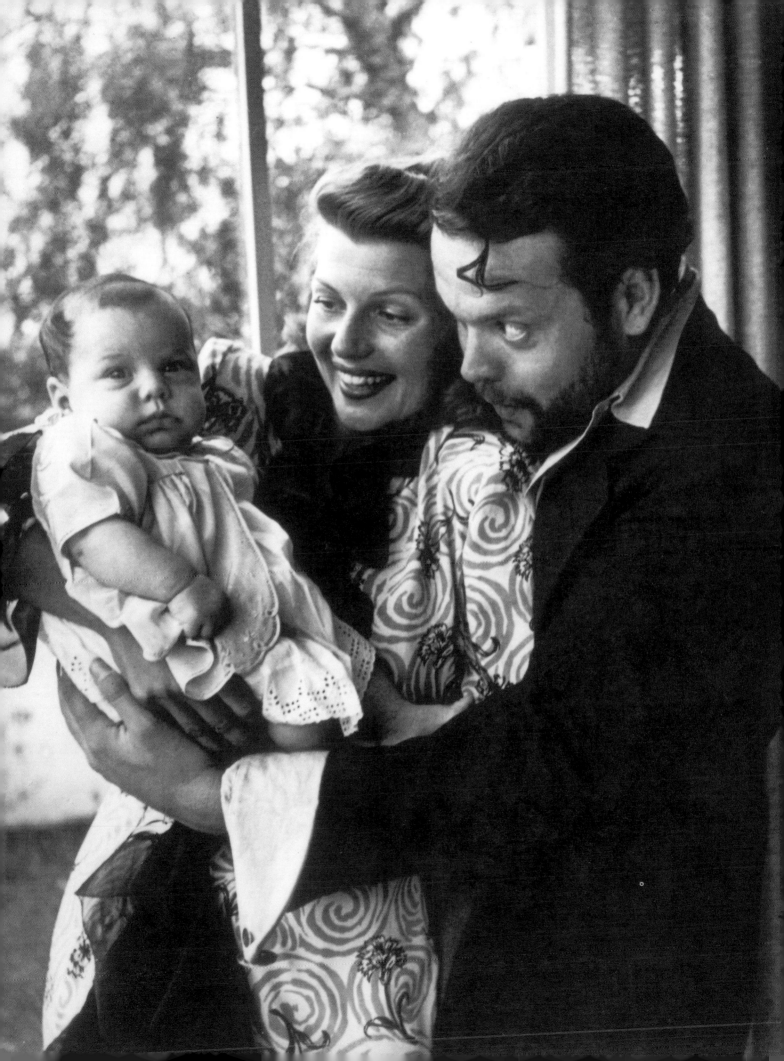

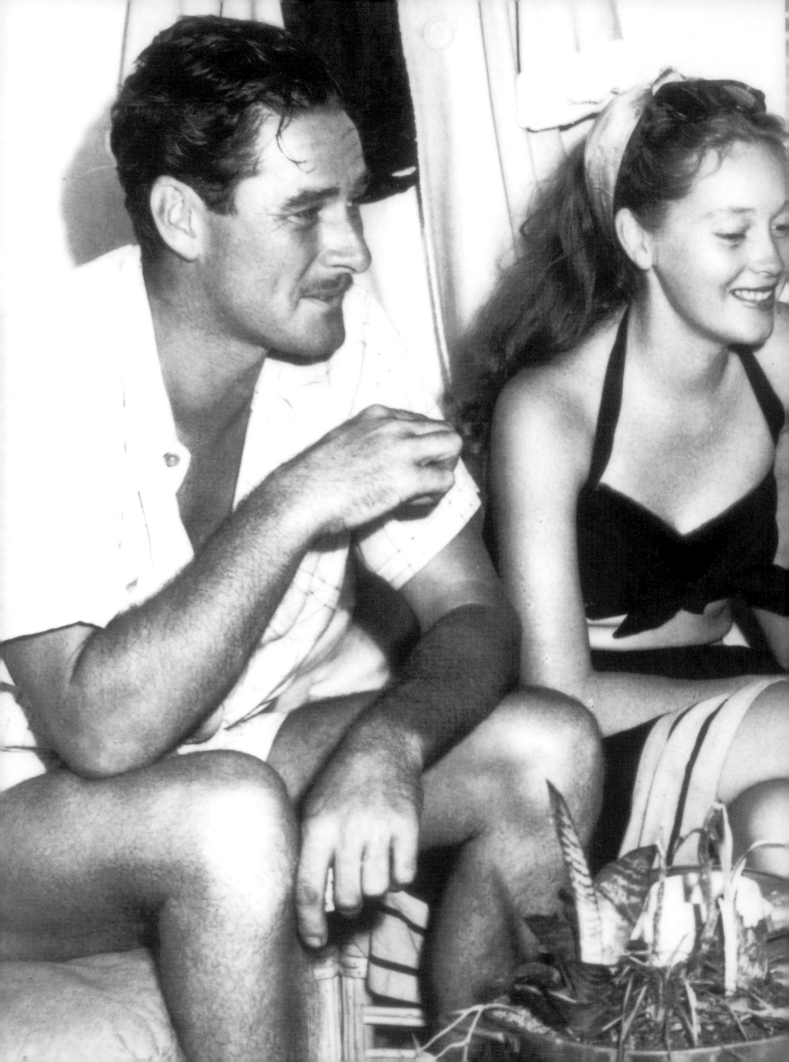

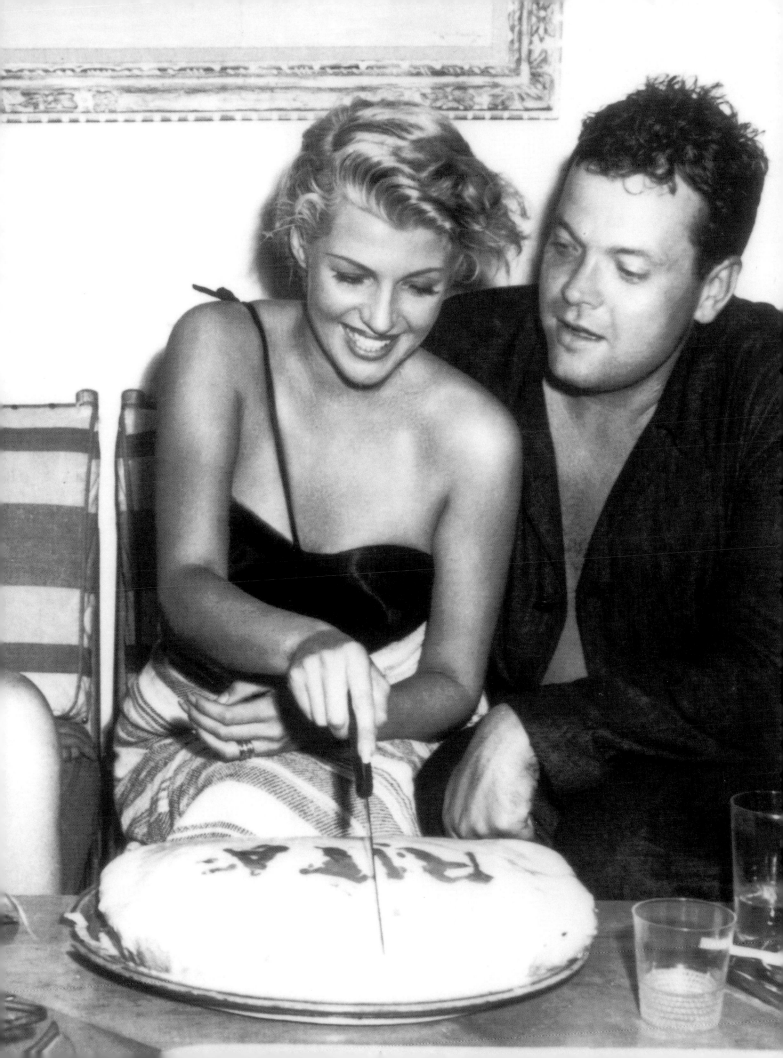

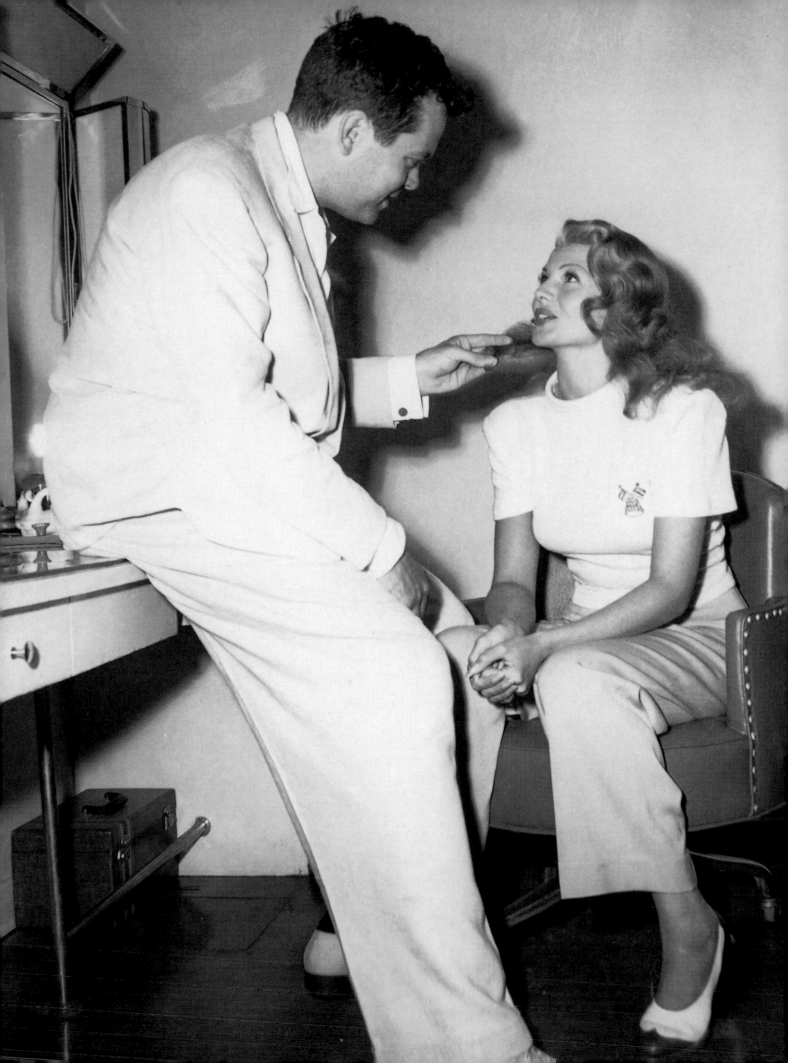

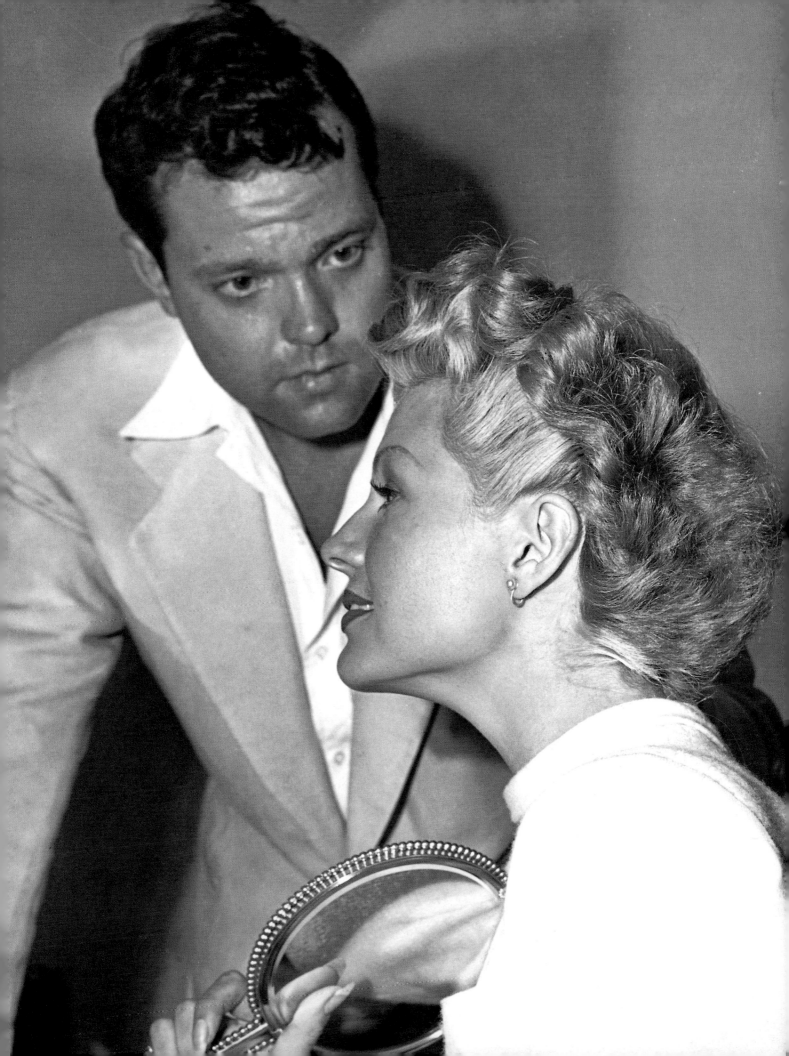

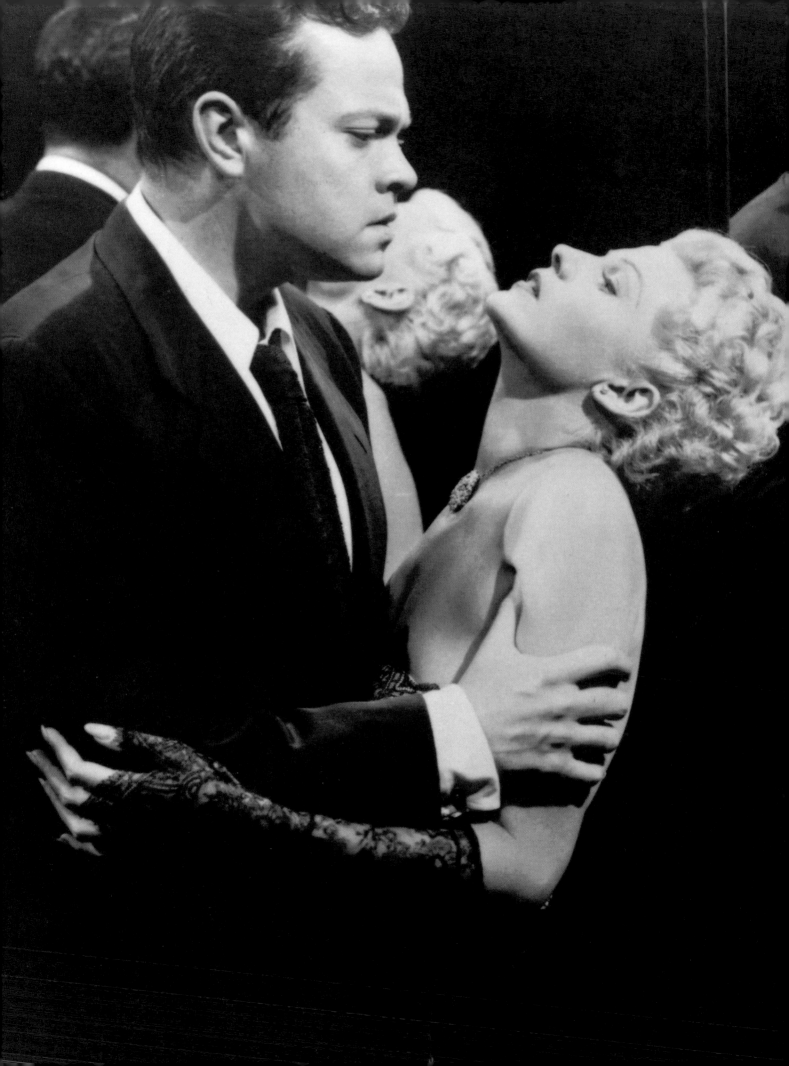

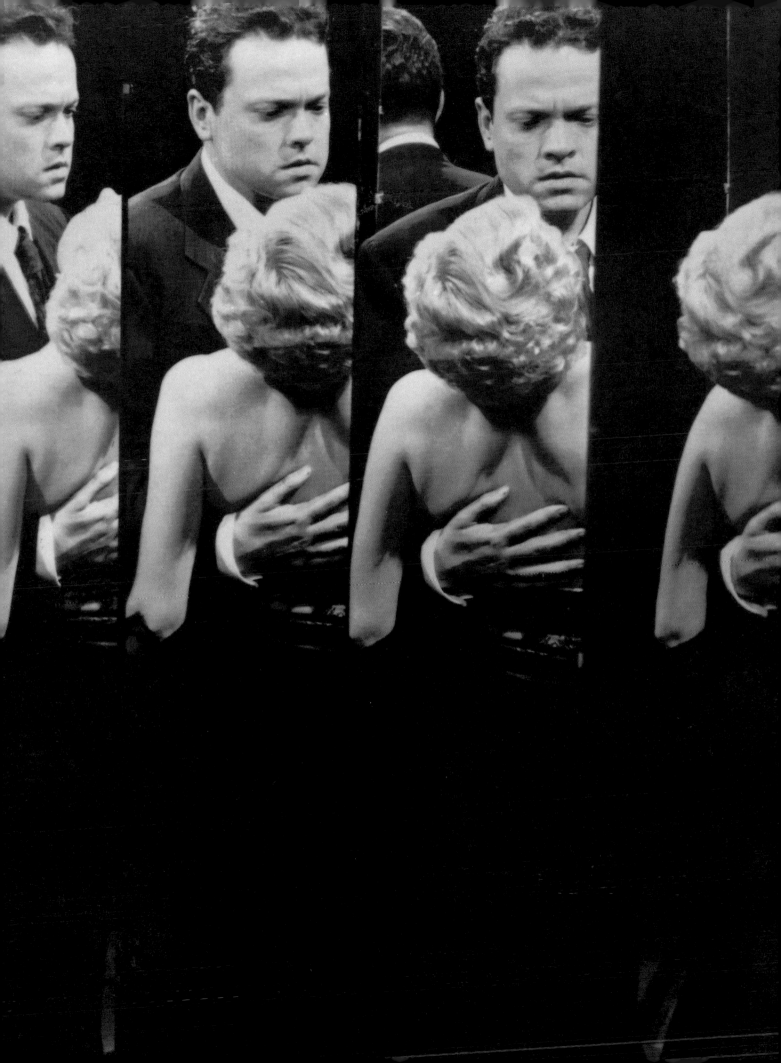

Romy
& Delon

Young love

Romy and Alain, "the eternal fiancés." They played, laughed, and parted without life really separating them.
– What seduced him during the shooting of *Christine* (1958) was Sissi's freshness. But it wasn't love at first sight. She found him "far too handsome, his hair far too neat, wearing a suit that was far too fashionable." For him, Romy was a "pretty girl, but temperamental and very tiresome."
– She went to see him in Paris. She had her hair cut at Alexandre to please him. Their romance began under a hair dryer.
– She managed to get her family on her side. And their official engagement was celebrated in 1959 in Lugano, where Romy's mother lived. Between them their combined ages added up to only forty-five years.
– In their home on Quai Malaquais, in Paris.
– Their film work forced them apart. One night, when she came back from Hollywood, what was waiting for Romy were roses, not Alain. "I'm giving you back your freedom, and leaving you my heart."
– 1968. Separated, unhappy, but acclaimed for *La Piscine* [The Pool]. "I don't know how to do anything in life, but everything in film...." Alain played opposite her in that film, which brought her stardom, in the full radiance of her thirtieth year.

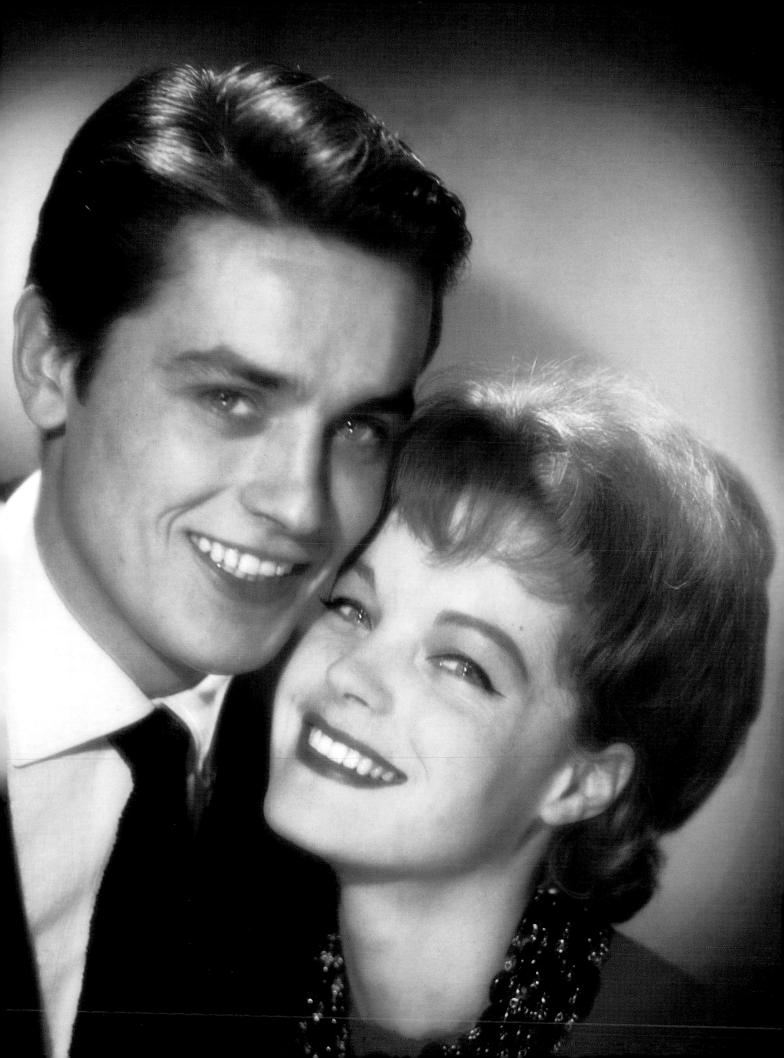

In the bedroom where Romy was resting, Alain Delon wrote her this last letter.

FAREWELL MY PUPPELÉ

I'm watching you sleep. I'm next to you, by the bed. You're wearing a long black and red tunic, embroidered on the bodice. There are flowers, I think, but I'm not looking at them. I'm saying farewell to you, the longest of farewells, my Puppelé. That's what I used to call you. It meant "little doll" in German. I'm not looking at the flowers, but at your face and I'm thinking that you are beautiful, and that you may never have been so beautiful. I'm also thinking that this is the first time in my life—and yours—that I'm seeing you relaxed and at peace. How calm you are, how delicate and how beautiful. It's as if a hand had gently cleared your face of all the tensions and anxieties of unhappiness.

I'm watching you sleep. People tell me you're dead. I'm thinking of you, and me, and us. What am I guilty of? You ask yourself this question in front of a person you've loved and still love. This feeling washes over you, then ebbs, and then you tell yourself that you're not guilty, no, but you are responsible. I am. Because of me, it's in Paris that your heart stopped beating the other night. Because of me, because it was twenty-five years ago that I was chosen to be your partner in *Christine*. You came from Vienna and I was waiting for you in Paris with a bunch of flowers which I wasn't sure how to hold. But the film's producers had told me: "When she walks down the steps, you must walk toward her and give her these flowers." I was waiting for you with my flowers, like some fool, amid a horde of photographers. You walked down the steps. I walked toward you. You said to your mother: "Who is this guy?" She answered: "It must be Alain Delon, your partner...." Then nothing, no love at first sight, no. And then I went to Vienna where the film was being made. And then I fell madly in love with you. And you with me. We often asked ourselves that lover's question: "Who fell in love first, you or I?" We would count: "One, two, three!" and then we'd answer: "Neither you, nor I! Together!" My God, how young we were, and how happy we were. At the end of the film I said to you: "Come live with me, in France," and right away you said: "I will come." Do you remember? Your family and your parents were furious. And the whole of Austria and Germany treated me like a usurper, a kidnapper, accusing me of taking their "Empress" from them! Me, a Frenchman, who didn't speak a word of German. And you, Puppelé, who did not speak a word of French. We loved one another without words. We looked at each other and we laughed. Puppelé...and I was "Pépé"—grandpa.

After a few months I still didn't speak any German but you spoke French, and so well that we acted on the stage together, in France. Visconti was the director. He told us we looked like each other and, between our eyebrows, we had the same V that formed a frown of anger, fear of life, and anxiety. He called it the "Rembrandt V" because, he said, Rembrandt had that "V" in his self-portraits. As I watch you sleep I see the "Rembrandt V" is gone. You're not afraid anymore. You're not scared anymore. You're not on the lookout anymore. You're not hounded anymore. The hunt is over and you are resting.

I'm looking at you again and again. I know you so well and so deeply. I know who you are and why you are dead. Your character, as they say. I say to them, to the "others," that Romy's nature was her character. That's all. Leave me alone. You were violent because you were whole. A child who became a star very early. Your childish whims, tantrums and moods were always with good reason but unpredictable results. Get your professional authority unquestioned. Yes, there's also the child who isn't too sure what she's playing with. And who. And why. In this situation, anxiety and unhappiness rush through the gap; when you're Romy Schneider, and when your sensibility and temperament are on the razor's edge of life. How am I to explain to them who you were and who we are, we "the actors." To stay more or less on your own two feet, how can I explain to them that it's so difficult, that it takes such strength of character, and such balance? But how is that balance to be found, in this world which is ours; we, the jugglers and clowns and acrobats in this circus where spotlights gild us with fame? You once said: "I don't know how to do anything in life, but everything in film." No, the others can't understand that. And here I am crying out, while you rest and I weep close to you, no, no, no, this fearful profession is not a woman's profession. I know this because the man I am is the one who's known you best and understood you best. Because he's an actor, too. We belonged to the same breed, my Puppelé, we talked the same language. But I'm a man. They can't understand us, the others. Actors can. The others can't. There's no explanation. And when you're a woman, they can't understand that you can die of this. They say you were a myth. But the "myth" knows it isn't just that: a facade, a reflection, an appearance. It is king, prince, hero, Sissi, Madame Haneau, the seagull...but the myth goes home at night. Then it's just Romy, just a woman, with a life that's misunderstood, ill-accepted, maligned in the papers, besieged and hounded. So the myth suffers in its solitude. It frets. And the more aware it is, the more it topples into the blissful states provided by

alcohol and tranquilizers. It becomes a habit, then the rule, then a necessity. Then it can't be replaced by anything and the worn-and-torn heart stops because it's too tired to beat. It has been too manhandled and hurt, that heart that was just a woman's heart, at night, sitting in front of a glass.... They say that the despair your son David's death caused you killed you. No, they're wrong. It didn't kill you. It finished you. It's true what you said to Laurent, your last and wonderful companion: "I get the impression I'm coming to the end of the tunnel." It's true that you wanted to live, that you'd have loved to live. It's also true that you had reached the end of the tunnel, on Saturday, at dawn. That you were the only one to know it—when your heart was broken, that was the true end of the tunnel.

I'm writing to you as it comes to me. There's no order. My Puppelé, so aggressive, so hypersensitive. You've never been able to accept and understand the stakes and the game of this profession of public woman, which you chose and enjoyed. You didn't understand that you were a public figure and that was so important. You refused to play the game, and all the games this profession involves us in. You felt you were being attacked, pierced, violated in your privacy. You were forever on your guard, like an animal being hunted, "brought to bay" as they say of a doe. And you, you knew that with one hand fate was taking away from you what it had given you with the other. We lived more than five years together. You with me. Me with you. Together. Then life...our life, which had nothing to do with anyone else, separated us. But we would call each other. Often. Yes, that's exactly what it was: we sent out "calls." Then, in 1968, it was La Piscine [The Pool]. We were back together again, to work. I went to see you in Germany. I got to know your son, David.

After our film, you were my sister, and I your brother. Everything was pure and clear between us. No more passion. Better than that: our blood friendship, made up of being alike, and of words. And then your life and, in your footsteps, unhappiness and anxiety, anxiety.... The "others" will say: "What an actress! What a tragic actress!" They don't know that you are this tragic actress, in the cinema, because that's what you were in life, and you paid a high price for it. They don't realize that the dramas of your personal life rebounded on the screen, later on, in your parts. They can't guess that you were "kind" and "brilliant" in the cinema because you lived the tragedy alongside, and that you were deeply moving because you were lit up by the reflections of your personal dramas. And that you are only radiant because they burn you. Oh my Puppelé, what a labor of pain! Have I lived with you, or beside you?

Until David's death, though, there was the "profession" that kept your head above water. Then David was gone. And the profession wasn't enough anymore. So I wasn't surprised when I learned that you'd gone too. What did surprise me was that you were not complicit in your own death. But I knew your heart had been shattered. I said, "That was it, the end of the tunnel."

I'm watching you sleep. Yesterday you were still alive. It was nighttime. You said to Laurent: "Go to bed. I'll be up in a minute. I'm going to be with David for a while, listening to music." You said that every night...that you wanted to be alone with the memory of your dead child before going to bed. You sat down. You took paper and pencil and you started drawing. Drawings for Sarah. You were drawing for your little girl when your heart suddenly hurt you so badly. So beautiful. Beautiful, rich, famous, what more did you need? Peace and a little happiness.

I'm watching you sleep. I'm alone again. I say to myself, you loved me. I loved you. I made you into a Frenchwoman, a French star. Yes, I do feel responsible for that. And this country that you've loved, because of me, has become your country. France. Then Wolfie decided—and Laurent told him that you'd have wanted that—that you'd stay here and that you'd rest forever on French soil. At Boissy. Where, in a few days, your son, David, will come and join you. In a little village where you'd just gotten the keys to a house. You wanted to live there, near Laurent, near Sarah, your daughter. There you'll sleep forever. In France. Near us, near me. I helped with your departure to Boissy, to take some of the weight off Laurent and your family. But I won't go to the church, or the cemetery. You know I could never protect you from that crowd, from that turmoil so greedy for "spectacle," which made you so afraid, which made you tremble. Forgive me. I'll go and see you the day after and we'll be alone. My Puppelé, I'm looking at you again and again. I want to devour you with my eyes, and tell you over and over that you've never been so beautiful and so calm. Rest now. I'm here.

I've learned a little German. "Ich liebe dich." I love you. I love you...my Puppelé.

Alain Delon

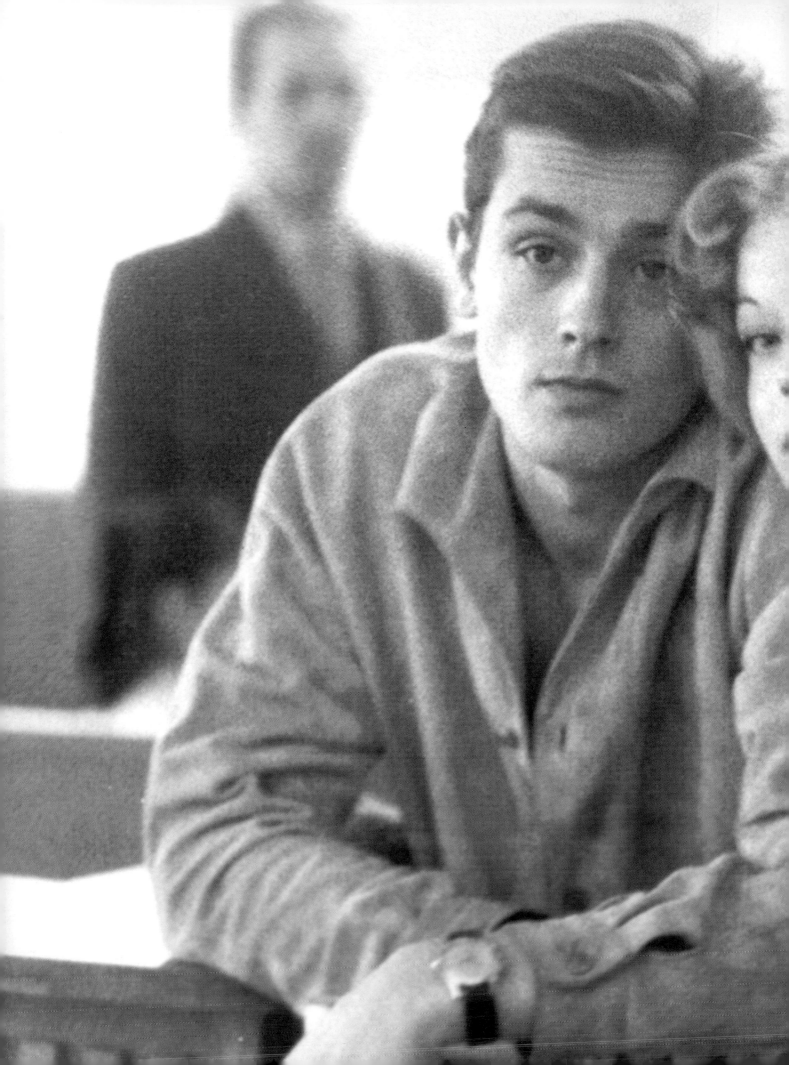

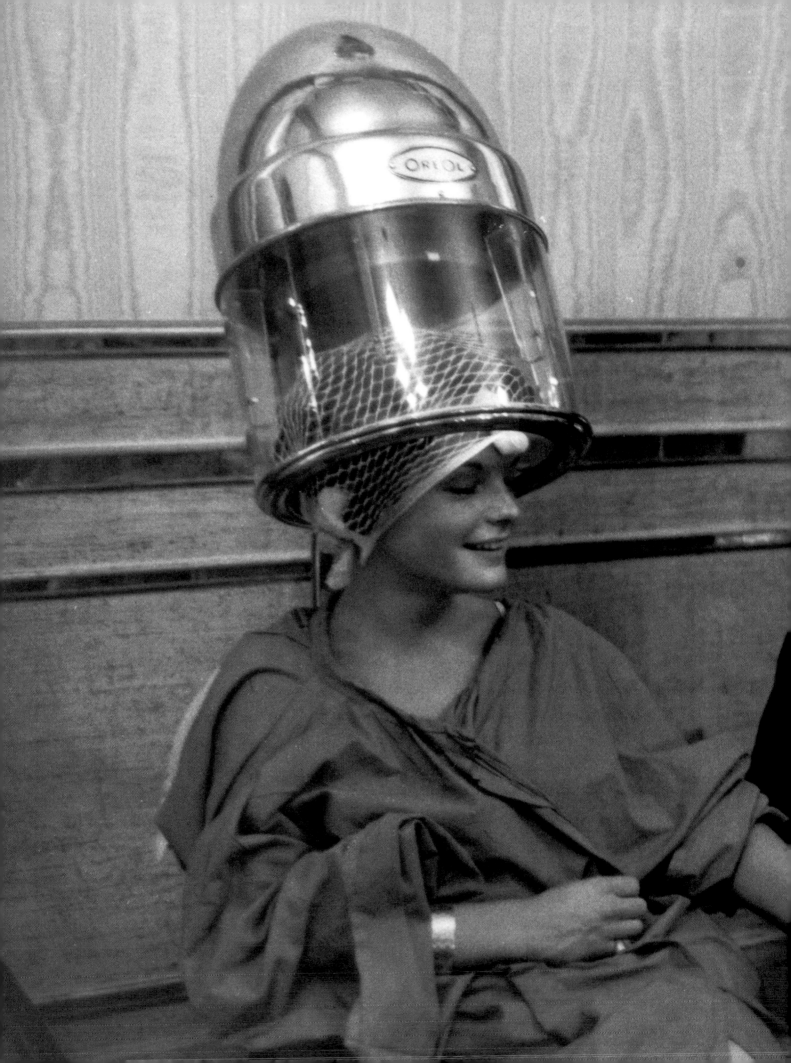

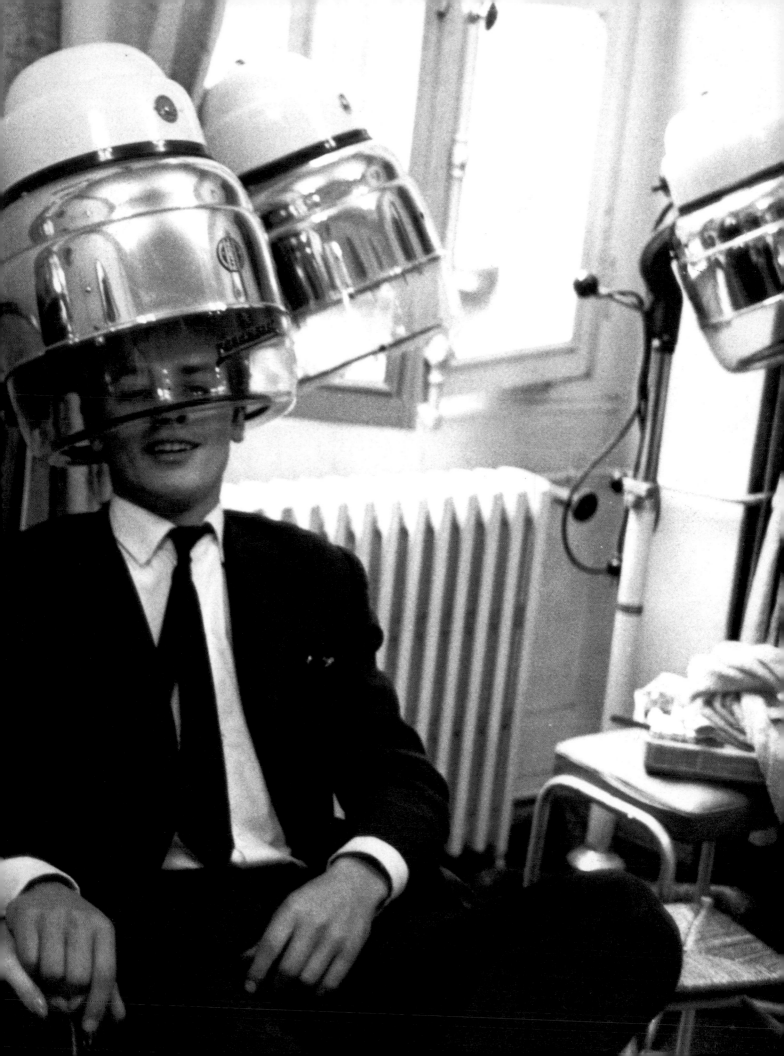

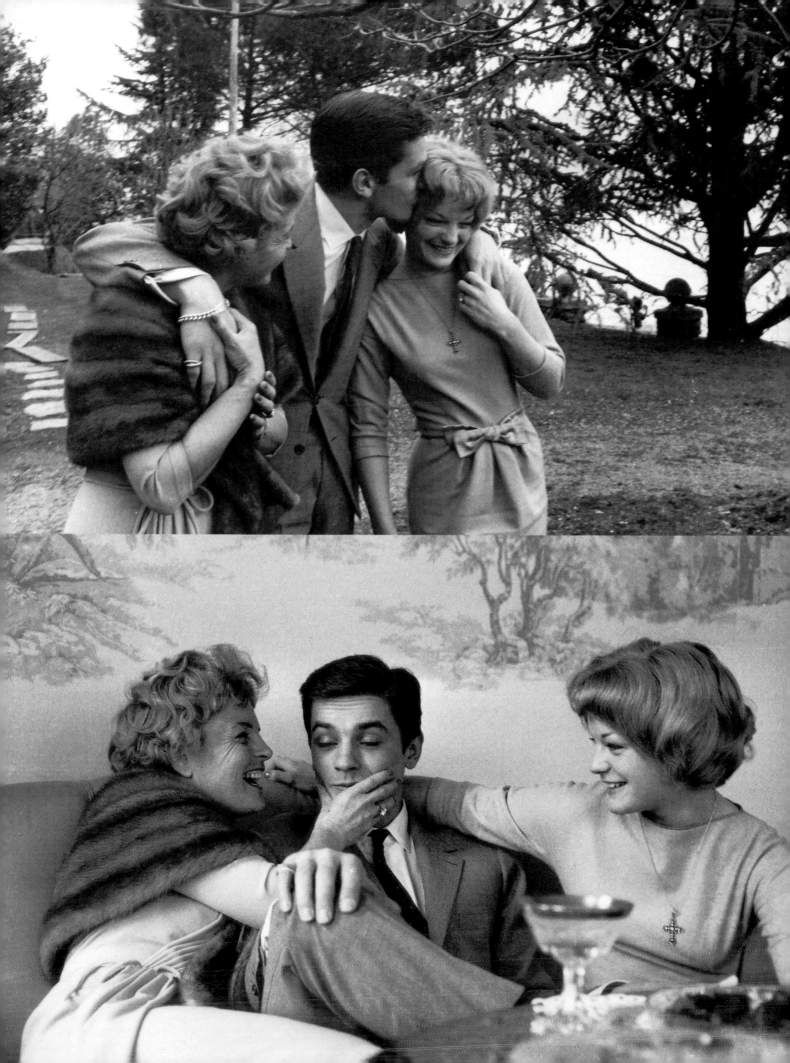

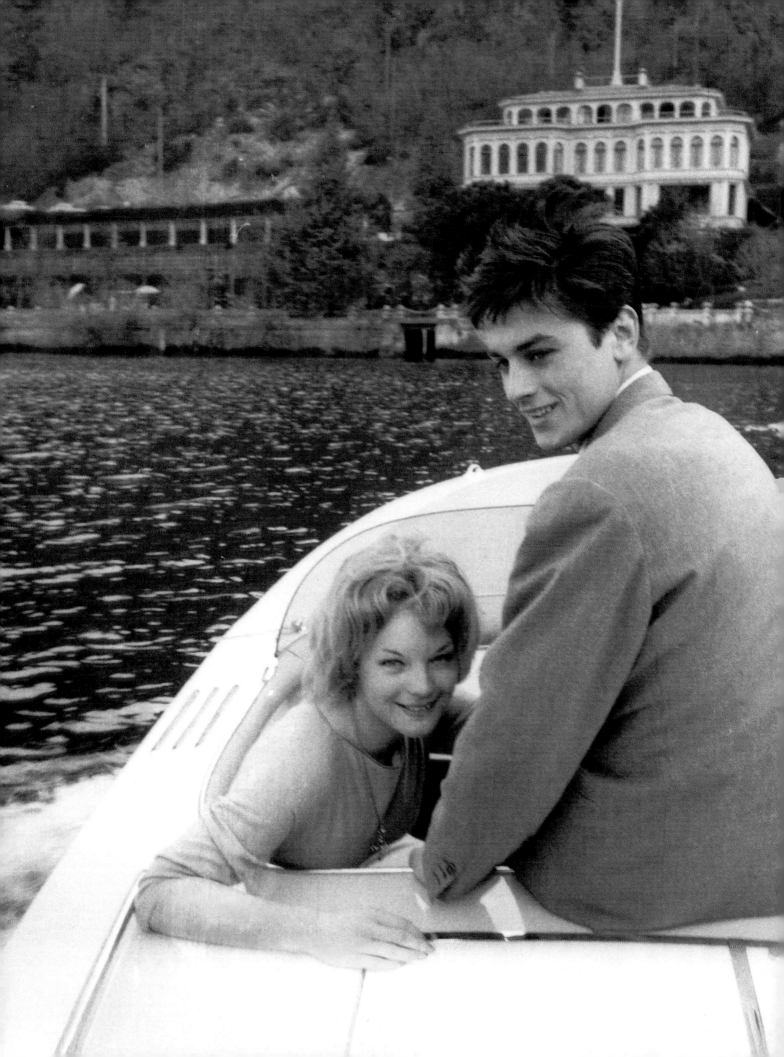

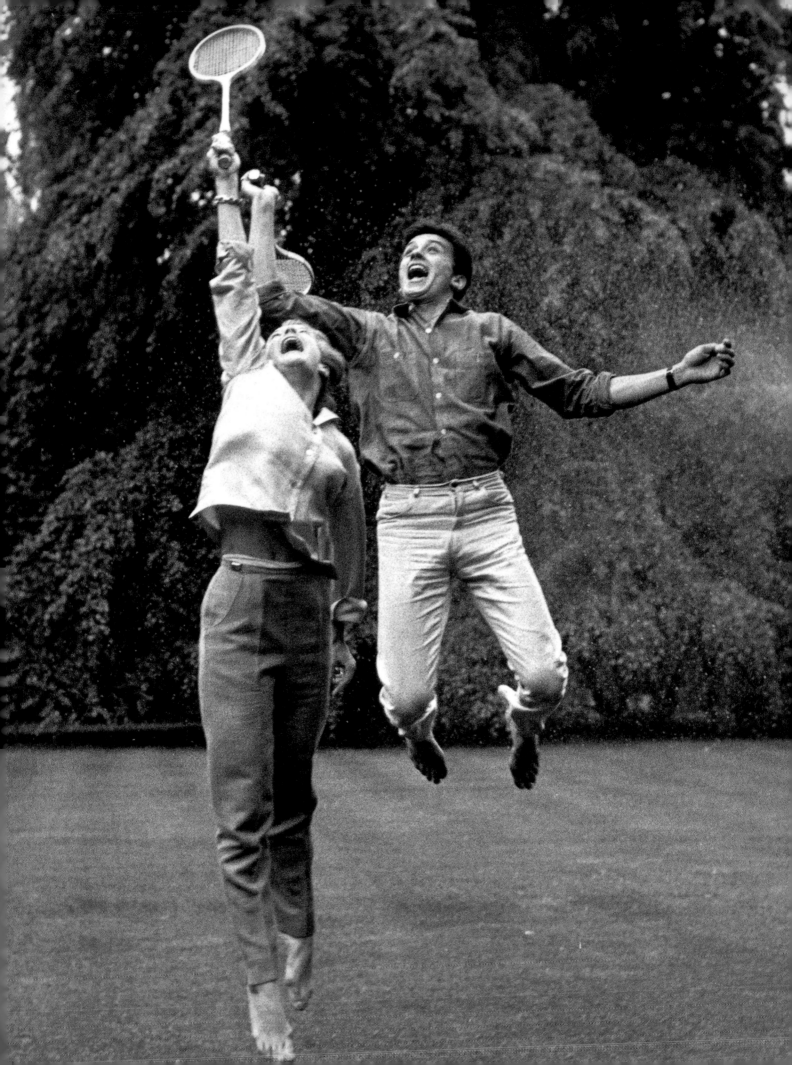

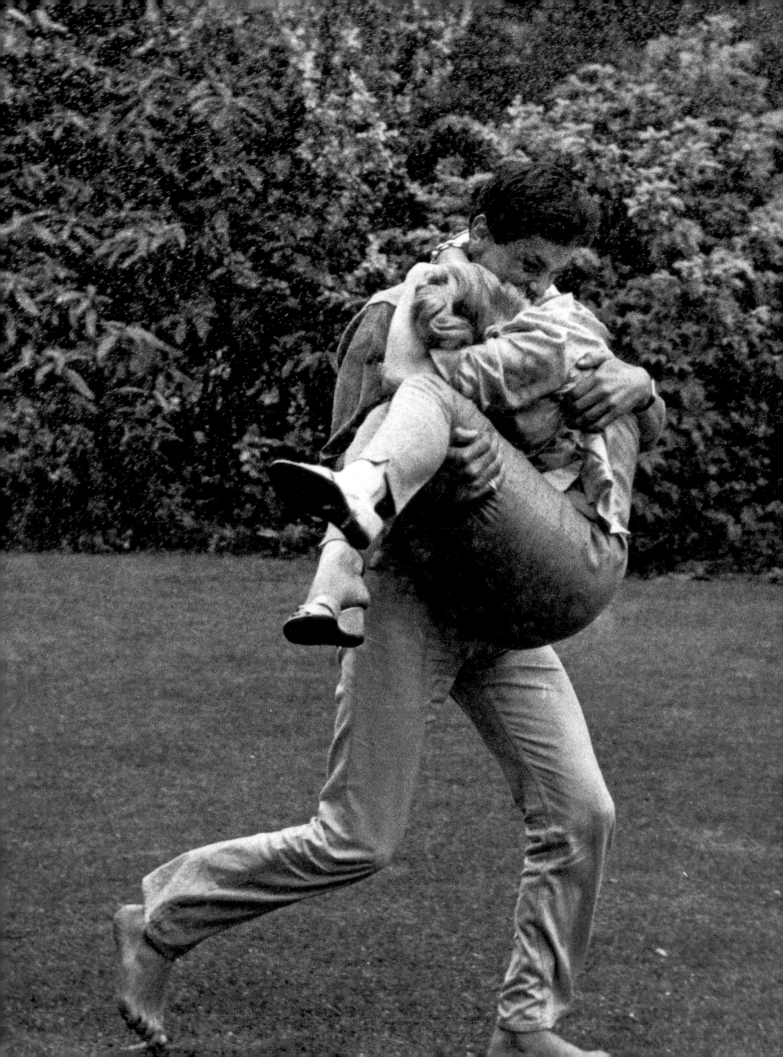

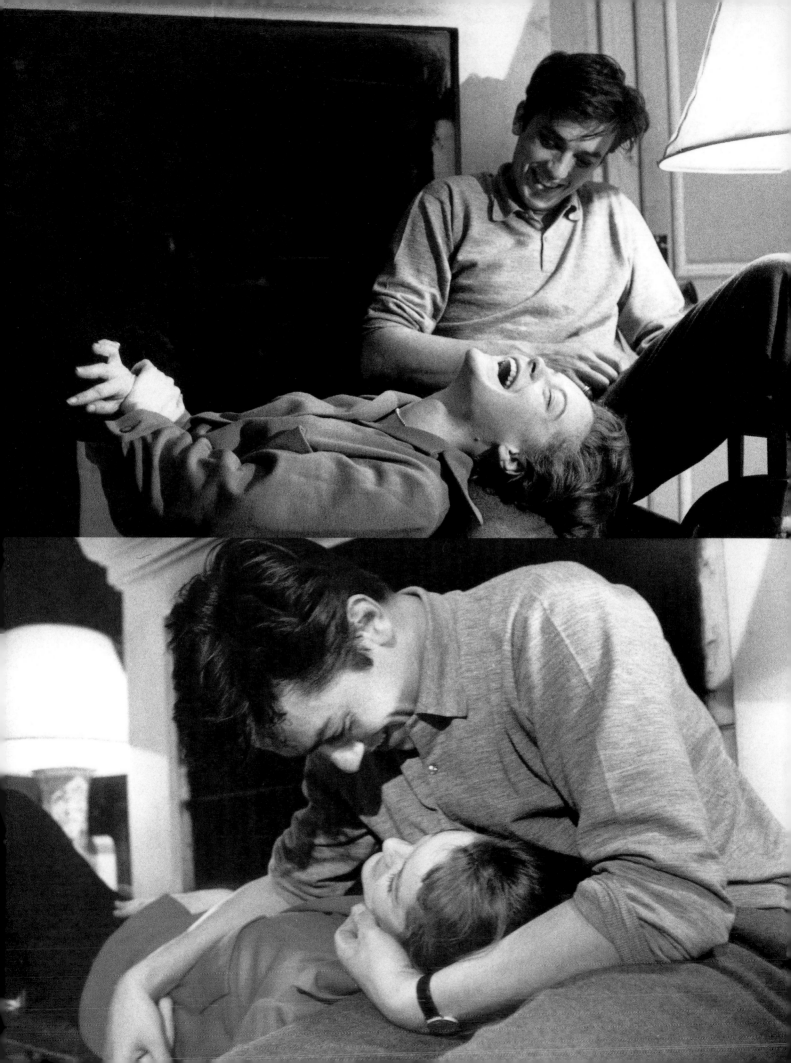

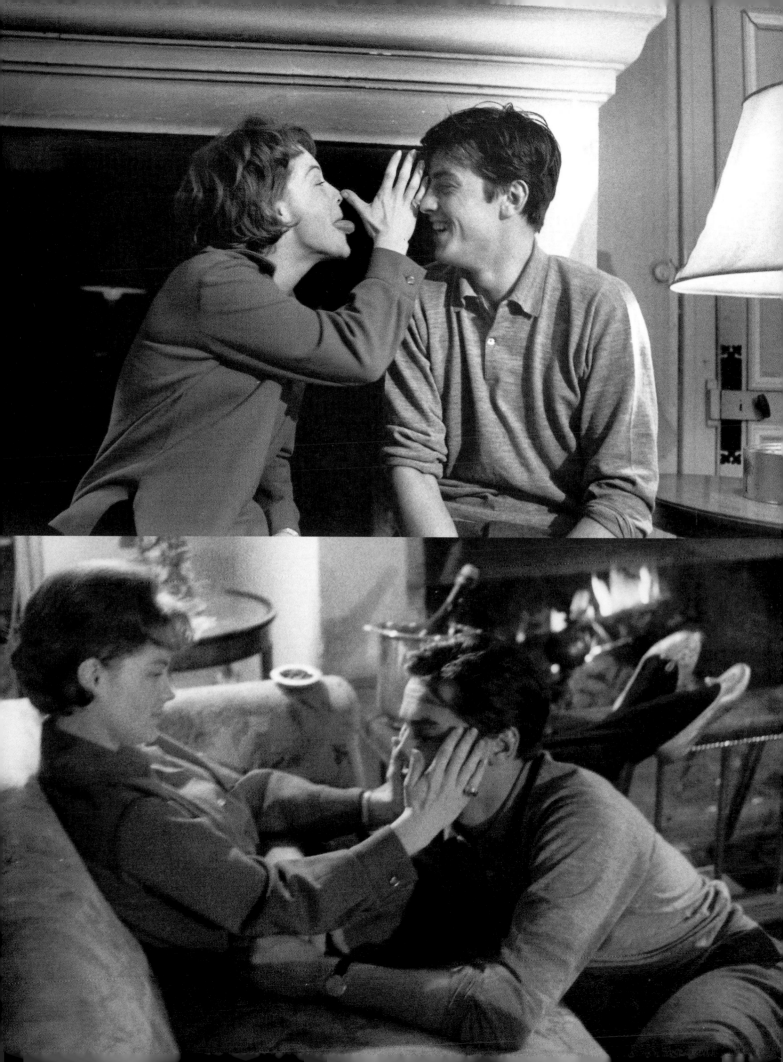

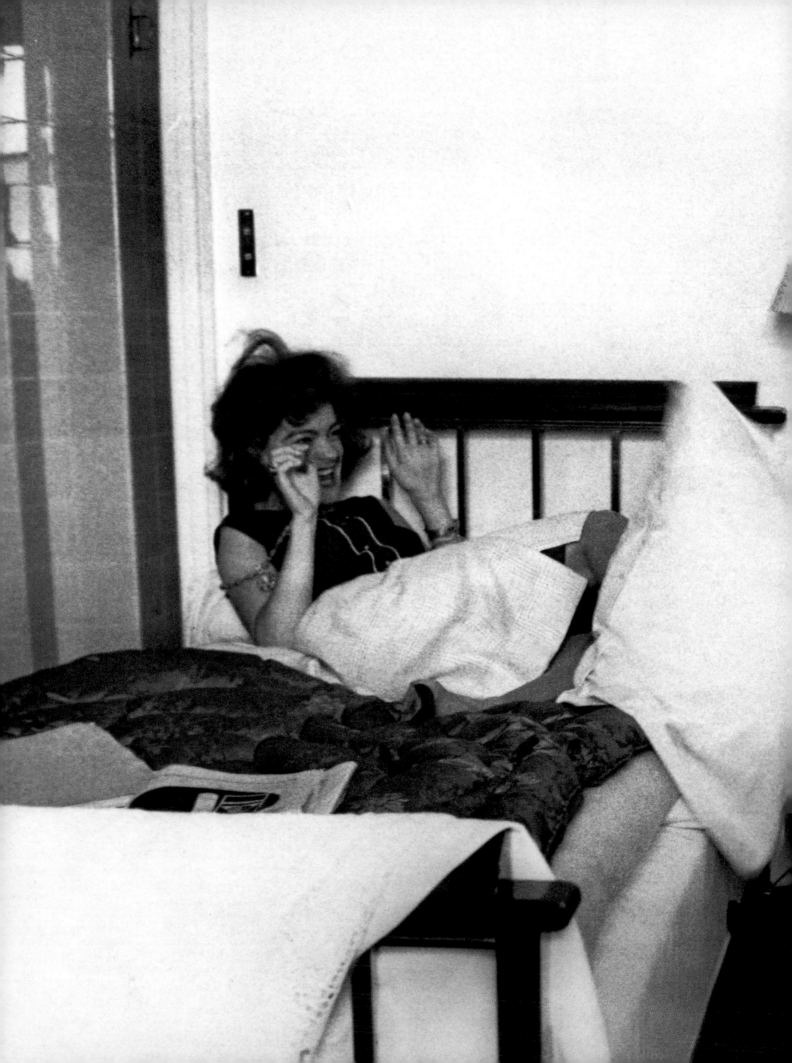

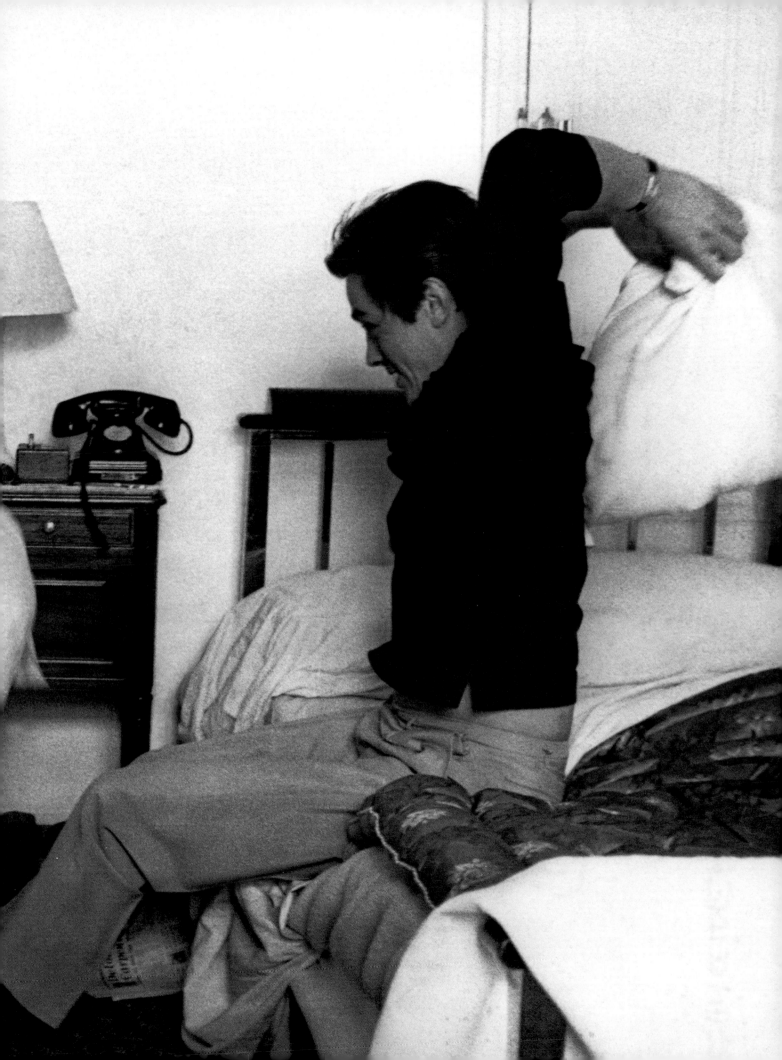

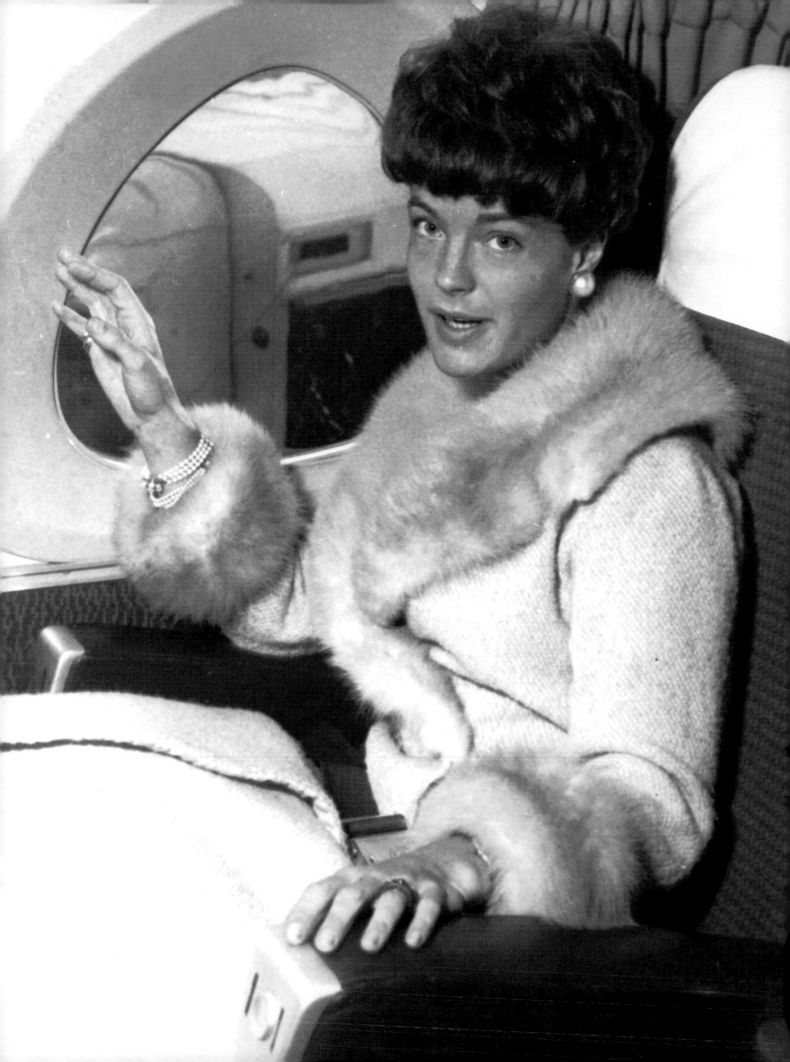

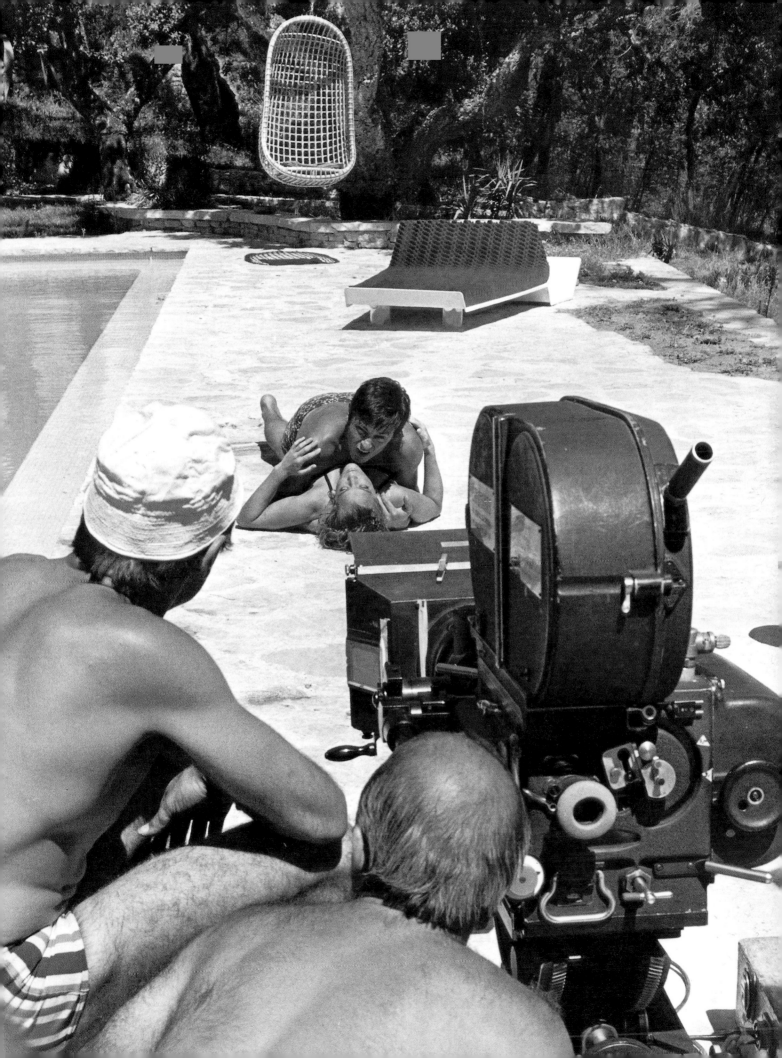

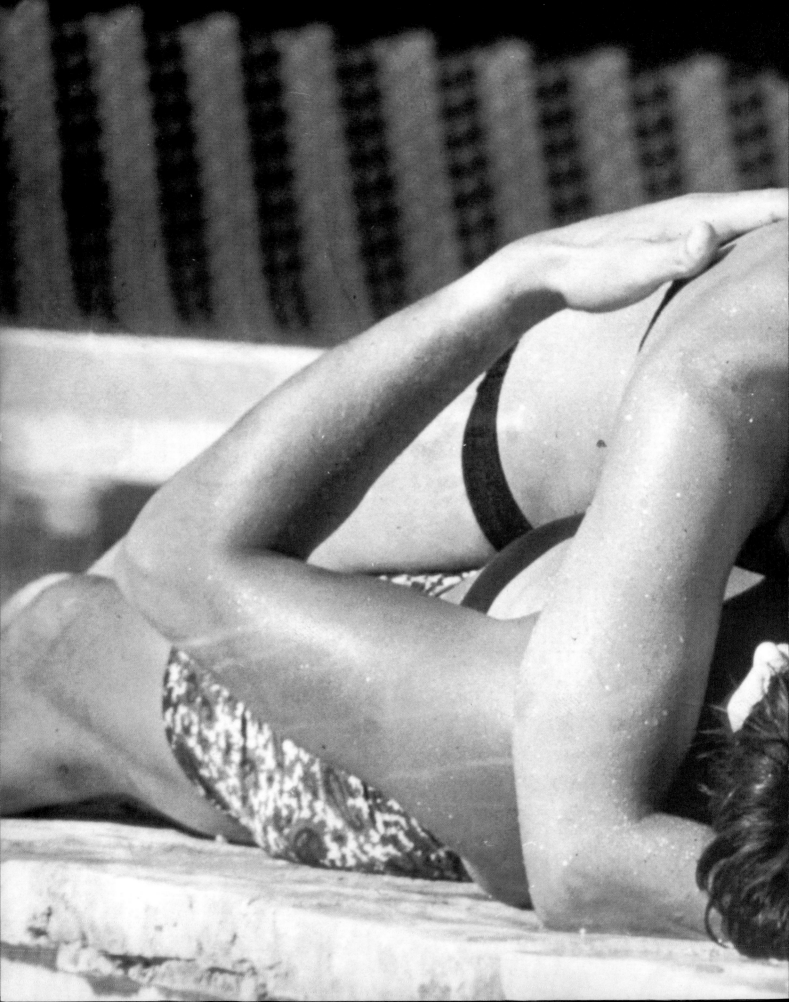

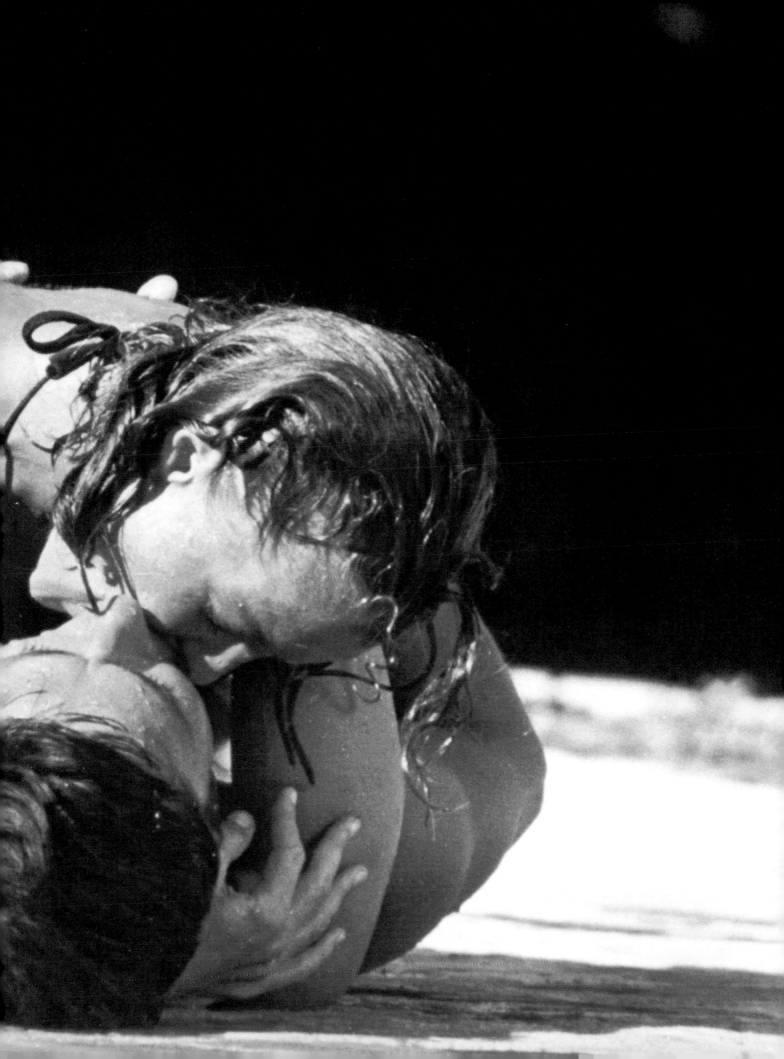

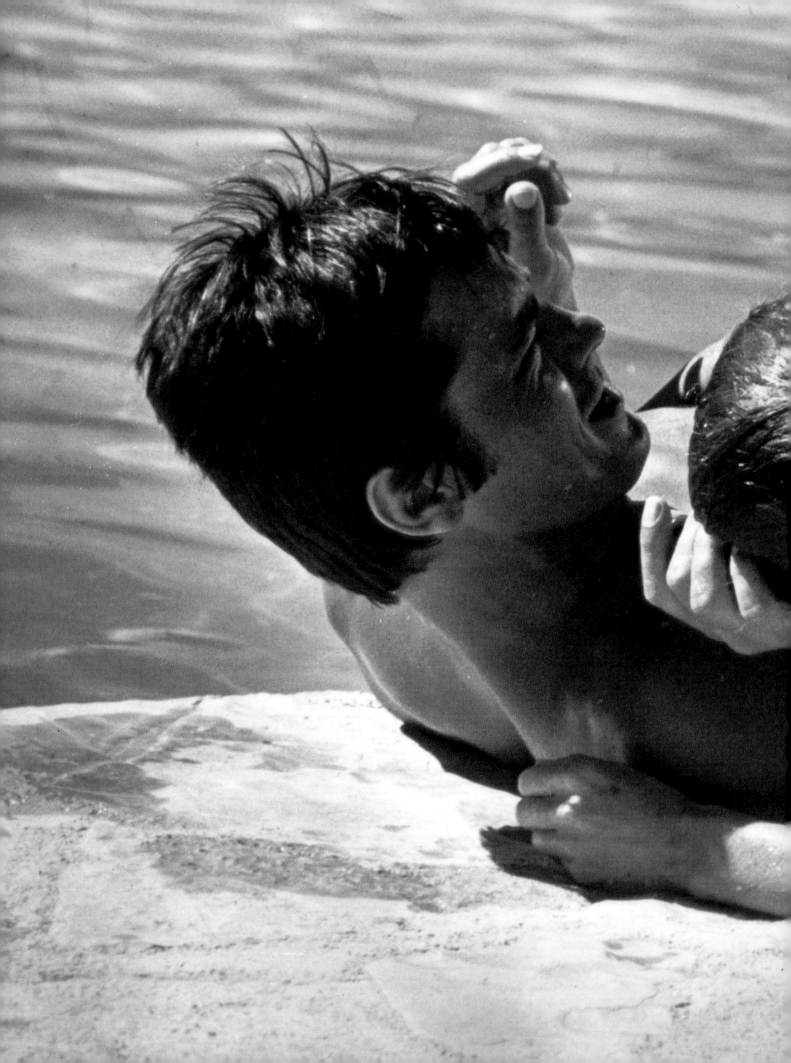

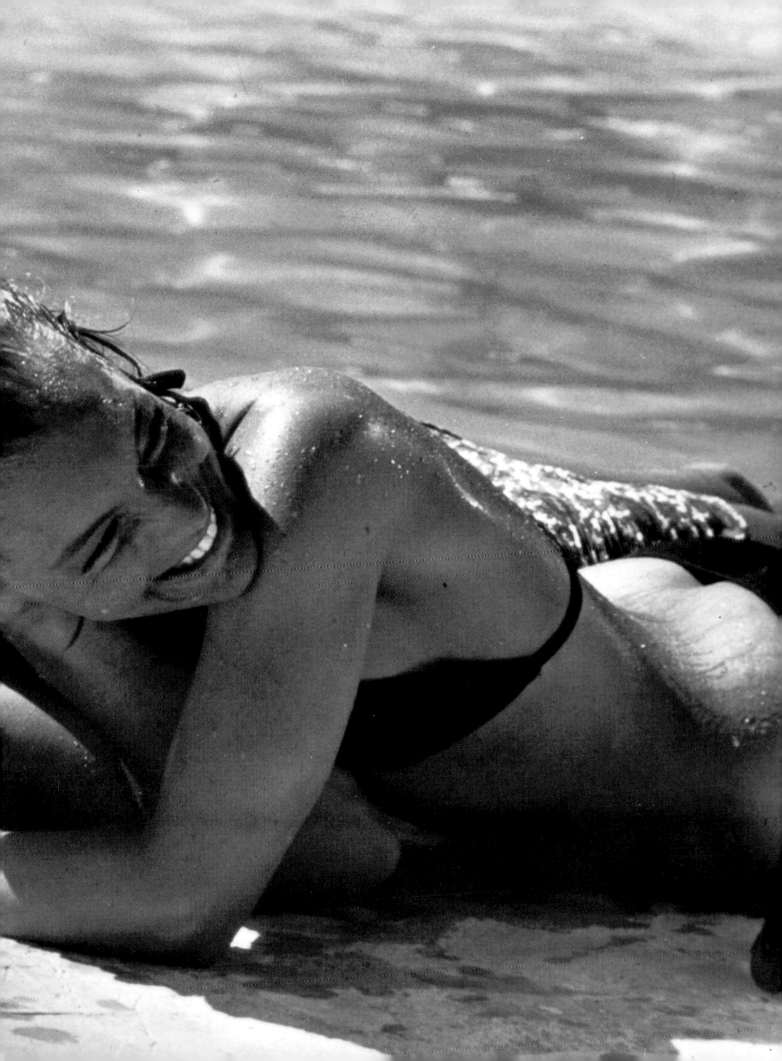

Jackie & John Kennedy

An American love story

It was like dreaming in real time: they were young, beautiful, rich and ambitious. They were what every American wanted to be. All America would fall in love with them—and all the world.

– As a journalist for the *Herald Tribune*, she interviewed the "new lion" of politics. "Let's go have a drink somewhere," he suggested. But she refused.

– Hyannis Port. The Kennedy compound, hub of a family dynasty and an increasingly fleeting world.

– Engaged, she was twenty-three, he thirty-five. The only witness a photobooth.

– September 12, 1953, they wanted a "discreet" wedding...1,200 guests and 3,000 inquisitive bystanders came to witness the American "royal wedding."

– Both families were there at the Bouvier's Hammersmith Farm. Bridesmaids and groomsmen were picture perfect.

– So radiant beside the young senator.

– The illustrious Kennedy clan—two brothers and three sisters flank the bride and groom.

– Dancing with her father-in-law, then with the future 35th President of the United States. "I've just married a whirlwind," Jackie confided. "He's indestructible."

– Everything was in place for a happy ending until that fateful day in November 1963. A senseless, brutal end.

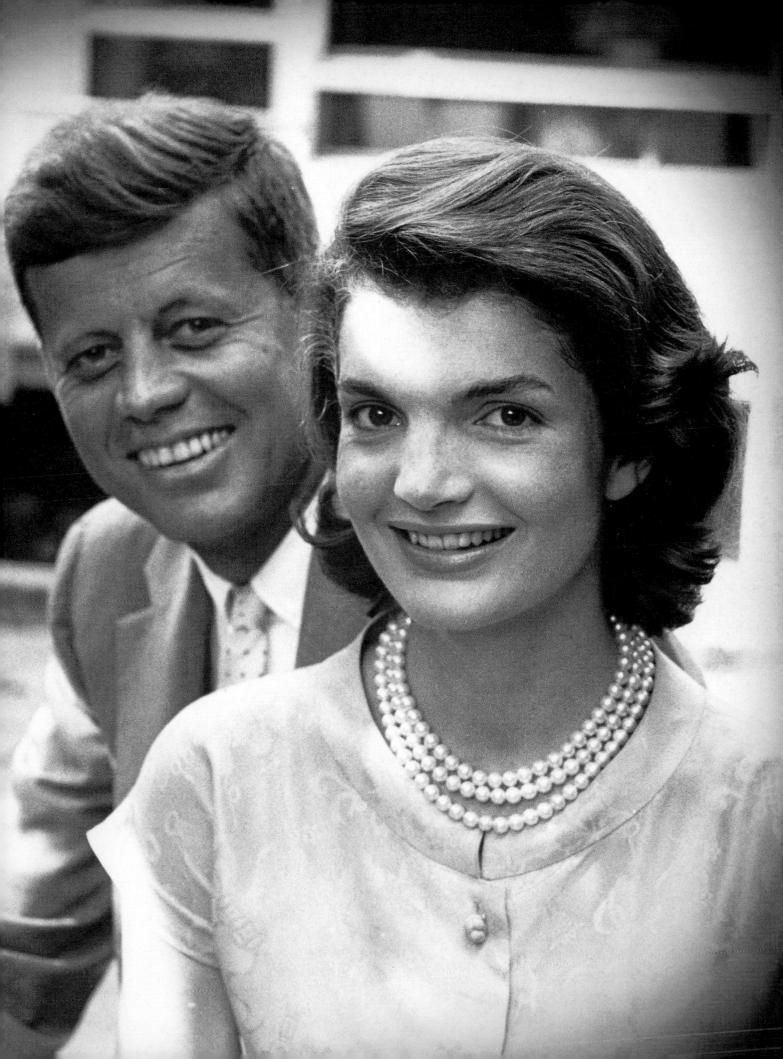

November 12, 1953, lost in the tide of 3,000 onlookers waiting for the moment when they could catch a glimpse of the bride over the wall of white-gloved policemen, a bystander muttered: "My God, so it's really true. Do you know what we say back home in Boston? We say that the Kennedy clan left Ireland to escape from the potato famine in 1847, and they've never wanted for potatoes ever since."

It is true that the inquisitive throng gathered in Newport around the little brown stone church of St. Mary's, on that unseasonably mild afternoon, got all they bargained for in terms of pomp and circumstance; true, too, that Jacqueline Bouvier, who had dreamed of a small and simple wedding, got quite a lot more than she'd ever imagined.

The church itself could only accommodate half the 1,200 guests, and it was amid a fine, colorful mess that the photographers, who'd traveled from Boston, Washington and New York, captured the image of that diminutive bride in her ivory satin gown and pale pink veil, escorted by a retinue of twelve bridesmaids in pink dresses matching that veil. Jackie smiled, but not for the photographers. The wind, really no more than a warm autumn breeze, made her veil billow and played with the bangs of her short hair. That's what she found funny, at that moment when, for all that American high society clustering about the Kennedys and the Bouviers, she should have looked worthy of the extraordinary destiny awaiting her—solemn and composed.

In the church, filled with white chrysanthemums and pink gladioli, members of Congress, stiff politicians, and gossips in beautiful hats were starting to whisper that yes, the Kennedys might be rich now, but they were nouveaux riches and that the less ostentatious Bouviers represented the real "old guard." In the congregation, verging as it was on petty scandalmongering, Jackie's entrance was the signal for everyone to relax. Then John F. Kennedy appeared at the top of the steps, literally borne along by his fourteen groomsmen. Richard Cushing, archbishop of Boston, conducted the wedding service, complete with mass. It was he who recited the special apostolic blessing that Pope Pius XII had sent to the newly weds. The ceremony lasted forty minutes—forty minutes of torture, too, for John F. Kennedy. Those who noticed how pale he looked were moved by the thought that it was the pallor of emotion. Only Bobby Kennedy, John's brother and best man, knew that kneeling at the altar was excruciatingly painful for the bridegroom—his old football injury hurt him terribly whenever he had to bend his back. The wedding party was held at Hammersmith Farm, the grand estate where Jacqueline had spent her girlhood. The light breeze tugged at the tablecloths laid about the gardens and on the terraces. The large-format family photo ritual was enacted in a meadow sprinkled with autumn flowers— the young married couple surrounded by their twelve bridesmaids and their fourteen groomsmen. The *Life* crew that had come down from New York reworked the material for their own use. America's most widely read magazine saw fit to devote six pages to that wedding and all its promise.

That same night Jackie and John abandoned the five-story farm now cluttered with gifts, and flew to Mexico. The backdrop to their happy honeymoon was a pink house perched on a clifftop in Acapulco. It was a true Kennedy who emerged from that little house of tricks on John's arm—John whom she called by his diminutive, Jack.

"I married a whirlwind," Jackie later confessed. "He's indestructible. People who try to keep up with him drop like flies. Guess what? Me too!" This whirlwind was not just a man, but a whole family. The year was 1953 and since John had been elected senator for Massachusetts, all the country's political pundits were agreed in saying that it was not just that particular Kennedy, but the entire Kennedy clan that had invaded the American political scene like a hurricane.

And to their considerable credit, too. In the days when the Kennedys (Joe, John, Bobby and Teddy) were kids, you could still read job offers in small ads in Boston's newspapers that ran thus: "Protestants only, No Irish need apply." For instance, when the patriarch Joseph Kennedy was appointed chairman of an electrical equipment company in Massachusetts in 1917, it caused nothing less than a scandal among the board of directors. And yet it fell to that first Kennedy to show his sons the way forward. The Irishman who, in those early days, earned $1,500 a year, in a two-bit bank going nowhere, amassed a fortune calculated to be in the hundreds of millions of dollars. As a producer of early silent westerns, as the man who financed Eric von Stroheim's greatest Hollywood films, and as the owner of a chain of movie theaters, in just a few months he earned his first $5 million, which he gambled on the Stock Exchange. Known as "the lone wolf of Wall Street," he bought, sold, speculated and carried off high-risk transactions, and was "regarded as a genius when it came to making money." At the same time, Joseph Kennedy was importing whisky and gin (he had embarked on this activity in a purely medical capacity during Prohibition). President Truman—who was not fond of Kennedy the elder, to put it mildly—advised all his associates to drink nothing but Bourbon, "because every time you drink Scotch, you're making Kennedy richer." He hadn't waited until he had amassed such a fortune to become a close friend of Franklin D. Roosevelt, who duly appointed him ambassador to London's Court of St. James in 1938. But as a public advocate of American non-inter-

vention in Europe, he was recalled in 1940. Which, of course, enabled him to return to his financial empire. "When they come of age," the head of the clan was wont to say, "I'll give all my children a million dollars each." Alas! he had a mere nine offspring.

The eldest, Joe, was earmarked to realize the political ambitions that had eluded his father. But he was killed in action as a World War II pilot, and it fell to John to assume the honor of defending the clan colors. After a brief attempt to set up home in New York, where the ambitious multi-millionaire had taken his whole family, complete with governesses, dogs and pets in a special wagon, the Kennedys returned to Massachusetts, to Hyannis Port. It was there, on their return from Mexico, that the newlyweds Jack and Jackie first lived, and it was there that they returned so often in later years.

"They're all fantastic and as soon as you get engaged to one of them, you become fantastic yourself," Jackie would exclaim when she talked about her brothers-in-law.

She could well have been swallowed up by all those guys who got up at the crack of dawn and spent their time going from playing tennis, to sailing; from playing golf, to swimming; from playing football, to many another sport, too, without stopping. Instead of being swallowed up, however, she achieved the amazing feat of becoming more of a Kennedy than the Kennedys, still managing to remain true to herself at the same time. While they swung golf clubs, she went riding. When they ran along the beach, she would paint them running along the beach. And while they appreciated a chair for its comfort, she thanked God that the chair was a Louis XV.

As far as the brothers were concerned, there was only one conversational topic that she dreaded, and that was politics. For, during her engagement, it was politics that had robbed her of those long, intimate evenings that she had dreamed of spending with Jack, and which had to be cancelled or put off time and time again, because the elusive John had to honor invitations from 200—or was it 2000?—constituents. Apart from their long holidays at Hyannis Port, the early years of this marriage between a cultured young woman and a team of sportsmen were spent moving house, setting up home, sudden departures, haphazard visits, and impromptu arrivals. As a shrewd young bride, she had espoused one principle in particular: never talk politics. "How on earth is he expected to relax after his day's work if the first thing I ask him is: 'What's happening in Laos, darling?'"

On one anniversary, she gave him a watercolor which might well have been called: "How the Kennedys celebrate their wedding anniversaries." The picture was divided into two parts: in the first, a naively drawn Jack lay on his back in a hospital bed being visited by Jacqueline; in the second, it was Jacqueline in bed with Jack visiting her.

That allegory was not a witty cartoon. It was a reference to the first gloomy pages of their true story in which the voters of Massachusetts must only know the rosy chapters. Truth be told, when John got home from his campaign tours, he suffered the same pain as the pain that drained the blood from his face on the prayer stool at their wedding in St. Mary's. That same old football injury that he'd sustained at Harvard so many years ago, and that the war had greatly exacerbated. The scene was the Pacific. John's ship was sliced in two by a Japanese destroyer and John was hurled onto the deck, landing on his spine. He spent hours in the sea, pulling behind him one of his badly burnt men. John returned home a hero, but with an unbearable pain in his back. The first operation he had in 1944 was a failure. On October 21, 1954, barely a year into his marriage, Jacqueline went with John to a New York hospital. An infection had set in. A tearful Jackie and the whole family gathered at the patient's bedside. The surgeons didn't think he'd get through the night. Jackie asked that he be administered the last rites.

Then a miracle happened. Before daybreak, John felt so much better that the doctors decided that the best solution would be for him to spend the Christmas holidays in Palm Beach, Florida, on his father's property. A long and painful convalescence followed. Eight months spent moving as little as possible. Jackie urged her husband to set his memoirs in order. She became his researcher-cum-archivist and, paragraph by paragraph, his first reader. *Profiles in Courage* won the Pulitzer prize, and became a bestseller.

So that was the first picture in Jackie's anniversary diptych. To make it easier to figure out the second one, depicting Jackie in a hospital bed with John visiting her, it should be remembered that those Kennedys who smiled so readily for crowds and photographers—reasons of State, smiles of State—had just lost their second unborn child. Jackie's second miscarriage was more serious. They had to perform a Caesarian, and she'd almost died.

When she recovered, she appointed herself a lengthy and agreeable task: putting a little order in her husband's life, imbuing beauty in the order, and gaiety in the beauty. The first form this task took was the purchase of a house, Hickory Hill in Virginia, then a second one, and finally the right one, in Georgetown, a residential neighborhood in Washington, D.C. This last home was all red brick, with a lovely three-floor facade. In the living room there was a fine

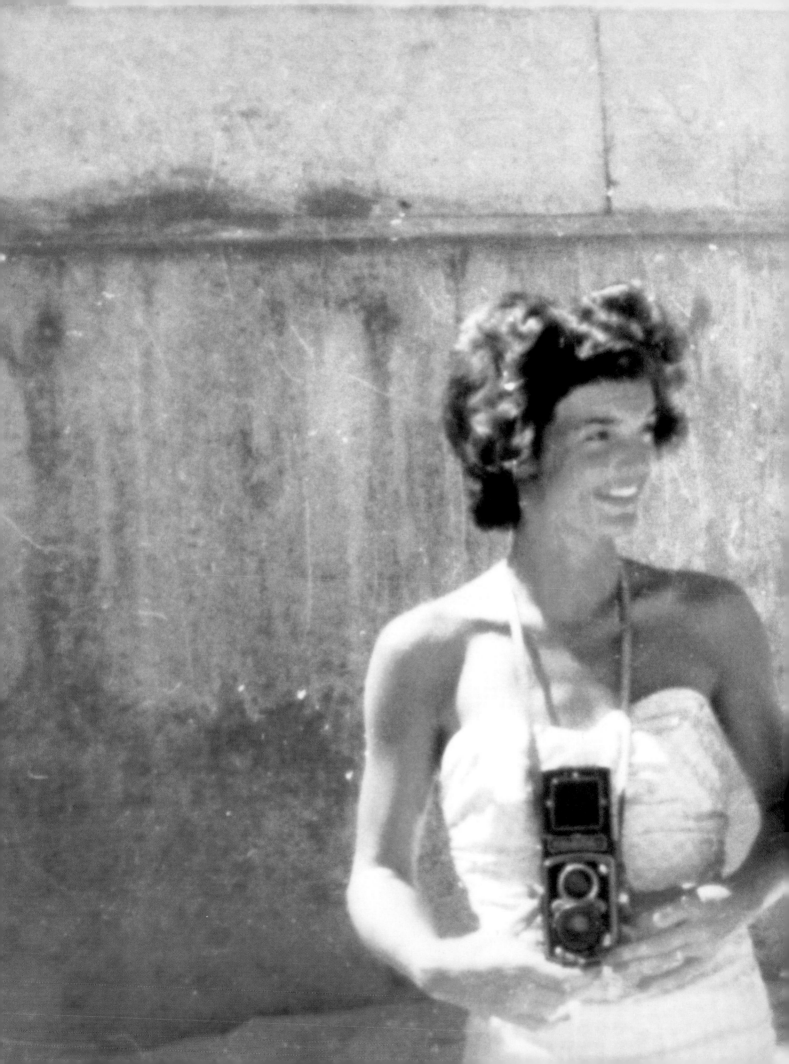

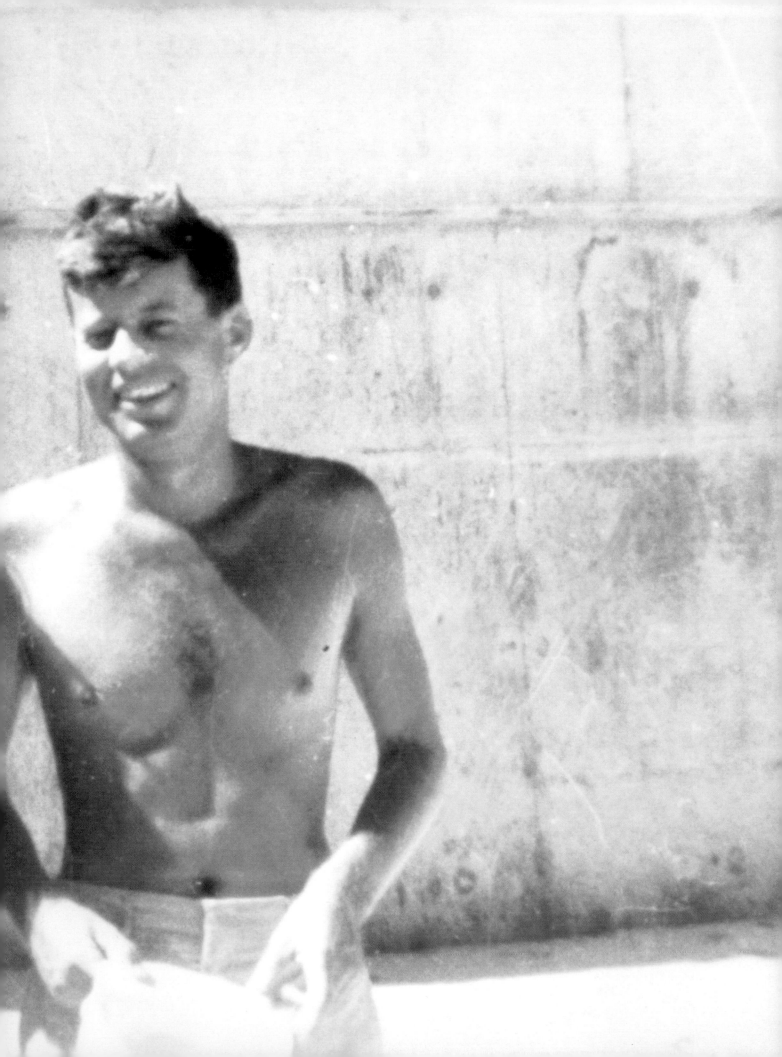

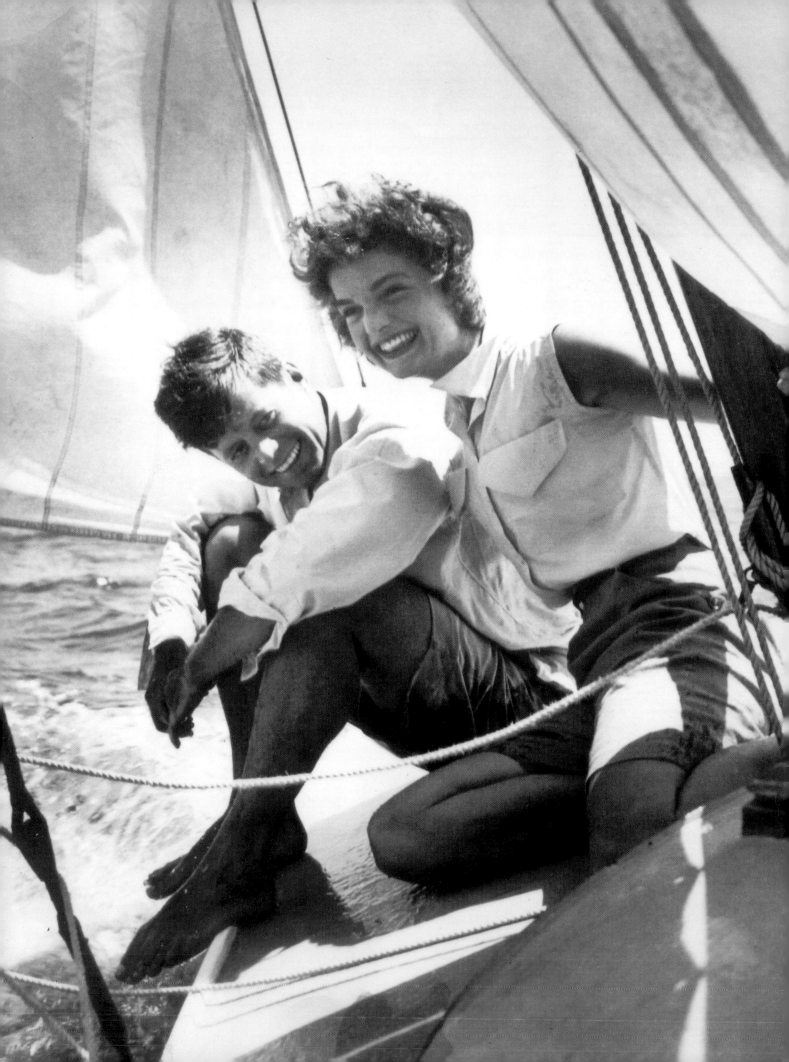

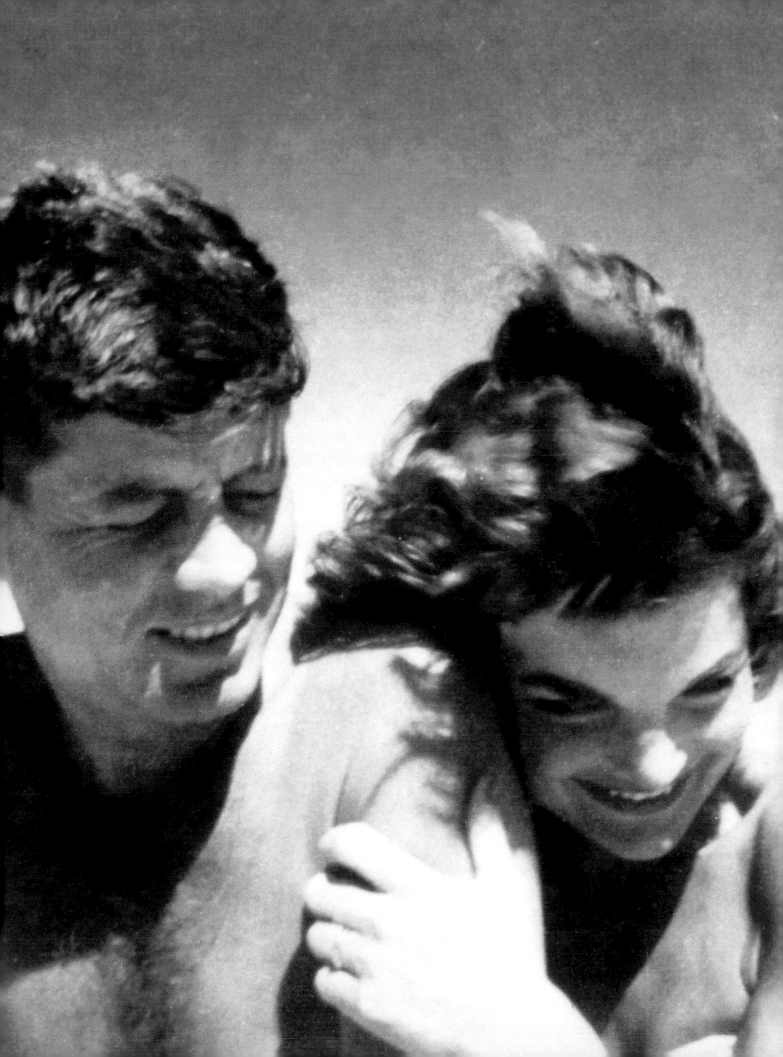

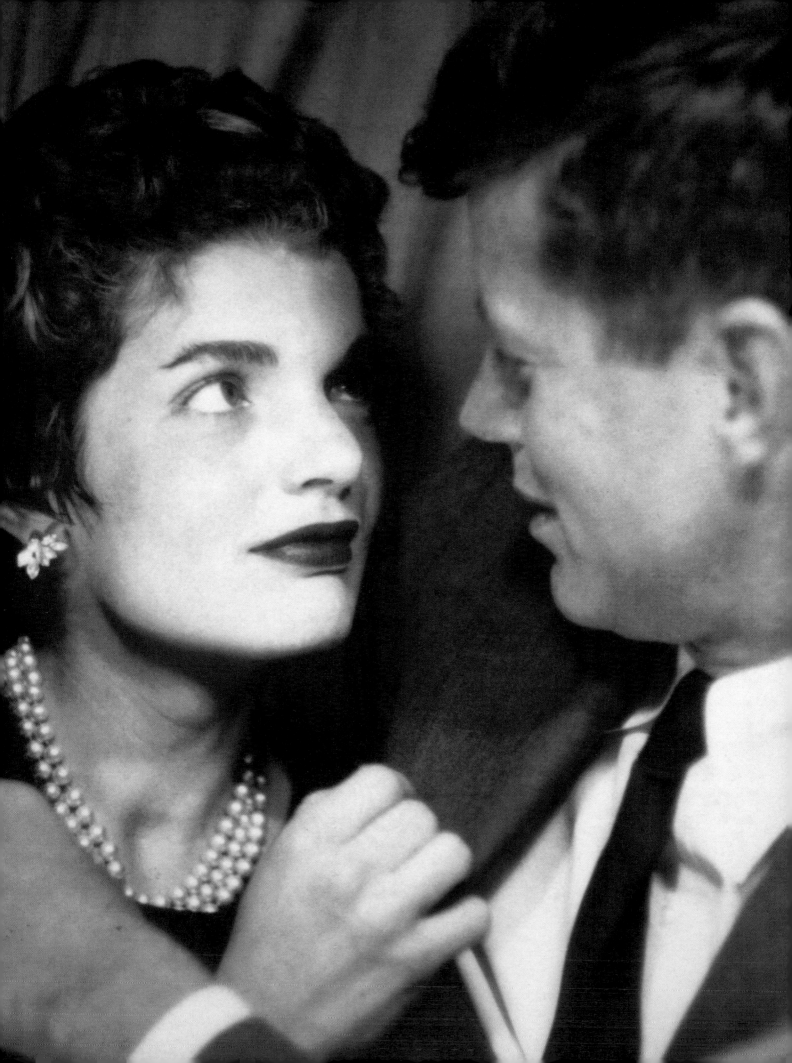

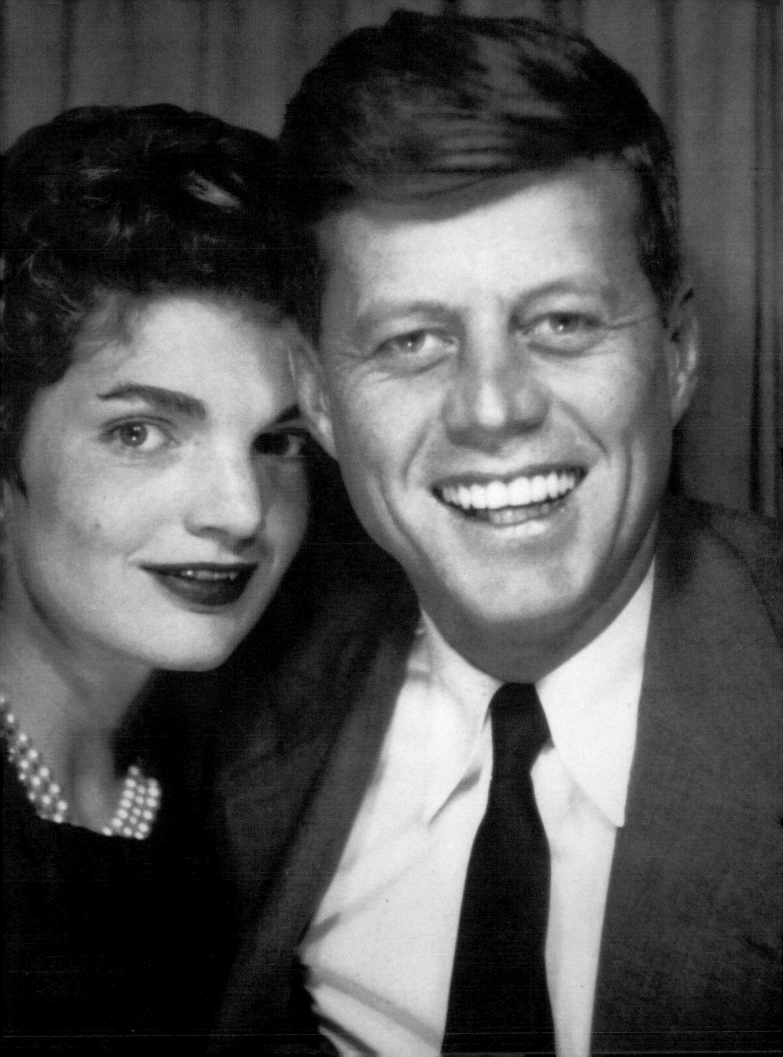

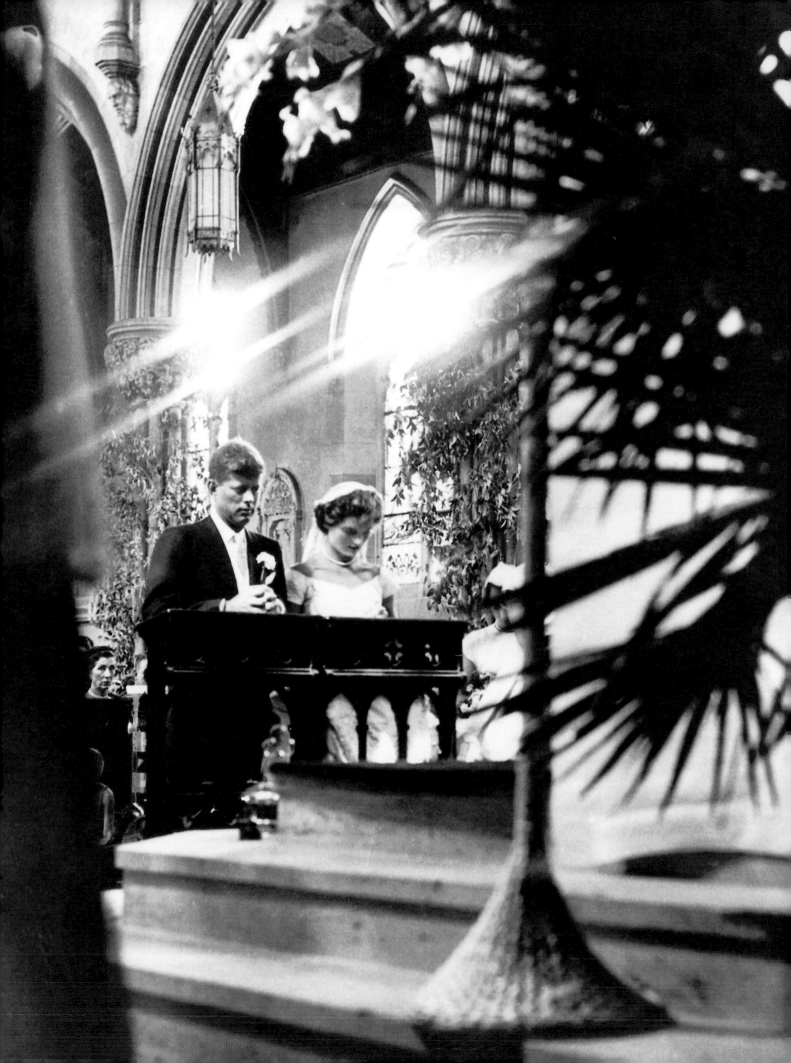

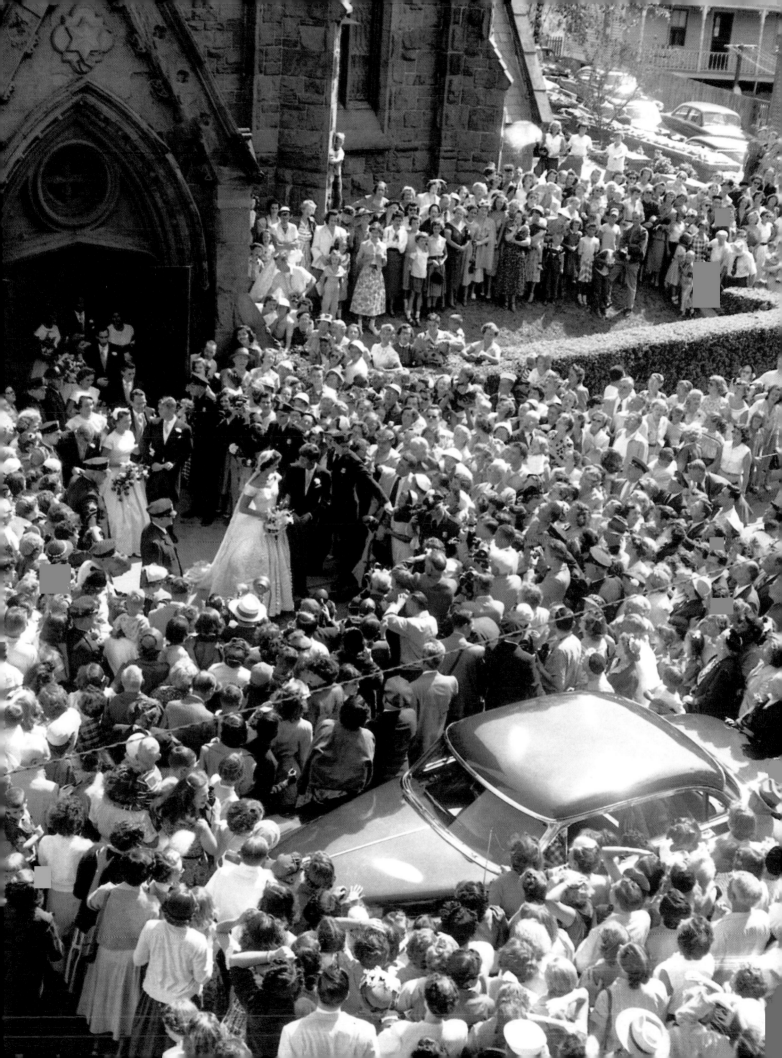

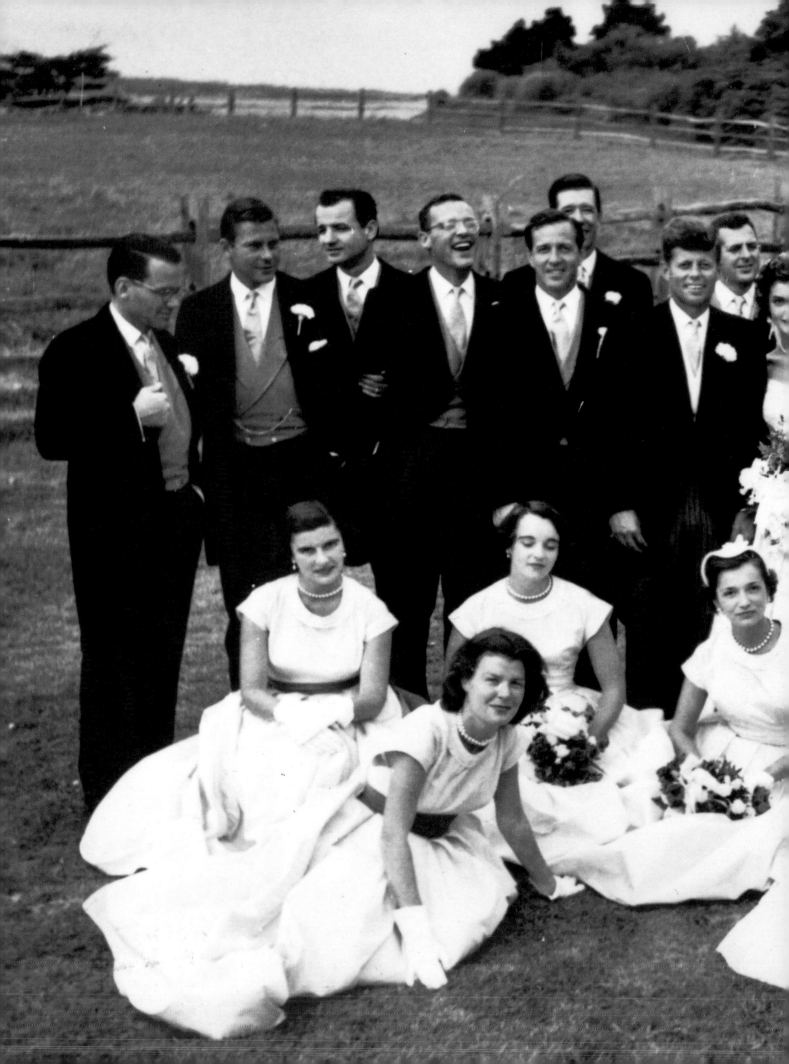

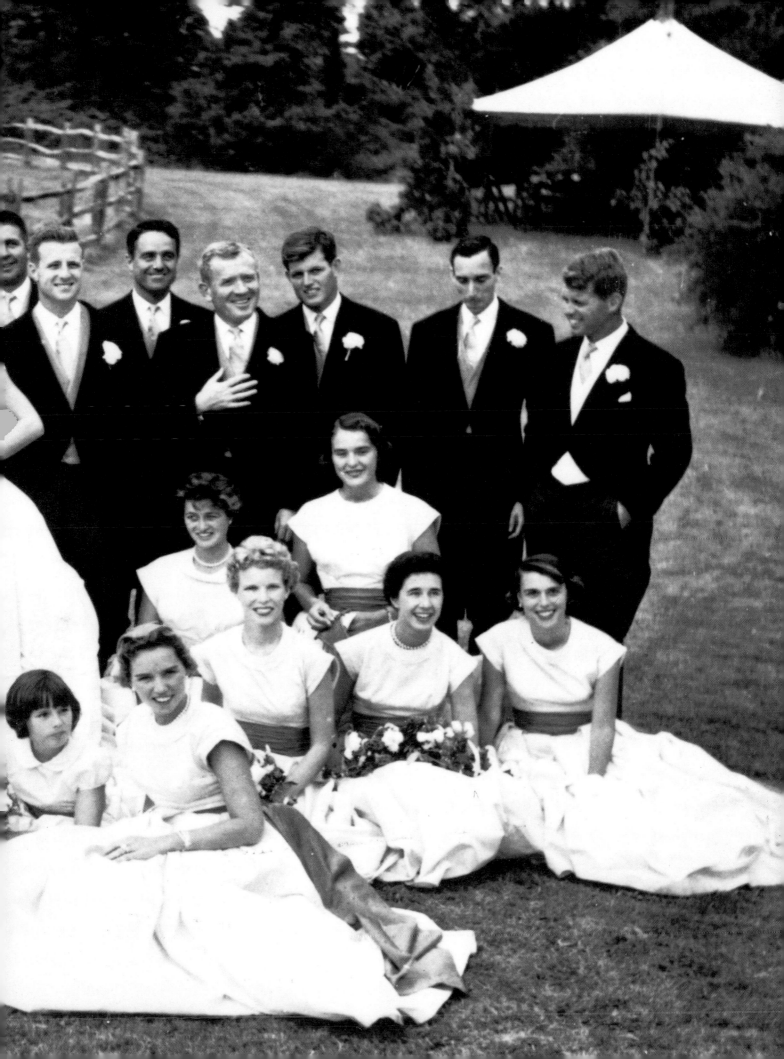

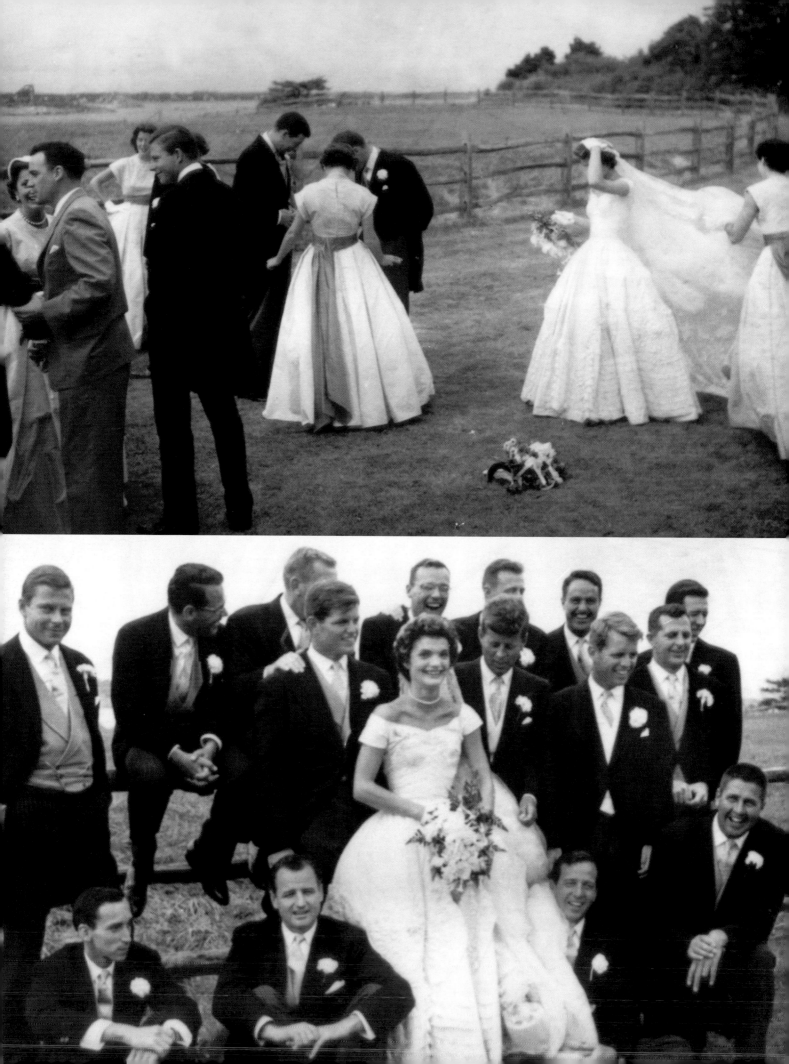

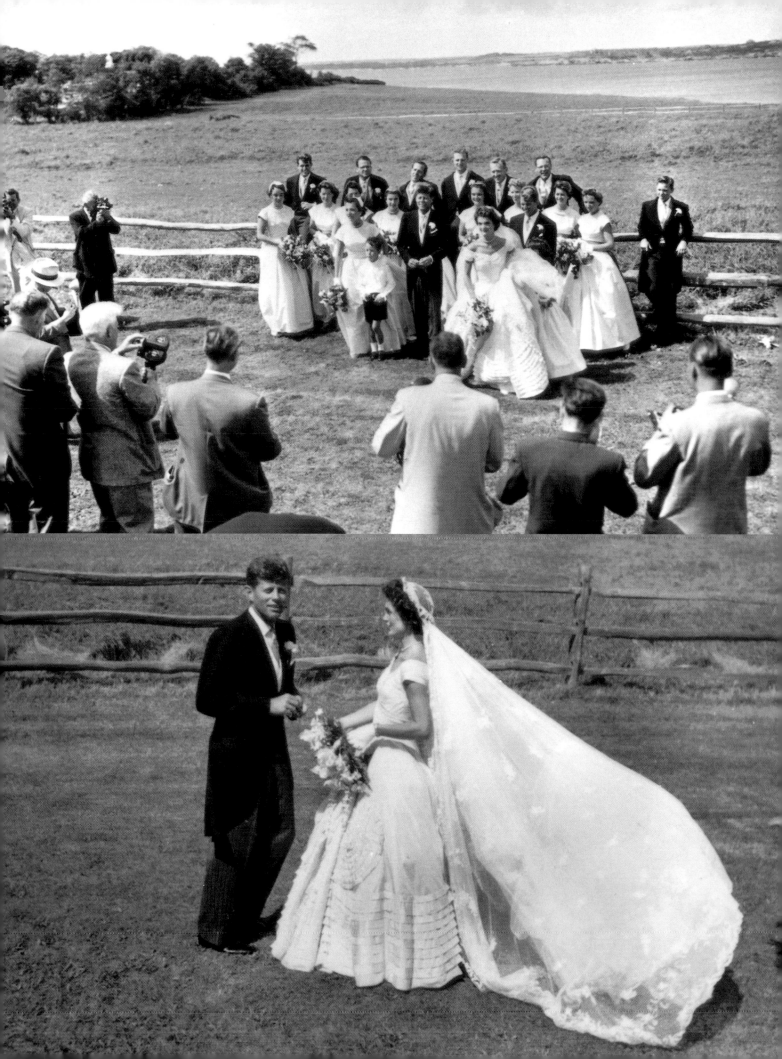

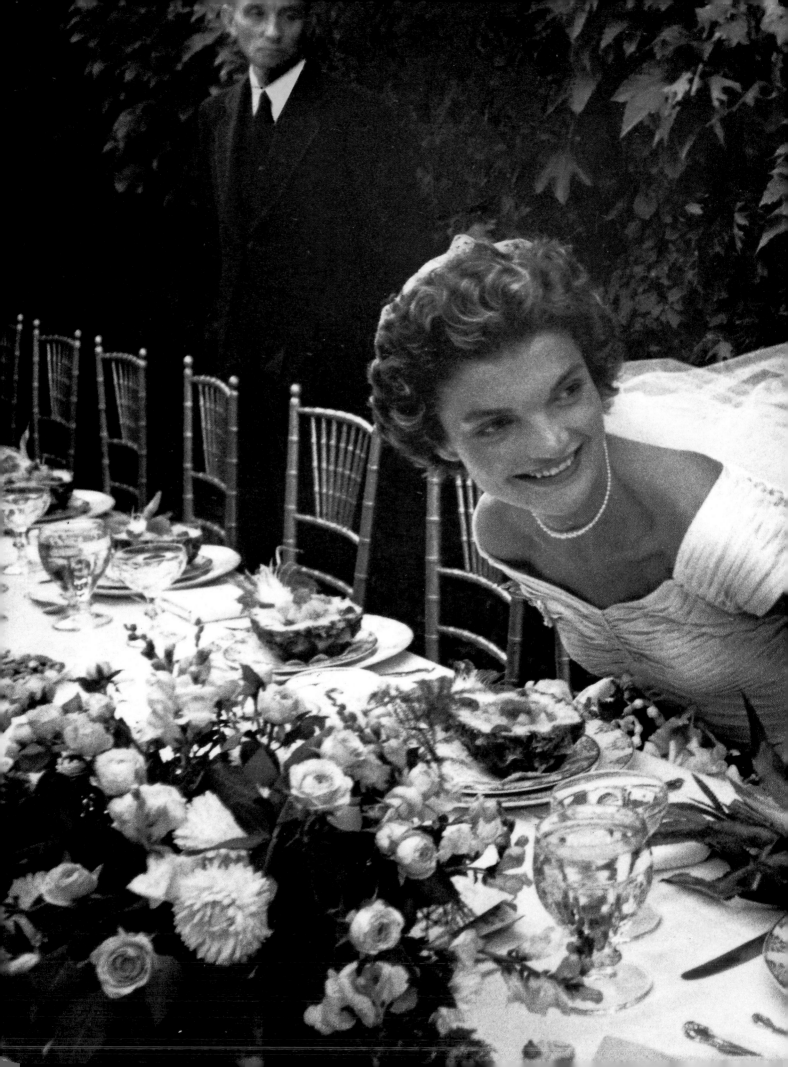

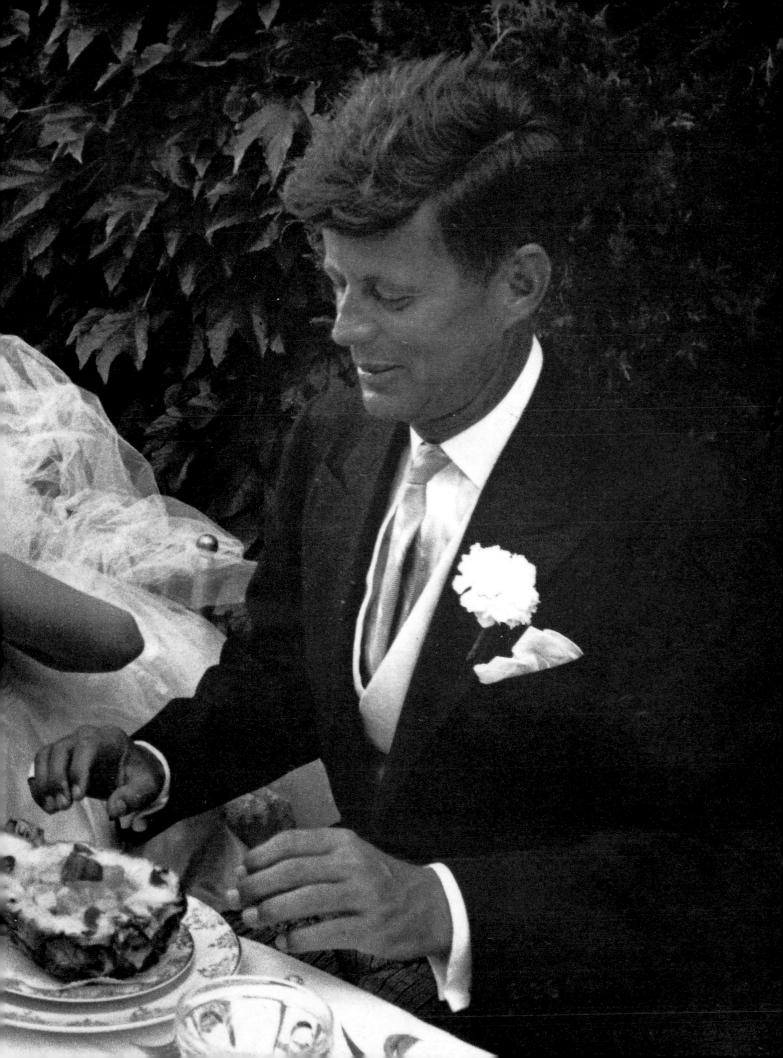

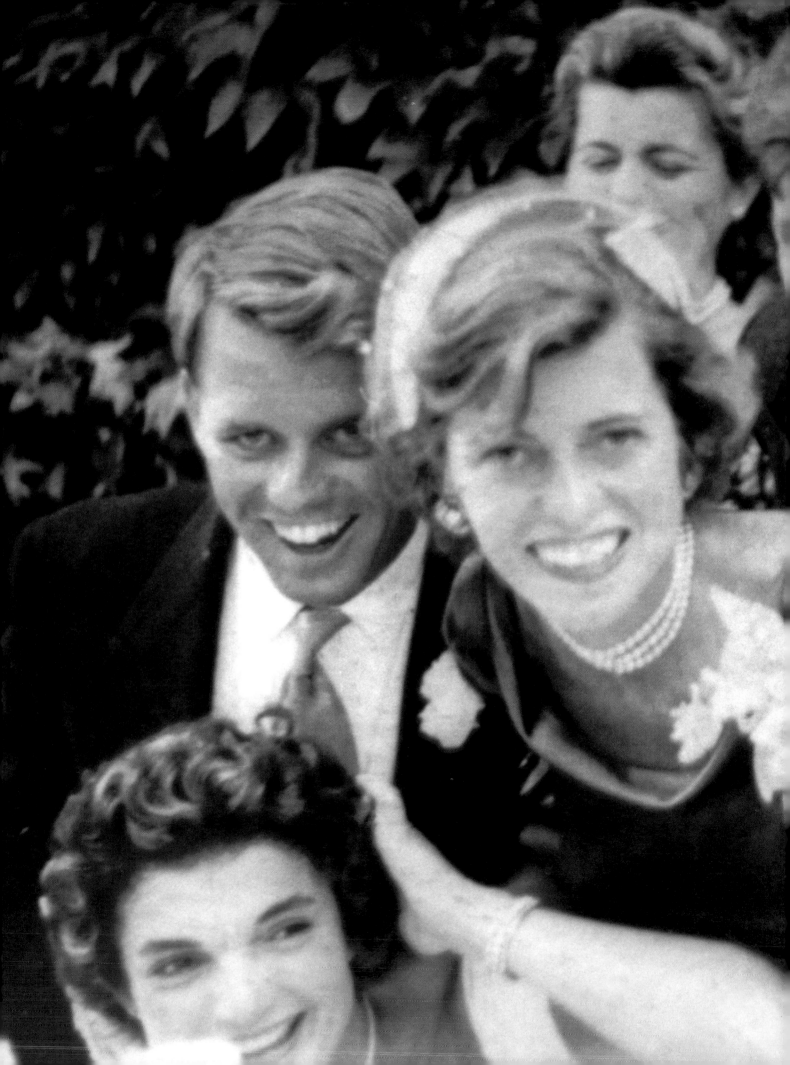

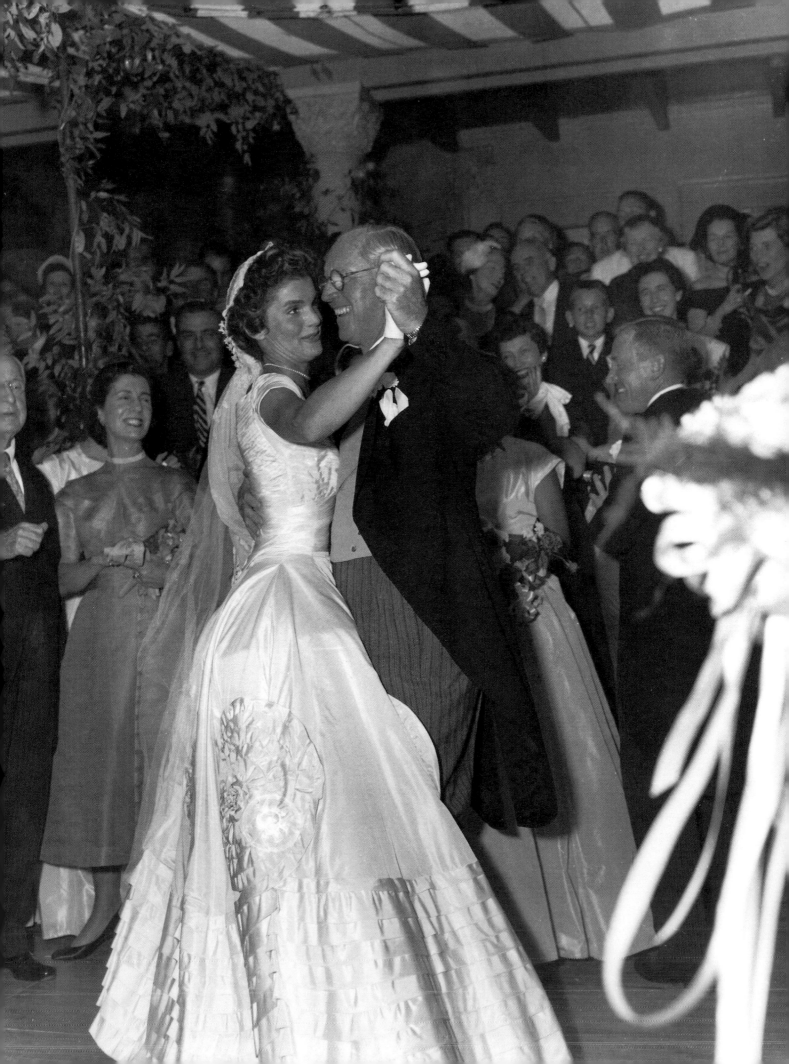

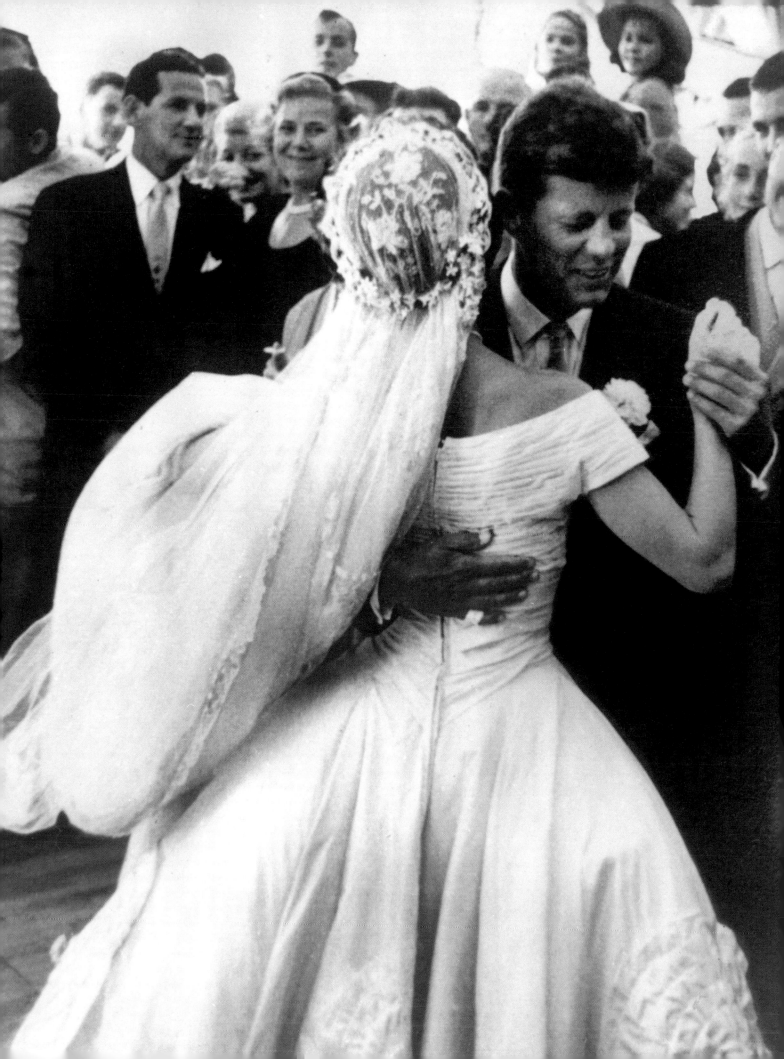

fireplace. And then came everything that Jackie brought into the house: Louis XV and Louis XVI furniture, a 19th-century Boudin painting, some Vernet drawings. The walls were in soft, subtle hues, there were flowers everywhere, and there was the most precious piece of furniture of all for that particular married couple, a baby's cradle. And that baby had already been born—Caroline Kennedy was already three months old. When she came into the world, her mother had spent that whole first night watching her lying there asleep. The real proof that Caroline existed was the fact that for two years her father cancelled almost completely his usually unavoidable and invariably tiresome political trips.

But suddenly it was 1959. And that meant election year was on its way. So, whatever the cost, a healed and much cheered John had to get back on the speech trail, even though he had been living quite a different life. And what a lot of speeches he made! At least ten thousand invitations to hold forth about the policies of the Democrats. All those people who invited him to speak, who listened to him, and who were counting on him, already had it in their heads that John Kennedy would be President of the United States from 1960 to 1964. The only person who didn't think he would was Jacqueline. At a semi-official dinner she asked wide-eyed: "Do you really think John wants to be president?"

None of which stopped the future president from telling anyone who happened to ask how Caroline's mother was doing: "When Jacqueline does something, she does it well." It was campaign season, and a tough campaign not just for one state, but for all the states in the Union. There was only one rule: get out of bed every morning, come rain come shine, at six o'clock. Jackie waged that war as best she could, staying at John's side as often as she could, following him from one venue to the next. She had no option but to freeze her smile on her face, because she had to be smiling all the time. On average, there were two thousand hands to shake each and every day, and she had to have a friendly word for every person whose hand she shook. She canvassed for votes on a more or less door-to-door basis, and she went into as many stores as she could and told the shoppers: "Please vote for my husband!" If she'd dared, she'd start her young married life again, at the time when John confined the Kennedy ambitions just to Massachusetts. When she'd get his lunch box to him through his dedicated supporters, saying: "That way he won't forget to eat."

But it was too late for that, the Great Wheel had been set in motion. Instead of private little lovers' sandwiches, they had to preside over huge banquets with thousands of place settings, as required by the party. One day, when there were just six guests separating her from her husband, Jacqueline

happily clapped her hands: "We haven't had lunch so close together for four months," she said.

Before the big day there's always a big day-before. This one was when John made his appearance in Los Angeles at the National Democratic Convention, where he was to be formally adopted as the presidential candidate. Jacqueline was at Hyannis Port with her mother and her father-in-law. When the telephone rang at five in the morning, a step ahead of the TV, to announce that first victory, Jacqueline decided that the time had come for her to do something. And she used the only weapons she had: the pretty brunette grabbed her columnist's pen. Every week, right up until the final ballot, she wrote a column which was published in every newspaper in the land. It was the diary of the wife of a candidate in the race to be President of the United States. But her writings weren't enough; she had to complement her written words with spoken ones. The apolitical Jackie rolled up her sleeves to help in the victory of that husband about whom malicious women's tongues were declaring, that with that haircut, he'd never be President. In just a few months, she gave lectures on the most off-the-cuff topics, from schools to infant illnesses. She held tea parties to collect campaign funds, she wrote personally to the wives of important voters, she appeared on television with Caroline in her arms, and was always ready to smile for the cameras. And then she pulled off some major feats. She, who had a horror of what she called "chitchat" and "natter," made a series of speeches in New York, in Spanish, and Italian and French, geared to persuade the foreign minorities in the world's most cosmopolitan city to vote for Kennedy.

November 8th came around. At Hyannis Port they could finally enjoy a few moments of Kennedy intimacy again. After dinner, the whole clan went into the living room and gathered round the TV screen to watch the scores being chalked up in the greatest match any Kennedy had ever played on any field. At 10:30 P.M., Kennedy was so far ahead that Jacqueline threw her arms round his neck and exclaimed: "Oh! darling, you're president now."

He answered very calmly: "No, it's still too soon."

By 11:30, Nixon had made up the lost ground.

"Jackie, you must get some sleep," John said, his tone very serious, because he was thinking of the baby due to be born in just a few weeks. At three in the morning, he went up to bed, too, and everything was still up in the air. When he woke up, he was president. With a tiny majority of just 112,881 votes. As their car drove them down to Washington amid a cacophony of honking car horns, escorted for the first time by Secret Service vehicles, Jackie didn't know whether to laugh or cry—and did both.

Benno Graziani

Farah Diba & the Shah

The fairy tale

As an anonymous student, Farah studied architecture in Paris. A handsome Iranian appeared and asked her for her hand. He was the Shah of Iran, she became his Empress.

– For her first costume ball at the School of Architecture she dressed up as a Roman empress. Was it a sign? The Shah entertained Iranian students at the embassy; and so the fairy tale began.

– December 29, 1959: the wedding of Farah and the Shah. The stars had been consulted to set the date and this one promised a long and happy union. He was forty, she just twenty-one.

– The years couldn't dull their passion. On the day she was crowned empress, they swapped a private glance.

– 1960. The most caring of photographers—the Shah himself photographing his much-awaited son.

– The delights and pleasures of life with their four children, before the fall.

– With parents who were always so close. Their son wanted to immortalize this intimate moment himself.

– On September 16, 1979, the Shah and his family flee Iran. The exile he thought would be temporary turned out to be permanent. President Mubarak played host to him in Egypt. Their exile then took them to Morocco, the Bahamas, Mexico and the United States.

It was spring 1957, the end of her first term at the Paris School of Architecture, and time for the freshman "initiation." This was a time-honored tradition, where the freshmen are forced to "submit" to a series of rituals and pranks played all in good fun, but often resulting in severe embarrassment on the part of the initiates. Farah Diba had just enrolled in the school and despite three months of classes and the rigor of workshops, the jostling crowds at the student cafeteria and the general high spirits of students getting to know each other and enjoying life in Paris, the young Iranian woman had maintained a courteous but unmistakable distance between herself and her fellow students. So when hazing day came around and the older students were all looking forward to a good laugh at the expense of their juniors, the aloof Farah Diba made a perfect target. First they perched her on a drafting table and demanded a belly dance. The young woman didn't bat an eyelash. Instead, she coolly announced that she'd oblige with a dance from her native country. Her elegant, sensuous movements captivated her audience and everyone clapped wildly, but they weren't through with her yet. It was "truth or dare" time when the freshman must answer even the most indiscreet question or risk being doused with a nasty concoction—cold Nescafé grounds in water thrown squarely in the glib freshman's face. Soaked to the skin and befouled with coffee grounds, Farah kept smiling, turning the tables on her tormentors. Her composure so disturbed them that finally the Master of Ceremonies himself stepped forward to pose his own question.

"Have you ever kissed a boy?" he asked.

"No," answered Farah.

A tremendous "Oooooh!" rose from the three-hundred onlookers. The emcee, a tall, charismatic character, came toward Farah and grabbed her by the waist. The room went silent, a palpable electricity in the air. But satisfaction was not to be theirs...suddenly the impudent man let her go, moving away almost sheepishly. For in Farah's large, dark eyes he'd seen something he'd never seen before; a spark, a blaze that warned him just as it drew him in. He knew he was playing with fire and the game was over. But everything ended happily in a lively costume ball at the students' favorite bistro near the university. Farah came dressed as a Roman empress. "Do you know how well that costume suits you?" Lisa, Farah's best Iranian girlfriend asked her, adding with a laugh, "Why don't you marry our Emperor?"

"Why not?" retorted the high-spirited Farah, laughing even louder.

Back to the Teheran of an earlier time: October 27, 1954. Another lively day, years before Farah had even thought of Paris. On that day, in the city's new stadium, the joyful capital was celebrating its sovereign's 35th birthday. In full regalia, the Emperor sat on a dais above the festive crowd. Mohammed Reza had just regained power in the style of a true monarch and was about to start introducing reforms in the land. The future seemed his. Beside him sat a beautiful young woman, all smiles and grace: his second wife, Soraya (whose reign as Empress was to be limited when she could not produce an heir).

On the lawn, surrounded by rows of seats teeming with people, a young girl scout marched toward the imperial dais with the flag of her troop outstretched before her. Behind her marched the young "cubs" in perfect time. At the foot of the dais she stopped, standing at attention. She is sixteen and her name is Farah Diba. It was the first time that Farah had been so near her sovereign and she was bursting with pride. Farah was not an aristocratic girl, she did not even hail from high society. She was an orphan whose father, Major Diba, contracted stomach cancer and left her and her mother penniless. Farah's mother sent her to live with her Uncle Gothbi, an architect who owned a small house to the north of the city. The family all contributed to her studies at the Jeanne-d'Arc School, where Farah spent nine years under the keen eyes of the French nuns who taught there. This had been the wish of her father, who had done his military studies at Saint-Cyr. At the age of fifteen, she was admitted to the Franco-Iranian Lycée and excelled in her studies, sailing through her two baccalaureate exams. She worked so hard that her 18th birthday nearly passed without her knowing it. Soon she would be leaving to pursue her studies and find a career for herself.

Meanwhile, with the oil boom and all the public works decreed by the state, Farah's Uncle Gothbi had made a fortune in just two years. Now the family lived in a vast white-marble house in the elegant suburb of Darous. Farah was like one of the family with her own large bedroom cheerily decorated to suit her fondness for gaiety and laughter.

After her first year in Paris, Farah returned to her uncle's house, but, without quite knowing quite why, she felt apprehensive and sad. Her next year in Paris would cost more money and Uncle Gothbi had put everything he had into his palatial home. How would she manage school? But when her cousin Rezah, Uncle Gothbi's son and her oldest friend, decided to throw a party, she put her fears aside and cheerfully helped her cousin plan for the event. Little did she know that this event would turn out to be more than just a party, but a turning point in her life. In between dances she confided to a friend some of her concerns. "You ought to go see Zahedi, the emperor's son-in-law," her

friend suggested. "He runs the foreign scholarship office."
As confident and rebellious as this young woman is, she finds herself lacking for words as the Shah himself asks her a simple question: "Do you like skiing?" For upon visiting the scholarship office, Farah's demeanor had so charmed the emperor's son-in-law that he invited her to come visit the Royal Family at home. So there she sat among the tapestries, servants running to and fro and the Queen Mother sitting just to her left. The kindly old lady was herself full of mischief with eyes that sparkled as brightly as the tiara perched in her white hair. But it was the steady gaze of the man asking her questions across the table that made her stammer and blush.

At the Shah's question, Farah glanced to her left and to her right to where Ardechir Zahedi and his wife Shanaz, the emperor's daughter, were sitting. But all the two young people could do was smile at her encouragingly, just as they had the week before when she'd visited their office to see about a scholarship.

"We know you, Miss Diba. You're lovely and you're sweet," Shanaz had said. "We'd like it if you would come and see us at the palace."

Now, sitting across from the Shah with his friendly conversation and engaging glances, all she could think about was last May in Paris when the Shah himself had visited the Iranian students at her school. After the students were introduced, Farah had turned to her friend Lisa to whisper, "He's the sexiest man I've ever seen!" Now, for the first time in her life, Farah was blushing from head to toe.

But her natural straightforwardness and self-possession did not fail her and Farah was able to pluck up her courage.

"No, Your Majesty, I don't ski, it's too cold."

The Shah looked down at his plate, his beautiful hands stroking the fine porcelain.

"And what about hunting?" he ventured

Another SOS to her right. But the Zahedis were too engrossed in dessert to register her distress.

"No, Your Majesty, I prefer animals alive."

There was a silence, like the calm before a storm. Suddenly a loud guffawing laughter filled the room. Farah had managed to tickle the Queen Mother who laughed merrily at the girl's nervous pluck.

"I like you, young lady, will you come with me to the drawing room?"

Fast forward to a day some months later. Mohammed Reza Shah is enjoying his favorite pastime—flying. Beside him, tucked into the copilot's seat, sits Farah Diba gazing at the noble profile of the man beside her. She thinks of herself, three days before, delivered home at nightfall in a palace car, entering the large white living room and collapsing into the arms of her mother sobbing tears of joy. Since then, she who was so fond of planning and contemplating her every action hadn't had two minutes to reflect. She had been swept off her feet.

At the airport, as she is helped from the car with the Shah by her side, soldiers lifted their arms to salute her. At the end of the runway a small blue aircraft awaited them. As the Shah leaned toward her to help fasten her safety belt he smiled such a smile that she knew no words were needed. And as the little airplane rose off the ground so did her heart, so full of love for the gallant man beside her.

Now the plane is landing, the flight over Tehran hadn't lasted an hour. But Farah would remember it for the rest of her life. She wanted to run straight home and tell her mother how, at ten thousand feet above the city roofs in the wonderful stillness of the sky, she had finally been able to answer the Shah's question effortlessly. "Yes, I will marry you."

Months later, at the Crillon Hotel in Paris, the door to room 420 opens and there stand five students from the School of Architecture. They are greeted by a young brown-haired girl sitting in a crimson armchair. Instead of yesterday's Farah—the schoolmate with whom they'd worked and laughed—they are looking at a woman they've never set eyes on before.

The boldest among them walks to the record player on a gilt coffee table behind masses of white roses. His hand shakes as he lowers the needle and the loudspeaker emits an awful noise.

"You see," says the young man "you have changed. Before you'd have bawled me out."

"No!" the young woman protests, "I haven't changed." "Okay," says one of the other students, "look in your bag and see if you've still got any metro tickets." Farah dives into her elegant new bag. And there, at the very bottom is an old book of second class tickets and a book of meal coupons from the university canteen.

"I'm keeping them," Farah says, "they're still valid."

They laugh, the way they used to.

Soon a servant comes in to give Farah a message.

He stoops down and in a low voice says "Empress...."

Georges Menant

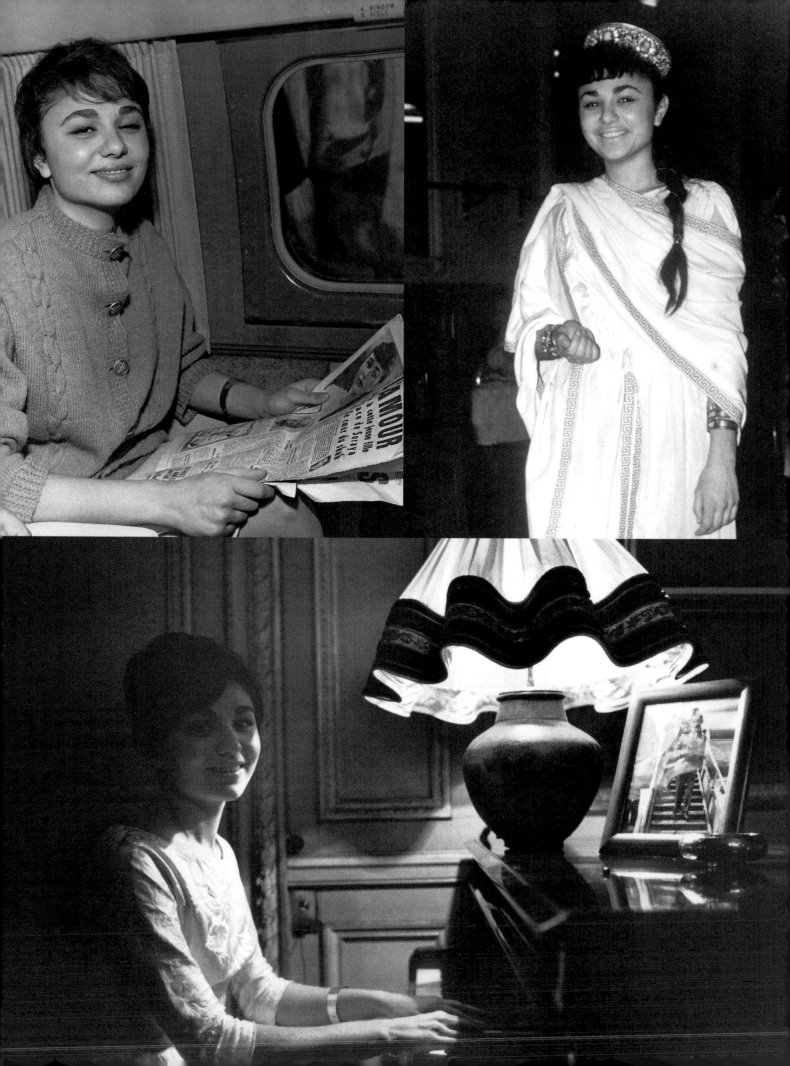

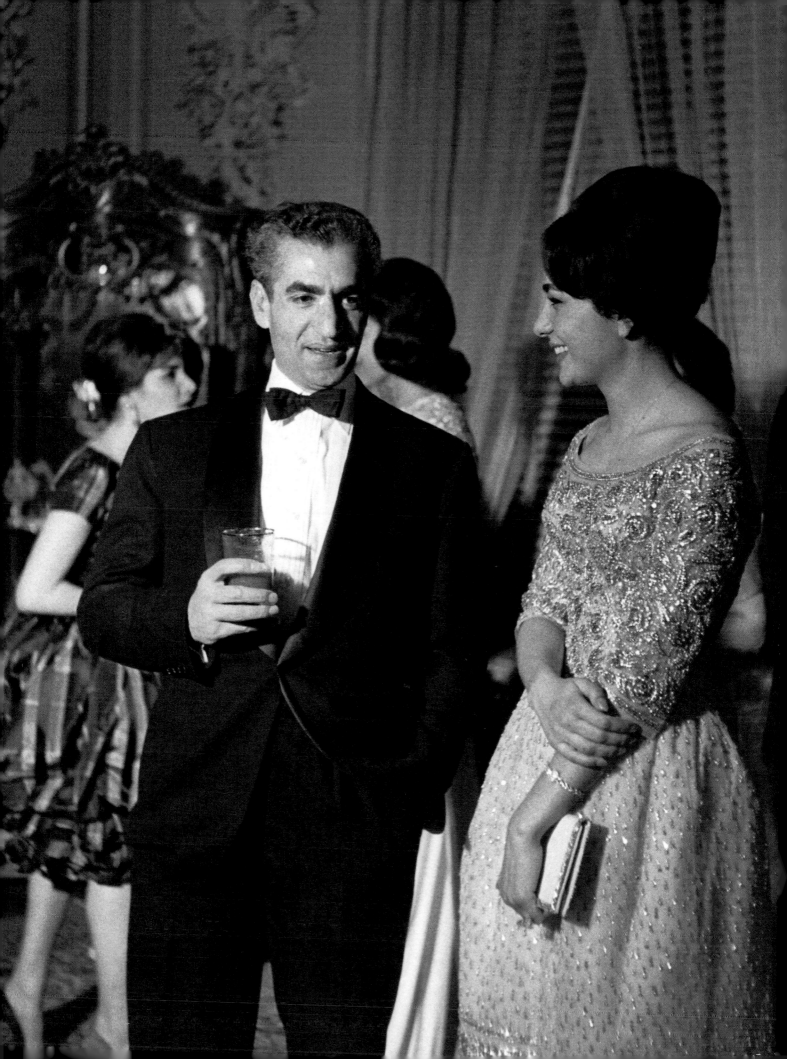

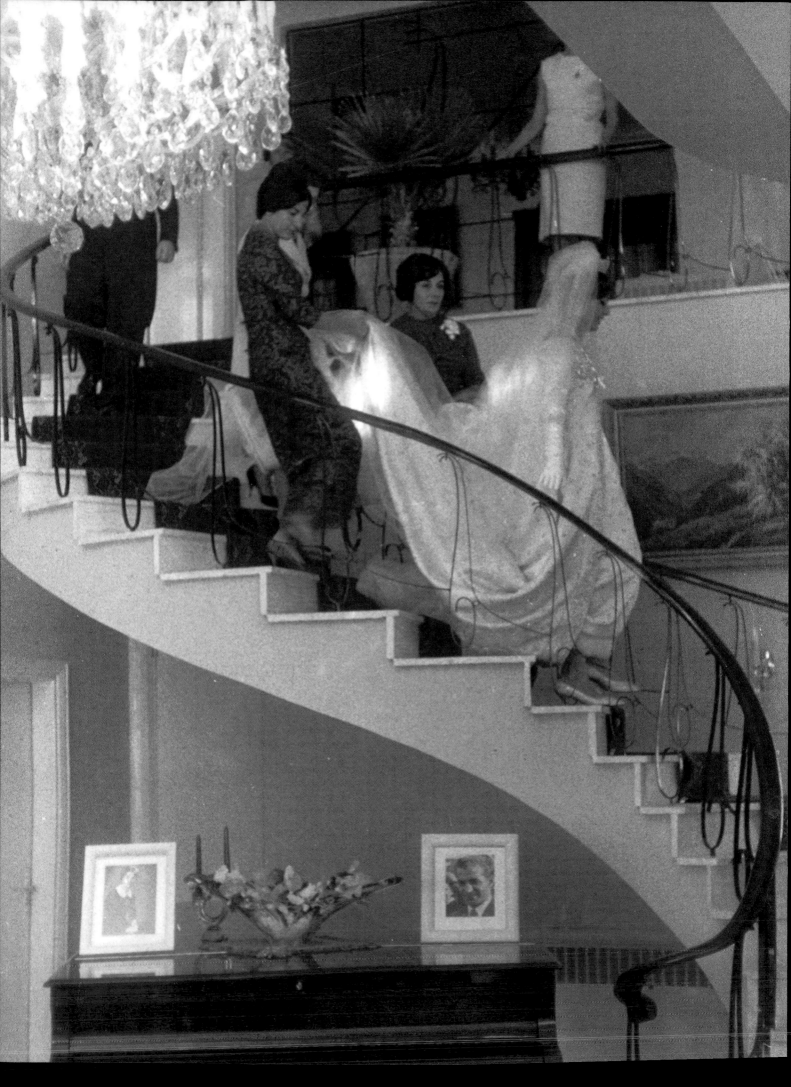

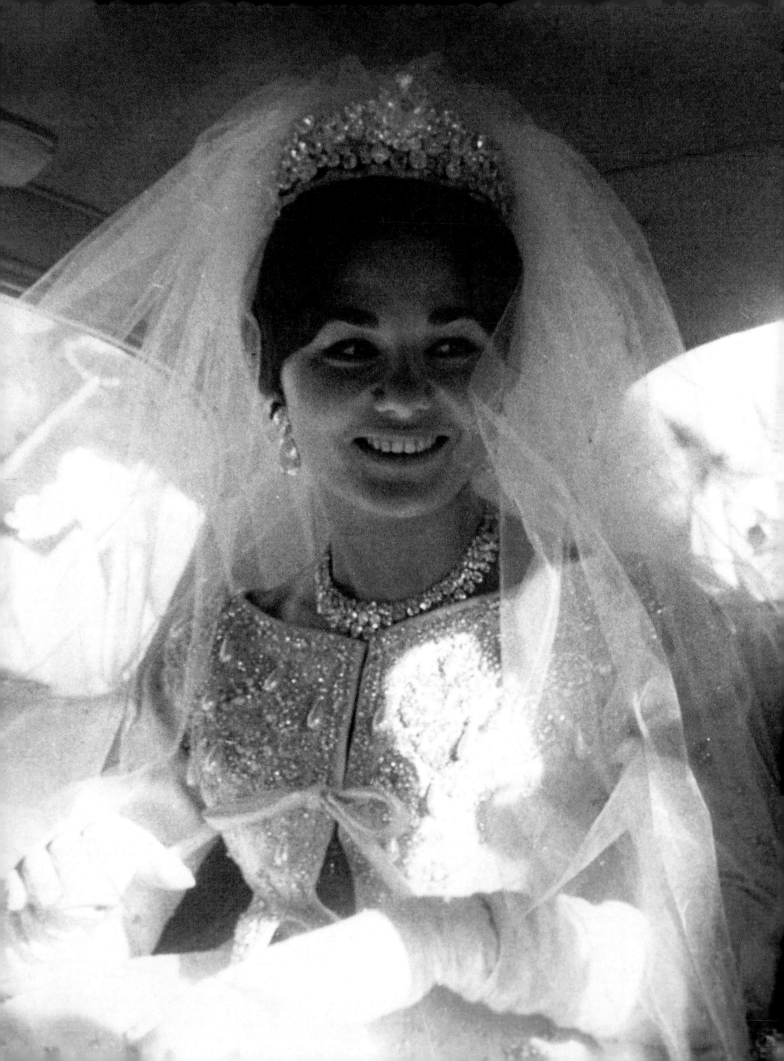

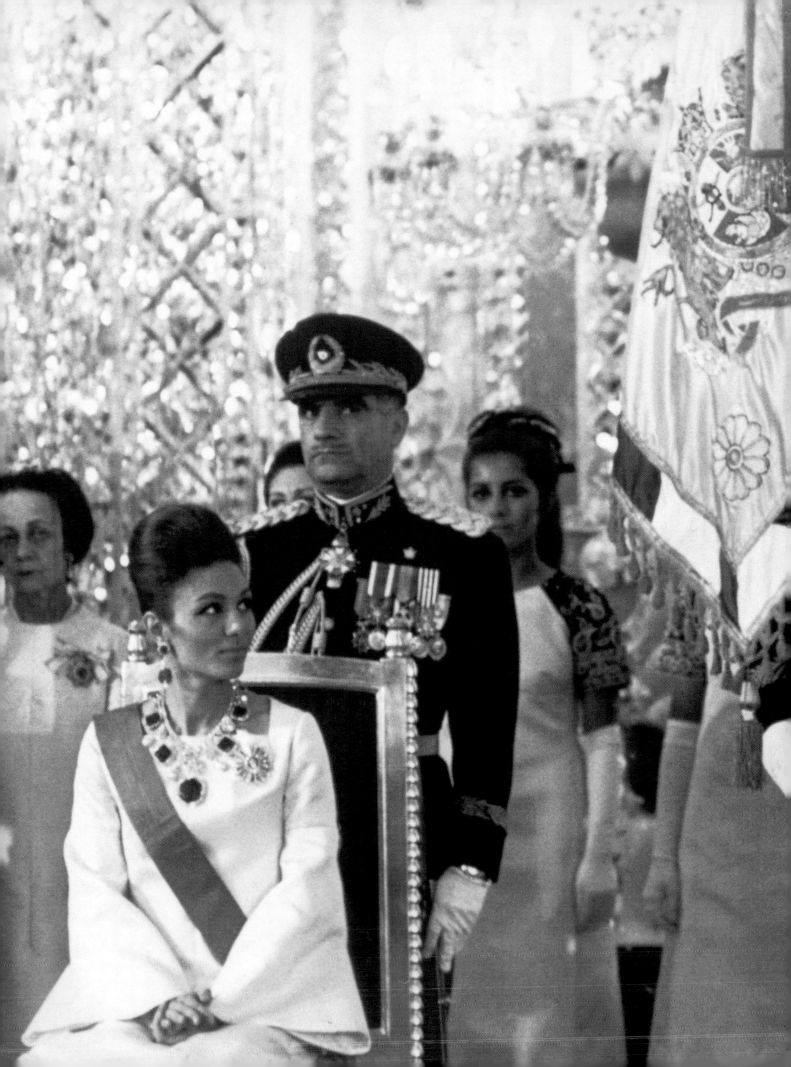

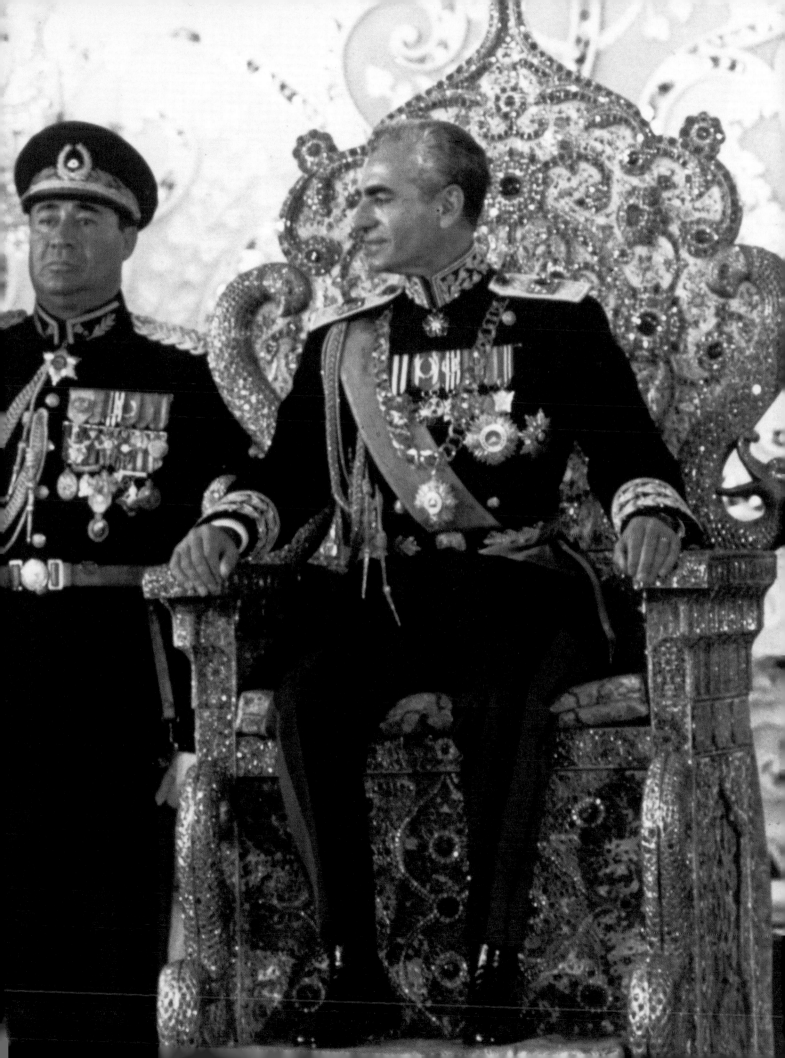

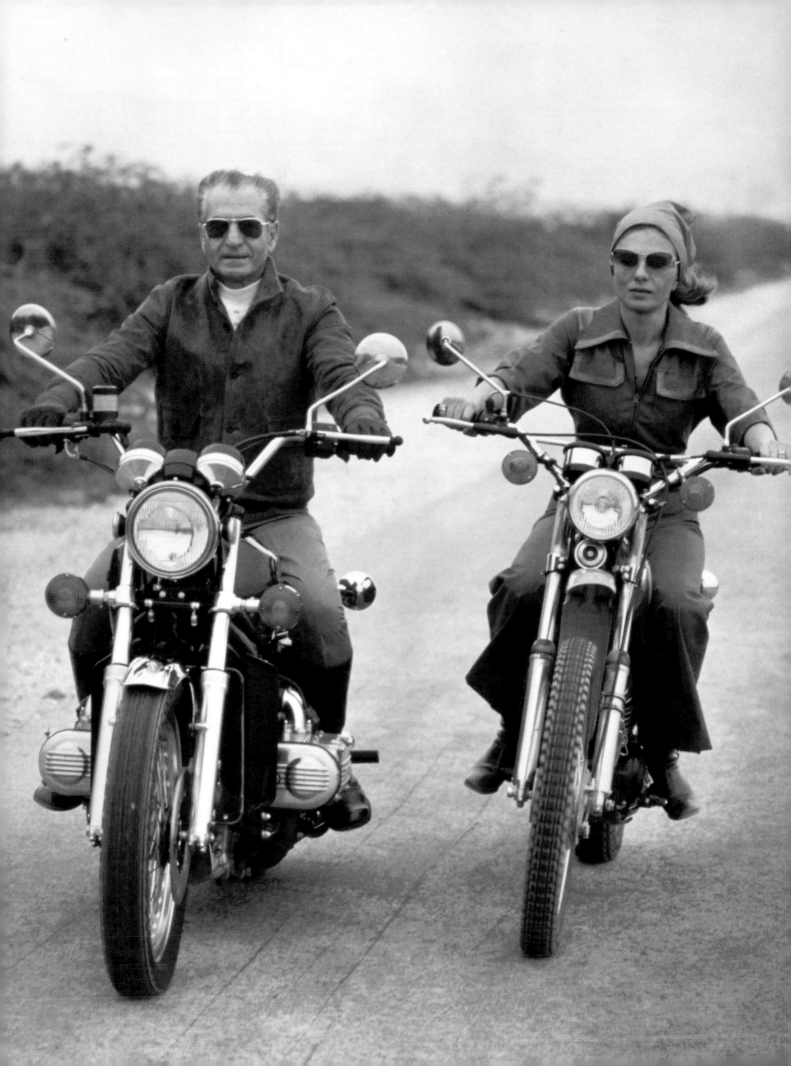

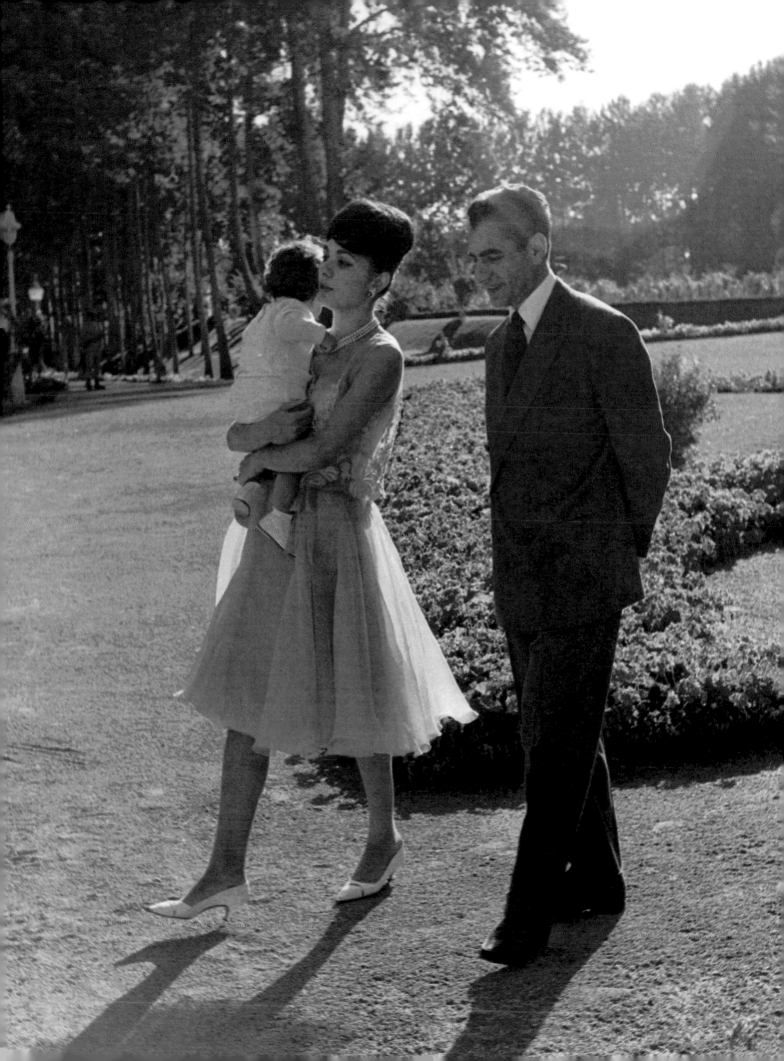

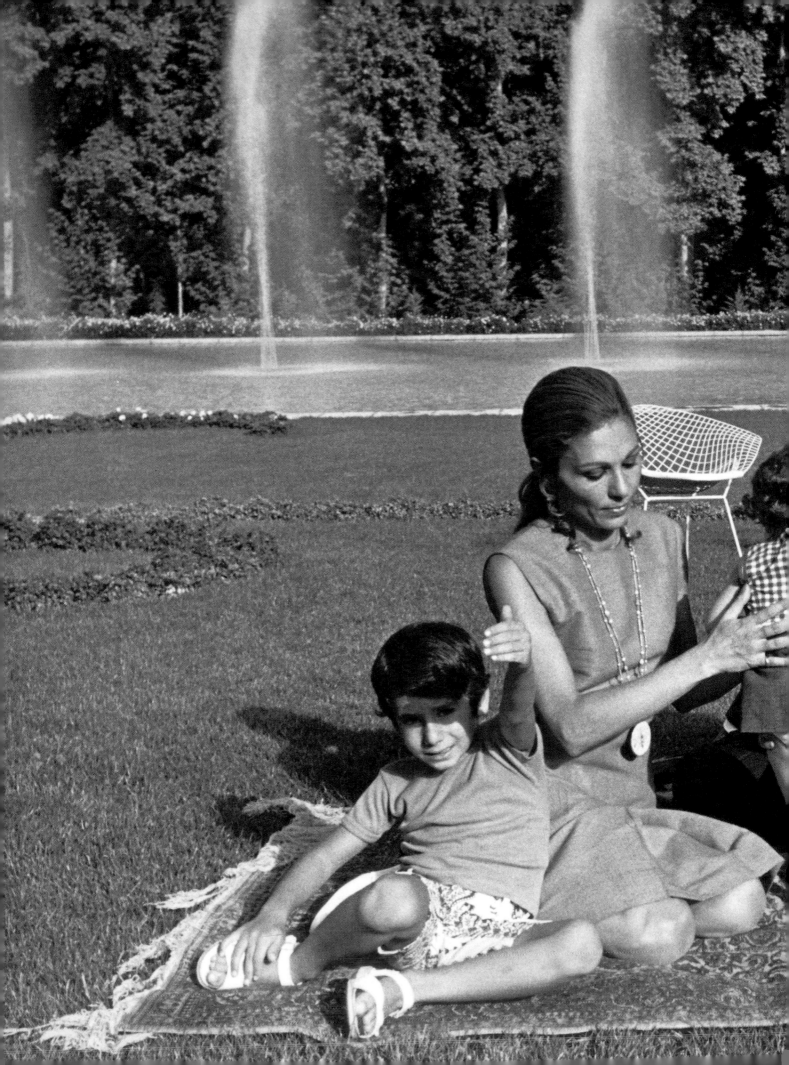

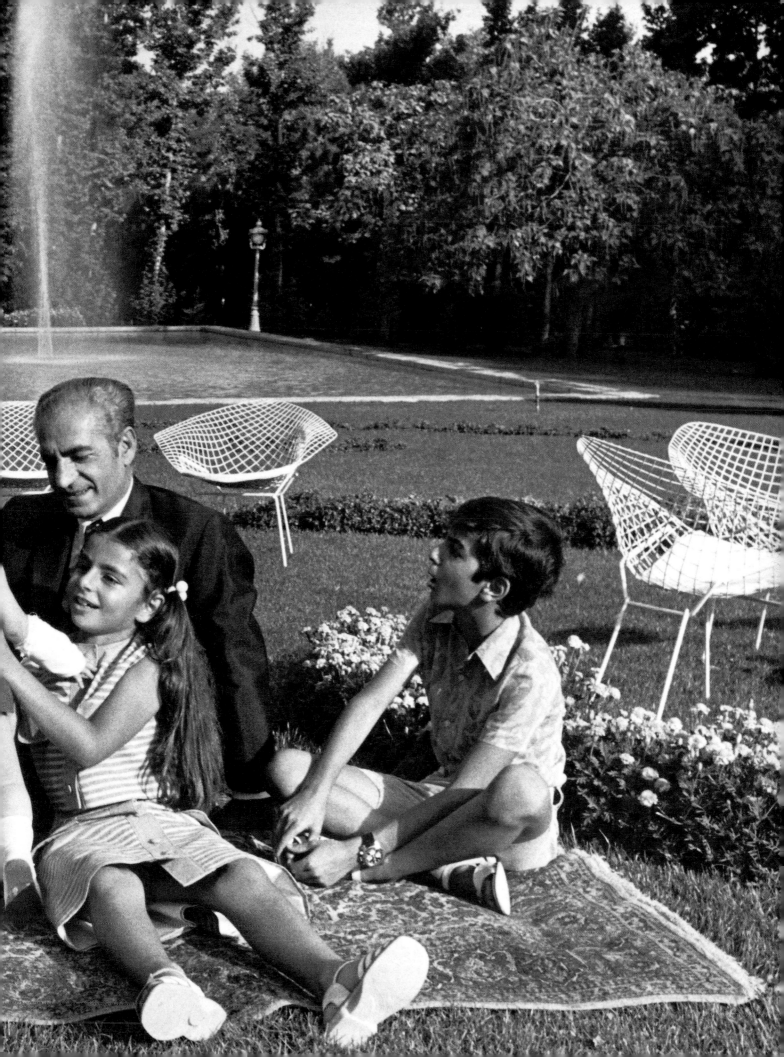

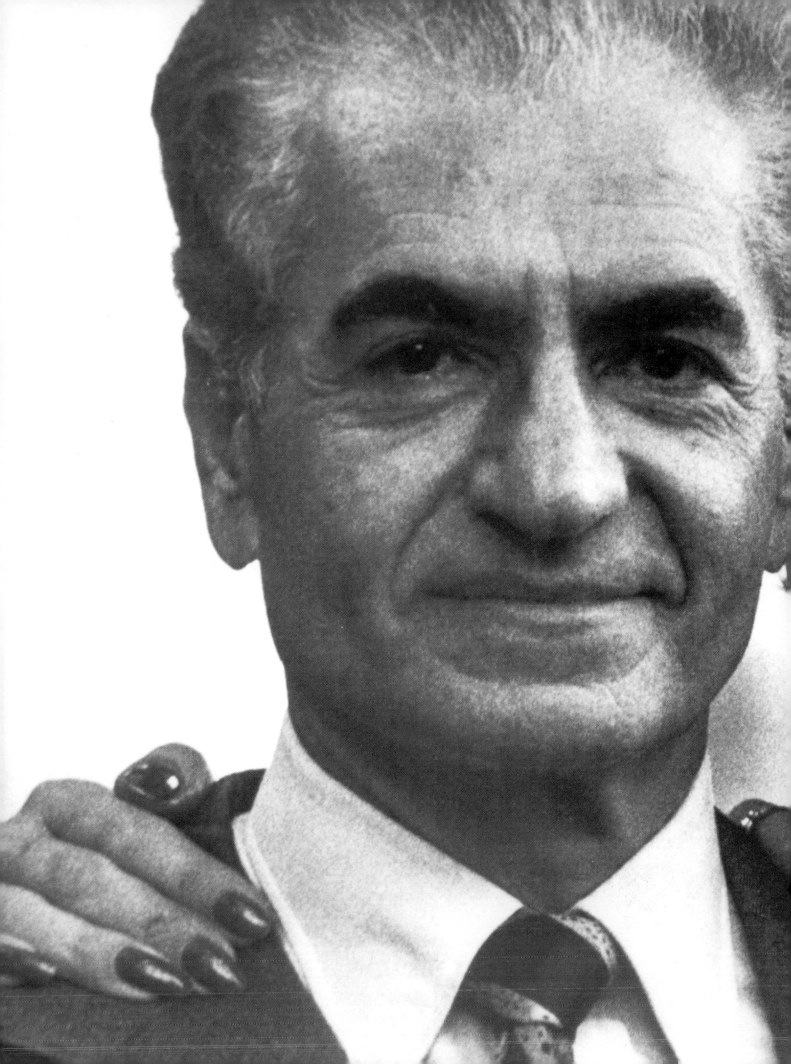

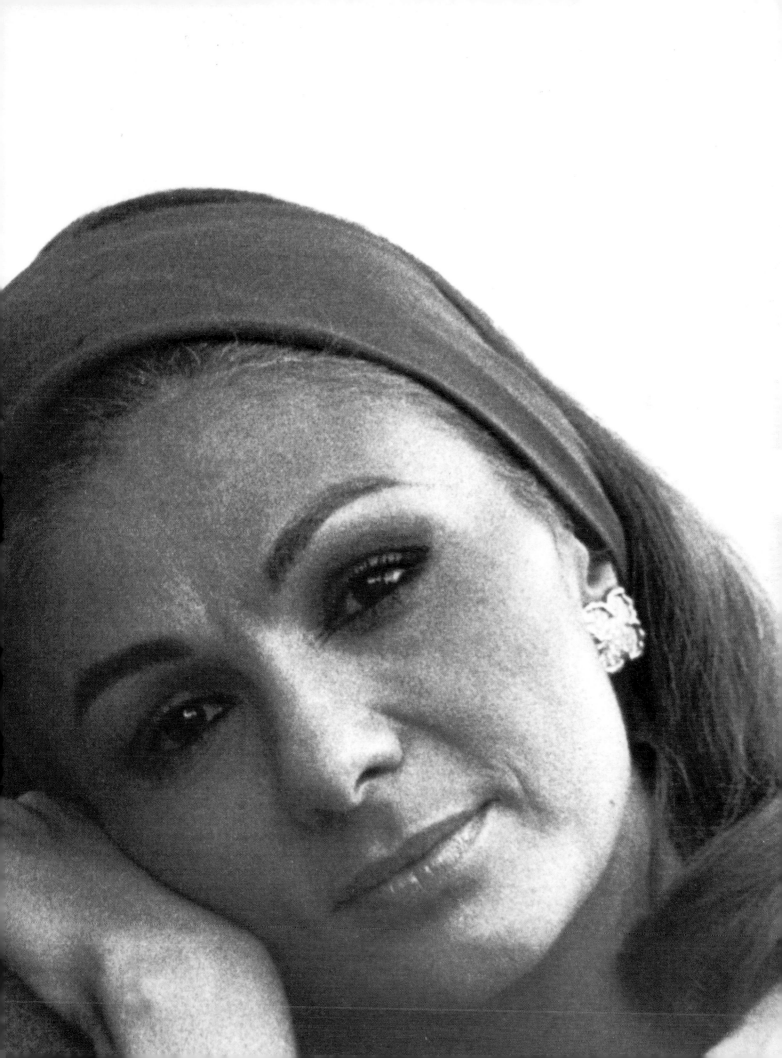

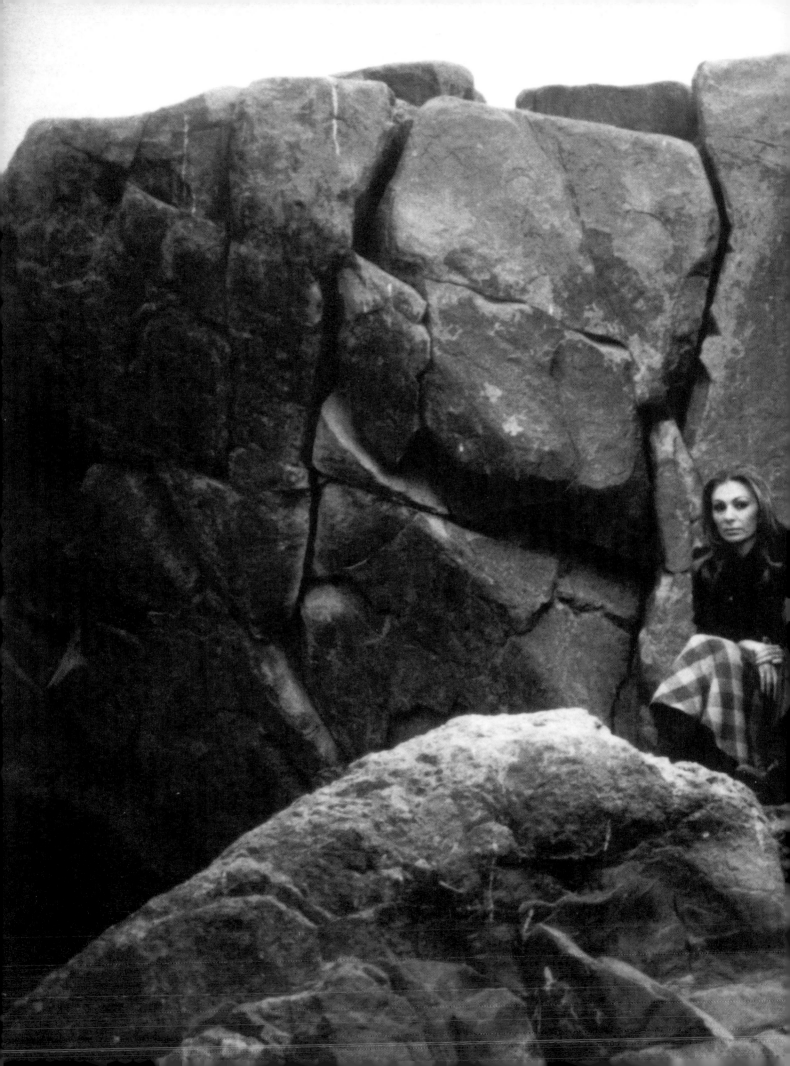

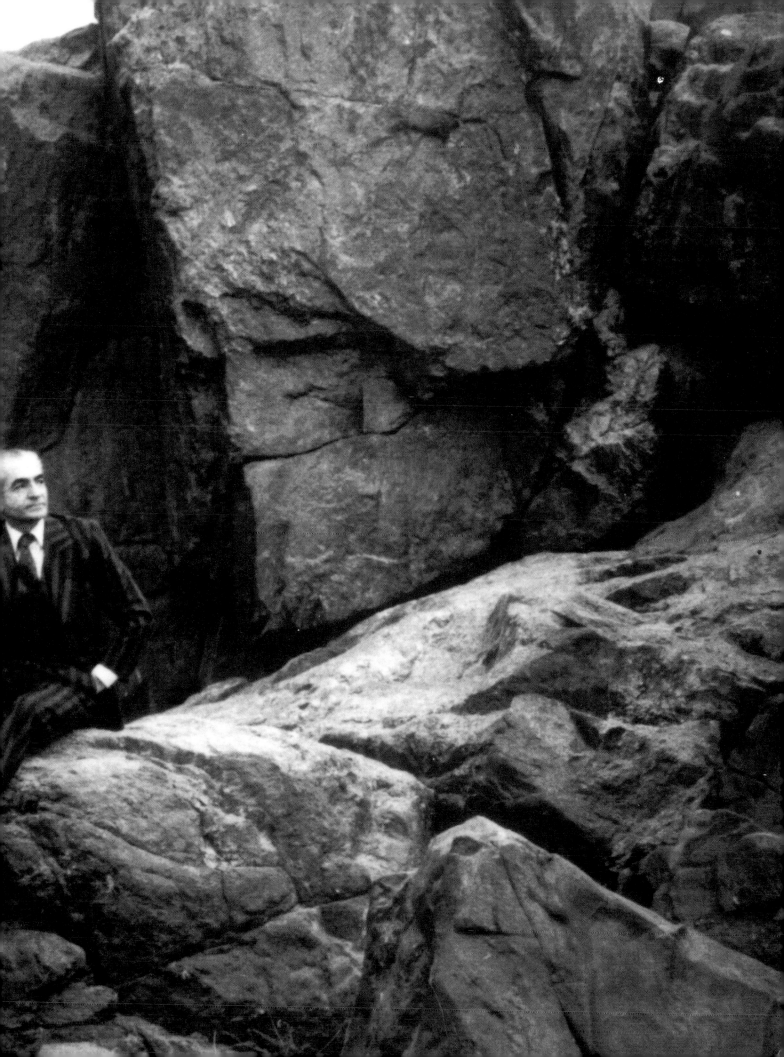

Lennon & Yoko

Their love? A whole world

They built a world together, unto themselves. They lived that world—the two as one.

– It was an everlasting love, a love with no past (*Don't Let Me Down*).

– Jamming with Eric Clapton, Keith Richards and Mitch Mitchell. Yoko was there (January 1968).

– "We worked a whole night and we made love when the sun came up." John photographed the couple, and the picture graced the controversial cover of the *Two Virgins* album (1968).

– Marriage in Gibraltar, on March 20, 1969. The souvenir polaroid.

– The bed-in for peace in Montreal, May 1969. They even used their honeymoon to promote their ideas.

– Demos. They wanted to try and change the world.

– "I'd always dreamed of meeting an artist who'd be like me." At home in Greenwich Village.

– Eighteen months apart, eighteen months of crisis. Then they hoisted the white flag. Sean, their son, arrived (1975).

– They recorded *Double Fantasy* and, like in *Two Virgins*, produced a film in which they made love.

– Their world tour project died with John, murdered outside the Dakota, the apartment building where they lived in Manhattan.

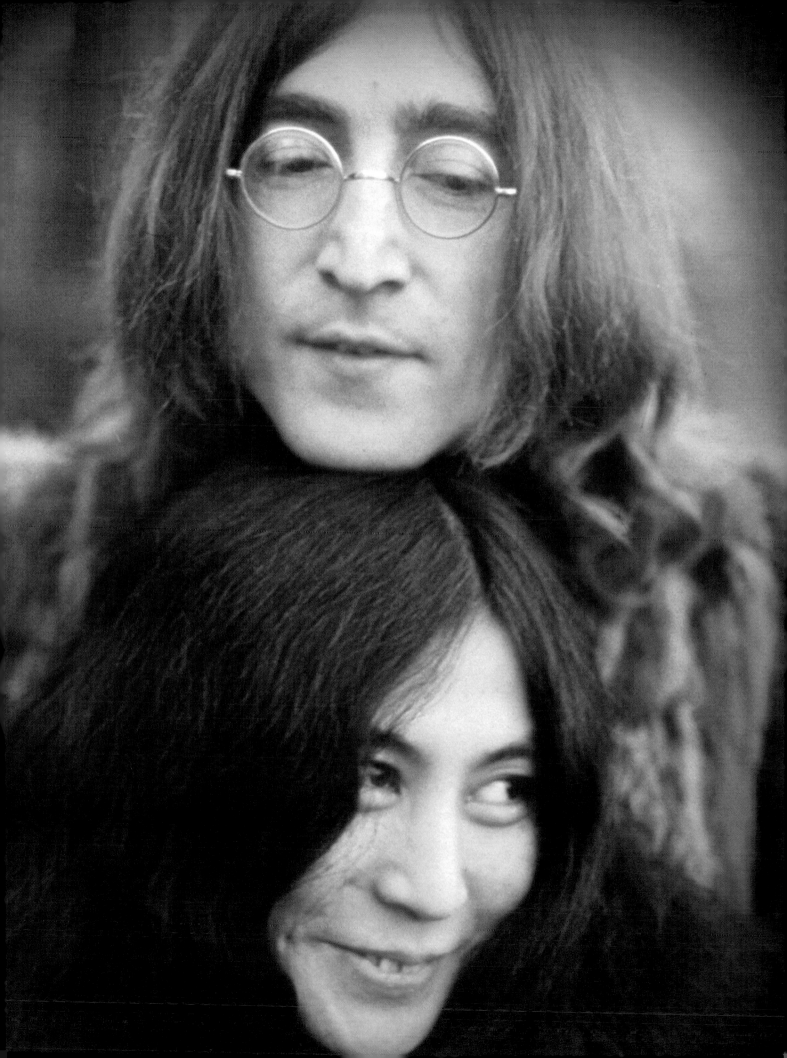

Dany Jucaud:

– Four years ago John Lennon was murdered. Since then, you've never left the apartment where you lived together. His things are still where they always used to be. Don't you think there's something a bit unhealthy about going on living on memories?

Yoko Ono:

– No. I've been very happy here. We had a beautiful life. Being here is a bit like still living with him.

– I admire the way you keep his memory alive. Why do you?

– John and I made an extraordinary partnership. One-off. I can't just put a stop to our dialogue from one day to the next. John still lives on through his songs. You can't kill a human being so easily....

– Isn't it also a way for you to stay in the news?

– No. I'm a person in my own right. I'm Yoko Ono. If I'd died before John, he would have talked about me the same way. Our dialogue is a dialogue of love. He created so many things that it will take more than ten years to get people to know them: collages and drawings which he never had a chance to show. It would be a crime if I kept them all to myself.

– By living with John, you sparked off a lot of hatred. Why's that?

– If I'd been blonde and English, it wouldn't have been the same. I'm oriental, so I'm different. I came from another planet. We suffered a lot from those accusations. John isn't here any more. People have calmed down a bit. But it's even harder today, because I'm on my own, dealing with the world, without any points of reference. When people hate you too much, there comes a time when that hatred gives you the strength to protect yourself from others.

– It seems that you were the one who wore the trousers. That the man in your couple was you.

– That's not true. Nobody could dominate John. I was his equal. I looked after him, I protected him, the way any other woman would have done. No more, no less.

– You were both very possessive....

– No. We were quite simply sufficient unto ourselves. People have never forgiven us for that.

– What was so exceptional about your relationship? What did you have going more than other people?

– An amazing past, in a nutshell. John with the Beatles. Me with my life. Very few Japanese women have experienced what I have. We weren't able to share our story with anyone. We lived ten years of intense communications and exchanges. Together we constructed a new reality which was us.

– What did you bring each mutually?

– When we met, we were both completely turned in on ourselves. I was very naive, I'd always been protected. I didn't know anything about life. John introduced me to "real" life. The problems of the working class. For my part, I introduced him to another way of living. I initiated him in other philosophies. Thanks to him, I learned how to have an interest in other people rather than in just myself.

– What period do you have the best memories of?

– From 1970 to 1975. We had totally dropped out of sight. We lived in hibernation in the very heart of New York. No pressures. Nothing. Paradise.

– You never felt like chucking it all in and radically changing your life?

– Yes. We often talked about that. But we were artists. As such, we needed to communicate with other people. A total break would have been unthinkable.

– When you talk about your life together, I get the impression that you only had good times. You never talk about the other times.

– We had terrible quarrels and fights, like all couples. Our understanding of each other didn't just happen from one day to the next. After a few years, we raised the white flag. We accepted each other the way we were.

– What is it that you miss the most today?

– His sensitivity. John could read between the lines. His laugh, most of all. He had a tremendous sense of humor. What we liked best of all in the world was to stay at home and have fun. We lived like kids.

– When your son Sean was born, John dealt with the diapers, and you looked after the business end. That's not very usual.

– I've never been terribly maternal. John would always say to me: "Don't worry. If it's too hard for you, I'll deal with it." And that's what he did. Personally, I'd always looked at money with a certain disdain. An artist should not have to bother with such things. That's how we came to decide that he'd take care of Sean, and I'd deal with business. After his death, to my greatest surprise, I realized that my son was my only reason for living. Without him I'd have gone under.

– You don't have a reputation for being softhearted.

– I'm a woman like all women. With my weaknesses. I don't think I'm someone outstanding. My situation, alone, may be unique. It's necessity that gives me strength.

– You're always saying that you feel "guilty" for John's death. How come?

– I'm obsessed by the idea that if we'd had bodyguards that evening it would never have happened. That I could have prevented what did happen from happening. There were times when I had forebodings.... When I talked to John about them, he just laughed at me. We should have been more careful. But you know, I'd never have thought anyone wished us ill.

– *What would you like to have today, that you haven't already got?*

– Safety. We've had some terrible threats. [Yoko refuses to talk about them.] Sean is under protection round-the-clock with bodyguards, and so am I.

– *Don't you find it's like robbing him of his childhood to make him live in these conditions?*

– I don't have any choice. One day Sean said to me: "Mummy, never go out without a bodyguard. If you die I'll be an orphan." Sean's never known any other life. One day, we were talking about John's death. Sean looked at me and said: "But I'm alive, Mummy."

– *Isn't this permanent anxiety a high price to pay for fame and fortune?*

– There's always a price to pay in life. This is the price I'm paying.

– *Tell me about Sean.*

– He's an extremely well-balanced little boy. Very bright. He's got John's wit and mind and a bit of my shyness. He's already leading his own life.

– *There was a rumor at one time that you were going to marry again.*

– It's false. I don't know how my life will work out. But for the time being I'm living on my own. I don't need a father for Sean. We have a live-in nanny who looks after him. John was at once his father and his mother. Nobody can replace him.

– *In a recent interview, Julian [John's son from his first marriage to Cynthia] accused you of not having behaved well towards him, and of not giving him any money.*

– I don't hold it against him. He's suffered from the problems that all children of divorced parents have. I understand his fits of anger. I'm very happy that things are going well for him today. He'll feel better about himself. I'm making mistakes at the age of fifty. He's allowed to make a few at eighteen.

– *Have you stayed in touch with the Beatles?*

– Professionally, yes.

– *What's been the hardest ordeal for you to get over since John's death?*

– My relations with businessmen and lawyers. This is the problem all widows have. Let's say that mine are on a bigger scale.

– *People say you're one of the richest women in the United States [Yoko inherited more than $150 million from Lennon.] Do you know what your fortune is really worth?*

– No.

– *You were born rich [Ono's father was one of the most prominent bankers in Japan]. You've never been short of money. Do you know what it's like to be poor?*

– During the war I knew what it was like to be hungry. There was nothing left to eat anywhere. We had money, but money didn't mean anything. We had to swap jewels for a bowl of rice.

– *You have the reputation of being a formidable business woman.*

– I've become one out of necessity. It's not my hobby. It's a job, like any other job. I try to do it well.

– *You have a daughter aged twenty-one called Kyoto, but you never talk about her. Where is she?*

– I don't know. When I was thirty, I was fighting to find a foothold in the world. I wasn't ready to have a child. Then I divorced. My husband, Tom Cox, went off with our little daughter. We've hardly ever seen each other since then. In 1979, she called us. She wanted to pay us a visit. John was over the moon. We got everything ready at home. But she never came. When John died, Kyoto sent me a telegram with her condolences. Since then I haven't heard a thing from her.

– *Have you ever wished Chapmann, the man who shot your husband, dead?*

– I try to think about him as little as possible... There's a terrible anger inside me. So huge that not even Chapmann's death would calm it down. I'm trying to turn it into love for the world, so that acts like that will never happen again. John's murder was a gratuitous act. It's marked our age. I'd like his death to serve some purpose, at least. I'd like it to make us be aware of the danger we're in.

– *Do you think it's possible to change the world?*

– I don't know. But we don't have any choice. We must try. Sean is the future. I dream of a better world for him.

Yoko Ono was interviewed by Dany Jucaud.

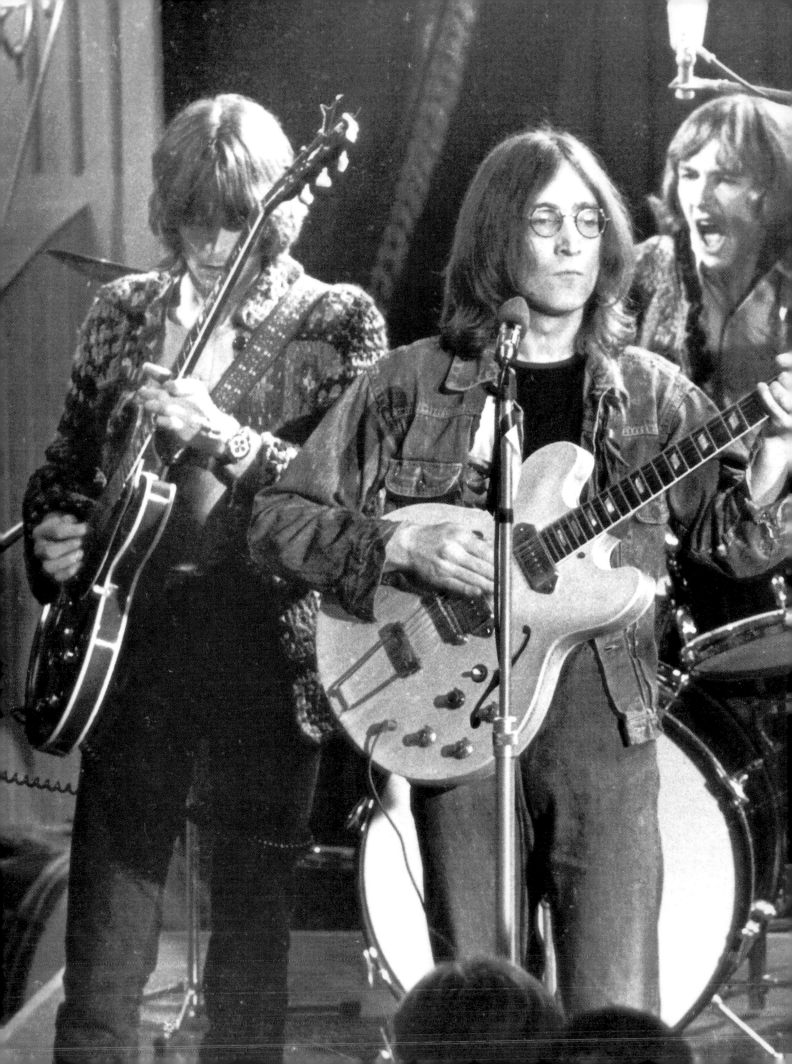

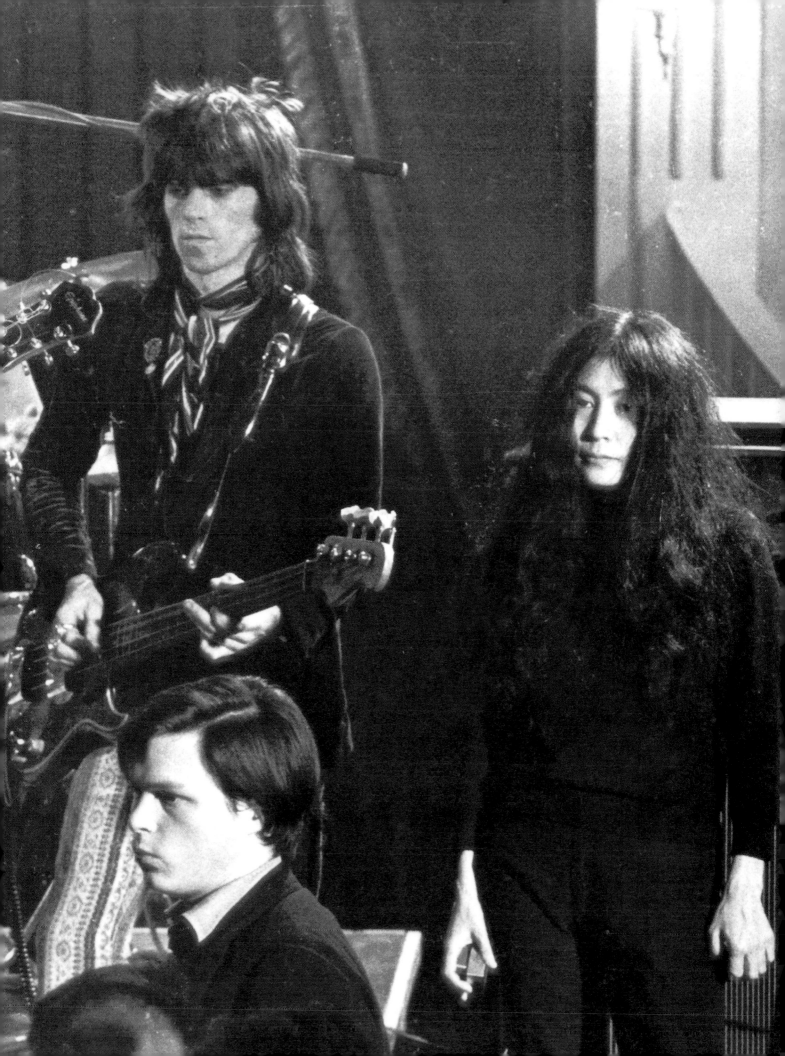

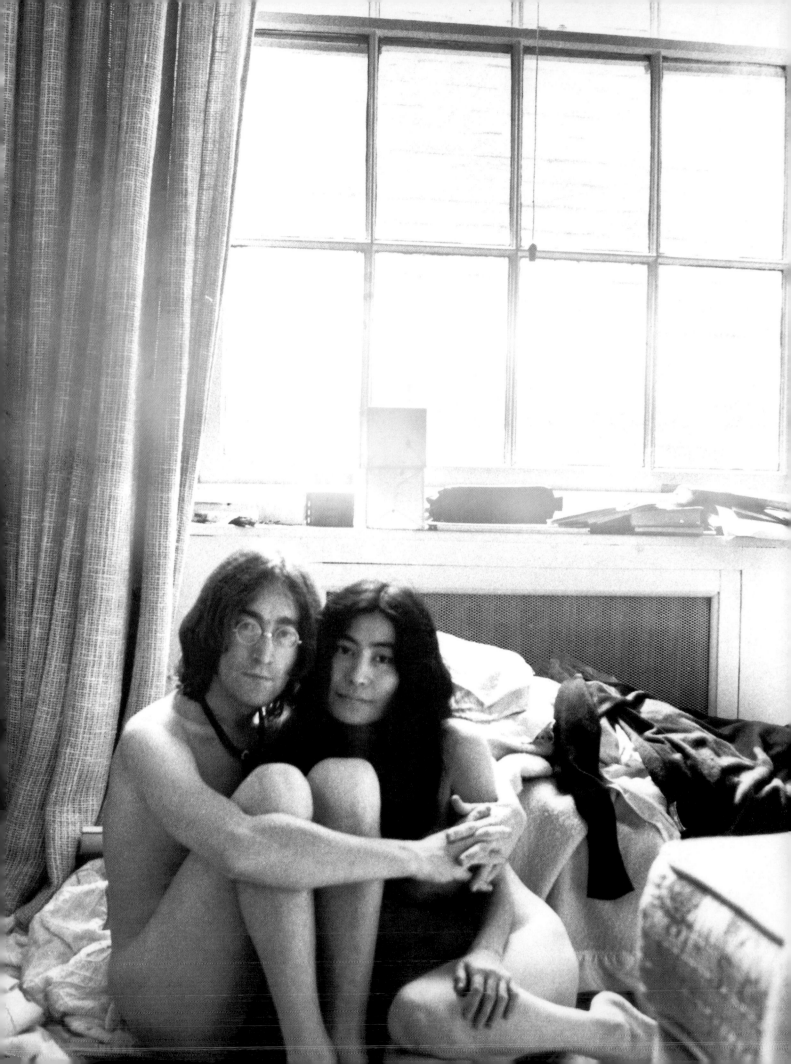

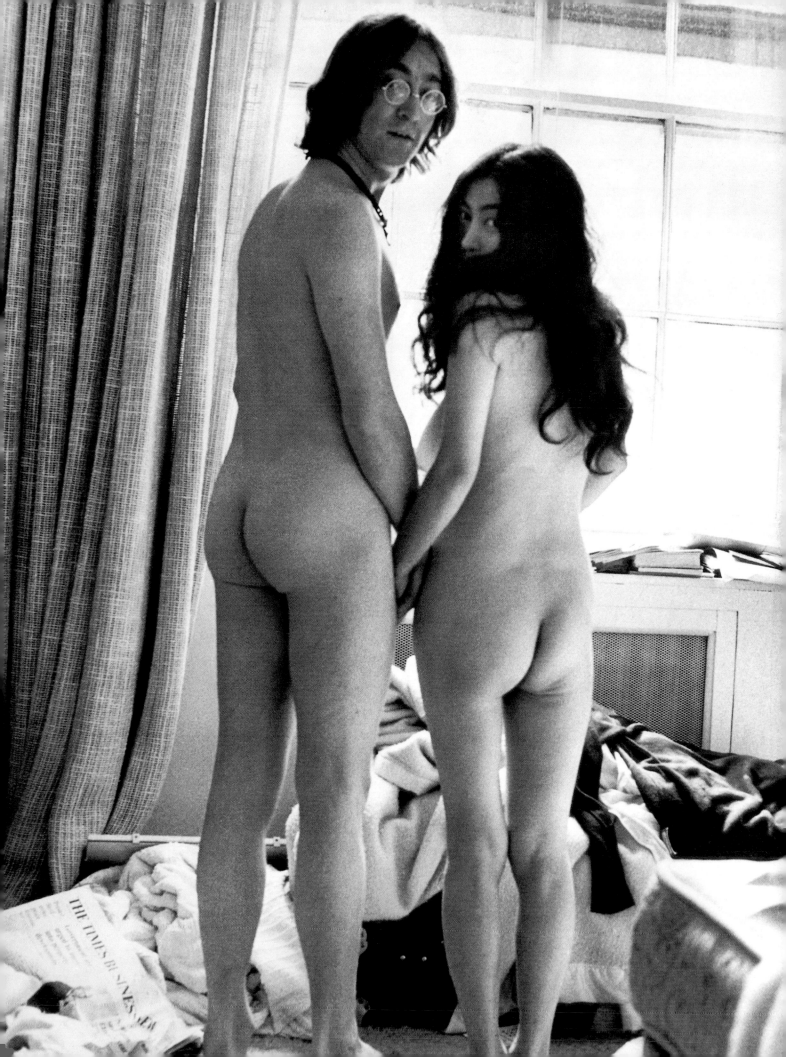

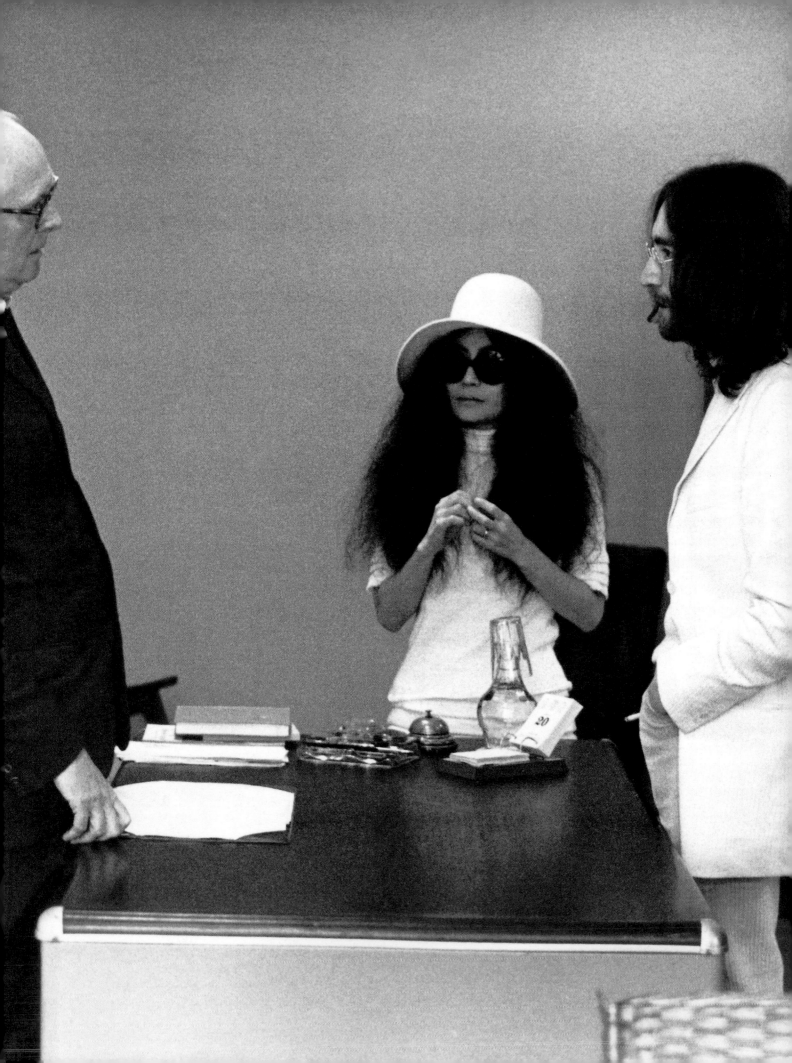

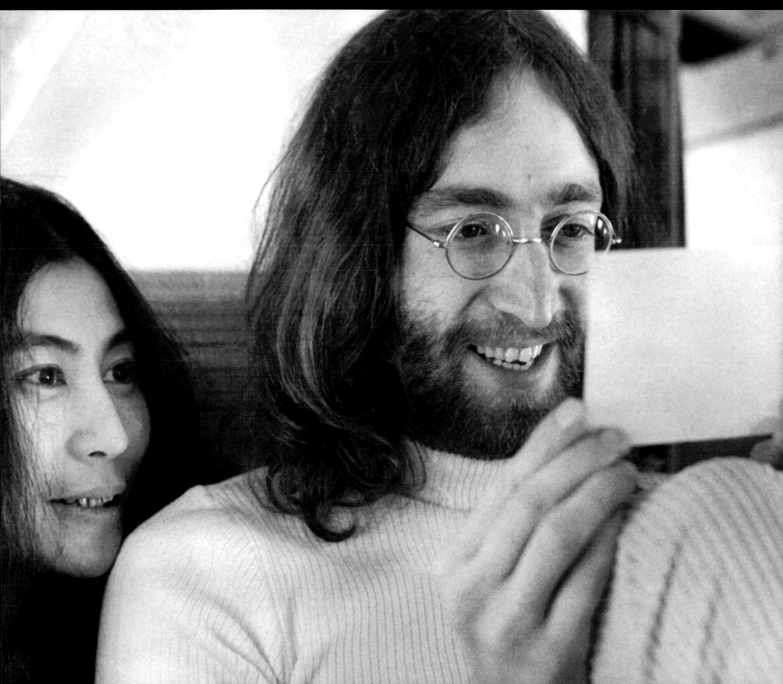

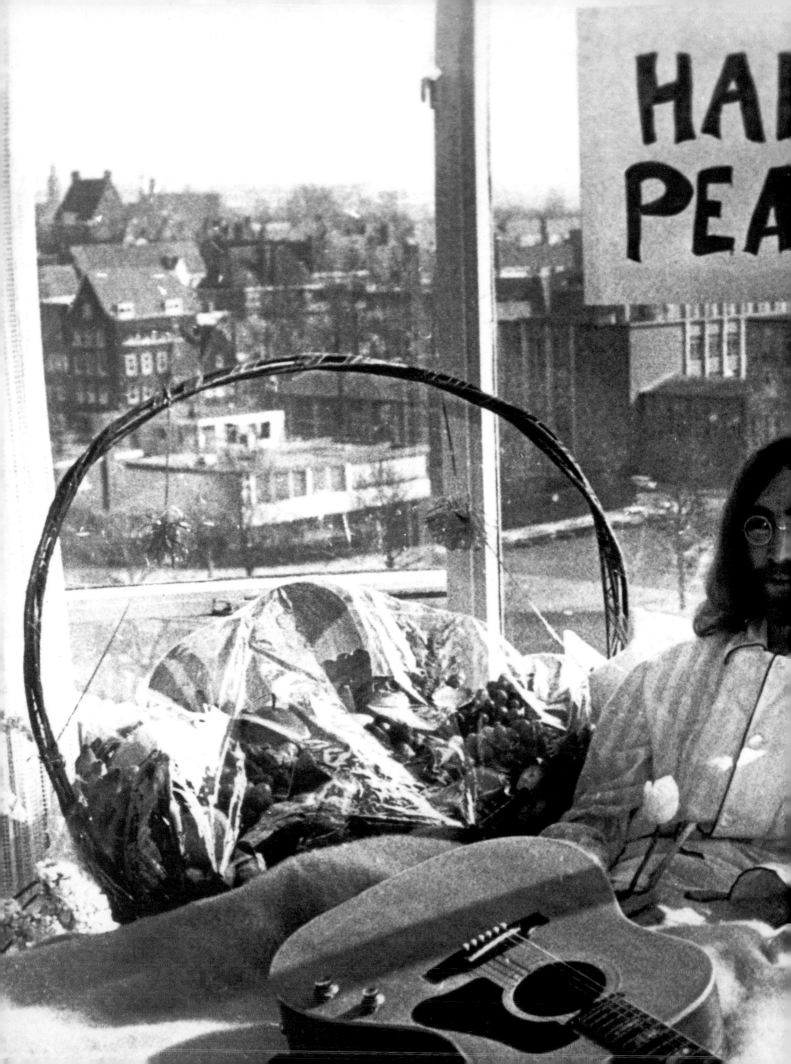

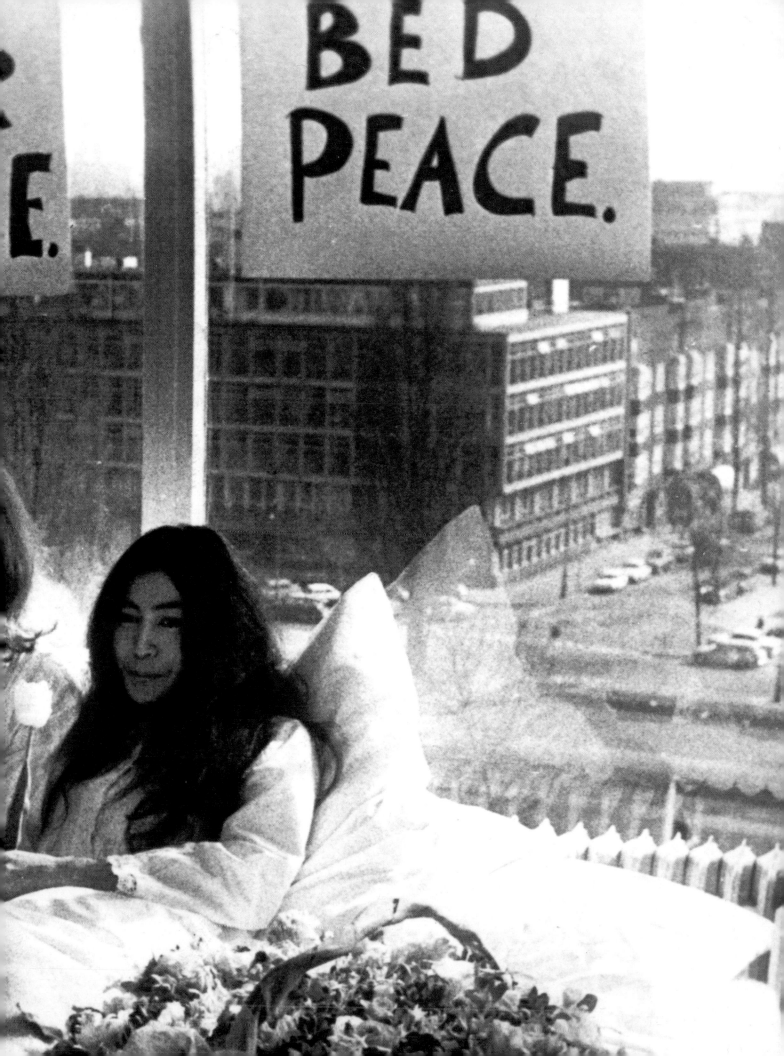

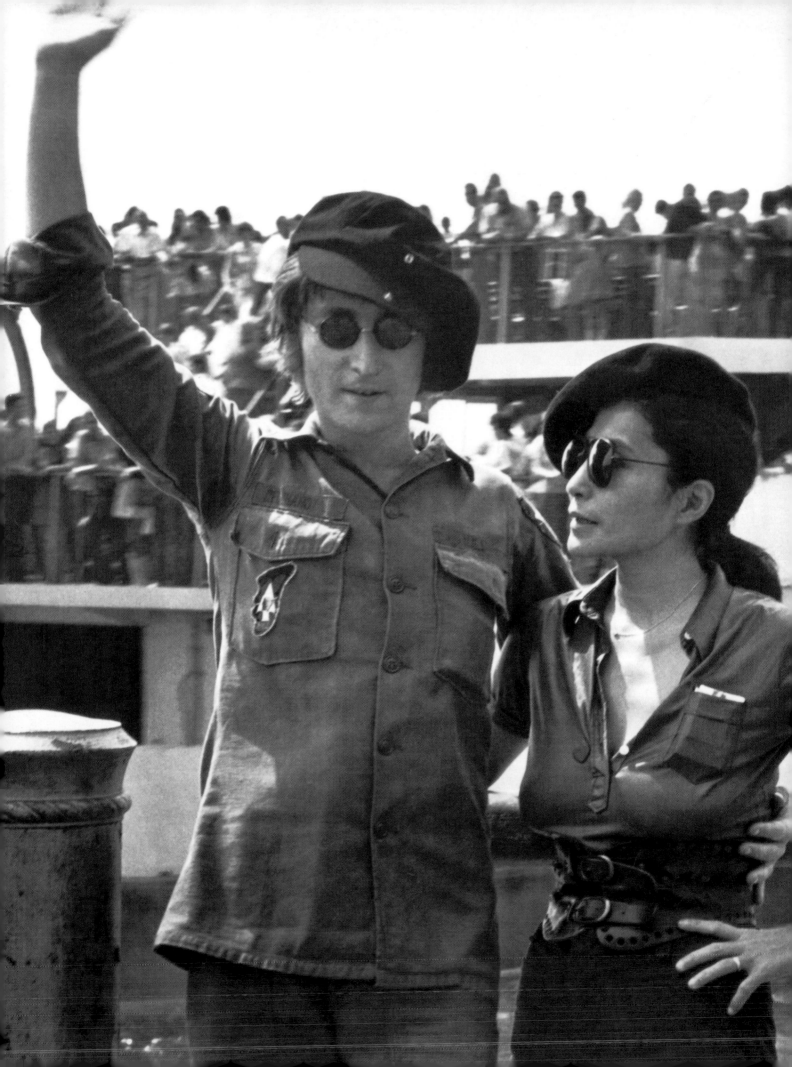

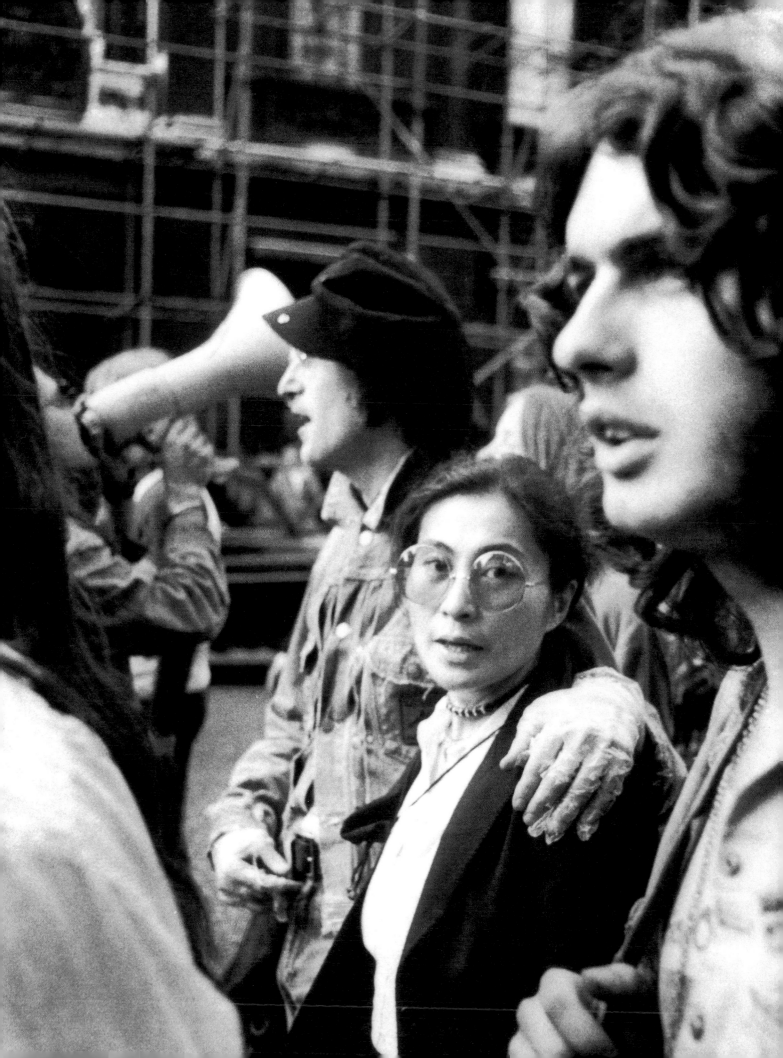

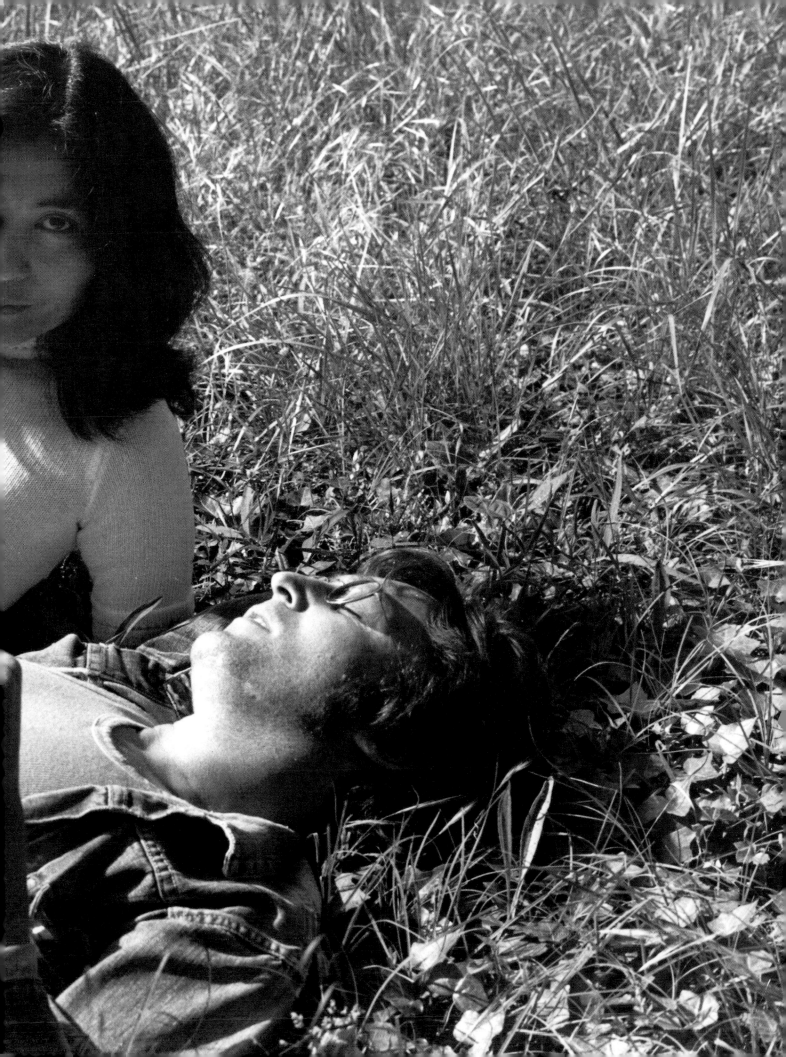

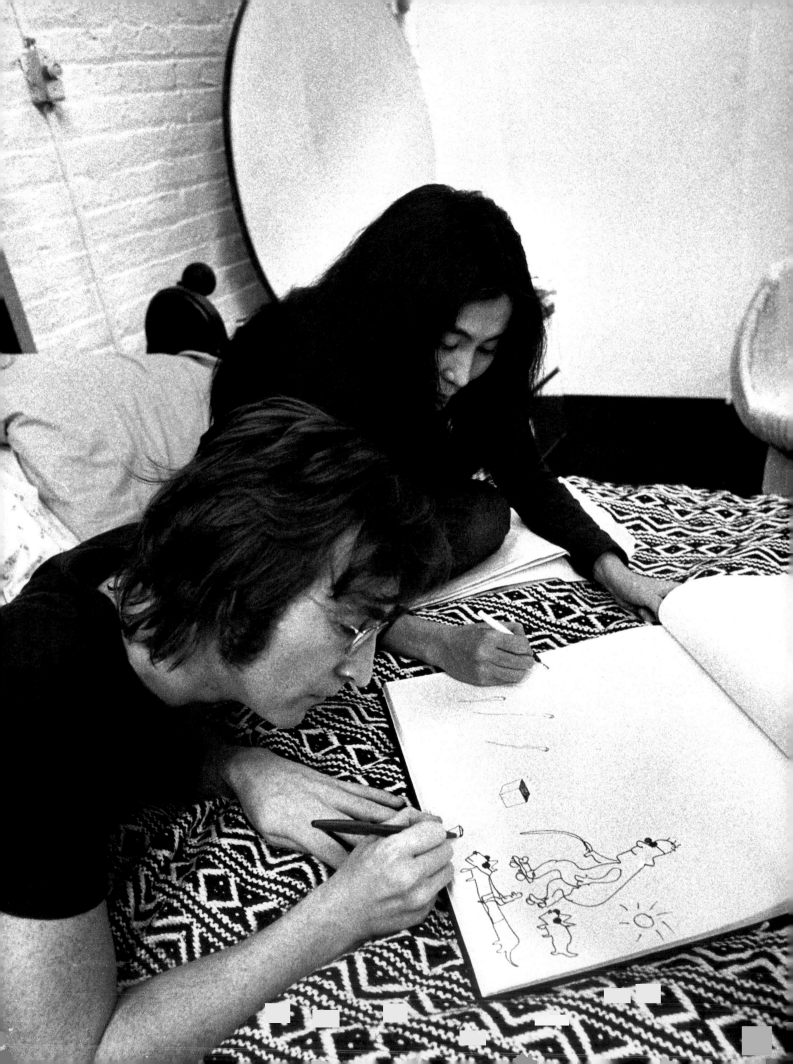

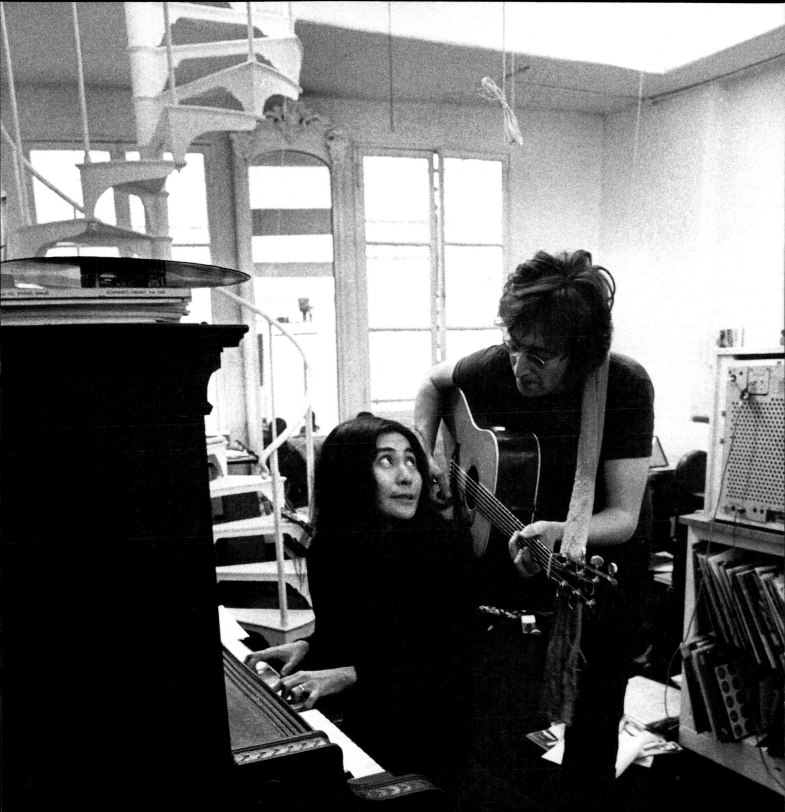

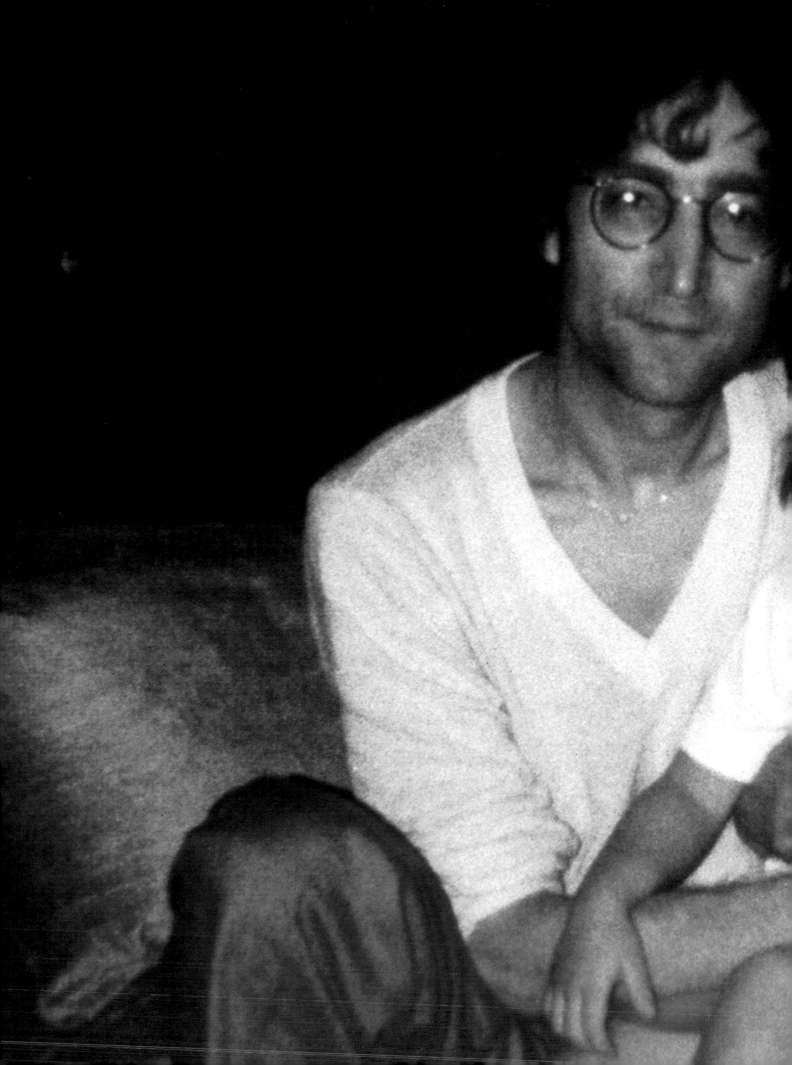

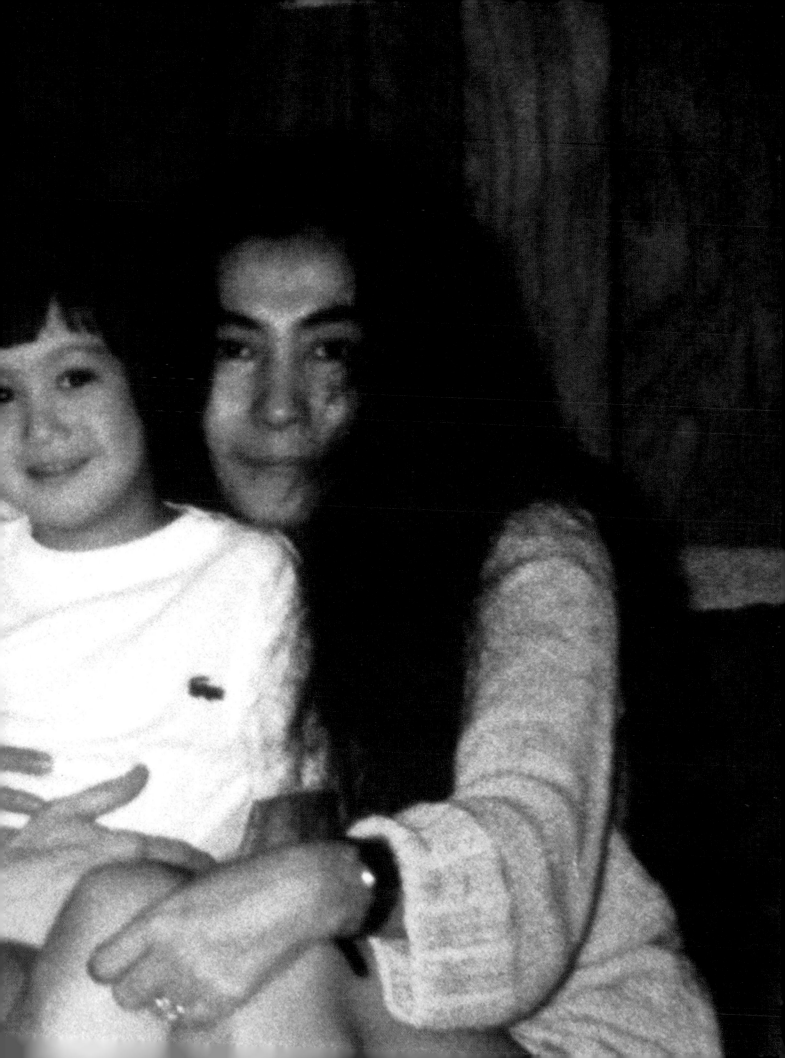

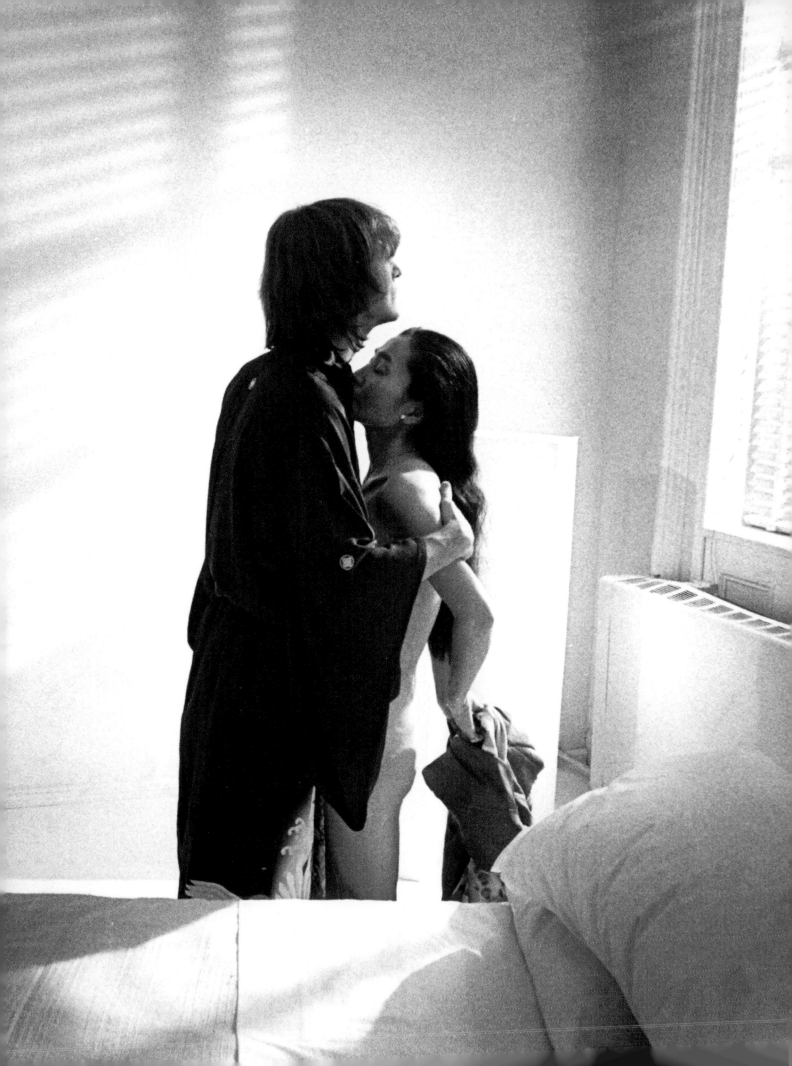

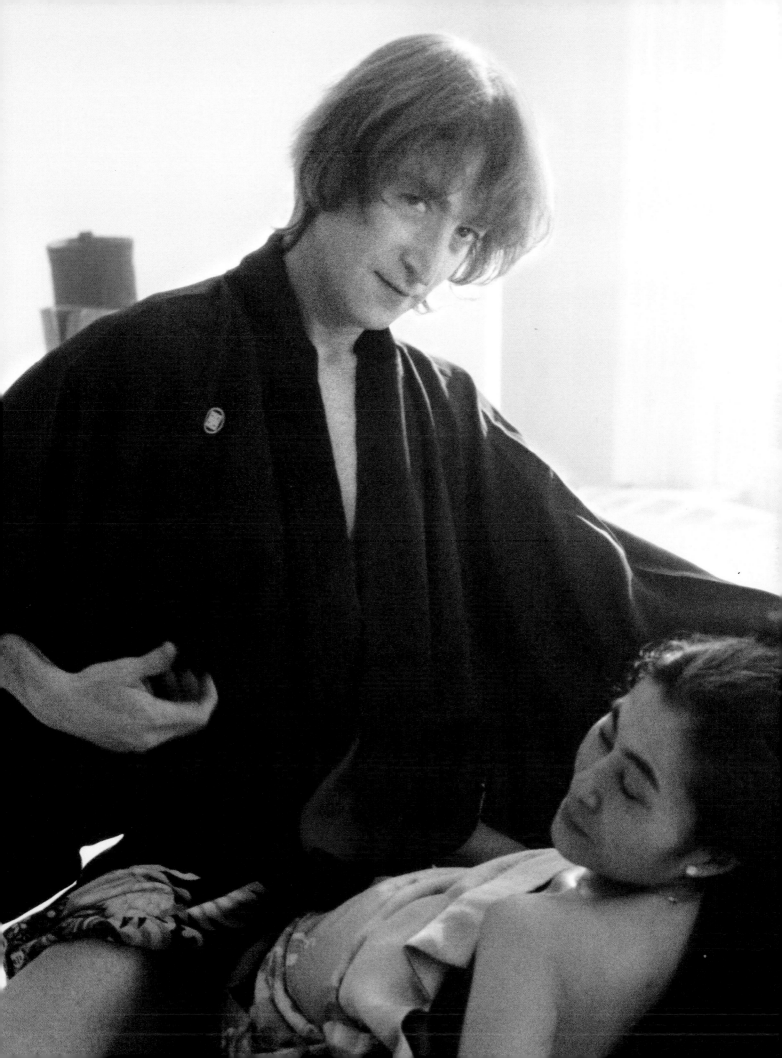

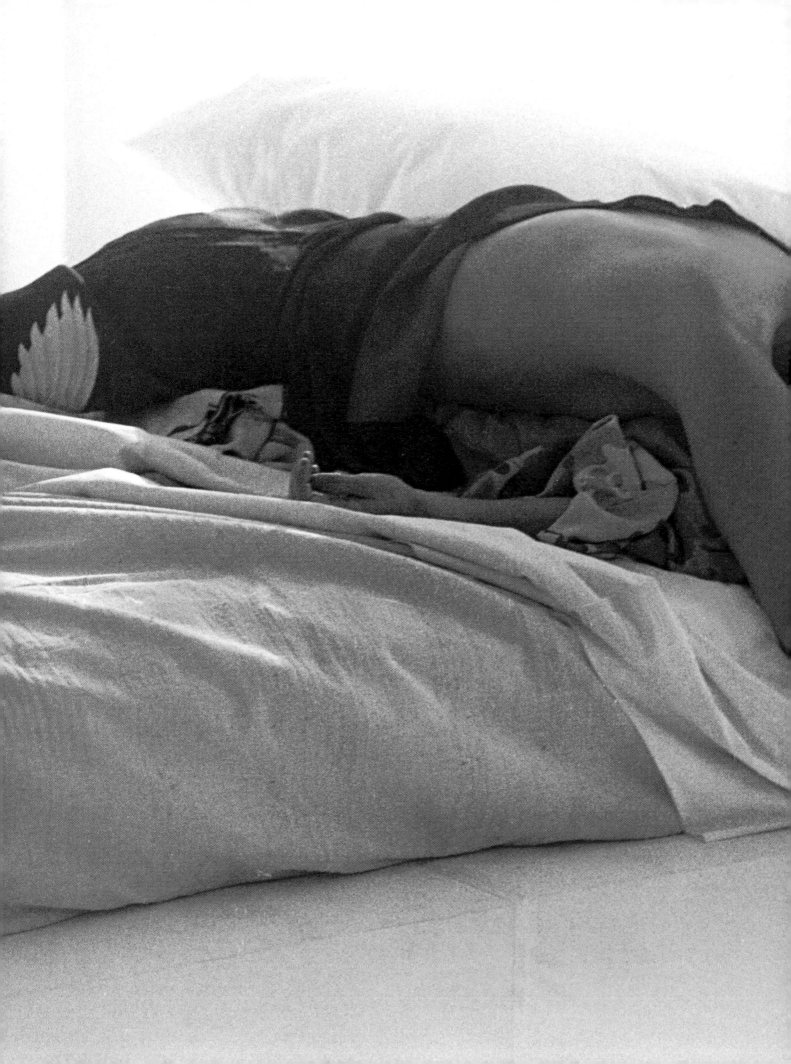

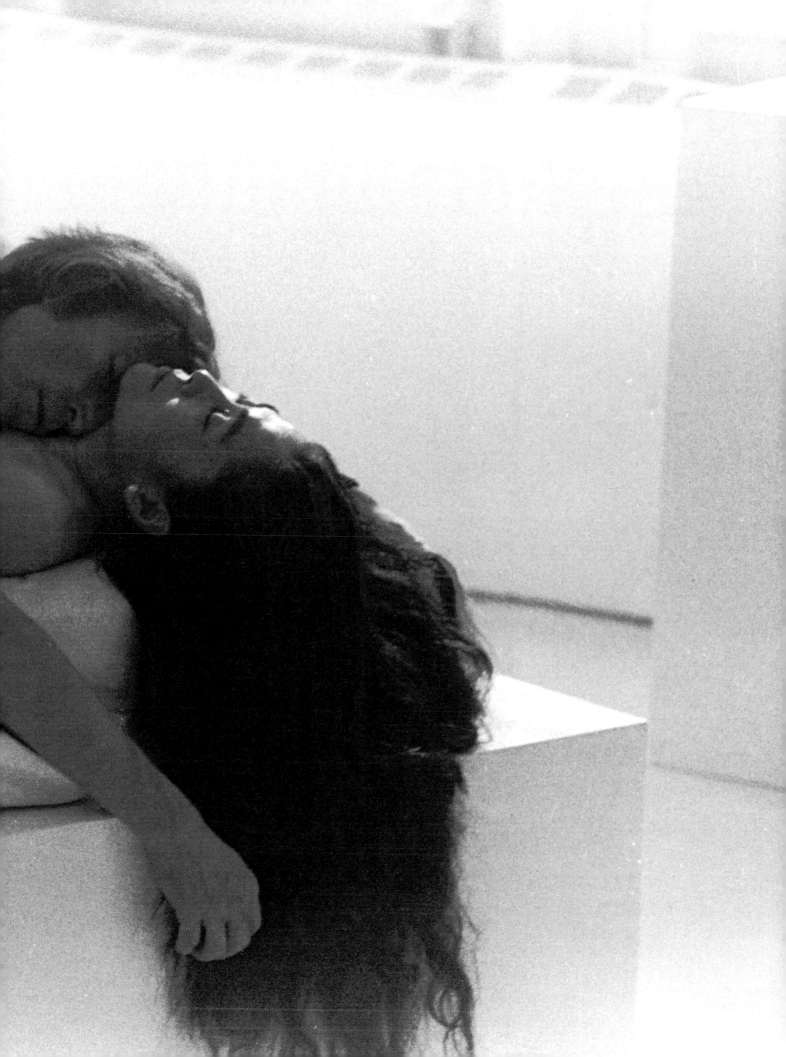

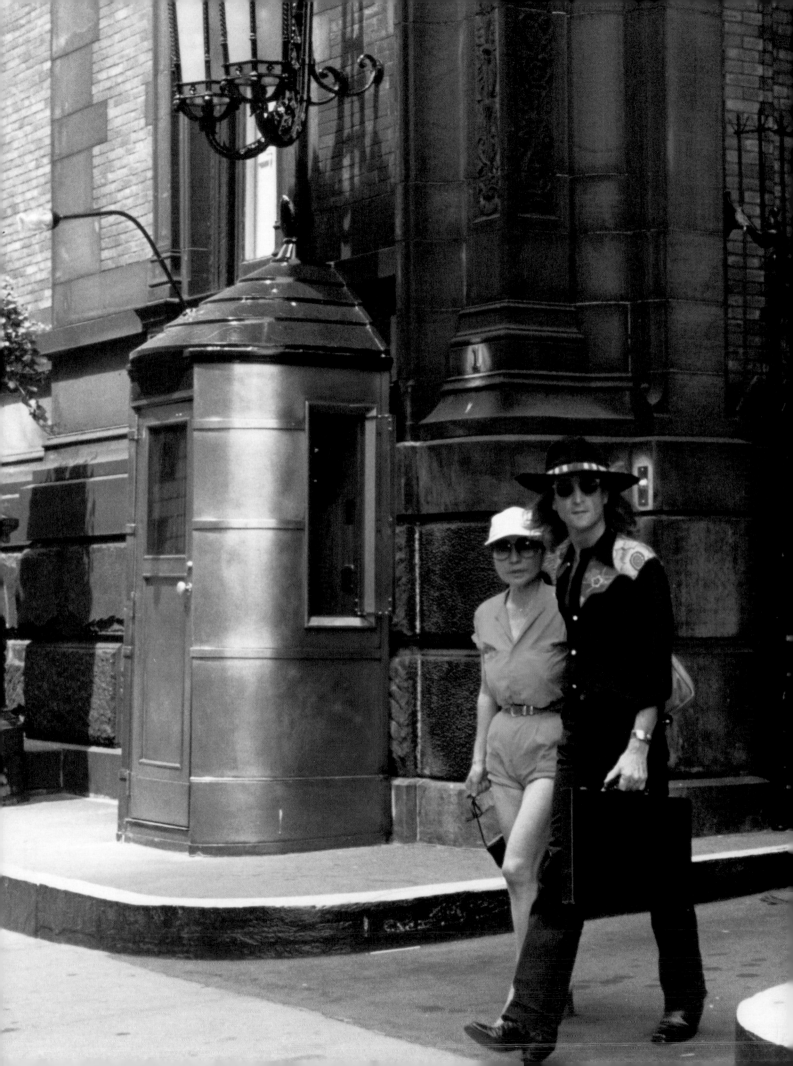

Acknowledgements

The publisher wishes to thank Florence Rossier and Alain Jeanne
for their great help.
Thanks to Didier Rapaud, Pierre Vergnol, Claude Barthe, Pascal
Beno, Yvo Chorne, Geneviève Musitelli, Dominique d'Orglandes,
Gérard Ratineaud.